DIFFERENTIAL AESTHETICS

The area of philosophy formerly known as aesthetics lags behind much recent thinking about culture. Its relevance to contemporary practice can seem highly questionable, and indeed it has been explicitly attacked as anti-radical or unprogressive.

Is it now possible to revisit those issues of value, judgement and sensuous experience that are the proper ground of traditional aesthetics without reinstating unitary understandings of 'the subject' or creating a 'new aestheticism'? What are the deep and serious reasons why feminism, gender studies, materialism, postcolonialism and other radical approaches have been suspicious of these questions? Are they only of interest to Western critics, or does the practice of art internationally offer new insights? Contributors in *Differential Aesthetics* reference diverse thought and practices in China, Ireland, Britain, America, Malaysia, France, Australia in order to open out these questions and render the various discourses and disciplines more permeable to each other.

Differential Aesthetics presents an international collection of essays by leading and new writers and includes artists and philosophers arguing that the philosophy of art must be rewritten for the information age, and that the thought of feminists working in aesthetics has a major contribution to make. This is of relevance far beyond any narrow definition of feminism, and its absence from such debates of the issues, as there are on the left or in radical discussions of art, should be addressed. This book explores how the issues of sexed power, located subjectivity and the body in art are crucial in aesthetics, enabling the ground gained through the critical shift into ideology in the aftermath of the 1960s to be maintained. But equally, it addresses the contemporary art practices and historical questions that became highly problematic as a result. The (social) body and the material are indispensable. Historical issues in Western aesthetics are addressed from Plato, through Kant and the German Enlightenment, selected according to their centrality or persistence as structural, while contemporary art practices remain the primary reference point.

Focusing on visual art, but including contributions on writing, music, dance cyberart and film, this book bridges divisions in contemporary thought, and, crucially, practices, and points to greater understanding of the power and appeal of cultural production. The opening section insists on the need for any philosophy of art to maintain contact with the art of its time by presenting a selection of statements by artists and examples of their work. The essays also include contributions from individuals active both in theory and practice.

'Penny Florence and Nicola Foster have gathered together a fascinating collection of essays addressing one central question: what is the relevance of feminism to the way we think about the category of the aesthetic and vice versa, what relevance does the aesthetic have for feminist theories and practices? A collection of essays, but really of 'voices' – since the points of views embraced are too diverse for a single overriding discourse or language to prevail – from artists with no formal training in philosophy, to philosophers with no experience of art practice to those who have both.

It is a serious and brilliant collection, un-dogmatic in its selection, and it sustains an exceptional level of intellectual energy from start to finish. With so little around that imaginatively addresses this area, it is sure to find a broad and enthusiastic readership. A landmark in its field for years to come.'

–Norman Bryson, Professor of Fine Art and Theory
at The Slade School of Fine Art

'This lively collection affords fresh insights into the world of contemporary aesthetics. The notion of a "differential" aesthetic casts into relief relationships among artists, theorists, and cultural movements that might otherwise go unnoticed, postulating a structure by which the divergent developments among individuals, groups, and forms of expression may be ordered and understood. Not only does this collection represent current evolutions in feminist thinking about art and aesthetic values, it posits a schema for conceiving the dynamism that marks culture and its changes.'

–Carolyn W. Korsmeyer (Editor *Aesthetics: The Big Questions*)

Differential Aesthetics
Art practices, philosophy and feminist understandings

Edited by

PENNY FLORENCE
Falmouth College of Arts, UK

NICOLA FOSTER
University College, Suffolk, UK

Ashgate

Aldershot • Burlington USA • Singapore • Sydney

Published by
Ashgate Publishing Ltd
Gower House
Croft Road
Aldershot
Hants GU11 3HR
England

Ashgate Publishing Company
131 Main Street
Burlington, VT 05401-5600 USA

Ashgate website: http://www.ashgate.com

British Library Cataloguing in Publication Data
Differential aesthetics : art practices, philosophy and
 feminist understandings
 1. Aesthetics 2. Art - Philosophy 3. Feminist theory
 I. Florence, Penny II. Foster, Nicola
 111.8'5'082

Library of Congress Control Number: 00-134813

ISBN 0 7546 1493 X

Front: *Firelung* 2000. Mary Anson. (See Fig. 2.)
Back: *The Science Fiction Version* 1998. Jeremy Gilbert-Rolfe. (See Fig. 6.)

Printed and bound in Great Britain by MPG Books Ltd, Bodmin, Cornwall

Contents

List of Colour Plates

List of Black and White Figures

List of Contributors

Mary Anson is a painter and a writer. She has transformed some of her short stories into film with an award from Cornwall Media Resource and has worked with Cornish film makers on short films shown internationally. She is currently working on a PhD at Falmouth College of Arts looking for the meeting point between practice and theory via her work on site-specific painting and sculpture and exploring the relations between character and space.

Wilhelmina Barns-Graham is an outstanding painter associated with St Ives modernism, but not defined by it. Born in 1912 in Scotland, she remains at the height of her powers. She has been exhibiting since the 1940s and her work is in major public and private collections in England, the USA and Australia. Her recent output is filled with brilliance and colour, and is widely considered to confirm her place in the history of art.

Rosemary Betterton is Reader in the Institute for Women's Studies at the University of Lancaster, teaching in the area of feminist theory and visual culture. Her recent publications include *An Intimate Distance: Women, Artists and the Body* (1996) and contributions to G. Pollock (ed.) *Generations and Geographies in the Visual Arts: Feminist Readings* (1996) and K. Deepwell (ed.) *Women Artists and Modernism* (1998).

Barb Bolt is Lecturer in Art and Design at the University of Sunshine Coast, Queensland Australia. She is a practising artist and a writer on art, currently completing a PhD in philosophy on the performativity and politics of contemporary visual practice. In addition to her exhibitions, her published articles include 'Shedding Light for the Matter', 'Impulsive Practices: Painting and the Logic of Sensation', 'Towards a Digital Aesthetic', 'Queer zine inter/erupts the endurance of ideas' and 'The Aesthetics of abuse and the power of representation'.

RyyA Bread© is a practising artist, originally from the USA, who moved to Britain in 1993. Her current work includes an installation and performance, based on multiple subject positions of her own 'identity text'.

She is at present completing her PhD at Falmouth College of Arts, combining 'linguistic' and 'artistic' practices through an embodied methodology.

Christine Conley is a part-time lecturer in art history at the University of Ottawa, Ontario Canada, and has previously taught at York University, Toronto, Canada. She is a former independent curator and critic who has long been engaged with feminist cultural production. Her PhD thesis at the University of Essex was on the gender politics of allegory in relation to Charlotte Salmon, Eva Hesse and Mary Kelly. She has subsequently written reviews for *Parachute* and has published on Charlotte Salmon in the Canadian *Pflung* and in *RACAR*.

Catherine Constable is Lecturer in Film Studies at Sheffield Hallam University UK. She has a PhD in philosophy from the University of Warwick on 'Surfaces of Reflection: RE/constructing Woman as Image'. She has co-edited *Going Australian: Reconfiguring Feminism and Philosophy* for *Hypatia* (forthcoming) and has published several essays in journals and collected editions.

Sean Cubitt is Chair of Screen and Media Studies at the University of Waikato, New Zealand, previously Reader in Video and Media Studies at Liverpool John Moores University, UK. He is the author of *Digital Aesthetics* and of numerous publications on contemporary arts, media and culture. He is currently working on several books (on simulation for Sage, on special effects cinema for MIT) and co-editing an anthology on post-colonial science fiction with Ziauddin Sardar.

Vicki Feaver Vicki Feaver has published two collections of poetry, *Close Relatives* (Secker, 1981) and *The Handless Maiden* (Cape, 1994) which was awarded a Heinemann Prize and short-listed for the Forward Prize. Her poem *Judith* won the 1993 Forward Prize for the Best Single Poem and she recently received a Cholmondeley Award. A selection of her work is included in volume two of the new *Penguin Modern Poets*. She is Professor of Poetry at University College, Chichester.

Robyn Ferrell is Professor of Philosophy at the University of Macquarie, Australia. She is the author of *Passion in Theory: Conceptions of Freud and Lacan* (1996), a novel *The Weather and Other Gods*, and numerous academic and literary essays.

Penny Florence is Professor and Director of Research at Falmouth College of Arts. Since gaining her doctorate at the University of York for a thesis on French poetry and painting, she has worked in English, French and Art History departments, and as an independent filmmaker. She has published widely on cultural theory, art, film and feminism. She thus brings the view of an inveterate interdisciplinarian to bear on her current research interests which include a CD-ROM of Mallarmé's poem *Un coup de dés jamais n'abolira le hasard* and Barbara Hepworth.

Nicola Foster is Senior Lecturer and Course Leader, History and Theory of Visual Art, University College, Suffolk. She is also a Visiting Lecturer at several Art Schools. She is on the Editorial Board of *Women's Philosophy Review* and has published several articles on philosophy, aesthetics and the history and theory of art. She is currently completing her PhD in philosophy at the University of Essex, UK.

Barbara Freeman is an artist who was born in London in 1937 and now works in Belfast, Northern Ireland. She studied Fine Art at St Martin's, Camberwell and Hammersmith Colleges of Art and has been exhibiting her paintings, prints, sculptures and installations since 1966, including many solo shows. She has works in international public and private collections.

Jeremy Gilbert-Rolfe is a British born artist and writer who lives and works in the USA where he teaches in the Graduate School, Art Center, Pasadena, California. His publications include *Immanence and Contradiction: Recent Essays on the Artistic Devise* (1986); *Beyond Piety: Critical Essays on the Visual Arts, 1986-1993* (1994); *Beauty and the Contemporary Sublime* (1999) and with Frank Gehry, *The City and Music: Architecture and Theory in the Work of Frank Gehry* (2000). He has won several awards for both painting and criticism, including an NEA Fellowship, a Guggenheim Fellowship and more recently The Frank Jewett Mather Award.

Lubaina Himid was born in Zanzibar Tanzania and is currently Reader in Contemporary Art at the University of Central Lancashire, UK, and a practising artist. Her recent shows include *Hogarth on Hogarth* at the Victoria & Albert Museum, UK, *Venitian Maps* at Harris Museum, *Zanzibar* at Oriel Mostyn, *Memory Woman* at Wellington City Art Gallery and *PLAN B* at the Tate Gallery St Ives. Current projects include a book on Betye Saar, an essay on Hogarth for Yale UP, an exhibition in Bergen Norway exploring Leprosy/Histories and an exhibition in Bolton Lancashire titled *Double Life* exploring Memory/Family/Identity.

Jo Hsieh was born in Taiwan in 1967 and has exhibited widely, achieving recognition in international competitions. She graduated from Chelsea College of Art in 1996 and from the Royal College of Art in 1998. Jo joined the PhD programme at Falmouth College of Arts in 1998.

Rachel Jones is a lecturer at the University of Dundee, Scotland, UK. She is co-editor of *Going Australian: Reconfiguring Feminism and Philosophy* for *Hypatia*, and of *Matter of Critique: Rereading in Kant's Philosophy* (2000), and the author of several articles on Kant and aesthetics.

Petra Kuppers is a community artist and a Postdoctoral Research Fellow in Performing Arts at Manchester Metropolitan University, UK. Her publications include edited issues on New Mainstream Images of Disability for *Disability Studies Quarterly* and on Disability and Performance for *Contemporary Theatre Review*. She has published several journal articles on identity politics and performance, dance and cultural theory. She won the Lisa Ullman Travelling Scholarship in 1998 and an Arts Council Training Grant in 1999 to research into community dance and new media. She is currently preparing a book *Between Representation and Embodiment: Bodies, Freaks, Filmdance*.

Bracha Lichtenberg Ettinger is an artist and psychoanalyst. She was born in Israel and now lives and works in Paris and Tel Aviv. She has had numerous solo exhibitions at major museums including the Israel Museum, Jerusalem; Le Palais des Beaux-Arts, Brussels; Le Noveau Musée, Villeurbanne and the Museum of Modern Art, Oxford. She has participated in many contemporary group exhibitions such as *Face à l'Histoire* (Pompidou Centre, Paris) and *Kabinet* (Stedlijk Museum, Amsterdam). She is the author of numerous essays and several books, including *The Matrixial Gaze, Halala Autistswork* and *Lapusus: Notes on Painting*. Her collected essays *Matrixial Gaze and Borderspace* is forthcoming with Minnesota UP.

Yuen-yi Lo is a Hong-Kong artist and designer. In 1979 she gained a two year scholarship from the Italian Government to study Fine Art in L'Academia di Bella Arti in Florence. She read for the MA in Drawing at the Wimbledon School of Art, London where she gained the first prize at the Wimbledon Studio Postgraduate Drawing Award in 1998 and in 1999 she gained 'highly commended' at 'Freeze Framed: A Moment of Drawing'. She has exhibited widely in Hong-Kong and Britain.

Marsha Meskimmon is Lecturer in Art History at Loughborough University, UK. Her research interests are in women's art and feminist theory. She is the author of *The Art of Reflection: Women Artists' Self-Portraiture in the Twentieth Century* (1996); *Engendering the City: Women Artists and Urban Space* (1997) and *We Weren't Modern enough: Women Artists and the Limits of German Modernism* (1999), as well as numerous articles.

Judy Purdom has recently completed a PhD in philosophy at the University of Warwick, UK on Deleuze and painting. She has published articles on Deleuze and Merleau-Ponty, contributed to *Third Text* and is a co-editor of *Going Australian: Reconfiguring Feminism and Philosophy* for *Hypatia* (forthcoming).

Valerie Reardon is a photographer and writer who lectures part-time at Falmouth College of Art in the faculty of Art and Design Studies and the faculty of Media and Culture. She has exhibited in the UK and in Germany and has published numerous articles and reviews in both the American and British art press. She is currently working on a book about the American artist Hannelore Baron about whom she wrote her PhD.

Deborah Robinson is an artist who works in painting and photography and is a lecturer in Fine Art at the University of Plymouth. She is currently involved in research experimenting with the transformation of text achieved by putting it through a visual process.

Hilary Robinson is Senior Lecturer at the School of Art and Design, University of Ulster, Belfast, Northern Ireland, where she is also Co-ordinator of Research. Educated as a painter in the 1970s, she began writing in the 1980s on the body and images of sexuality in art. Her PhD is on the implications of the writings of Irigaray for feminist art practices. She is the author of *Visibly Female: Feminism and Art Today – An Anthology* (1987) and is currently working on an anthology for Blackwell *Feminism/Art/Theory 1968 – 2000*.

Lesley Sanderson is a practising artist born in Malaysia. She is a lecturer at Sheffield Hallam University and at the Wimbledon School of Art, London. Sanderson has shown widely in exhibitions such as *The British Art Show* 1990, *New North* and *Transforming the Crown* (NY). She is currently involved in collaborative work with the artist Neil Conroy with whom she has exhibited in *East International* 2000.

Nancy Spero is an American artist and feminist. She began working and exhibiting in Chicago and Paris in the 1950s and moved to New York in 1964 where she still lives and works. She has had many major exhibitions around the world. In 1987 the Institute of Contemporary Arts in London held a retrospective, and in 1999, the new Ikon Gallery in Birmingham, UK opened with a solo show of her work.

Barbara Underwood is a musician and a philosopher. She has published several articles in journals both in Britain and abroad. She has recently completed a PhD thesis at the University of Manchester on Plato's gendered configuration of music and is at present working on a book on the same topic.

Partou Zia is an award-winning artist who was born in Tehran, Persia (now Iran), in 1958. She has degrees from the University of Warwick and the Slade School of Fine Art. She has exhibited widely, including several one-person exhibitions. She is member of the Newlyn Society of Artists and is currently completing her PhD at Falmouth College of Arts.

Acknowledgements

This collection would have never become a reality without the co-operation and generous support we received at every stage. It is thus a pleasure to thank everyone who has helped us in its production, though we regret there is never the space to name everyone or to specify all the different ways in which people have contributed. They are all nevertheless greatly appreciated.

Christine Battersby is particularly prominent in deserving our thanks, not only because of her groundbreaking work in feminist philosophy and aesthetics, but also because this book grows out of an initiative of hers. She invited us to edit a Special Issue on Aesthetics for the *Women's Philosophy Review* of which she is the General Editor. It quickly became apparent that we had a much larger and more interdisciplinary selection of material than could possibly be published in a Special Issue of a philosophy journal. We therefore decided to produce two complementary publications in the form of this book and the Special Issue. There is of course some degree of overlap between them, but their aims are different, and interested readers will find in the *Women's Philosophy Review Special Issue on Aesthetics* more Artists' work, as well as Exhibition Catalogue and Book Reviews, Conference Reports and a selection of Survey Articles on feminist aesthetics internationally. Christine also introduced us to our splendid editor, Sarah Lloyd at Ashgate Press, with whom it has been a pleasure to work, especially under the kind of pressure that meeting a tight deadline has entailed.

We also wish to thank Peg Brand for her scholarly comments on the manuscript, done with admirable dispatch and clarity. We are all indebted to her important and indefatigable work in aesthetics, especially in opening up analytic aesthetics generally to issues such as feminism, race and gender.

As editors, we owe a great debt to the artists and writers in their respective disciplines whose work is included in this collection, and who have worked so constructively with us on the project. But there is another group who

also should be mentioned here, and it includes some of the present contributors. They are the speakers at the *Feminism and the Aesthetics of Difference* conference held at Falmouth College of Arts and at the University of London Institute of Romance Studies on September 8-9th 1995. That event was significant in developing this book. In the spirit of Monique Wittig's recitation of *Les Guerillières*, and, more prosaically, in alphabetical order, those who gave papers were: Sara Ahmed, Ronn Beattie, Jane Calow, David Cottington, Humphrey Couchman, Katy Deepwell, Elizabeth Eastmond, Bracha Lichtenberg Ettinger, Alison Finch, Rose Frain, Margaret Garlake, Hélène Gill, Jane Grant, Vivien Green-Fryd, Alex Hughes, Kate Ince, Mercedes Kemp, Ruth Lingford, Fran Lloyd, Marie-Anne Mancio, Marsha Meskimmon, Malcolm Miles, Andrea Noble, Mary Orr, Ian Paterson, Doina Petrescu, Griselda Pollock, Todd Porterfield, Frances Presley, Jane Prophet, Matthew Rampley, Valerie Reardon, Dee Reynolds, Lisa Rull, Gill Rye, Leena Kore Schroder, Lyndsey Stonebridge, Harriet Tarlo, Anne Wagner, Nedira Yakir.

Penny Florence wishes to acknowledge the generous support of the Research Fund at Falmouth College of Arts (FCA). We both also want to thank Simon Culliford of the Photography Department at FCA for his brilliant work on the visual material, and Paul Monnington and Nathan Prisk of FCA IT staff for their invaluable expertise. Finally, our particular thanks to Dionne Jones, Research Administrator at FCA, for going the extra mile.

Part 1

Introduction: Philosophy and Feminism

Penny Florence and Nicola Foster

> *And like any artist with no art form, she*
> *became dangerous.*
>
> Toni Morrison, *Sula*[1]

> *The aesthetic is not the political, but it may make*
> *the political possible.*
>
> Isobel Armstrong[2]

This is an interdisciplinary and international collection on aesthetics with contributions from artists and philosophers and the range of thinkers about art in between.[3] It aims to provide a forum for the kinds of question that used to be addressed within traditional aesthetics, but which have until recently been sidelined in critical writing about art and indeed in many of the most important art practices. The reasons for this are both simple and complex, and we try to address both, though obviously to do so exhaustively would require much more than any one volume could offer. The following question, put in parenthesis by Isobel Armstrong in 1993, pinpoints one of the most important: she is writing primarily in (spirited, erudite and witty) response to Terry Eagleton's *Ideology of the Aesthetic*, but also here referring to David Lloyd's in many ways suprising *rapprochement* of Derrida and Paul de Man.[4]

> Is this powerful convergence of so many masculine texts in the anti-aesthetic related to the present historical moment of feminist thought? This massive attack coincides with the last twenty years, when women's creativity has burgeoned, and aesthetic artefacts, writing and cultural production have been a huge part of the feminist agenda and the energies which have created a feminist counter public sphere. This attack has occurred just when aesthetic

productions have been politicized for emancipatory writing, just when discursive networks of feminist production have challenged the managed society, establishing a form of communality despite the fragmentation of feminisms. This is a proper question, not a recrimination, for the project of reclaiming the aesthetic for the left is as important as reclaiming it for feminism: the two are bound together. (Armstrong 1993, 180)

The intervening seven years since Armstrong wrote the above have seen the attacks on feminisms of all colours and on the Left both sustained and diversified.[5] The last few years have also seen a shift in most critical approaches to the aesthetic including those either self-identified or seen as feminist. Analytic Philosophy, however, seems to have inhabited a reassuring and blessed place in which any such growth has been negligible.[6]

This collection explores ways of setting such variable developments into meaningful relation without assimilating them the one to the other. The collection as a whole is clearly situated in relation to feminists' approaches, but we hope it will not be read as limited to them. As in another context bell hooks has put it, 'To make oneself vulnerable to the seduction of difference, to seek an encounter with the Other, does not require that one relinquish forever one's mainstream positionality' (hooks 1992, 23). Or, we might add, *vice versa*. Despite the bad press, we understand contemporary feminism to be supple enough to enable negotiation of new levels of interconnection, at the same time as sufficiently incisive to continue to critique culture and thought, not least its own. That is to say, these essays are part of a feminist agenda insofar as feminism is their primary reference-point. But they are working towards a broadly participatory understanding that argues why thinking about aesthetics in general should be attending to what feminism/s (and their derivatives or associated philosophies) have to bring to contemporary thinking about art and aesthetics. Feminism as an interrogation of the notion of disinterest is always already in the position of antagonist in relation to central aesthetic assumptions and tenets.

According to the Oxford English Dictionary, the term *differential* means: relating to, depending on, or exhibiting the difference of two or more [...] (physical) qualities or effects. Differential in our understanding concerns the relation of the physical/material to all the energies, ideas and psycho-

social elements that are often posed as not-material. This is a crucial point, and it is examined and elaborated in many ways in the essays that follow. The question of how to understand the transitions between the material and representation has been open, at least since Freud. The relationships between the so-called 'physical'/'material' and representations has become a central philosophical question that is inseparable from the aesthetic. Thus, the issue of difference and the differential has to be considered in any politicised reading of art and aesthetics, and perhaps also when theorising aesthetics in interart terms.

In the article cited above, Armstrong was writing about literature. Aesthetic issues in the visual arts, the moving image and music, not to mention the nascent digital arts or indeed Cultural Studies, are variously articulated and foregrounded. While keeping sight of these specific insights and applications, a differential approach to aesthetics must also have explanatory power as an interart theoretic. The essays collected here refer to music, film, visual art, writing, philosophy, cyberart, dance and performance. It is furthermore our contention that the slow re-emergence of interest in the aesthetic must be considered in relation to developments in art practice, and that those changes make the need to rethink the aesthetic more urgent still. We have therefore included both Artists' Statements and Critical Essays, placing the former right at the beginning. Further commentary on the aims of each section, and on the statements and essays themselves, is set out in our individual Section Introductions.

In no way, then, is it our intention to argue for a return to a traditional framework or to promote what has been called the new aestheticism. The idea, variously expressed on the Left, that the aesthetic is a category that is inherently rightist must have the entire range of persons from the conservative to those of repressive or fascist bent laughing all the way to the arms bank. Nor is it to argue for a feminist aesthetics of the kind so thoroughly critiqued by Rita Felski at the end of the 1980s.[7] (Though we do not want to dismiss earlier feminist developments – the point is exactly that there have *been* developments, and continue to be.) Janet Wolff described the exhibition she planned to curate, *Women at the Whitney 1910-1930*, as follows: 'If we can characterise feminist revisionism (rediscovering women artists and incorporating them into the canon) as

1970s feminism, then I would say (at the risk of equally broad generalisation) that the Whitney project became one of 1990s feminism – the analysis of gender construction as it operates in the field of modern art and its institutions' (Wolff 1999, 119).[8] Following on from this, we might chance the suggestion that feminisms in the first decade of 2000 will build on these to elaborate differentials, internal certainly, but especially perhaps externally, in relation to those whose work is co-extensive with feminism, even while it may resist it.

This general situation puts a particular cast on the fact that the excellent work that has been done in explicitly feminist aesthetics has received nothing like the kind of serious attention it deserves. The kind of argument made by Christine Battersby in her 1991 essay 'Situating the aesthetic: A Feminist Defence' still seems to be necessary.[9] That essay was in a collection edited by Andrew Benjamin and Peter Osborne *Thinking Art: Beyond Traditional Aesthetics* (1991), but the book remains an honourable and welcome exception to the majority. Like the feminist collections *Aesthetics in Feminist Perspective* (Hein and Korsmeyer 1993) and *Feminism and Tradition in Aesthetics* (Brand and Korsmeyer 1995), what they have to say has not been anywhere near adequately built upon and developed.[10] There is also an increase in introductory readers and overview texts whose frameworks remain utterly inadequate to contemporary artists or to progressive students of culture.[11] This is not necessarily to say that the present moment is all negativity, however, as Korsmeyer's recent *Aesthetics: the Big Questions* (1999) shows, as well as the inclusion of sections on feminism in recent philosophical dictionaries. Peg Brand and Mary Devereux also have a new *Hypatia* collection planned as a follow up to 1993 Hein and Korsmeyer edition. We see *Differential Aesthetics* as working in this context. It is not that there is nothing 'out there', but rather that it remains both fragmented and without the kind of interdisciplinary work or 'critical mass' that can render the discourses fully permeable to each other.

So there is now a growing body of feminist work on aesthetics, and it deserves to be better known. This collection aims to stimulate further recognition of the work that has been done, and to broaden debate on how it can be more effectively circulated. For even among feminists, it is the case that feminist work on aesthetics seems to be relatively little understood. This may be partly because the move into ideology of so much art by women was explicitly intended and interpreted as anti-aesthetic

(Margaret Iversen's essay 'The Deflationary Impulse: Postmodernism, Feminism and the Anti-Aesthetic' is very good on this [Iversen in Benjamin and Osborne 1991, 81-94], Or in this collection, see Gilbert-Rolfe's 'periodisation' of feminist art in America : from the archaic, the severe and heroic to the presumptively achieved, or elsewhere towards, for example, the sublime). The idea persists that it is not possible to rethink aesthetics in such a way as to build on the gains that resulted from that strategy.12 It may also, disturbingly, be that the newer generation of women scholars do not (yet?) recognise that feminist thought is of relevance to them.13 When it comes to art practice, the situation is perhaps more problematic still. In the U.S., some young women artists either explicitly deny any feminist interest or influence or they make art that is now called 'girlie art' or 'bimbo art'. Indeed, one of the UK *Sensation* show artists, Lisa Yuskavage has been referred to in this way.14 The strategy of creating images of women that invoke stereotypes of dumb blondes, big-breasted sex symbols is a risky one, and it remains to be seen whether this kind of play on gender stereotypes is as free as its makers imagine. To say that in some ways it can look very old and predictable to promote this kind of blunt transgression is not necessarily to make a repressive argument. It is to raise questions of differentials in identification, audience, tradition and strategic efficacy, as well as in aesthetics.

Artists play an important role in the theorisation of art. This ought to be obvious, not least because they have pushed the boundaries of art well beyond the breaking point of traditional aesthetics thus forcing new definitions. But because artists and philosophers of art have each inhabited very different discursive, social and epistemological worlds, there are difficulties for anyone wishing to address aesthetics in such a way as to bring them together. Far from being a weakness, this difficulty can be made a strength, as possibly demonstrated in the provocative collection *Uncontrollable Beauty* (Beckley and Shapiro 1998), whose editors Bill Beckley and David Shapiro are both artist-theorists (in visual art and literature respectively). *Differential Aesthetics* seeks to build on that strength as part of its broader understanding of differentials. Contributors range from artists with little formal training in philosophical aesthetics, through those who have straddled both, to philosophers with no experience

of practice. We have not sought to homogenise the writerly energies of our contributors into one regularised academic style or approach. We hope that the reader will find the resultant variety of articulations on related themes, together with the breadth of media covered, productive in thinking about issues that are common to all art forms at the same time as sufficiently varied in application to cast new light on those common issues. It is not now possible to return to an understanding of aesthetics that ignores either interart, cyberart or medium specific conceptualisations, or that again frames such ideas within an unchanged tradition.

These arguments, although presented here in relation to aesthetics in particular, also carry implications for philosophy in general, and as the work of Drucilla Cornell evidences they carry over into actual structures of power and control, for example in jurisprudence (Cornell 1991,1995). Hilde Hein considers the place of aesthetics in feminist theory as central to its philosophical innovation (Hein 1995), while Joseph Margolis has argued the mutual relevance of feminism and analytic philosophy (Margolis 1995). Penelope Deutscher's *Yielding Gender*, which constitutes an intervention in the history of philosophy, while it does not take up aesthetics as such, analyses gender and 'constitutive instability' in such a way as to be of considerable relevance (Deutscher 1997). The point is that 'the aesthetic' can and should be theorised as part of contextualised and contemporary understandings of art and thought in societies past and present, and not as a minor sub-section of an academic discipline.

The feminist contribution to culture perhaps suffers as much as it has benefited from its political tradition. While theorists including those considering aesthetics may now embrace the idea that disinterest is an impossibility, feminist thought is still seen as lacking it. Doubtless this is part of the general problem of perceptions of the Left-ist related thought;[15] it is seen as insular, especially in its insistence on generic class divisions, with which gender may in some respects be analogous. It would matter little that feminist insights should eventually become subject to the kind of invisibility that results from transformation and assimilation were it also the case that the core insistence on differentials such as race and gender had been thoroughly understood. This is not so. The 'feminism' that receives such a bad press today is frequently – usually - a caricature of a selection of 70s moments. What is more, these versions of feminist ideas are also usually generalised to the point of undeniability – no specific

arguments are mentioned or, crucially, attributed, so that debate is cut short, limited in application or trivialised.[16]

This makes it particularly important to demonstrate ways in which feminism, or feminist perspective/s, has fundamental insights to offer even those who might not accept any need for gender/sex specificity at any level. The following example is from one of the few texts on aesthetics to refer to feminism at all, apart from those by feminists. The point of taking it up is to demonstrate that the writer could have found grounds for much more challenging and fundamental debate than the ones he chose. This is a lost opportunity all round.

In his *Critical Aesthetics and Postmodernism* (Crowther 1996 [1993]) Paul Crowther, a regular contributor to the debates in the U.K., critiques what he calls the 'gendercentric' approach to violence in painting. In no case does he give specific examples. His interesting discussion of violence in representation could have had greater resonance had he actually looked at particular feminist arguments. His passing mention of Gentileschi's *Judith and Holofernes* makes Whitney Chadwick (1990) a reasonable guess as an assumed target for his remarks. But leaving it open to guesswork is not to make scholarly reference or debate, and he does not take up any of Chadwick's points about the depiction of violence either by women artists or female protagonists in the represented scene. Crowther's version of the 'gendercentric' approach maintains, 'If the work is violent (and especially if it involves violence towards women), then to enjoy the work is to enjoy it on the oppressive basis of sexuality in a patriarchal society' (Crowther 1996, 110). This is the limit of what he thinks has been suggested.

It is certainly true of some feminists' positions, though not all feminists by any means find the idea of patriarchy either relevant or useful in this way. Leaving aside the great range of hotly contested debates - on violence, identification, spectatorship, subject-formation, sexuality (including fetishism and S/M) and power within and beyond aesthetics which are elided in this simplification - what is particularly suprising is Crowther's explanation. He suggests that what is lacking in feminists' analyses is the recognition of 'the fact that the viewer is here engaging with a violent painting rather than a real scene of violence can restructure the response in

a significant way', (Crowther 1996, 104). The seriousness and level of sophistication of contemporary feminist discussions around how representation interfaces with reality, and what theoretical models or approaches have to offer individually or in combination, deserves rather more exact commentary than this.

After illustrating his point with a few anecdotal examples, he goes on to say that 'whereas the contemplation of violence in real life is inhibited by a sense of conscience and a sense of the independent reality of the events taking place, in painting these constraints are removed. The viewer can achieve a complete appropriation of the violence in terms of his or her personal fantasies and interests' (Crowther 1996, 105). This gives no insight into any interrelation between fantasy and 'real life', nor does it consider the extent to which the individual is constructed by representation, whether viewed in light of performative theories, more strictly psychoanalytic thought or its later more philosophical revisions. In this collection, Barb Bolt's work on the Western assumption, that representation is always mediated, examines the iconic and the notion of the methektic in signification in light of indigenous Australian art and her own practice. By inserting into her argument examples from Western art history, she indicates that this is a suppressed current within it. Her insistence on the energetic potential of matter is vital to an examination of the aesthetic.

This gives a clue as to the real point of taking up what Crowther has to say. Just as we get to a really fundamental level, where Crowther touches on his own pessimism and his underlying sense of separateness (release from which is one effect of aesthetic 'unity' in his version), he moves on to setting out 'our' response to various formal elements. Crowther suggests in passing that 'if our world view is materialist, a sense of finitude ... must be paramount. It is here, I would suggest, that we must look for the ultimate origin of that desire for violent transgression upon which painting sometimes draws' (ibid). The connectivity explored in this collection is configured quite differently from the old idea of *formal* unity through which Crowther is led into misrecognition and detachment, along with most traditionalists, and it is far more fit for purpose when it comes to understanding art since the beginnings of modernism, and especially recent art. Recuperating these kinds of art to formal unity is a task indeed.

The position of this collection is clearly materialist, but not in Crowther's sense. Both the 'differential' redefinition of the material referred to above, and how it might relate to 'finitude', are taken up in complementary ways by several of our contributors in their theory and practices. It hardly needs saying that they relate to embodiment in significant ways – as Crowther intends his work should. But feminist work on the embodied, actualised understanding of being and object-relatedness (in strong as well as other senses) is trivialised in Crowther's account, however true of individual positions it may or may not be. It may be effective in the short term to critique a philosophy for the views of its most simplistic exponents, but it has little to do with truth. It may be that the refusal of feminisms to acknowledge a canon makes it more vulnerable to this – there is no single source text or canon, which even in this day of the absent original still seems to be necessary.

The question of what purposes the ghost of *feminism* might serve to those who proclaim its death is implicitly put by Gilbert-Rolfe's witty conceits. His comment on the way feminist art practice might be understood to sit within institutional discourses of art require to be taken on board both by feminism and by all its coevals. So does the hypothesis that the sublime might have been feminine to start with, and that an 'alternative' to a masculine sublime might be androgynous; in this and other areas, the way he suggests combining Lyotard with Kristeva may well offer additional ways forward to that proposed by Christine Battersby (1995), or in this collection Rachel Jones, who seeks to subvert the Kantian sublime rather than look for 'alternatives'.

Situating feminist perspectives on art and aesthetics within wider cultural debates is still a business in which the stakes are high. Not all feminists want to become mainstream and while contestation can be a form of collusion,[17] the cultural role of the *agent provocateur* is not to be underestimated, as the Guerrilla Girls have shown. Feminism is not beyond the charge of pious certainty, nor is any self-aware movement, and to rest with it is to wither. If feminism is not now about the discovery of a freedom from restraints that is yet ethical, and quarrelsome to boot, then it is not worthy of its histories and interventions.

Implicit in much of what has just been set forth is the notion that ideas require specific strategies if they are to travel successfully. The 'politics of transmission' apply to discursive and disciplinary border crossings in ways comparable with interlingual translation.[18] This is to say that there is *intra*cultural work of 'translation' between intellectual and disciplinary groups that requires to be done if mutually beneficial exchange is to take place. Inevitably this collection grows out of British feminism, but in different ways it looks outwards to, Australia, Canada, China, France, Germany, Iran, Malaysia, and the USA.[19] It does so in ways that are inevitably incomplete, but that at least begin to demonstrate the inadequacy of a self-defining understanding of aesthetics.

This is further complicated by the fact that there is now a real sense of commonality between feminists worldwide on certain issues and grounds where there may not be on others. The work of Alice Walker, for example, as an African American writer on female genital mutilation is stark in its confrontation of these differences between women of colour within differing traditions. There should be no mistake that representation is crucial to such differentials. *Warrior Marks* (Walker and Parmar 1993)[20] travels widely *intra*culturally as well as interculturally, and in its account of the development of the film is a powerful insight into art-making as process. It is not a simple matter to demonstrate ways of communicating how this signifies in the context of aesthetics. Yet it does. And it does so through a sometimes unstated, but nevertheless constant, insistence on the complexity of the relation between the material and the symbolic. Only a differential way of thinking can provide the framework for this.

The consequences of the comparative disregard of feminist work in the field of aesthetics, to which we have referred, can be illustrated in the British case through a survey of the past forty years made by the present editor of the *British Journal of Aesthetics*, which predictably made nothing of the feminist contribution. At the end of the survey, Peter Lamarque admits that the journal served primarily to clarify existing aesthetic discussions by seeking to identify universal definitions for art and aesthetic experience. One wonders at the redundancy of this activity over a period such as the latter part of the twentieth century. The problem, however, is not necessarily seeking to identify what really constitutes art and aesthetic experience, it is doing so in an already identified definition of 'great' artists, 'great' art and, what is more, its potential audience. It almost goes without saying that contributors were on the whole male, white and middle

class. But there is still work to be done on how the 'essential' qualities identified are actually limited to that group's experience, and how their articulation as universal human experience, continues to impact.

Lamarque ends his survey with a cautious call for change in suggesting that perhaps a 'sense of the indispensability of aesthetics and its linkage to all aspects of human life' will return 'beauty to its traditional place beside goodness and truth' and 'would restore a perspective to academic aesthetics' which has become narrow in scope. At the end of the twentieth century the stronghold of analytic aesthetics in Britain had come to recognise that the insularity - and so called, autonomy - of aesthetics is philosophically no longer defendable.

But to 'return beauty to its traditional place beside goodness and truth'? As we have already indicated, this is hardly going to restore a sense of the relevance of art. Could a project seeking to return to traditional conceptions of 'the Good' really be seen as an ethical project for the twenty-first century, following recent re-articulations of ethics after Levinas? (As an example, consider his insistence on the ethical obligation to the 'other', which seeks to maintain an ethical dimension to difference.) It is crucial that feminist aesthetics is understood to involve this level of complexity especially at the level of inter-subjective relations, and is not misread as the kind of retrograde enterprise outlined by Lamarque.

Modernity is often characterised by an unbridgeable gap between art, truth and ethics for the 'universal' (male) subject. While analytic aesthetics has chosen to limit its discussion of these kinds of issue to an already prescribed and restricted field – that of the disinterested experience of the beautiful - other areas of philosophy have sought more interrogative strategies.

Martin Heidegger's radical re-articulations of both art and truth offer one interesting re-interpretation which could be productively used by feminists, despite several other difficulties with his philosophy overall. For Heidegger, art is but a form of truth. Beauty, he says 'does not occur alongside and apart from ... truth. When truth sets itself into the work, it appears. Appearance [...] is beauty. Thus the beautiful belongs to the

advent of truth [...] It does not exist merely relative to pleasure and purely as its object' (Heidegger, 1971, 81). Heidegger's remark brings truth within the aesthetic. Thus the aesthetic, for Heidegger, is no mere object of pleasure for a so-called 'universal' subject, but rather an event of revealing and of 'opening' a world. This articulation comes surprisingly close to several feminist articulations and evaluations of art, even though their overall approaches may otherwise be in some respects significantly divergent.

In Irigaray or Ettinger (see her essay in this collection), the aesthetic as connectivity is theorised in different ways as beginning with the conjuction of the material with the psychic, in the mother's body – this is also true in a Kleinian sense of Armstrong. If all of them share the same underlying reference point, it is very differently theorised in each. To frame the issues this way reflects major differences in the varying strands in feminist thought, but what is common to them all is that it immediately installs sexual difference and the gendered universal at the heart of the aesthetic. Indeed, it is possible to argue that it is precisely here that it always has been, but worked according to an agenda that was far from neutral in ethical or any other terms. That is/was an agenda that remains of relevance to all subjects interested in freedom. There is no necessary contradiction between the ethical and pleasure; or to put it the other way round, there is no necessary correlation between the ethical and either the pious or the repressive.

To explore the full ethical dimension of these retheorisations is clearly beyond the scope of this Introduction, but what the overall situation evidences is how profoundly the question of value has been (at least potentially) shifted away from resting on the circularity of the discussions about 'taste' or *formal* connectivity and into significant issues around the relationship between aesthetics and ethics.[21] That art might be ethical may say nothing about artists; it may or may not concern intention and possible interpretations. To say that the aesthetic, like play, is *perhaps* morally neutral, but to work with conceptualising the aesthetic as the experience of connection is to posit a variety of possible arguments which are both universal and sexed. As Kristeva's remark below shows, play is gendered, especially in public, since as soon as any action is public a whole range of representations and power relations are invoked: 'For while a sort of equality or even a dramaturgy is admissible in bed, perhaps provoking the man's humiliation but also his pleasure, this genre of play in the social and

public arena is very difficult to tolerate for both parties, and principally for men' (Kristeva 1998, 327).

Isobel Armstrong ends the article with which we began with seven laconically expressed thoughts about the future. We are thoroughly in agreement with the underlying sentiments of what she says, especially with the idea of the aesthetic as play *qua* play (Armstrong 1993, 184). That is to say, it is as true play rather than as self-consciously subversive play that the aesthetic comes into full force. This may not be to separate them totally, but it is to locate the vital place where occurs 'the transformation of categories which constitutes a change in the structure of thought itself' (ibid.). This affords the basis on which a claim for the contradictory potential of the aesthetic as ethical and political can be made without loss or reduction of its lawlessness. For the transformation of thought is inevitably *about* knowledge - constitutive of it - and as such is necessary to political change. *Transformation* is inherently characterised by its dynamics, not its definition, and is therefore resistant to codification. Hence, of course, the riskiness of the aesthetic and its flirtation with the mad and the empty.

But perhaps as important is the implication that this understanding of the aesthetic is both differential and universal. It is capable of being historicised and specifically located interculturally and *intra*culturally, as it does not presuppose a transcendent or utopian ahistorical space. Play is both of and on the edge of culture/s. Artistic invention is never *ex nihilo*, and aesthetic impact depends on codification in ways analogous to, though not completely assimilable to, communication.

The present is one that opens on to considerable possibilities. The necessary groundwork has been done over the last twenty years both by feminists and by others working in parallel to open up the field. If we have not mentioned some of the dominant names in this it is precisely because they *are* dominant; they appear in abundance in the pages that follow. The relation to them of feminist or differential thinking will in the historical present necessarily be conflicted. What exactly *is* the historical relation between Lacan, Deleuze, Derrida Lyotard et al and feminism? (Clearly we have no pretensions to providing one answer.) The former three are read as

the structural, while feminism has been restricted to being about the specifics of gender – or gender understood as a specific. But seeing feminism as only 'about' gender conceals its radical *structural* impact. The beginnings of feminism predates all the dominant white male theorists, as do those of so-called postcolonial or Black thought; they have not just been in the culture since a long time back, but have been constitutive of it. The point is not 'who got there first'. *Is* gender like race and class? *Does* it have preferred status over these? The practitioners and writers in this collection move around these vital questions to bring art and thought on these matters into disputatious and pregnant relation.

The jury may still be out, but the room will be full of beautiful argumentation.

Notes

1　Cited in Renita Weems '"Artists without Art Form": A Look at one Black Woman's World of Unrevered Black Women' (Smith 1983). For an analysis of the invisibility of Black modernism in the visual arts, see Wallace 1993.

2　'So what's all this about the mother's body?: The aesthetic, gender and the polis' (Armstrong 1993) first published in Still, Judith and Worton, Michael (eds.) *Textualities and Sexualities. Reading Theories and Practices.* Manchester: Manchester U.P.

3　This is a general introduction which refers only selectively to some essays, making no attempt to give an overall sense of each one. For specific commentary on each contribution, please see the Section Introductions.

4　Armstrong raises many important issues in this excellent article, which takes as its point of departure the revealing moment in Eagleton's chapter on Kant where his distaste for the aesthetic becomes fused with the mother's body (Eagleton 1990, 91).'What is interesting is not that Kant is shackled to the mother's body: the founding moment of relationship with the mother's body can perfectly well belong to an account of the aesthetic [...] but that Eagleton seems to think this is the worst thing he can say about the aesthetic' (174).

5　Developments since the collapse of the USSR have seen much of the former Left dissolve into the mendacity of postideology, while far Rightist ideologies have crawled back to offer dangerous certainties in the confusion. If this does not seem bathetic, and for the record, in terms of attacks on intellectual freedom, one of us has seen publishers' readers reports so vicious that one publisher actually apologised for theirs. Individual women were quite seriously undermined. At the moment of going to Press, Germaine Greer has

been subject to a physical assault by a young woman; whatever the specifics of that case, the press coverage in Britain constitutes a further attack on Professor Greer. To compare the might of the pen and sword is to admit of their possible confusion.

6 But see Margolis 1995 for an argument that envisions a postanalytic, postfeminist, reconciliation of aesthetic issues.

7 In her chapter 'Against Feminist Aesthetics', Felski defined this as 'any theoretical position which argues a necessary or privileged relationship between female gender and a particular literary structure, style or form' (1989, 19). Her position is further developed in her contribution to the Brand and Korsmeyer collection, where she rightly says that what is needed is 'a more diversified model of the relationship between politics and aesthetics (than implied by "feminist aesthetics")' (Felski 1995, 443).

8 It is clear that Wolff regards aesthetics as inseparable from this, not only because her article begins with her realisation of her own aesthetic (anti-realist) assumptions in making the selection of work, but also because she consistently relates the history of the Whitney and its operation to what might be summarised as the masculinisation of modernism through formal selectivity.

9 As well as her very well known *Gender and Genius* (1989), see also Battersby's recent book *The Phenomenal Woman: Feminist Metaphysics and the Patterns of Identity* (1998).

10 The present editors have developed this point in Florence and Foster 1998, a review essay of the Brand and Korsmeyer book.

11 A glance at Noel Carroll's book *Philosophy of Art* (Carroll 1999, Routledge), for example, reveals no reference to feminism, gender, women or sexual difference in any form. Nor does it make reference to David Carroll's *Paraesthetics*, which is widely read. It is a good example of how the analytic tradition remains inward-looking.

12 See for example Felski (1989).

13 This is in some senses an economic point, and in others one of biology. Women are often not brought up against structural socio-ecomonic problems until they have to start making choices about career and family, nor do some of the more intractable organisational rigidities kick in until a more mature stage in one's cultural and/or career activity. We celebrate the fact that this is far better now than it was in the 1960s and 70s, but it is by no means resolved.

14 We are grateful to Peg Brand for reminding us of this instance and of the general point.

15 This is said in the context of the idea 'post-ideology', which has always struck me as a dishonest oxymoron.

16 See also Florence in Swift and Swift 2000, 66-8 et passim.

17 As Gilbert-Rolfe points out in this collection.

18 The phrase is Sherry Simon's (Simon 1996).

19 For surveys that offer aspects on the relevance of aesthetics to women artists
 and writers in Ireland and Algeria see Hilary Robinson's survey on Ireland and
 Melanie Selfe's survey on Algeria, in Florence and Foster (eds.), (2000).

20 See also Walker's earlier novel *Possessing the Secret of Joy* 1992.

21 See for example the recently organised conference titled "Address" and the
 Aesthetics-ethics Dichtomy'. An extended conference report by Monique
 Roelofs can be found in Florence and Foster (2000). See also the recent book
 by Levinson (ed), (1998), Aesthetics and ethics. See also on ethics *inter alia*:
 Roth and King Roth (1998) on art and design; Hodge (1995) on Heidegger;
 and Chanter (1995) on Irigaray. The primary focus is of the last two is
 however somewhat different.

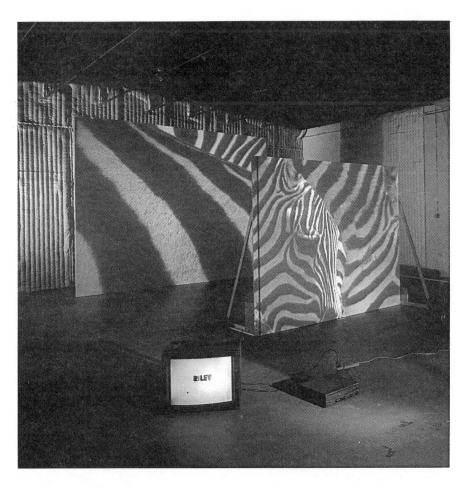

Fig. 1. *Bridget Riley made a painting* 1998. Diana Thater. Video installation. False wall 8ft x 10ft 6". Photo Frederick Nielsen. Courtesy MAK Center for Art and Architecture, L.A. (See also Plate 1.)

Part 2

Contemporary Practices

Penny Florence and Nicola Foster

Introduction

There have been few books on philosophical aesthetics, if any, that start
with works of art and the views of artists, and fewer still with works
predominantly by either women or contemporary artists. Add to this a
cross-cultural dimension, and the challenge to aesthetics of starting this
book with the work of contemporary artists who are mainly women should
be clear. There are, of course, other ways of ensuring philosophical
relevance. But at the present moment the case needs to be made for an
aesthetics that is adequate to the current situation of art production and
dissemination. This section opens the book with a strategic selection of
examples of work and some statements about the relevance to the artists
concerned of aesthetics. It is not a systematic survey, nor do we make any
claims about its balance or its exhaustiveness. The artists were asked to
respond to a very general and conversationally worded question about
whether they thought about aesthetics in their practice, and if so, how. If
not, they were asked why not. At least half the artists approached did not
have anything to say about aesthetics at all, and some were hostile to the
very idea of aesthetics. Those works and statements that appear here are
intended to contribute to ensuring that the relationship between art and
aesthetics is kept in view, that it is understood as differential and symbiotic,
and that the historical hierarchised rift between their practice is rethought.
We would insist also on writing as a practice, and so have included Vicki
Feaver's ekphrastic work, which emphasises writerly practice as visual
alongside forms more usually thought of as 'visual'. Hers is not the kind of
'visual poetry' that deploys shape or other visual markers, but rather
inquires into the way 'symbols in the psyche' can resonate, regardless of
medium.

There is another aim in this section. It is to give a brief indication of some
of the issues that arise out of a growing genealogy in women's art
production[1] crossculturally. As Diana Thater's witty installation (Fig. 1)

indicates, women active in art are enriched by knowing their female genealogies across geographical space as well as being secure in the mainstream within which some may now work (Thater is American, has worked in Britain, and pays tribute to the English artist Bridget Riley). The presence in this section of the distinguished St Ives artist, Wilhelmina Barns-Graham, now in her eighties and producing her most brilliant mature work, implicitly poses questions about the construction of a modernity that marginalised her work and that of most of her generation without eclipsing it. Happily no longer absent, the work yet remains under-discussed, especially at this fundamental, structuring level (Yakir 1995). Belfast artist Barbara Freeman is of the next generation, and her work has moved through an exploration of Constructivism, abstraction and feminism to a similarly unbounded maturity. But it is a very different process, in which Freeman works with writers and musicians in a collaborative approach that would bear close inspection in rethinking the relations of abstraction and music, for example.

Earlier theories of the philosophy of art were developed in relation to the art that was then contemporary. As Brand points out in 'Glaring Omissions in Traditional Theories of Art' (Brand 1999), such philosophical accounts of art and aesthetics - especially in the analytical tradition – very rarely include the work of women artists. Hence, their work is at best only ever an add-on or modification to philosophical discussions in aesthetics. They are not fundamental to the definitions. Much remains to be done in considering how the kind of genealogy indicated here might challenge the basis of art's philosophy.

A central issue within aesthetics is evaluation, and the evaluation of women's art has, to say the least, been problematic. Indeed, to some extent the same has come to apply to the contemporary in art, especially where innovation is involved, since at least the mid nineteenth century. Historically works by women artists were often deemed to be of poor quality, or, where this assessment could not be maintained, equally often reattributed to male artists or judged derivative from them.

In the 1970s, feminists responded to this by suggesting other criteria with which to judge and evaluate such historical works. By the 1980s the debate moved to social historical approaches which sought to show why and how women's art was marginalised: an approach most famously and consistently pursued by Griselda Pollock who opened the field for feminist scholarship in the social history of art. However, the social history approach led Pollock to argue that 'feminist art history has to reject ...

evaluative criticism and stop merely juggling the aesthetic criteria for appreciating art. Instead it should concentrate on historical forms of explanation of women's artistic production', (Pollock 1988, 27). Pollock's work since then evidences a considerable move from this position, but it does exemplify a general shift at that time away from 'the aesthetic' both in feminism and in progressive thinking about art of almost all kinds. The issue of aesthetics as such was deemed to be patriarchal and thus inimical to feminist discussions. There were perhaps good reasons for this approach at that time. Much groundwork has since been done, not least in ways of examining values without reinstalling the 'universal' subject an 'his' narratives. Such work illuminates for example one reason that has since been occluded why social historians of art saw their job to be of social importance, not merely academic: if art and attitudes to art can operate as an instrument of social change they can only do so precisely because art is something other than the social *tout court,* and in that not separable from evaluation and aesthetic judgement.

However, as Brand points out, in the analytical tradition at least, philosophers, 'rarely argue for the artistic status of a work of art that had not already been deemed a paradigm [canonical] by art critics or art historians' (Brand 1999, 179). Hence, philosophers approaching the issue of art and aesthetics simply 'continue to relay upon an old version of art history' (Brand 1999, 179). Not surprisingly, few references are made to the work of women artists in the analytic aesthetic discourse. Shades of *Old Mistresses* once again. Yet particularly in philosophy, it still needs saying and developing.

Brand suggests that one of the reasons why philosophical aesthetics has so far neglected to include the work of women artists in its aesthetic discussions is partly due to the fact that 'the entire history of art has been based on paradigms. It is the history of the 'great masters' their 'genius', their 'masterpieces'. Their history is clearly traceable back to the Greeks' (Brand 1999, 179), and as such can be articulated as a linear narrative which started in Classical Greece. The issue of art historical narratives that establish paradigms of 'Great Art' and 'Great Artists' has of course been of major concern to feminist art historians since the early 1970s. More recently there have been several publications[2] seeking to challenge the traditional canon in which the work of women artists is rarely featured as 'Great Art', or women artists as 'Great Artists'.

In theories of Modernity at least, the prerogative of philosophy has been profoundly challenged in two vital senses: in its capacity to assign status to works of art, and to define 'what art is' (a question that for some was rendered pointless). In deciding to open this collection with reproductions of artistic work, mostly accompanied by the artist's own statement about aesthetics in relation to it, we are placing the artist and the work clearly in tension with the theorists and their theorisations. As Purdom argues in this collection in relation to the American feminist artist Nancy Spero, the forms of contemporary art are inherently philosophical in their own right. They are also interventions in their own histories.[3] If there is a need for a new formation to replace the canon, what might be its fundaments?

Spero's work is by now well known and widely acknowledged. She has been exhibiting work since the early 1950s and her work has been widely reviewed and written on. Her recent exhibition at the Ikon Gallery, Birmingham, U.K., made her work more widely available to the mainstream British audience.

Some of the artists in this section are thus relatively well-known (at least in the countries where they are active), some are less clearly so. The work of Israeli born artist Bracha Lichtenberg Ettinger who has been living and working in Paris since 1982, and exhibiting internationally since then, may as yet not be widely known in Britain, though it is widely acknowledged in France, Belgium, Israel and the USA.[4] Malaysian born British artist Lesley Sanderson may as yet not be internationally well known, though she had several major exhibitions in Britain and her work has been discussed in several publications.[5] Sanderson has been exhibiting work since the mid 1980s.

Some others in this section are currently research students. We made a positive decision to include their work in order to show both an outline or aspect of a genealogy of female artists, as well as works in progress which might suggest some possible future developments. The Hong-Kong artist Yuen-yi Lo was also Sanderson's student at the Wimbledon School of Art. Lo has been exhibiting since the mid 1990s and her work won several awards. But even here, characterising some of the artists as students is not straightforward or necessarily about chronology. Some of the students have taken time out of successful artistic and/or academic careers to rethink their work in a more philosophical framework. Sanderson and Lo are indicative of the tip of another iceberg in the form of postcolonial women artists. Two other students who are also successful if not 'established' artists are Jo

Hsieh and Partou Zia, both PhD students at Falmouth,[6] and both widely exhibited – and selling, Hsieh especially in the USA. Hsieh was born in Taiwan and has studied printmaking techniques and traditions both in China and in Britain. Her prints and 3-D work emerge from an exploration of an East-West spiritual conjunction that is all too easily assumed as 'known'. Zia, who is Iranian in origin, can be compared with Hsieh in that she interrogates Western understandings of 'spirit'. But there the comparison probably ends. Zia's oil paintings, self-portraits and church interiors, move through the visionary world of women mystics that she explores in her writing and artist's books to suggest a realm that knows its relation to matter and figuration at the very moment it exceeds it. RyyA Bread©'s ironic professional name is indicative of her practice-related interrogation of subjectivity – 'subjective-specific corporeality', as she calls it. For her, the form and medium follow the idea; whatever the inquiry or new knowledge seems to require, she will foreground developing the most appropriate means of articulation.

Can any of the genealogy we have signalled be discerned in terms of form? This is not to return to an idea of 'peinture feminine', but rather to ask a sexed historical question. For example, work by Sanderson, Lo, Ettinger and Spero can be described primarily in terms of drawing, often using superimposed images, photographs and texts. While these methods are not exclusively used by female artists, it is interesting to note that they are predominantly used by them.[7]

All four artists are concerned with language, more specifically the language of expression and representation. Lo's use of text and language in *Mapping* (1998) is as a critique of the Chinese language in which the fact that certain terms are always already sexed is actually visible in the characters. Debbie Robinson's work is focussed on the other hand on painting and its recent histories, often incorporating text that is inspirational, but that also comes to challenge the modernist tradition out of which she is working: the tiny spirals of text suggest a glancing, peering and close viewing that qualifies the modernist totalising vision. This clearly works in a more abstract way than Spero's anti-narratives, yet both make formal interventions. Using text is thus very far from a single kind of gesture or from a primarily concern with textual meaning as an 'other' to the image.

Robinson's painterly concerns coincide in certain ways with those of the one male artist in this section, yet they manifest in very different work. Both share an interest in the beautiful that is both present and historical, yet Robinson's unease with the tradition contrasts strikingly with Gilbert-Rolfe's playfulness. While being very painterly works - thoroughly engaged explorations of colour-space and mobility - Gilbert-Rolfe's oil paintings are also very knowing and ultimately communicative. This is not to say they can in any direct sense be 'read'. Painting, like poetry, used proudly to aspire to what is beyond legibility; without this aspiration, the justification for the whole edifice that is now institutionalised art practice falls. Art truly made for its own sake *is art engagé*. Many of the artists in this section move around this contradiction in a more or less deliberate choreography. If the genealogy we are suggesting is to take its place in the fundamentals of a differential history, it cannot be female only, however or wherever the sex is located. It will have to take account of absence as a structuring element, as in the photography of Valerie Reardon, whose work risks the unseen and non-present to destabilise the notion of the machinic eye or 'gaze'.

We hope that in presenting a range of works with the focus clearly on female artists, we will open an opportunity for philosophical discussion to reconsider its reliance on already established paradigms of 'Great Art' and 'Great Artists'. If works of art do now operate in a philosophical discourse as well as what was previously artistic discourse, there is an even greater need than ever to connect such works to the tradition, however rebarbatively. Similarly, such work has to be read as history, however reconstructed and non-linear. The difficulty facing us all is still that no such non-exclusionary, conflicted and differential, mutating history is available in art, art history or philosophy. This is an enormous task that can hardly be attempted here. But in our selection of works we have paid attention to the need for it.

Notes

1 We have included one male artist, knowing we are open to the charge of tokenism. Others either did not respond or were unconstructive in their hostility. If our inclusion of one only is tokenism, the idea signified by this token is one of recognition across difference, of engagement and dialogue. We wish to engage with our interlocutors and to increase their number.

2 Most notably, Griselda Pollock's recent book *Differencing the Canon: Feminist Desire and the Writing of Art's Histories* where Pollock seeks 'to read against the paternal grain for the Maternal', (Pollock 1999, 18).

3 A similar point is made by Benjamin and Osborne (1991, xi) 'In a period in which works of art have taken upon themselves the ... definition of their status as "art" (P) philosophy and criticism have become inextricably intertwined, and both become bound to art history'.

4 Her work was included in the important show *Inside the Visible* - see Zegher 1996.

5 For example, Rosemary Betterton (1996) *An Intimate Distance: Women, Artists and the Body*, Routledge.

6 PhD students' work at the interface between theory and practice includes RyyA Bread© and Mary Anson and Debborah Robinson. The first two are at FCA and the last is at the University of Plymouth.

7 For a longer discussion on the issue of drawing, see the exhibition catalogue edited by Catherine Zegher (1996) for the Exhibition *Inside the Visible*, an exhibition which included works by Nancy Spero and Bracha Lichtenberg Ettinger. For a longer discussion of the use of drawing by female artists see Nicola Foster's essay 'Boundaries of Sight and Touch: Memoirs of the Blind and the Caressed' in Judith Mottram's *Drawing Across Boundaries*, Loughborough University, forthcoming.

Artist's Statement

Mary Anson

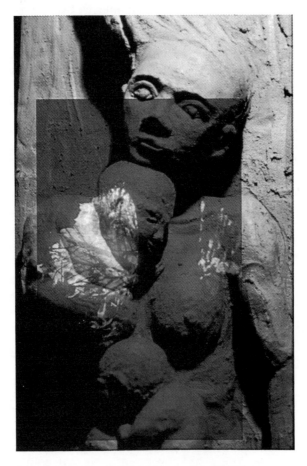

Fig. 2. *Firelung* 2000. Composite digital
photomontage of 1) clay relief sculpture and 2)
clay bowl with burning branch on sea.
Dimensions variable. (See front cover.)

The container for a philosophy of beauty is the inherent beauty of the earth, for which the stories of human beings are almost inconsequential. This relation of material as earth which contains and supports human life sits uneasily with the invisibility of the feminine as mother which supports, but is not supported by, human work.

The language of aesthetics can be sparse: I like, I do not like. Why? There is an identification: lungs breathe, fire on a dead tree, cast in a dark sea. I like, I do not like. What? Two events, two moments, two things happening, stitched together in time to make one memory contained and altered by another which in turn is altered by that which it contains.

For my pleasure, I like the presence of a story, even if evoked through a moment, and most interesting when the story and the moment contradict, because the tiniest of moments contains infinite narratives, any and all of which could be true. Walter Benjamin's idea about the value that stories gain when they are about to disappear affirms something that I notice in the impetus behind my work and ties that content up with desire, the language of emotion, wanting to fix and see something once I know it will not last. I like, I do not like, in a way that can tie even horror up into time and space. No doubt that the stories can get complicated.

The language of aesthetics as the language of taste, though it hovers around the borderlands of incorporation, can be disembodied. As the artist Breyten Breytenbach says: 'I digest and defecate an awareness of being just to imagine that I know that I was'.

I have an anxiety about the image here, which is its closeness to a religious icon (Fig. 2). This particular anxiety confirms the element of identification in the aesthetic, in that anxiety is caused by the ego. I use *icon* in the sense of an image that attempts transcendence of narrative and provokes its presence in the present. In fact the mother and child are iconic because the burning lung that they share takes them out of story and into the moment of a breath. However the black sea/square containing the fire is the limit of the overlap of two events and half of the mother's head is outside of and contains the overlap in the same way that I/we are outside of the frame.

A philosophy of beauty is based on an understanding/knowledge of the language of emotion. I like the play that happens in the English language when it is I who stand under the sky and the earth that stands under me – joy of joys, the earth understands me!

Artist's Statement

Wilhelmina Barns-Graham

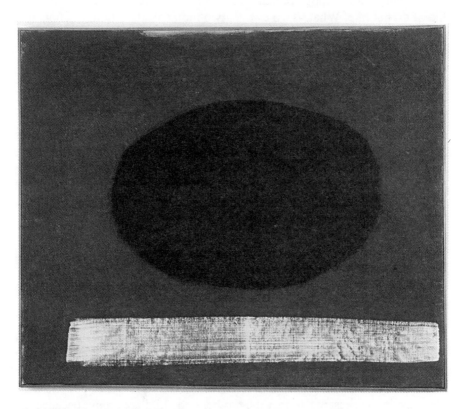

Fig. 3. *Black Oval* 1957-9. Oil on canvas. 84.2cm x 102.8cm.
The Tate Gallery, St Ives. (See also Plate 2.)

Recent phase a celebration of life, an immediate expression of energy, vitality, joy, with an element of risk, the unexpected.

Colour as colour, texture as texture, so blue is not sky, green is not grass, but is an object in itself, so that it is itself.

The feel of the work, completed when the idea of this feel has been fulfilled.

Frequently using primary colours, each can suggest a shape, inside oneself and remembering the importance of structure and simplicity. Avoiding the purely decorative.

Real space has its own value, not to be associated with previous centuries of emphasis on the illusion of space.

Brush strokes can be slim, thin, fat, textured, light, aggressive, risky, delicate or unexpected, daring or quiet, with their own energy or life and exuberance.

Artist's Statement

RyyA Bread ©

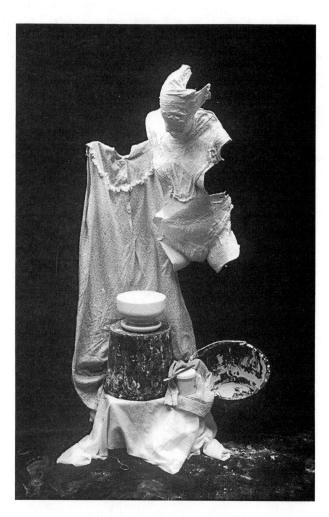

Fig. 4. *To Perform* 1998. *Identity Text* series 1998
on. Colour photograph of materials for plaster
coating sculptural works. Scale variable.

My work revolves around 'myself' and issues of subjectivity, rather than prioritising notions of 'other': such as an audience, or model. The aesthetics of my work focus on the relationship between materiality and image: the materiality of my own body and that of the materials I work with, in relation to my image(s) of myself and the images that I produce through my work (which are also of myself). These concerns reflect an interwoven relation between the material and imaginary aspects of embodiment, which underlies my interest in artistic practice. The work is not limited in medium; but moves between sculptural form, installation and photographic/ digital images. The shift between medium also alters perspective on the relations between materiality and image, since each medium emphasises particular aspects of this dynamic. Rather than create a split between image and materiality, my work aims to demonstrate that this relationship is fluid and interactive; and that it is mediated through individual embodied experience. This approach is rooted within a feminist discourse, in that it acknowledges the significance of sexual difference and seeks to represent an individual body that is not defined in terms of 'other', but in relation to the multiple dimensions of the Self.

Artist's Statement

Vicki Feaver

Not the flowers men give women –
delicately-scented freesias,
stiff red roses, carnations
the shades of bridesmaid's dresses,
almost sapless flowers,
drying and fading – but flowers
that wilt as soon as their stems
are cut, leaves blackening
as if blighted by the enzymes
in our breath, rotting to a slime
we have to scour from the rims
of vases; flowers that burst
from tight, explosive buds, rayed
like the sun, that lit the path
up the Thracian mountain, that we wound
into our hair. Stamped on
in ecstatic dance, that remind us
we are killers, can tear the heads
off men's shoulders;
flowers we still bring
secretly and shamefully
into the house, stroking
our arms and breasts and legs
with their hot orange fringes,
the smell of arousal.

Marigolds – from The Handless Maiden, Cape, 1994

Sometimes I find something so exactly as I desire it, it is almost as if the image of it already existed in my mind and I have found the perfect mirror of it. This sometimes, though rarely, happens with poems. It happened recently in Italy when I came across a shop run by an old man who made his own puppets. Most of them were based on traditional models. There were lots of Pinochios. These reproductions were not terribly interesting to me. But on the counter there was a glove puppet of an old woman: the head constructed of wood and plaster and painted very crudely – bright red lips, black eyebrows, globular blue eyes; the hair dabbed with blue paint; the body cut from the sleeve of an old lilac-coloured silk dress. I had to buy her. She is a caricature. But she is also my mother and grandmother. She is both terrifying and pathetic. When I put my hand into the hole in her neck and move her head she lives. To a great extent when I write a poem about a painting it is out of a desire to possess that painting. I want to possess it out of a kind of envy. I would like to have painted it. But also there must be something in it that resonates with something in me. In the poem I wrote about Roger Hilton's picture 'Oi Yoi Yoi', it is a sense of my identity as a woman: the kind of woman I am. I would hate to be the subject of a conventional portrait: especially of a nude portrait. It is the opposite of freedom: a kind of pinning down, like a dead butterfly. But Hilton's woman in that painting can be anything she wants.

In 'The Red Cupboard', based on the painting by Pierre Bonnard, I was also motivated by wanting to create a momento of a painting that immediately struck me as having a symbolic content that seemed to echo similar symbols in my psyche. I saw it hanging in the Hayward and there were no postcards of it and it was not reproduced in any of the books on Bonnard. The poem, in a sense, is the answer to the question: why is the painting so important to me? It begins by describing the painting but moves on to my own memories and preoccupations with the lives and histories of women.

'Marigolds' began with wanting to paint some. I looked all over, preferably for children's finger paint, so I could engage bodily with it, dipping my fingers into brilliant colours. The poem was my attempt to do this in words. But once I swapped to the medium of words, I was not just simply trying to get down the sensual pleasure of the flowers, I was engaged with subverting poetic conventions of women as flowers, and thinking about the nature of women's sexuality and potential for violence, and making connections with the legend of the Bacchae. All this could possibly have been suggested in a painting; but it is the actual fabric of the poem.

Artist's Statement

Barbara Freeman

Fig. 5. *Daughters of the Lonesome Isle* (after Cage). Oil and wax on board. 122cm x 248cm. (See Plate 3.)

I can only answer this request concerning aesthetics as a painter, with a painter's preoccupations. I think a lot about aesthetic problems; by which I mean that body of thought knowledge and experience that deals with how paintings have meaning, relate to experience, and to the objective world. That deals with how paintings map back onto the world even when they are not pictures. I ask myself how ideas mesh with materials (materials both as *stuff*, pigments etc., but also as languages). This is important since I have been working in close collaboration with composers and their different kinds of material – musical material. Music is a vast resource of methods and basic organisational ideas, and contemporary music in particular, by using every technique from chance to total serialism, is an encyclopaedia waiting to be opened. And what it opens is a way out of the whimsical idea of self-expression, personal biography and social 'relevance'. The real answers to these questions do not come out as sentences, but as paintings. Some of my earlier work was based within a feminist dialogue on the body, experienced subjectively and objectively, through sickness and death. All good work deals, somewhere, with issues of power; that work was about loss of power. My recent collaborations have been, in a general sense, about the sharing and diffusion of power. The *kind* of thoughtfulness and attention I put into my work seems to me of the kind a female artist might exercise. This is important, but I do not know how to explain how.

Artist's Statement

Jeremy Gilbert-Rolfe

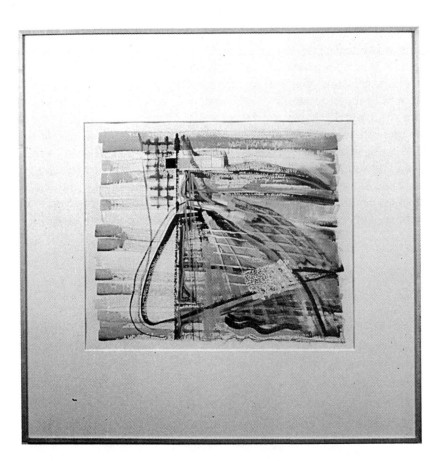

Fig. 6. *The Science Fiction Version* 1998. Gouache on paper.
25 5/8" x 30 5/8". 45" x 45" framed. (See back cover.)

Most contemporary artists and those around them sustain the predilections of the eighteenth century in wanting not to talk about beauty, because it is not tough and rough. Accordingly, while beauty is associated with aesthetics, the sublime continues to be readily associated with (for the most part cultural) politics in the general and particular because it is not beautiful, and may be rough and tough. Long before Adorno, artists saw the sublime as the quickest way out of the aesthetic, which is to say, outside of what appeared to be the prevailing conditions of judgement regarding works of art—the sublime as sometimes gateway to the raw and at others to the banal, in both cases construed as the real. As in Stephen Melville's description of installation art as the contemporary conventional form of the sublime—provisional, mutable, repeatable but never exactly as it once was because of its dependence on context as a primary signifier—that could imply that the sublime might become the conventional sign of the extra-aesthetic, a scary thought that should, I think, have a place in one's thinking if one is in one way or another engaged with art now. It would be the sense, for example, in which one feels that were a Martian familiar with cultural history since the eighteenth-century to land in New York she would perceive the contemporary situation to be one in which the academy has been reinvented as its symbolic negation, governed accordingly by a restricted, and timid, aesthetic of the anti-aesthetic.

Artist's Statement

Lubaina Himid

Fig. 7. *Plan B* 1999. Acrylic on canvas. 4ft h x 10ft w.
(See Plate 4.)

One. Revenge, *Rochdale Art Gallery, 1992*

Patterns, colours, cloth flapping, beating in the wind. Robes wrapped against the sun and the cold of the night. Fabric highly coloured, woven, sewn together. Umbrellas, tents, canopies, flags, banners. The patterns on the cloths hold the clues to events.

Two. Revenge, *Rochdale Art Gallery, 1992*

Pattern and colour are not random elements nor are they put down for decorative play. They are a new way of re-writing untold tales. Their language is more akin to the call of birds or the growth and blossoming of flowers; meaningful if you speak the language.

Three. Beach House, *Wrexham Arts Centre, 1995*

Secret weekend now revealed; Brighton. An endless row of beach huts, pale pink, deep magenta, lilac, purple, salmon, apricot, sky, lemon, orange, banana, violet, pale green, turquoise; small and ready for flasks of tea with iced buns or white wine with chicken sandwiches. Shiny little buttons stitched neatly to the waistcoat shore.

Four. Zanzibar, *Oriel Mostyn, 1999*

My mother kept a basket of shells from Zanzibar as an ornament for many years. For some reason I cannot remember if she still has them even though I was in her house only two weeks ago. One shell was very smooth and round, it was beige and had brown spots, the basket was shallow and thin, pale and brittle. There was a white shell, also quite round, but ridged. It was thin and light and almost translucent. Coral, white and pink, good to look at, but horrible and rough to touch. Smooth shells with ridged openings, which I longed to pop into my mouth like a delicious sweetie.

Five. 'Art Review', *March 2000*

I chased lilacs, pinks, yellows, blues and greens by the hundred. White dazzled and deep purple enthralled me. I looked and mixed, looked again, mixed again, splashed all day, every day. Pools appear, tumbling blocks re-occur, chairs come and go, people stay away, words vanish.

Six. 2000

As an idea forms and searches for another idea to balance itself against, colours come and demand to be a part of the show. As the research and the pieces of paper develop, other colours and ideas push and shove into the frame. What matters is not 'how will it look?' but 'what will it do?'. Of course, what it will do does depend on how it looks, but the most interesting elements that a painting of mine should have are an inkling of danger, a call for change and a sense of the gloriousness of possibility and the deliciousness of paint.

Artist's Statement

Jo Hsieh

Fig. 8. *Upadana-41* 1999. Mixed media on canvas. 30cm x 21 cm.
Exhibited at the Taipei Art Fair International, Taiwan. (See Plate 5.)

Non-space is the basis of my work. The notion of non-space relates to a spiritual inner world that is both pure and free. Non-space has no certain forms, limits or rules. It is also paradoxical in that it is both a state of emptiness and fullness.

The colour of non-space is clear as water and it can be mixed with any colour. Visually, psychologically, subconsciously and philosophically, different colour has different meaning and reaction to human spirit.

At present in my work the colour of non-space is blue, representing the symbol of life and spirit.

Artist's Statement

Bracha Lichtenberg Ettinger

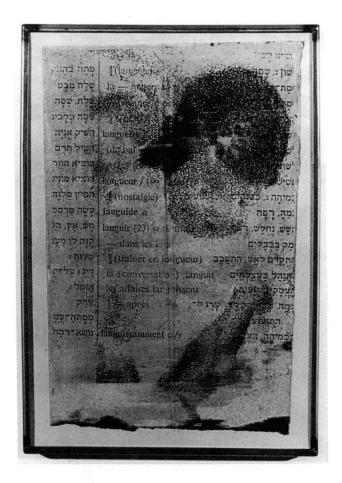

Fig. 9. *Mamalangue no. 1* 1992. Mixed media on canvas. 34.5cm x 23cm.

My work negotiates a fragile borderspace between practices of painting and psychoanalysis. In painting as transcryptum, from the invisible and the indicible I try to attain a with-in-visible screen, accessed only if shared-in-difference with several others. In writing I try to suggest a script that can only have been written as transtextuality. For the last seven years I have been working on two series of paintings: the *Autistworks* and the *Eurydices*. There my recent ideas received their trembling first non-verbal articulations.

But theory had to be developed from these grains.
But painting does not surrender to theory.
But theory does not collapse into painting.
But even though theory is not art, for me today both theory and painting are parts of my artworking.
But still I do not wish to abolish the borderlines between practices and theories and between painting and psychoanalysis. I rather wish to complexify their links and continually negotiate their differences and create a space where they can momentarily meet. But, both are for me now different forms of artworking.
But theory is not art, but some forms of it are.
But maybe art is theory-in-form, but sensual and affective.

If I cross some cultural borderlines, it is in-side painting to begin with that this transgression arises – and I try from with-in the effects and affects of painting's transgression to cross some phallic frontiers of the psychoanalytic theory – and to allow these effects and affects to enlarge the understanding of the transferential web and to slightly transform the psychoanalytic practice. Painting allows for theory but escapes it all the same, while theory goes its own way, never to produce a painting but to meet a new one at the next crossroads. Thus, by continually negotiating at the same time the limits of the visual in and by the visual which is never 'purely' such, and theoretical ideas, the spiritual and symbologenic potentiality of artworking infiltrates other boundaries which are unconsciously, synaesthetically, affectively and symbolically linked to it. Infiltered and thus opened up – the boundaries can now allow for further apprehending, for a different making sense, for thinking and healing while becoming more vulnerable and accessing the trauma of others and of the world.

Artist's Statement

Valerie Reardon

Fig. 10. Untitled 1995. Black and White. Silver gelatin print.

To comment on the way in which 'the aesthetic' functions in my visual practice assumes (incorrectly) that I have thought through and adopted an understanding of 'the aesthetic' as a unified concept which can be accessed in advance and somehow made use of. But nonetheless, to pose the question requires me to think about the images I make in order to determine something about the constitutive elements that for me make up a 'good' or successful picture. The struggle of course concerns translation, the rendering of a multi-layered and complex visual language into the clumsy fixity of words.

Taking and making a photograph such as this one is for me a process that requires an attitude of not knowing, a suspension of thought in favour of receptive free fall. In this way, the 'taking' does not constitute a theft in which power is exercised through the relationship between the see-er and the seen. Relinquishing scopophilic control to the point of not looking reveals the sight of chance occurrences. The camera closes its eye for a split second and records precisely what is not seen like a sudden flash of lightening or a shooting star that's over before the exclamation has time to form. I can never see what the camera sees and it is the pursuit of that unseen second that motivates much of my practice.

Initially of course I must put myself in the place of the picture, the particular *mise-en-scène* that offers a sense of the familiar. Recognition works at the level of resonance, a bodily response to the conditions of light and shade; a figure (friend or stranger) half obscured or in motion; water's capacity for fracture. If there is an identifiable aesthetic at play, it centres around the glimpse, those not quite seen events that interline consciousness. I set the controls, slowing the shutter speed in order to capture chance, to prolong the experience, to forestall death.

Artist's Statement

Deborah Robinson

Fig. 11. Detail from *Inscriptions* series
1998. Wax, interference colour, text on
muslin. 28" x 32". Collection of the
Artist.

The Modernist idea that the artist responds to the 'demands of the medium' positions painting as radically 'other' to the self. To explore this persistent notion, my method brings into collision the conflictual paradigms of modernism and feminism. To engage with the medium of painting on my own terms I redirect decisions made at intermittent moments of vulnerability, here using text, Irigaray's *Marine Lover*. There are moments whilst making, however rare, of fusion between touch and medium, where it is possible to surrender to the blindness that operates at the heart of painting; the sliding toward the sensory, rather than what is seen/objectified. These are points of real vulnerability.

There is a sense of complete uninterrupted moments of connectedness to images evoked through text, accessible through glancing at words, avoiding being caught in logical structures. In this way, the text releases images or sensations, which never become entire, but are nonetheless intense. I have attempted to give form to partial images released by words, not necessarily visual, but seated in bodily sensations.

I positioned spirals of text across the surface of my paintings, in lines of five and positioned by eye, each held by transparent glue. This presented a problem, they looked 'stuck on', and it was necessary to establish a figure/ground relationship within the picture surface. The solution was to pour liquid wax into each coil. After several experiments I found that by doing this I could forge a connection between the flat pictorial surface and the three dimensional text. At this point, I perceived the text as line upon line of holes, each plugged by wax. Words within the centre of each spiral were totally covered, muffled, gagged, lost to view.

The text jams an experiential reading of the work. Operating as a formalist device, it makes the viewer move in close to read the words. I hope to subvert the controlling and distant nature of a Greenbergian 'at onceness'.

There is a barely perceptible line between work in which aesthetic values are secondary to the creative innovation and those where they are foregrounded. To 'aestheticise' is a criticism; it means that a work is shamelessly orientated toward beauty, crossing the line into non-sight, the senses. To theorise this space a complex aesthetic of difference is needed. The power is an exhibition of knowledge of the established conventions and the violence to break these. For me aesthetics is 'outing' the terms of the beautiful. A consideration of the complexity of latency caught within frame upon frame of meaning.

Artist's Statement

Lesley Sanderson

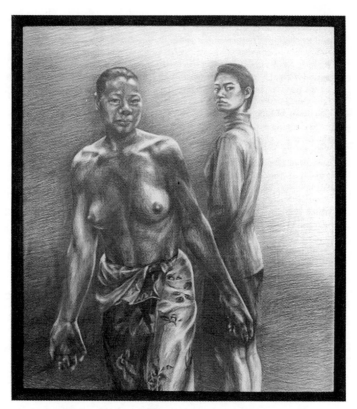

Fig. 12. *What are you looking at?* 1998. Graphite on paper. 60" x 70".

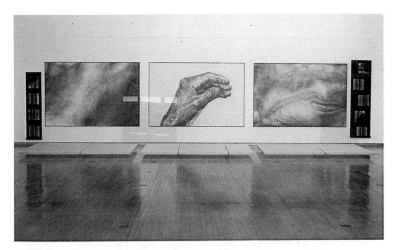

Fig. 13. *These Colours Run* 1994. Mixed media installation.
27.5ft x 8ft x 7ft. (See also Plate 6.)

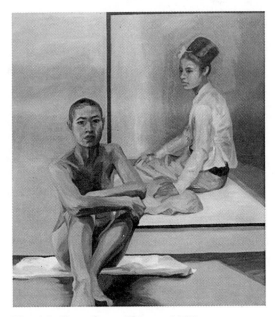

Fig. 14. *Time for a Change* 1988.
Oil on canvas. 66" x 72".

Artist's Statement

Nancy Spero

Fig. 15. *Goddess Nut and Torture Victim* 1991.
Handprinting and printed collage. 19.5" x 24.5".
Collection Amy Schlegl.

In the mid-70s I decided it was time to join my political activities and interests with my art, to investigate the status of women. I was involved with women artists' action and discussion groups since 1969, WAR (Women Artists in Revolution), the Ad Hoc Committee of Women Artists, and A.I.R Gallery 1972, the first all-women's gallery of that time.

My art became more externalised, that is, directed to the realities of women at work, in celebration, the dance, birth, maturation, women's victimisation, war, rape, etc. through time. The facts of the political torture of women and victimisation were real. So was the demand for possible sexual liberation in which we could move in the world without constraint.

In New York City in 1968 a radical group of women artists, WAR, separated from a radical general political group, AWC (Art Workers Coalition). Male artists were analysing the operation of power structures within the art world but failing to include the question of women artists, their evident absences. I believe this awakening occurred virtually simultaneously with the French women students, intellectuals, artists, etc. during the student upheavals of 1968. They refused to carry coffee to the 'barricades' resisting and rebelling against the domination of their male counterparts and women's consignment as minor adjuncts to male leadership in the wars of liberation!

I see no conflict in working with feminist theory and activism and the practice of my art. Feminism means taking nothing regarding women's status for granted, a scepticism of the status quo, the underlying sense that change can occur and that our investigations and exposés will have added up to significant action. A more universal consciousness and articulation of the basic problems of women's oppression – i.e., of all oppression.

Artist's Statement

Yuen-yi Lo

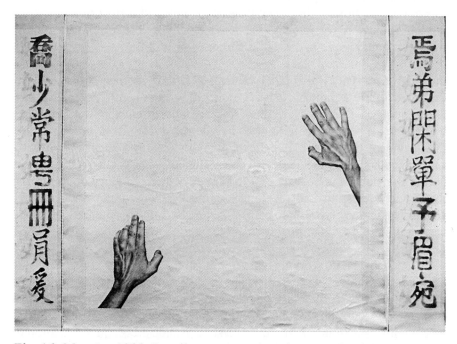

Fig. 16. *Mapping* 1998. Pencil on canvas, thread on wood strips.
183cm x 244cm (the triptych).

(Editors' note: The Chinese characters above have been altered by the artist to take out the feminine markers. This would be immediately identified by the Chinese reader. Following the standard Hanyu Pinyin orthography from Mathew's Chinese-English Dictionary, the originals, for example, of characters two and six above, from top left with translation, are:

娣 DI: a younger sister, wife of a younger or elder brother

媚 MEI: to flatter; to fawn on; to love; to coax; attractive; fascinating; seductive

These two were selected because the visual alteration is particularly clear. The gendering of the English translations is as obvious in all the rest of them. Cf. Suzette Haden Elgin's invention of 'Láadan' in her SF Novel *Native Tongue*. There is also a grammar, *A First Dictionary and Grammar of Láadan*, Madison WI, SF3, 1988.)

NUSHU – the Women's Script

Once upon a time there lived in China a young woman by the name of Pan-qiao who had extraordinary sewing skills. One day, while picking herbs at a hillside she was kidnapped and taken to another village. Out of loneliness and despair she employed the patterns from her sewing and embroidery skills to devise 1,080 characters which she used to write letters delivered to her own village by her dog. After 49 days and nights the script was decoded by 49 of Pan-qiao female friends who continued to use the script.

Sometime during the Chinese Song Dynasty (960 - 1270 AD), a beautiful and intelligent young woman by the name of Hu Xiu-ying, was recruited as one of the Emperor's concubines. At the end of seven years stay at the Imperial Palace, she spent only 3 nights with the Emperor. She felt isolated and ignored. She devised a secret script and wrote about her grievances on a handkerchief and had it delivered to her family. The clue to understanding the message was to read the script diagonally in the local dialect. Soon, this script was spread and used among women in the area.

These and other myths and legends (like that of Nine-catty) come from the Jiangyong Country, Hunan province, China where a script used solely by women was in use for hundred of years. The script is called *Nushu*. In the Chinese dialect, Nushu means literally: women's script.

The Nushu script is a phonetic system of writing derived from the local dialect, using an inverted system of grammar and syntax very different from Chinese. So far, some one thousand characters have been identified. Some research studies suggest that the script might date from as early as the Shang Dynasty (1600 – 1100 BC), others suggest that it existed since the late Ming Dynasty (1368 – 1644 AD) or the early Qing Dynasty (1645-1916AD). The script was written with ink and brush and was without punctuation. According to some women, Nushu was originally written with bamboo sticks with ink or charcoal on paper or cloth, then placed on thighs. Some writings were also on paper fans or embroidered on scarves. The script was used primarily in personal communications: diaries, letters to friends, wedding day wishes, prayers, folk songs. When the owner of the manuscript died it was customary to burn the manuscript so that its owner could read it in the after-life. Hence, relatively few manuscripts survived and the women's script remained unknown to the outside world until the early 1980s.

Artist's Statement

Partou Zia

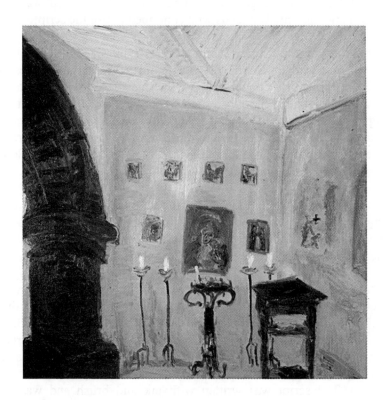

Fig. 17. *Icon, St Peter's Church* 1999.
Oil on panel. 122cm x 122cm.
(See Plate 7.)

When someone says of my painting 'that's beautiful', I am both pleased and confused. I both shudder and smile with a strange sense of dissatisfaction. And how should I see this thing I call painting; wrought out of a mist of unknowables, to be fixed and placed within the precipice-edged framework of a 'picture'. I am aware that there is no finite interpretation of *beauty*. So why refute that which is claimed [by artists and philosophers] to be unfounded, or at least indeterminate. This thing that is the theory of that which pertains to the beautiful, is already handed down to me, a painter, by Modernist and Post-Modernist alike; the yoke of Romanticism, and the solipsist fallacy of Modernism.

In the very process of the uncertainty which belies my self-reflexive rhetoric in the paintings, I discover a kind of ground or certainty from where I can recognise and name the aesthetic. I do not act as the vanguard of either the post-enlightenment Modernists' hierarchised sense of self v. other, or the brutish irony of Post-Modern dalliance with the all and the nothing. My task in the work is as an archaeologist: I dig and scrape, and categorise my findings, in order to discover meaning, and placement.

It is not some spurious 'quality' [Greenberg] inherent in my particular painterly gesture, or choice of subject that drives me on. My true ambitions within the paintings, through and beyond the physically tangible, and the time-span process of practice, is ultimately concerned with discovering the unique voice of the 'I'. There is no pre-conceived idea of aesthetics. Only where the true, unmolested voice of the self is perceived amidst all the fashionable vacuum, does a piece of work promote the notion of that which pertains to the beautiful: aesthetics of perception.

In the (Western) Beginning

Penny Florence and Nicola Foster

Introduction

After several years in 'disinterested' aesthetics has been largely ignored, a number of publications have recently shown a renewed interest in the topic. Although most recent writings do not confine themselves to the narrow meaning of analytical aesthetics, its influence remains. After all, it dominated the philosophical sub-discipline for most of this century, in the English speaking world, at least. This is an approach described by Crowther as 'essentialist', since it merely seeks to identify what is essential to art and aesthetic experience in an already identified definition of canonical art and its potential audience.

However, prior to the advent of modernity and with it the establishment of the philosophical sub-discipline of aesthetics, discussions of art and beauty were treated as an integral part of philosophy together with issues of ethics and truth. Recently, the renewed interest in looking at aesthetic issues in a larger philosophical context has come from varied, yet often interconnected, interests. Feminists are seeking to show that only by re-contextualising aesthetic discussions in the philosophical tradition as a whole can we begin to address the lack of female presence on the fundamental level or in the mainstream as philosophers, artists, or art historians. They have been prominent among the growing numbers who recognise that discussions of aesthetics that remain isolated from ethics are lacking.[1] Equally, discussions of ethics need to address some of the same issues as aesthetics[2] as indeed to some extent do even discussions of epistemology and science[3] (for example, when looking at a microscope and identifying a structure, it is often an aesthetic structure to start with). It is for these (basic and brief) reasons that our inquiry begins with a look at the received 'Western beginning': the work of Plato.

The two essays in this Section present very different perspectives on the work of Plato: generally acknowledged as the 'father' of the philosophical tradition for whom beauty is goodness and truth. Common to both essays, however, is that their interpretations and re-readings are developed out of the range of growing established female scholarship in philosophy overall, as opposed perhaps to aesthetics or to histories of art, literature or cultural studies.

Music has held a privileged position among the arts as the most elevated, as is perhaps most widely known through Pater's nineteenth century formulation of music as the condition to which all other arts aspire. Barbara Underwood's essay 'Beautiful Music - a Fixed Pitch?' focuses on Plato's articulation of the aesthetic in his comments on this definitional art. She points out that musical structure in the West developed 'as a continuous thread out of Pythagorean Platonic ideas' - already articulated as gendered principles - that form the basis of Western aesthetic discourse on music. Plato can thus be seen as the 'father' of Western understandings of music as well as philosophy, establishing beauty beside goodness and truth.

Underwood shows that for Plato, the universe is a single unity governed by numerical pattern. However, she points out, Plato replaces the notion of a mythical female figure who holds war and love in tension, with a rationality which reduces everything to a unity gendered as male. Music (aesthetics) is also reduced. It is reduced to perfect mathematical proportions, which prioritises unity/rationality and thus the unity of the dyad, not the tension of the couple. For music, she argues, this means that a reasoning process controls and orders all physical sound, and the rational process – gendered male - is deemed both beautiful and good. Underwood's project can also be read as an attempt to expose Plato's ethics through his discussion of the aesthetic. She shows his articulation of 'the Good' to be gendered, and as such neither universal nor 'the Good' for both males and females. Females are simply excluded from the aesthetic, while ethical considerations simply circumvent them.

Robyn Ferrell in her essay 'Love and Writing', also seeks to interrogate Platonic articulations of the aesthetic in relation to articulations of the good and the true. However, Ferrell reads Plato through recent deconstructive and psychoanalytical theories and seeks to recover the sensual from the Platonic argument. Hence her emphasis is on an understanding of aesthetics in terms of 'that which pertains to the senses', though her project as a whole is with a view towards discussions of art. In recovering the sensual in art she hopes to open the text to readings which will recover an aesthetic

in the images of love and writing which the Platonic text repudiates. Ferrell's project of reading Plato is not unlike Irigaray's reading of Plato (Irigaray, 1974), in that they both seek to unveil the sensual and embodiment: Irigaray in the form of the maternal body, Ferrell in Platonic images of love and writing. For both, their respective projects are essentially ethical, precisely because they seek to expose the traditional understanding of ethics as unethical - in their exclusion of female participation in philosophy, art practices and art discourse in general.

Notes

1 For example the recent publication edited by Jerrold Levinson (1998) titled *Aesthetics and Ethics: Essays at the Intersection*, CUP.
2 For example see Marcia Eaton's Book Review in the *Journal of Aesthetics and Art Criticism* 58; 1 Winter 2000: 73-74, where she says: 'I think that moral philosophers (and hence philosophers generally) will come to see how important aesthetics is only when we aestheticians can demonstrate that, as Levinson puts it, there are both theoretical and applied aesthetic issues in ethics, not just vice versa... aesthetic issues and assessments are not just "frills" that make life better. Rather the very meaning of "good" in the phrase "a good life", I believe, requires attention to aesthetic as well as ethical questions', (page 74).
3 A forthcoming Special Issue for *Hypatia* on this issue is at present being edited by Peg Brand and Mary Devereaux.

Chapter 1

Love and Writing – *Phaedrus* and the *Symposium*

Robyn Ferrell

Love and writing are joined in Plato, according to a logic which relies on the very image it denies. Socrates denounces writing as a poor surrogate for intimate human speech; and he recommends that lust should lead the soul toward sublimation rather than consummation. Yet, it is through their repudiated images that love and writing teach us to overcome them.

This argumentative strategy is a *disavowal*, in the technical psychoanalytic sense of the term. But that observation is not what makes my following argument worth making. The interest in tracing out the 'encrypting' of love and writing for a philosophical aesthetics - I am here using the term 'aesthetic' to designate its original wider field of meaning, 'that which pertains to the senses', as well as in the narrower sense of a philosophy specifically dealing with the artistic - lies in retrieving a sensuality, and an embodiment, which lies obscured in the Platonic texts.

I call this disavowal a 'logic' and a 'strategy', rather than an 'error', because, although it offends against Aristotelian logic, it is a gesture so embedded in Socrates' vision of *philosophy itself* that it underwrites Platonic ontology with a haunting ambivalence.

Pagan Socrates

... without allowing him to say anything further, I got up and covered him with my own clothes - for it was winter - and then laid

myself down under his worn cloak, and threw my arms round this truly superhuman and wonderful man, and remained thus the whole night long. Here again, Socrates, you cannot deny that I am telling the truth. But in spite of all my efforts he proved completely superior to my charms and triumphed over them and put them to scorn, insulting me in the very point on which I piqued myself, gentlemen of the jury - I may well call you that, since you have the case of Socrates' disdainful behaviour before you. I swear by all the gods in heaven that for anything that had happened between us when I got up after sleeping with Socrates, I might have been sleeping with my father or elder brother. (Plato 1951, §219b-d)[1]

Alcibiades recounts the peculiar *resistance* in Socrates to the erotic, in his confession to the *Symposium* of the night he attempted seduction. He is put out that Socrates should be inured to his charms, but on reflection, can only admire a strength of purpose that prefers a principle over the pleasure of the moment, and even over the pleasure of the lapse.

What principle is it that Socrates preserves? Not the moral law that finds temptation itself to be torture; this is too christian a passion. For Socrates, to be distracted or arrested at the stage of the carnal is not a moral fault, so much as an intellectual failing. The pagan Socrates is that terrifying figure (as Nietzsche observes in *The Birth of Tragedy*) who has principle where pleasure should be; indeed, Socrates is the man *who makes principle his pleasure*. It is worth examining that strangely philosophical erotics, its cold and its heat.

The questions that Plato's philosophy poses for an aesthetics, and for the analysis of the part played by feeling in experience, depart not from the usual resentment of art and artists expressed in the *Republic*, but from his more suggestive comments on madness and love in *Phaedrus* and the *Symposium*.

Socrates' much-lauded moderation is free from the ascetic element which it might suggest if read through Kantian/Christian thought.[2] This is a man who reasons; even - especially - around his pleasures. This Socrates is quite prepared to indulge, but is resistant to intoxicants - by the end of the *Symposium*, he is the only one left standing, despite the amount of drinking that goes on through that intense night. The narrator tells us:

He went to the Lyceum and washed, and spent the day as he would any other, and finally towards evening, went home to bed. (1951, §223d)

In short, we might suspect that Socrates is a *myth*, a man of such exaggerated virtue that he can only represent an ideal of perfection by which ordinary mortals might better be able to live.[3] Yet Socrates is also tried and condemned for corrupting the youth of Athens; for his dangerous liaison with ideas and also with the erotics of ideas. That there is something threatening in the figure of Socrates, or even menacing, is suggested in the rare tone of Alcibiades' candid speech at the dream-end of the *Symposium*, in which we see Socrates in a strange, intimate light.[4]

Light plays its part in the *mise-en-scène* of Socrates' erotics. In *Phaedrus*, man and boy are lying on the bank of the river in the idyllic noon-day heat - the subject under discussion is love and writing, but the heady, heavy languid light is not the light of day so much as the light conducive to vision and mirage. By contrast, the dreamy text of the *Symposium* evokes eros as deep night. The setting is a dinner party, a night of celebration at the event of the poet Agathon's major literary award. It is an illustrious gathering, lit by glamour; the cleverest in Athens present, and Athens being the cleverest place that there was, a star-studded event.

Socrates advises Phaedrus of the true love that can write on the soul of the beloved and impress thereon some understanding. But does Alcibiades really love Socrates? His thoughtless passion brings him to the perception that there is a lesson in Socrates' refusal, but he fails to understand where, through the resistance, he is being led.

We might even reflect on the fact that these confidences of Alcibiades' are, in the first instance, authorial detail. How does Plato know about this night of seduction; or, how does he invent it? Was it ever that the man and boy beneath the cloak were Socrates and Plato, not Alcibiades, or did he ever wish it were? Does *Plato* love Socrates? We may find the evidence of it in the loving care he takes with his portraits, and yet, loving Socrates does not make Plato blind to his faults; on his philosophy, *only in loving Socrates* will the boy come to know him or anything, and so come to learn of his

faults - if this ugliness, this resistance, this anti-erotics turn out to be a fault. Plato creates a character so full of fascination and repugnance it is hard to believe it is *not* love.

Divine Madness

In the allegory of the charioteers and the horses, Socrates depicts a psychology of a human creature with its noble side and base side, and an agency which must needs direct it - this division is internal to the human soul. But for Socrates, there is no equality between souls; some souls are better at bringing themselves to proximity with the divine, described in mythic form in the famous image of the procession over the Elysian fields to the vault of heaven:

> Now the souls that are termed immortal, when they reach the summit of the arch, go outside the vault and stand upon the back of the universe; standing there they are carried round by its revolution while they contemplate which lies outside the heavens [...]

> [...] The region of which I speak is the abode of the reality with which true knowledge is concerned, a reality without colour or shape, intangible but utterly real, apprehensible only by intellect which is the pilot of the soul.

> [...] And in the course of its journey it beholds [...] not the knowledge which is attached to things which come into being, nor the knowledge which varies with the object which we now call real, but the absolute knowledge which corresponds to what is absolutely real in the fullest sense [...] (1985, §247c-e)

The myth cherishes powerful 'Platonic' ideals of standing outside the specific moment; outside generation, outside instantiation, outside embodiment, there to encounter timeless, ethereal experience. Socrates notes drily, 'Such is the life of the gods'. But behind the gods comes traipsing the procession of souls of various imperfections, in their sad corruption and inadequacy.

> It is impossible for a soul that has never seen the truth to enter into our human shape; it takes a man to understand by the use of

universals, and to collect out of the multiplicity of sense-impressions a unity arrived at by a process of reason. Such a process is simply the recollection of the thing which our soul once perceived when it took its journey with a god ... (1985, §249c)

In this cosmology, only from a fragment of the divine can a soul become human. That which characterises humanity is, according to Socrates, *intelligence of universals* and put more specifically, being able to proceed from the many particulars of sense to one conception of reason.

This movement from sense to reason, also found in Diotima's speech in the *Symposium*, is the common root of Plato's love and writing. In reaching beyond the senses, one encounters not just the divine and the philosophical, but one enacts, properly, humanity. This is Socrates' aesthetic.

Our embodiment is represented as a fall from grace; in the myth, one falls into the body, a depiction of imperfection. Precisely because one is in a body, one knows oneself not to be divine; because the body is mortal, this in and of itself proves the case that one is something less than a god. We have a living tomb, says Socrates – a wonderful contradiction - which we carry about, now that we are imprisoned in the body, 'like an oyster in his shell'.

Beauty has a special place in this tragedy of falling to earth. Beauty is sensual, it is perceptible by the senses, but it is also of the forms. It evokes for us that divine. It is the beauty of the lover that draws one, that reminds one of the vision of other perfection that one had before one became embodied. So, while it may be a living tomb, it is nevertheless through this embodiment that one reaches back to the divine, to the experience of the divine.

The wing is the corporeal element most akin to the divine, its function to carry something aloft. (1985, §246e) There is, all the same, a strange ambiguity about this wing, to what extent it is, and is not, completely carnal. The wing recurs in the story of eros as a quasi-penis, something that fills and inflates and throbs (*ibid.*, §251-2).[5] In love, Socrates envisages

the soul and its wing as inflated by desire, a source of pain for the lover causing him to do extravagant things - to put aside social convention and ignore the constraints of mothers and other relations in the urgency of this quest for the divine.

In this, Socrates is not completely negative about the obsession of the lover - at its best, the lover is in the grip of a philosophical passion and a mystical necessity to get close to the original experience of essence. And in explaining how he can have access to it through the beautiful form of his lover, Socrates offers love as a philosophical quest and even as a philosophical action. Thus, to allow oneself to be distracted by the carnal and to consummate love physically is to miss the point. Ordinary loving couples have honour, he concedes, but couples who become truly philosophical lovers enact not a carnal relation, but a marriage between souls.

There are many kinds of madness that are god-given, and artistic inspiration and mystic talent are among them. But love is a universal madness, commonly met with in ordinary human life, and a precious thing if handled properly.

The madness which belongs to the philosopher is closely aligned with the madness of love, only a step on from it, as the *Symposium* will teach. It is a madness that seeks only the vision of the divine, is only interested in that vision and and no longer with other earthly distractions. We are told that, 'That is why it is right that the soul of the philosopher alone should regain its wings; for it is always dwelling in memory as best it may upon those things which a god owes his divinity to dwelling upon. It is only by the right use of such aids to recollection, which form a continual initiation into the perfect mystic vision that a man can become perfect in the true sense of the word. Because he stands apart from the common objects of human ambition and applies himself to the divine, he is reproached by most men for being out of his wits; they do not realise he is in fact possessed by a god' (1985, §249-50). This fourth type of madness is the noblest.

Thereby, the privilege given by Socrates to the philosopher is to be the *consummate lover*. The philosopher knows desire is the way into the divine, and into a relationship with an old memory. Seen more clearly in the *Symposium*, this proposes a relation *internal to oneself*, a relation with the past of one's soul and the vision that soul was accorded in a pre-carnate

time. And the lover becomes an instrument, or even a means to an end.[6] More, Plato suggests since it is archetypally the philosopher that makes this move, so the philosopher is the *archetype of the human*. Philosophical activity, going from the many of sense to the one of reason, is the defining feature or the most perfect expression of humanity - an extraordinary privilege to extend. It is clear that Plato/Socrates saw in his own philosophical activity a divine effort. Extended to the dialectical method that Socrates uses with his young friends, the flirtatious interaction between Phaedrus and Socrates, far from being a literary distraction from the theory, becomes the point of it. It becomes a philosophical gesture, and in it erotics and philosophy are joined.

Perhaps Plato wrote dialogues not merely as a record of Socratic teaching, but as a philosophical commitment to this uniting of love and knowledge in the deportment of conversation. And if, as Socrates says at the end of *Phaedrus*, that it would be best to take the lover and educate him well as a philosophical enterprise, the dialogue might enact, in writing, philosophy as an amorous encounter. [7]

But writing also threatens this encounter, as its contrary, causing Socrates famously to denounce the practice. The god Thoth came to the king of Egypt offering wonderful inventions, among them writing.[8] But the king considered the invention to be a double-edged sword; and, 'The fact is, Phaedrus', Socrates corroborates:

> that writing involves a similar disadvantage to painting. The productions of paintings look like living beings but if you ask them a question they maintain a solemn silence. The same holds true of written words; you might suppose that they understand what they are saying but if you ask them what they mean by anything they simply return the same answer over and over again. Besides, once a thing is committed to writing it circulates equally amongst those who understand the subject and those who have no business with it; a writing cannot distinguish between suitable and unsuitable readers... (1985, §275d-e)

This idea, novel to a democratic cast of mind, represents truth as specific, requiring an appropriate reader. Socrates has in mind his philosophical relation as an alternative, the 'living and animate speech of a man with knowledge, of which written speech might fairly be called a kind of shadow' (1985, §276b) He juxtaposes this idea of two parties to the communication of understanding to the seeming indifference of the written word which addresses everyone equally, and which is liable therefore to be misunderstood in any imaginable manner.

Here love enters writing; for the communication should be of an intimate kind, the soft sibilants of the lover being highly valued and carefully attended to. Socrates exploits the power of this speech as a kind of writing; 'written on the soul of the hearer together with understanding'... 'which you find when a man employs the art of dialectic, as opposed to rhetoric, and fastening upon a suitable soul plants and sows in it truths accompanied by knowledge' (1985, §277).

Love and writing are joined here, in *Phaedrus*, where the philosophical enterprise is described using love, and specifically using the expectation that the good soul will be receptive to a kind of writing, which invokes the remembered vision of the divine. Love writes on the soul, through the judicious penmanship of the lover.

But writing is also rebuked, since it only stands in for the ideas it represents, and worse, is not equipped to do so because it cannot defend them; it is a poor substitute for the 'real thing', i.e. love. Love, itself, suffers this repudiation; as the expression of the senses and the carnal, it is the very barrier to our being divine; and yet, there is also a kind of love - strictly a perversion of love - a passion which is one step more abstracted than erotic love and yet draws its strength from it. This double-dealing with metaphor, using its own properties to surmount it, is completely characteristic of Plato's story; not just of writing, but also of love.

Plato's move is a kind of conceptual cheating; conducting, in two moves, the theft of meaning from the notion while all the time affecting a distance. This sharp practice is the same as that which he has described as 'moving from the particular to the universal', and is the very nature *attributed to the human*. The audacity of this becomes even clearer when we consider Socrates' praise of love in the *Symposium*.

Love as Interpretation

The story has it that the narrator's informant encountered Socrates wearing shoes and having had a bath, and this extraordinary set of circumstances provoked him to ask 'where are you going?' And Socrates said, 'I am going to dinner, you had better come'. This is how our informant happened to witness the event. A student of literature might already see how the thing has been set up, dreams within dreams, as a potently unreliable account of event. The elaborate framing of the dialogue has a curious effect on it, epistemically, and may protect it from the force of truth, stories about the eccentric Socrates having been passed on in Athens for years.

Present at the dinner are, among others, Agathon, the tragic poet at whose place the party takes place, Socrates, Phaedrus, Aristophanes (comic poet), and Alcibiades, here portrayed as brilliant, dissident and notorious, on a night at the zenith of his power. But Alcibiades will be held responsible for the failure of Athenian campaigns that bring on the downfall of the city-state and arguably set the whole of the Greek states on their ruinous path. Alcibiades is a sinister evocation in the dialogue, and all the more so because he appears here *before the future*. Since the subsequent events are almost surely known to the narrator's friend, the future hangs over this dialogue with its own peculiar menace.[9]

But the ambivalence of speech and proposition is further felt since, after Socrates has given his speech and it appears as the expression of truth, a coda or consequence is marked in Alcibiades' entrance, drunk and rowdy, demanding to offer a panegyric of praise to love, in praising the figure of Socrates. As scorned lover, he reviles Socrates for being a liar and suggests that the rest of the company would be very foolish to take anything that he said as truth. As discussed above, he recounts stories of Socrates aimed at showing how resistant Socrates is to love, and in that way, what a perfect philosophical lover he makes, in Diotima's style. Socrates in reply does not hold back from a little malice in rejecting some of Alcibiades' comments, but does not deny the tale of attempted seduction.

At the end of the dialogue very much later we discover that Phaedrus has one home, several other people have fallen asleep and at the last, that only the poets Agathon and Aristophanes are left awake discussing with Socrates whether it is possible for a tragic poet to write comedy more easily than a comic poet to write tragedy. Socrates puts them to sleep, too, with his inexhaustible discourse, and so goes off into the dawn. The dialogue as a literary structure is thus framed in uncertainty; in the hearsay of its narration; the interventions of Alcibiades, who qualifies the authority of its central piece of wisdom; and the figure of Diotima, through whom that wisdom is spoken. Diotima tells Socrates:

> When a man, starting from this sensible world and making his way upward by a right use of his feeling of love for boys, begins to catch sight of that beauty, he is very near his goal. This is the right way of approaching or being initiated into the mysteries of love, to begin with examples of beauty in this world, and using them as steps to ascend continually with that absolute beauty as one's aim, from one instance of physical beauty to two and from two to all, then from physical beauty to moral beauty, and from moral beauty to the beauty of knowledge, until from knowledge of various kinds one arrives at the supreme knowledge whose sole object is that absolute beauty, and knows at last what absolute beauty is (1951, 211c).

In this leading image, we find described the same kind of metaphorical transfer observed in *Phaedrus*, proposed on the body of the beautiful. At stake is the divine, and proximity to the divine, as it was in *Phaedrus*, recapturing the vision as a way of coming closer to heaven.

Starting with love of the particular lover, and the particular face that first awakened the memory of the divine - but being wise and not merely in the grip of appetite - one comes to see that it is not the lover's body as such that consummates desire, but what it evokes of a more general category of beauty. It is evocative because beauty is the physical or the sensible representative of the good. So what one loves in the lover is the image he presents of divinity, and of the absolute.

We have seen that the formula of *Phaedrus* is that it is the nature of humanity to go from the particular to the general. That movement of abstraction, Diotima describes here more explicitly in her idea of how the love of beauty solicits the move from the particular to the general, until

beauty is met with at its most generalised in the absolute. This abstraction she recommends as the apotheosis of love.

Thus the object of love is 'to bring forth not images of beauty but realities'. Bearing in mind Plato's idea of the form being more real in the cosmological vision than any instance of it (according to the scheme proposed in book ten of the Republic), to have this love is to become 'a friend of gods' and to 'be immortal, if mortal man may'. It is a *philosophical* move to understand that the object of your passion is not the same thing as your passion, but that your passion can substitute by moving to understand something more than the literal lover.

But from when the lover recognises that his beloved could be replaced (to put it brutally, that he could find an equivalent satisfaction in the beauty of another) the lover learns the lesson which, in modern parlance, goes by the name of 'the sign'. To substitute is the function of the sign; the sign is that which *stands for* that which it represents. On this description, it is also the most general description of metaphor. The procedure that Plato describes as truly philosophical is the process of learning to substitute one representation for another, and this in a paradoxical direction that love takes, *toward* the real and *away from* representation.

The story of love in Plato thus relates to the story about writing, and both relate to philosophy, in a more than contingent way. They are joined in a common figure. If love is the tutelary experience, it is also and essentially involved in the process of image and representation; this is its motivation in showing how every face can be substituted for another face and still bear the meaning of love.

Diotima has already said love interprets between gods and men, so the idea of interpretation has been placed explicitly next to the idea of love, and raises the whole possibility of writing as being at the heart of this philosophical project of loving. At the same time, the very experience of love and of the tutelage of love is written into the scheme of the *desired alternative to writing*; the living speech, connecting the two in paradox.

But in the sense in which the lover is now not loved for him or herself, the idea offends our romantic ideas of love since, as Lacan observes, it is not enough to be the object of another's love - we desire to be *the cause of his desire*. Plato himself exhibits this tension when he *writes down* the very conversation that disqualifies writing. The question of the time of the philosophical encounter, and its space, likewise evoke the tension between the material and the abstract. If at first we believed that what is loved is the particular beauty of our beloved, this turns out to be not so much wrong, as shallow.

The ambition may be to arrive, in the end, at a place that is without image, that is imageless, but Plato is obliged to allow metaphors to stand in for this; the myth of the vault of heaven, for the imagelessness of the form; of the steps, as our progress to it. The ambition to distinguish the real from representation becomes incoherent in the vicinity of the metaphors. In extrapolating the case of a writing that is to be written on the soul, and in taking the body and carnal love as the basis for a movement which puts aside carnality to encounter the more perfect love - more real in Platonic terms than their appearances - the metaphor takes on a reality that the literal meaning does not have. The abstraction comes to mean more than the very particular that it was built on, and *to mean it more intensely*.

This is a profoundly ambivalent aesthetic. We have seen how love of the divine, or abstract, is the paradoxically human, of which the carnal and other bodily love is only a sensory approximation. From this, philosophy itself was rendered as the truly human impulse. The place of love in this is not represented as contingent, for it is through it that this transfer can be *effected*.

Thus, at the same time, *in the same movement*, i.e. of metaphor, abstraction is entrenched as the principle of love, philosophy and humanity. In this, we see the nature of metaphor - of which writing is itself used as a metaphor by Socrates - come to represent the deep paradox of the real for Plato/Socrates.

Is there room in this account to give back some of what has been taken from the sensual and from the sensible? Is the particular of beauty kept and recorded in that metaphorical beauty, as much as it is denigrated and put aside? The pagan Socrates will make a more ambivalent move; one in which the bodily, the lover and the *facia* of writing remain as 'interior' to

their abstraction - an image which is not so much cast out as *crossed out*; or, in which the particular is both contained and obscured in a resulting consciousness, in the abstraction or the metaphor.

Notes

1 Translations of passages from the *Symposium* and *Phaedrus* are Walter Hamilton's, for Penguin Books. I have throughout this book adopted translations for their vernacular tone. Where this may raise discrepancies from the usual sources quoted, both references are provided.

2 But cf. Michel Foucault's rich reading of Platonic erotics in *The Use of Pleasure* (1985) which indicates how the Greek stylising of homosexuality could be seen as a practice to the religious sublimation of the later time.

3 Nietzsche observes an affinity between Socrates and Christ. This attractive resistance of Socrates, for example, offers a parallel with the figure of Christ in the four Gospels, and sometimes approaches the messianic. Cf. Deleuze (1983).

4 Cf. the famously rich reading offered of the dialogue in Stanley Rosen (1987). Rosen notes that the *Phaedrus* and *Symposium* might be seen to be in direct contrast, on many points (Rosen, 1988).

5 See Gregory Vlastos' discussion of Socrates' sexual character in chapter one of his *Socrates: Ironist and moral philosopher* (1991) (among other places in his work). Psychoanalysis has not come to the end of this idea of narcissism; the possibility of the other representing a kind of circuit or mirror for this self is a Lacanian preoccupation, the same idea given a different vocabulary.

6 Cf. Jacques Derrida's discussion of these passages in 'Plato's Pharmacy', in *Dissemination* (1981).

7 Of the speeches in praise of love given at the *Symposium*, Aristophanes' is probably the most famous. But this view of the symmetry of lovers, for which the *Symposium* is sometimes cited, is not actually its moral. Socrates, although he does not directly reject it as he does some of the propositions Agathon puts up, leaves no room for it in the cosmic scheme as outlined in his own speech.

8 Cf. R.B. Rutherford's discussion, in *The Art of Plato*, (1995), London, Duckworth.

9 Cf. Tina Chanter on Irigaray's reading in *Ethics of Eros* (1995).

Chapter 2

Beautiful Music – A Fixed Pitch? Plato, Music and Gender

Barbara Underwood

In an article written in 1995 the leading contemporary religious composer John Tavener explains his music in terms drawn both directly and indirectly from Plato:

> Is there anywhere in the world today where the 'right notes' or tones have to be found before Parliament can be opened? This was the norm in Plato's Greece. ... I am neither philosopher nor theologian, but my work - my work of repentance that may or may not lead me towards a sacred art - can only be judged on how near the music that I write comes to its primordial origins. ... This is my work ... to try and find again something of the immeasurable magnificence, simplicity, and magisterial beauty and power that emanates from God, Who is the Source of Everything. (Tavener 1995, 49-54)

So why Plato? Despite the various changes and developments in music, philosophical and theological thinking, his influence pervades and in many ways undergirds that thinking. Much of musical structure in the West developed as a continuous thread out of Pythagorean Platonic ideas on how mathematical music relates to a fixed patterning of the cosmos, which became accepted also by Christians through such notables as St. Augustine, Nicomachus and Boethius. It was through the 'quadrivium' (Mediaeval University discipline in number, geometry, astronomy and music) inherited through the Pythagorean Plato that music was taught and became associated with philosophy and mathematical science (Chadwick, 1981,70-107). Famously, Leibniz (1646-1716) said in describing music that:

Music charms us although its beauty only consists in the harmony of
numbers, and in the account which we do not notice, but which the
soul none the less takes, of the beating or vibration of sounding
bodies, which meet each other at certain intervals.
(Leibniz 1973, 203)

Calling Plato's musical theoretical thinking into question reveals also that
the so-called 'neutral' or 'natural' qualities are built on gendered
principles. Those gendered principles are the ones that form the basis for
aesthetic discourses on music. Moreover, those principles are pernicious
toward women.

It has been argued that music, philosophy and theology are historically
deeply embedded within each other (Cohen 1993, 1-84). If that is the case,
and given also that certain feminists in theology and philosophy of religion
are critiquing and/or re-figuring aspects of Plato's dualism and its effects
on women throughout history,[1] then it follows that a similar critique or re-
figuring of Plato and his construction of the musical subject will map onto
philosophical and theological discourses as well. By the word 'subject' in
this context I mean the way Plato configured music both as a mathematical
topic and in relation to gender identity inscribed in that topic.

Like the Pythagoreans, Plato was fascinated with the idea that the universe
was a unity governed by or following a numerological pattern or model.
For Plato that pattern was a one-model universe which formed a unity
(Plato *Timaeus* 36e-37e, cf.92c). Where the Pythagoreans had developed
their Table of Opposites based on gendered bipolarities, he transformed it
by fusing their bipolarities into a single system and aligning it with a
numerical musical system (James 1995, 46)[2] through a process of
unification based on the use of number. But in order to do so he needed to
make a series of exclusions, occlusions, appropriations which reduced both
gender and music: gender is reduced to male gender and music is reduced
to perfect proportions within a mathematical framework. It is then
mathematical proportion as the possibility of perfection, which is seen as
beautiful and good and acts as a basis for aesthetic appreciation of music.

Firstly, I will give a brief account of Plato's Pythagorean credentials in
relation to gender. Secondly, I will go on to discuss how Plato appropriated
music in the light of Pythagorean numbers and their Table of Opposites
into his own discursive one model universe which nevertheless relies on

gender configurations for its argument. Thirdly, I want to explore in detail the uses to which he puts the number three, in relation to music and gender. And, finally, I discuss how his gendered configurations are taken to be identified with the beautiful, which is also tied in with the idea of the good. Moreover, it is gender configured this way which has been fed into and has come to represent the benchmark for aesthetics in music (Hornblower and Spawforth 1996, 29-30).

Part One

The Pythagorean Table of Opposites showed the universe as a duality, with a need for both the male and female in founding and maintaining it (Genova 1994, 42; Jentzen 1995, 31-32). However, the 'Table' placed all of the so-called 'good' qualities on the male side of the table and the 'bad' ones on the female side. The listings ran: Limit/Unlimited, Odd/Even, One/Multitude, Right/Left, Male/Female, Resting/Moving, Straight/Twisted, Light/Darkness, Good/Bad, Square/Oblong. The first pair of opposites, Limit and Unlimited, were the ones named as the fundamental principle of all things, and were symbolically male and female respectively. As Judith Genova succinctly put it, the 'other pairs of opposites were determined by the first and essentially functioned to name the basic dichotomous character of the world' (Genova 1994, 43).

The notion of the female Unlimited and male Limit was deeply embedded within ancient Pythagorean thinking. It pervaded their mythic, mystical, and religious life (Jentzen 1995, 32) and, importantly, was not separated from their abstract arithmetical theories. The universe was in some mystical way number. Additionally, the abstract and arithmetical symbolism was based on biological assumptions of the sexual nature of men and women. Women and men's sexual organs informed Pythagorean number theory. Their physical attributes generated and produced progeny. Cornford says:

> when numbers are divided into equal parts, the even is completely parted asunder, and leaves within itself as it were a receptive principle or space, whereas, when the odd is treated in the same

manner, there is always left over a middle [...] which is generative
[...] when numbers are equally divided, in the uneven number a unit
is left over in the middle, while in the even there is left a masterless
and numberless space, showing that it is defective and imperfect.
(Cornford 1923, 2)

Clearly, the receptive principle is, as Cornford goes on to say, the number
2, 'the Dyad, as the first even number, (which) stands for the female
receptive field, the void womb of unordered space, the evil principle of the
Unlimited' darkness: whereas the odd number, 'Triad is its opposite, the
good principle of Limit, the male whose union with the Unlimited
produces Limit' (Cornford 1923, 2). Thus, in their Table of Paired
Opposites the Pythagoreans showed a deep misogyny on various levels,
ranging from the organisation of the universe itself through to their
abstract number theory as described by Cornford.

Part Two

What Plato did, as I shall discuss later, was to turn the Pythagorean Table
of Opposites into a mathematical musical scheme which embraces the
whole cosmos (James 1995, 46). To this end he made very extensive
appropriative use of myths and number symbolism in his discussion of the
mathematical-musical universe (Burkert 1972, 468).[3] For example, the
way he re-configured the gendered bipolarities of the Pythagorean Table of
Opposites was to insist that 'it is not possible that two things alone should
be conjoined without a third' (Plato *Timaeus,* 31c). That third will be
significant. It will become clear that Plato did not simply include or
exclude women in his version of the binary table of contraries; instead, in a
subtle way he inscribed both men and women's identities, crystallising
them into abstract musical formulae which he then raised to the level of
dialectical reasoning.[4] Words take precedence over music:

...song is composed of three things, the words, the tune, and the
rhythm? ... And so far as it is words, it surely in no manner differs
from words not sung in the requirement of conformity to the patterns
and manner that we have prescribed? ... the music and the rhythm
must follow the speech. (Plato *Republic* 398d-e)

Plato's interest in the physical sound of music was limited to two facets: firstly, he wanted to examine how it should mirror mathematical theory, how that theory in turn should mirror the intelligible universe of reason, and how that kind of reasoning in turn dictates music's ethical stance. Secondly, he wanted to restrict its potential for disruption, a point which I deal with later on. Dealing with the former of these, and having already discounted the slack and effeminate modes and all those relating to use by women, Plato would only allow two acoustic musical modes[5] as acceptable in his ideal polis. These were the Dorian male mode and the Phrygian 'assumed' female mode.[6] The superior mode is assigned to the Dorian:

> but it would seem you have left the Dorian and Phrygian. I don't know the musical modes, I said, but leave us that mode that would fittingly imitate the utterances and the accents of a brave man who is engaged in warfare or in any enforced business [...] And another for such a man engaged in works of peace, not enforced ... [sic] . Leave us these two modes - the enforced and the voluntary - that will best imitate the utterances of men failing or succeeding, the temperate, the brave [...] (Plato *Republic* 399b-c)

McClain suggests that these modes alone would be sufficient or all that was necessary to fit both 'Pythagorean symmetry and rational numbers [...] without internal conflict' (McClain 1978, 128/129). Two interesting factors arise from this. Firstly, if Plato's system was to work as a whole ostensibly conjoining the male and female into a one model system, then it follows that once he had chosen the obvious and generally accepted male mode, i.e., the Dorian mode, as the superior one, he then had to find its suitable 'other'. Secondly, as McClain has suggested, mathematically the Phrygian mode fitted into the symmetry of the Dorian mode without internal conflict, thus providing Plato with a mathematical musical male/female bipolarity of the Pythagorean Table of Opposites, and one that is amenable to fitting together.

Because Plato was much more interested in dealing with the consistent underlying mathematical structure of fitting these modes together, he ignored the purpose to which it was generally accepted the Phrygian mode was put. He caused commentators from Aristotle onwards to question why

the Phrygian mode should be seen as the acceptable 'temperate other' (Aristotle 1962, 467f; West 1992, 180; Anderson 1966 73). In Greek culture generally, the Phrygian mode was considered an excitable mode and not temperate at all, and was related to Dionysiac frenzy. I suggest that the Phrygian mode provided Plato with a pseudo female other, in the guise of a mode used in the worship of Dionysus who was considered male and effeminate. Thus he could eliminate women *qua* women from his musical scheme. Moreover, feigning not to understand music theory Plato seems to demonstrate his preparedness to ignore both the generally accepted meaning of the mode and its understood use, in favour of its fortunate tendency to mirror the converse of the Dorian structure.

In the *Republic* Plato contrasts his own approach with what he considered the limitations of the approaches others take. He said:

> the numbers they seek are those found in these heard concords, but they do not ascend to generalized problems and the consideration which numbers are inherently concordant and which not and why in each case. ... for the investigation of the beautiful and the good, but if otherwise pursued, useless. (Plato *Republic* 531c-d)

What is apparent in Plato's idea of numbers (or musical mathematics) is that they should be used primarily, to find patterns of agreement within themselves, purely mathematically and not acoustically; concord meaning here 'agreement'.[7] Those numbers which 'inherently' agree seem to be those fixed numbers the discovery of which was attributed to Pythagoras (the octave ratio 2:1, the fifth 3:2 and the fourth 4:3 are the basis of Pythagorean music of the spheres). These are the ones to be used, raised above the mundane, to determine the 'investigation of the beautiful and the good...'.[8] In other words, for Plato getting the sum right is the first stage in determining the beautiful and the good. There are to be no other considerations allowed in his process about the aesthetic value of music. He is saying here that mathematics is used in order for thinking to ascend (and by ascend he means away from physical sound), which in turn will determine the beautiful and good, otherwise empiricism and mathematics are useless. For him numbers are either rational or irrational. Moreover, it is also true that Plato's method in his dialogues is for dialectic to have hegemony over mathematics. Mathematics becomes subordinate or absorbed into discourse, into meaning more than numbers. Consideration of music and numbers must further ascend into dialectics, into philosophy.

This means that Plato unites the Pythagorean Table of Opposites through mathematical musical number. Acoustic music, which emanates from the physical universe or from the body, is relegated to a subspecies. Then mathematical music becomes absorbed into dialectical philosophical discourse belonging to reason and the soul. This discourse in turn will determine the beautiful and the good. The whole process mirrors the radical separation of the soul from the body. It also indicates, as Grace Jantzen says, that for 'Plato [...] the soul is the real self and has access to true [...] knowledge, even while it is imprisoned in the body which distracts it by focusing its attention on things knowable by the senses.' (Jantzen 1995, 32).

It is clear then that mathematical musical structures, in the preliminary stages, are aligned on the male side of the Pythagorean Table; that is, on the side of limit. In the *Republic* Plato subtly proceeds to absorb women into the male category of limit, when he argues that girls and women should receive exactly the same musical and gymnastic education as male guardians within the city-state (Plato *Republic* 455e – 456b; cf. *Laws* 804 d-e). At first glance it seems to suggest that women can actually share in the true knowledge. But note that it is women who must measure up to the male established norm, rather than the other way round. In fact Plato says:

> The women and men, then, have the same nature in respect to the guardianship of the state, save in so far as the one is weaker, the other stronger. (Plato *Republic* 455e-456b; cf. *Timaeus* 18c)

By the 'same nature' Plato means male nature; he is saying that really women are the 'same' as men and not vice versa. It is men who shall be the benchmark, and women happen to be a weaker version of the same when measured against this benchmark. It was commonly assumed that women were considered not only physically weaker than men but mentally weaker as well. Interestingly, this notion will be mirrored Plato's mathematical musical scheme.

For Plato, then, number was a platform or stage on the way up towards higher, more pure and abstract way of thinking, making the physical follow

the abstract. In the *Philebus* he starts by insisting on the value of number and then moves on to music:

> when you have grasped number and quality of the intervals of the voice in respect to high and low pitch, and the limits of the intervals, and all the combinations derived from them, which the men of former times discovered and handed down to us, their successors, with the traditional name of harmonies, and also the corresponding effects in the movements of the body, which they say are measured by numbers and must be called rhythms and measures [...] - when you have thus grasped the facts, you have become a musician, and when by considering it in this way you have obtained a grasp of the other unity of all those which exist, you have become wise in respect to that unity. But the infinite number of individuals and the infinite number in each of them makes you in every instance indefinite in thought and of no account and not to be considered among the wise, so long as you have never fixed your eye upon any definite number in anything. (Plato *Philebus* 17d-e)

It is clear from this quotation not only that Plato considers number in music important, but also that he is clearly staying within the boundaries set by the gendered Pythagorean Table of Opposites. It is also clear, as I shall go on to discuss, that music is perceived as a measurable unity, and that unity is a system of consonant numbers, from which he will rise to dialectics. And it is this way of thinking which underpins future aesthetic principles in music.

Plato's method here signals the relegation and exclusion of whole discourses of 'otherness' which are associated with women. Those discourses relate not only to physical sounds in music, but also to women's methods of practice, their role in religious cult practices, their rituals and laments, which are excluded because they would be perceived as outside this number system. Plato refused to admit modes for laments, which were the traditional province of women in Greek culture (Holst-Warhalft 1992), into his ideal city-state: which makes his use of the Phrygian mode even more deceptive.

Part Three

I want to turn now to look at Plato's musical mathematical construction in closer detail. This would be coded male because of its 'limited' and rational nature, which would cause it to belong on the male side of the Table of Opposites. However, there is a notable addition:

> [...] it is proper to liken the Recipient to the Mother, the Source to the Father, and what is engendered between these two to the Offspring [...] (Plato *Timaeus* 50d)

I refer again here to Cornford where he says that in Pythagorean number symbolism the Dyad represents the female receptive field, the void womb of unordered space, the evil principle of the Unlimited darkness: while the Triad on the other hand is its opposite, the good principle of Limit, the male whose union with the Unlimited produces Limit. In the *Timaeus* Plato idealises these numbers. The Father, the immutable One, is the source and the Mother, the Dyad, is the Recipient. They produce the Offspring, i.e., the prime number 3, the Triad. But he also says that she, the Mother, should be described as a 'Kind invisible and unshaped [...] all receptive' (Plato *Timaeus* 51a) and not as anything specific such as earth, air, fire or water. This means she is the principle of no-thing. It is the offspring, the Triad or triangle, which 'we lay down as the principles of fire and all the other bodies' (Plato *Timaeus* 53d) and is therefore the principle of the potential for solid objects.

In Plato's reconfiguration of the Pythagorean Table, then, the number 3 which sits on the male 'odd' side of that Table and the meaningless number 2 which sits on the 'even' would mirror the idealised One and Dyad. All their progeny would be symbolised by the number 5 (2+3) signifying the nuptial number, and all would be male offspring.

The number 3 signifies the divine birth being the initial creation. Plato's desire is to bring the binary together under one head of reason, which connects the one of the Limit with the two of the Unlimited in order to combine the two together and thus produce a third. Plato is taking the Pythagorean table and pressing it into a comprehensive one-model

universe. The number 3 for him is not simply a passive odd number which sits on the male side of the table of opposites. Instead, it will fill in the 'gap' or 'masterless space' which he says lies between the 1 and 2.

Music illustrates this point. In musical terms what lies between the ratio 1 and 2 is an octave space. It is represented by the octave: that is the number 1 which represents a note, for example the note *d*, say on a piano; and the number 2 represents the note *d'* - the same note an octave higher. The number 3 is going to generate the intervals which fill the space created by the octave. This male number will for Plato bring unity or consonance, by filling the gap between the number one of Limit and the number two of the Unlimited. Plato is also punning on the Pythagorean notion of the unordered space, the female receptive field, when he says:

> My object, Protarchus, is to leave no gap in my test of pleasure and knowledge, if some part of each of them is pure and some part impure, in order that each of them may offer itself for judgement in a condition of purity, and thus make the judgement easier for you and me and all our audience. (Plato *Philebus* 52e)

There is an obvious *double entendre* about filling gaps between pleasure and knowledge: but the gap he really wants to fill is the octave gap: the 2:1 ratio, which expresses infinite, unlimited pleasure (and pain), with limit and thus knowledge. And so the triad or the three, the male member, the phallus, becomes a very important principle. Aristotle said 'the universe and all things (in it) are limited or determined by three' (Aristotle in Cornford 1923, 2). It is the key to unifying Pythagorean dualism. But as I shall go on to discuss, the number two, i.e. the female principle as the dangerous evil 'other' of Pythagorean darkness, disappears from sight; she is dissolved within the notion of the symbolic one and three (see also Plato, *Timaeus* 31-32bc).

In prioritising the number 3, Plato also appropriates its mythological aspect and changes the uses to which the Pythagoreans had put it. In myth the female figure Harmonia traditionally stood in between love and war. Notably women were keepers of 'harmony' in the Boeotian myth and Attic versions of harmony, and so was Moira, the goddess of the Fates, who kept order in Polytheism by departmentalisation (Burkert 1985, 248). Also, as Edward Lippman says:

The Boeotian myth makes Harmonia the daughter of Ares, the god of war, and Aphrodite, the goddess of love and beauty, while the Attic version develops the musical element: Harmonia is not only the daughter of Zeus and the Atlantide Elektra, but she is also the mother of the Muses. (Lippman 1964, 4)

So, within the mythic concept of duality, female 'harmonia' was the third term which holds the two polarities together in tension; and this female element was also included in some versions of musical and religious culture (Holst-Warhaft 1992).

For the Pythagoreans, by contrast, 'harmony' was a tool or metaphor used in many different guises. For example, it was a connecting link and was essentially physical:

[...] harmony does not necessarily involve either number or measurement. It means simply 'fitting together', as manifested typically in carpentry in the joining of two pieces of wood, and the prerequisite of the conception is thus the existence of two or more distinguishable entities somehow capable of mutual adjustment. (Lippman 1964, 2)

But, importantly, it is these versions which Plato appropriates into his own version of 'harmony', as the numerical third term becomes or remains firmly a male symbol. He transforms the myth of Harmony as beauty and balance into a purely rational principle that is called beautiful and good. Instead of myth, number measures his harmonia. He says that 'audible sound was bestowed for the sake of harmony' (Plato *Timaeus,* 47d) and that harmonies are 'measured by numbers' (Plato *Philebus,* 17d). Furthermore, harmony for Plato is also a metaphor for perfection-in-relation in the cosmos, mirrored by the mental reasoning process which pieces all aspects of reality together. Physical 'harmony' [or melody] is a pale reflection of that process; and, even then, it is this reflection if and only if it follows the rules of reasoning. Thus, his concept is to separate physical acoustics from the intelligible. This means that all physical sound, which must now be deemed male, is to be controlled and ordered by a

reasoning process, which is also defined male. It is this rational process which is deemed beautiful and good.

In the *Philebus* Plato says, crucially, that he puts 'an end to difference between the opposites and makes them commensurable and harmonious by the introduction of number' (Plato *Philebus,* 25e). The number three is also to do away with difference. So no longer is the duality held together in tension, but difference is to be eliminated. This means putting an end to the female principle altogether:

> We said that God revealed in the universe two elements, the infinite and the finite, did we not? ...Let us then assume these as two of our classes, and a third, made by combining these two...
> (Plato *Philebus* 23d)

By this move he has put an end to the notion of the mythical female figure who holds war and love in tension, just as he has already dispelled the physical aspects of harmony or acoustics.

Moreover, for Plato, as for the Pythagoreans, difference is gender difference, and has been *seemingly* done away with by the act of replacing difference with *seemingly* neutral number. But, as we have seen, he does not re-think Pythagorean number theory but, instead, plays on it. Specifically, he does not get rid of the underlying notion in the cultural mind-set of the Pythagoreans whereby the unlimited and the limited have gender implications, even though he is talking in terms of abstraction. The number 'three' actually becomes a metaphor and symbolically hardens the notion of maleness, without Plato having to mention gender. His contemporary audience would have understood and known his references without his having to mention them explicitly:

> Mix [...] [the infinite with the finite] and [...] if these two are both unified and then the third class is revealed (Plato *Philebus* 25d) - [*the male principle number which*] [...] creates a limit and establishes the whole art of music in all its perfection [...] (Plato *Philebus* 26a)

> [But] [...] if arithmetic and the sciences of measurement and weighing were taken away from all arts, what was left of any of them would be, so to speak, pretty worthless. (Plato *Philebus* 55e)

[i.e., the female principle] {my italics in square brackets}

The male principle establishes perfection and the female principle is worthless. All art is worthless without the third class - number; and this includes by extension all 'others' which are associated with the female principle and particularly acoustic material of music.

Part Four

I turn now, finally, to Plato's musical scheme that supposedly brings together the Pythagorean Table of Opposites of the Limit and Unlimited to produce his mathematical-musical one universal model, which will reflect the beautiful and the good. This shows overtly his view of the 'female other' as mere failure and his use of her as unlimited, ignoring all the 'other' other under this side of the table. This comes mainly from the *Timaeus*, where a unity is produced by the World Soul, which is explicitly musical (James, 1993,46; Barker, 198, 53; McClain, 1978) and consists of three elements, Sameness, Difference and Existence (or Being or Essence), which are mixed together (Plato *Timaeus* 35a-b). To summarise this roughly, Barker says that the

> soul must be involved both in the world of unified and eternal Forms ('Being') and in that of plurality and change ('Becoming', [...] 'that which is divided up among bodies'). It must also partake of the natures of both uniformity (the 'Same') and multiplicity or variety (the 'Different'). (Barker 1989, 59 n13)

Difference has two elements within it, male and female character. But difference here is a mixture that is compounded within each individual as well and so ostensibly male and female co-exist within the human frame. But there is no room for the completely 'other' as Plato's 'different' cannot admit something which is totally female. Plato says:

> human nature is two-fold, the superior sex is that which hereafter should be designated 'man'. (Plato *Timaeus*, 42a)

The better part shall be given to men. Plato makes this clear when he says that the many challenges men encounter through their lives, such as pleasure, pain, fear and anger and other such emotions, come from 'a different and opposite character' (ibid. 42b). Bearing in mind that Plato had said that human nature is two-fold, this leaves only the character of women which would produce such challenges. And he then makes this even clearer when he says:

> And if they shall master these they will live justly, but if they are mastered, unjustly. And he that has lived his appointed time well shall return again to his abode in his native star, and shall gain a life that is blessed and congenial; but whoso has failed therein shall be changed into woman's nature at the second birth ... (Plato *Timaeus* 42b-c)

So to be changed into a woman's nature is to be considered as failure.

But how then does this fit with the potentially androgynous scheme? It seems that the female is only acceptable as 'different' if she fits in with the scheme whereby she exits as a lesser part in the male character - the Phrygian to his Dorian perhaps. Therefore, to be fully human is to be 'male-male/female'. There is no possibility of being equally male/female because the male part is always superior. Nor is there any possibility of possessing a wholly female nature save as failure.

Woman, or rather her nature as depicted by the Pythagorean Table of Opposites as the 'evil' principle of darkness, seems to have been left out completely from Plato's scheme. She is simply a character failing; she only exists within the male frame.

Her function is as an 'empty' term, the number 2 signifying the octave, which is suppose to signify difference. But, as I have discussed above, difference or the 'other' is characterised as 'male-male/female'; and the octave space replicates this. The octave or the first ratio 2:1 which represents the gap between one note and the corresponding note at a higher pitch is not 'different' nor in musical terms 'dissonant'. It simply signifies the same note transferred at a higher pitch. The octave is merely the 'other' of the 'same'.

Moreover, this means that the limit and the unlimited represented by 1 and 2 respectively, which have been conjoined by the offspring 3 which I spoke of above, indicate that both (the divine) male and female so conjoined are symbolised by the number 3, the male triad. This generalised view of the universe is mirrored within individuals as well. The female 2 plus the male 3 equals 5, which in the system of number symbolism represents marriage and thus the product of that marriage: a male child. Therefore, 5 being an odd number, all properly constructed human children are male children. However, in Plato's marriage allegory he says:

> ...for divine begettings there is a period comprehended by a perfect number, and for mortal by the first ... (Plato, *Republic* 546b)

Ernest McClain suggests that the perfect number which comprehends divine births is the combination of $3 + 2 + 1 = 6$ (McClain 1978, 20). If this is the case, it shows Plato configuring an even 'better' birth than the traditional male/female binary. That is the one which would be produced by reducing the participation of the number 2 in the equation, by adding to the number 5 (the human male principle) the 1 of Zeus: a marriage of man to god (Plato *Timaeus* 28a-b).

As I mentioned above, Plato's interest in music was also to restrict its potency and, as it were, to get the marriage right. The marriage allegory in the *Republic* (Plato, *Republic*, 546d) argues for that kind of attunement. The logic of the marriage allegory helps him to reason a prevention of innovation and novelty in music. If he can set musical proportion as tuning not only for his polis or city-state but also for individual souls, he will prevent the likelihood of revolution. The revolution had already happened to a certain extent in music (Barker [ed.]) 1984, 128 n13). It was becoming disengaged from the words, and the conservatives considered different innovations in tunings as outrageous and unmusical. And of course Plato makes the link, or 'marriage', between the unmusical and the unethical (Plato *Republic* 546a-d; cf. Anderson 1997, 127). A good education in music, which meant more to the Greeks than it does today in the West, would mean stability within the city. For Plato, as for the ancient Greeks generally, music was more than accompaniment or mere entertainment (West 1992).

Ernest McClain, explains the conclusion of the marriage allegory, which is to look (his inverted commas as taken from the *Republic*) 'then, for the limit of both "better and worse" musical births...'. Although McClain continues his explanation in musical ratios which I cannot go into here, what is noteworthy in this is the importance he gives to what those ratios signify and what this in turn says about the meaning of the ratios rather than the ratios themselves. McClain says:

> [...] those tones 'fathered' by the divine male number 3 [...] generate 'rulers' or 'citizens of the highest property class', meaning fifths 2:3 and fourth 3:4 [...] tones fathered by the human male number 5 [...] generates 'auxiliaries' or 'citizens of the second highest property class,' meaning major thirds 4:5 and minor thirds 5:6. We can safely eliminate all factors of the female number 2 because they are merely octave replications of tones generated here by the odd, *male* numbers. (McClain 1978, 28)

So the true marriage allegory would really eliminate women; the true marriage is that between 'man' and 'god'. Aesthetically beautiful and good music is that made between man and the heavens and has little or nothing to do with women. The female principle, the number 2, has been rendered invisible as facilitating different octaves with the same internal structures within those octaves.

Consonance, octave 2:1 (male –male/female), fifth 3:2 (marriage) and fourth 4:3 (justice) in Plato's scheme, is a mirror of divine harmony (Plato *Timaeus* 79e-80b). Any other sound or interval or other ratios would be considered discordant and therefore set in complete opposition, save in a melody within a 'properly constituted scale' (West, 1992, 160). Plato, in the *Republic*, had, as we have seen, simply disallowed other modes in his city-state: therefore anything other than his specified conditions for consonance would be discordant. David Cohen who has written about the privileging of consonance over dissonance in the 9th century A.D. also argues that the Platonic view of consonance espoused by Boethius also necessitates the existence of disagreement and conflict of opinions. Clearly then, when in his version of consonance which seems to bring the 'same' and 'different' together, Plato is doing no such thing. The different or dissonance is actually outside of his scheme.

Conclusions

I have tried to show that Plato appropriated all formal aspects of music used or performed by women. His method relegates or excludes whole discourses of 'otherness' which are associated with women. Those discourses related not only to physical sounds in music, but also to women's methods of practice, their role in religious cult practices their rituals and laments.

He also appropriated existing myths and number symbolism within his discussion of the mathematical-musical universe, making it totally male. He turned the Pythagorean musical mathematics into a discursive tool that conjoined the bipolarities of the Pythagorean Table of Opposites. But in doing so he also absorbed, occluded and rendered invisible the female side of that table. In the *Republic* women have no musical mode and are depicted as a weaker version of the same; in the *Timaeus* they are dissolved into an invisible kind of receptacle, and in the *Philebus* they are totally ignored as a significant number. Instead, the number 3, the male principle of the Triad, becomes the significant number associated and identified with what is beautiful and fixed, which is the rational process also tied in with the idea of the good. It is music configured in this way which has been fed into and has come to represent the benchmark for aesthetics in music throughout Western history.

For women to have entered as 'different music', as the completely other rather than the male/female other of Plato's system, they would have been seen in opposition to the very male 'consonance' and therefore as 'dissonance'. Dissonance in this system, as with Boethius and through to the later Enlightenment, would be construed as irrational, unruly noise, worthless, harsh and violent; and so women remain in the position of the dangerous other. The possibility of reconfiguring aesthetics in music in a way that is different and not merely oppositional is the work which feminist musicologists are de-coding at the present time (McClary 1991; Citron 1993; Cusick 1994, 6-86). Feminist philosophy of music is perhaps on the way to picking up these threads for discussion.

Notes

1 For example: Bat-Ami Bar On (1994); Grace M Jentzen (1998); Adriana Cavareo 1995; Steven Shankman 1994; Nancy Tuana 1994.
2 Although the idea that Plato had utilised the Pythagorean table of opposites for the purposes of numerical relation is readily seen, I do not think that its gendered musical implications have as yet been fully explored.
3 Walter Burkert says that dismissing these abstract numbers as arcane and irrelevant would be to ignore roots that go very deep into their culture. I would add that these thread through to the present and that looking at the past may help us to reconfigure the future.
4 Plato in the *Phaedo* at 61ff says that philosophy is the greatest kind of music.
5 A 'mode' can be considered a framework of notes containing a given set of intervals, it can also be considered a strain or style.
6 *Republic* 399a. The Phrygian mode as female is argued by scholars (West 1992; Anderson 1966.73).
7 In the Greek Lexicon this can mean also bringing two or more voices together. The use of voices in Plato I think can be seen as ironical.
8 He does this by working out their arithmetic, geometric and harmonic means in an overarching system - see McClain 1978. Op.cit.

Part 4

And Then There Was (German) Enlightenment

Penny Florence and Nicola Foster

Introduction

In Section One we saw that an ethical difficulty arises in Plato's text through the gendered distinction established by the prioritisation of the intellectual over the sensible.

There can be a difficulty in setting out how the following innovative accounts may or may not relate to variations in 'western' tradition. This is a significant matter on many levels, but especially in the present context because of the marginalisation of feminist thinking, almost it seems because its feminism is perceived to render it limited in application. At the end of this section, Purdom for example takes up the notions of 'sensible being' and 'the being of the sensible', relating experience and the beautiful to a 'superior empiricism' that Deleuze explores as going beyond Kant. In this she is tracing points of mutual relevance within different inheritors of the German tradition that inflects aesthetics where it does not define it.

Both of the above, the relation of feminist thought and art first to Kant and then to the overall contemporary discussion of aesthetics, are the subject of Jeremy Gilbert-Rolfe's essay, *Kant's Ghost, Among Others*. This important topic has immense resonance both in the specific case of Kant in aesthetics and in the general case of feminist thinking as a philosophy and epistemology; Derrida's Marxian spectre is a shape-shifter whose invocation forces attention to uncomfortable factors with which feminism must deal. Gilbert-Rolfe's contentious style will doubtless provoke some readers; it will enliven the debate for some others, and should in any event make a worthwhile contribution to the debate over how feminism is located – or locates itself – in relation to its interlocutors.

In modernity, the prioritisation of the intellectual over the sensual is interiorised: the intellectual becomes a conception of a 'universal' disembodied moral agent or subject. For Plato - and most pre-eighteenth century writers - Beauty was understood in terms of perfect proportions which harmonise the Good and the True: Beauty was seen as a quality possessed by objects/ideas. In modernity, the interiorisation of the intellectual into the subject also involved a shift in the understanding of the aesthetic. Beauty was now seen to refer to the experience of perception: the pleasure, or pain, experienced by the perceiver. Baumgarten defined the aesthetic as 'the science of sensible knowledge' - as opposed the science of intellectual knowledge which would have included the Good and the True – opening the door the isolation of aesthetics from other philosophical concerns. Baumgarten's distinction allowed for the development of the modern sub-discipline of philosophy – nowadays, as we have said, described as 'analytical aesthetics' - which limits its inquiry to 'the philosophy or theory of taste', or 'the perception of the beautiful'. This is still the definition of 'aesthetics' offered by the *Oxford English Dictionary*.

Over the past ten years a growing female scholarship has developed on eighteenth century aesthetics. While analytic aesthetics sought to isolate aesthetic discussions from all other areas of philosophy in order to defend the claim of disembodied universality and disinterestedness, feminist approaches tended to do the opposite. It is precisely when the isolation of aesthetic discussions is shown to be inextricably connected to a range of other philosophical issues that the gender specific assumptions and implications of aesthetic discussions are exposed. Examples of how this can be done are available in Korsmeyer's essay 'Gendered Concepts in Hume's Standard of Taste', and in Batterby's essay 'Stages on Kant's Way: Aesthetics, Morality, and the Gendered Sublime', both in Brand and Korsmeyer (1995). Both Korsmeyer and Battersby show respectively that in Hume's account, as in Kant's, females are left on the margins or outside human nature and moral agency / subjectivity. As such - despite claims for universality in discussions of the aesthetic - females remain on the margins of or outside the aesthetic altogether.

In this Section, Rachel Jones' essay builds on Battersby's work on Kant's gendered articulation of the sublime, as well as on Irigaray's critique of the philosophical articulation of subjectivity in Western philosophy: an articulation which depends on the subject / object relationship. In Kant, the interiorisation of the (Platonic) intellectual takes the form of a relational process that establishes both the objective world and the subject at the same

time. Irigaray argues that in the philosophical tradition woman has been objectified rather than understood in terms of subject. Jones points out that Irigaray's claim that 'the constitutive role accorded to the object by Kant has effects beyond the control of the rational Enlightenment subject' is best exemplified in Kant's account of the sublime. By overcoming his terror of natural forces 'the subject is capable of imaginatively transcending both nature within [...] and without', and through this experience of striving towards infinity, the unconditional and the absolute: in short, becoming a moral agent/subject.

Kant's exclusion of women from the experience of the sublime, Jones argues after Battersby, excludes women from the conditions required for becoming both moral identities and genius / artists. Following Battersby, Jones proceeds to look for gaps in the tradition through which women's otherness has become a productive disruption, as in the work of the German Expressionist poet Claire Goll. An analysis of the impossible subject / object relationships in her poetry, Jones argues, allows the reader glimpses into how poetry might 'function for those who write from the side of woman, the side of the "other" and the "object"'. What also emerges is the possibility of an 'identity' that is 'grounded in a non-oppositional logic', an 'identity' which is 'inclusive of difference and change'. The implications of such critique are far reaching. The critique is not only of the Kantian sublime but also of the Kantian account of subjectivity that prioritises fixed subject and object identity in terms of solid unchanging substances. At the same time, the critique affords to aesthetics and the production of art the possibility of overcoming the constraints of the tradition, particularly for those who are at the margins.

While Kant's account of subjectivity develops through subject / object relations, Hegel's account in the *Phenomenology of Spirit,* is structured by an intersubjective performance encounter described as the master / slave dialectic. Like Jones, Petra Kuppers also looks to artistic forms – in Kuppers, performance art - to suggest gaps and moments of suspension and rupture in the process of subjectivity. And like Jones she reads Hegel through established female scholarship in the philosophical tradition in general:[1] though Kuppers' reading is often more implicit than explicit, her more explicit references are to feminist scholarship on performance arts. Kuppers reads - and strategically misreads - Hegel's master/slave dialectic as 'a traumatic scene of a consciousness never able to fully find itself, in order to find another entry point into the contemporary feminist difficulty of how to circumvent the problematic articulation of self/other. Several recent feminist texts - most notably Irigaray's - have identified the

difficulties of such articulations in which each term gains meaning only in relation to its other as opposite. Moreover, in the philosophical tradition, the former (self) is generally articulated in positive terms and is gendered male, while the latter is articulated in and through lack and negation (the other of...), and is gendered female. Kuppers' essay seeks to open readings of performance art which lead away from identity politics by 'troubling productively the edges and leakiness of identity'.

The final essay in this Section also takes up this theme in moving further still towards the contemporary. In this way it acts as a kind of bridge to the next Section, maintaining the continuities that might seem to be broken in our organisation into sections. Judy Purdom holds her argument on the border between identity and the aesthetic, examining how Nancy Spero turns aesthetic recognition into actual encounter. This goes well beyond ideas of aesthetic 'unity' to appreciate how formal innovation can ruin the narrative and regulatory codes of normative aesthetics to insist on the seriousness of the aesthetic in the broader regimes of power. What emerges is a consideration of the work of art itself as philosophy, transgressing another of the endings or limits imposed in traditional aesthetics. We would stress that the 'drive towards equivalence' that she analyses is common to the postmodern and the traditional in different ways, and neither is adequate to feminist aesthetics, or to any inclusive yet differential aesthetics to which it might contribute.

Note

1 The most famous feminist reading of Hegel's master / slave dialectic is of course de Beauvoir's short passage in *The Second Sex*. Kuppers takes a very different approach and thus makes no explicit references to it.

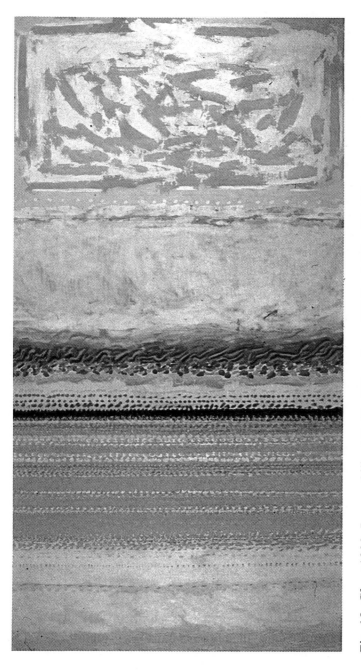

Fig. 18. *Ghost* 1998. Jeremy Gilbert-Rolfe. Oil on linen. 78½" x 147" x 2½–1½".

Chapter 3

Kant's Ghost, Among Others

Jeremy Gilbert-Rolfe

Kant and the Presence-Absence of Ethics

I never written anything for a primarily female audience before, not only that, but do so here knowing that, while ethics is important to feminist discussions of art and cultural production, my discussion of it may be unsatisfactory to some because I am going to say that in the contemporary art world the ethical in art is an idea complicated by its referring as much to the chosen province of a *kind* of art as to a question about what art in general should now be. A great deal of art and its discourses are overtly ethical in that they place the idea of the severe and obligatory ahead of that of the pleasurable and optional, with the implication that the pleasurable could only be such if it were to embody obligation rather than free choice. As Mary Mothersill has humorously observed, in Kant's case one finds oneself suspended on the difficulty posed by his combining the latter with an insistence that one make sure that it be universally shared (Mothersill 1992, p.46).[1] Kant's difficulty relates to the question of what to do with aesthetic experience, rather than with what works of art should be, but these have never been seen as inseparable areas of inquiry and were for a long time discussed in terms which were, broadly speaking, presumed to be his. However, I want to suggest that the question of art's or aesthetics' relationship to ethics has been further complicated by the prevalence in the contemporary art world, which is the world in which I live, of an art discourse which either seeks to obviate Kant or acts as though the obviation has already been achieved. In this it is a discourse unlike that from which it grew, but it could be seen to be as radically conservative rather than the alternative.

The Kant that this discourse seeks to do without is the one who describes judgement as proceeding from 'the aesthetic *normal idea*, which is the individual intuition (of the imagination) [...] (to) the *rational idea*, (which) deals with the ends of humanity so far as it is capable of sensuous

representation, and converts them into a principle for estimation of his (sic) outward form, through which these ends are revealed in their phenomenal effect' (Kant 1952, p.77 [German pagination 233]). Contemporary discourse would like to do without the first part. It distrusts the concept of intuition and much else about the subject Kant invents to exercise the freedom of thought he sees as essential to an aesthetic experience.

While many would still be prepared to accept that '(T)he greatest finality in the construction of (an ideal of beauty) [...] has its seat merely in the judging Subject', (Ibid) few could now be content with the subject Kant described. The contemporary will to obviation of Kant follows, however, not from this dissatisfaction as such—revision could as well preserve as abolish—but from defining the solution to the causes of this discontent as the elimination of aesthetics from art and its criticism. This is the difference between the present and the fairly recent past. For a long time the aesthetic was what the avant-garde invoked in order that it could transgress against it, usually by demystifying it. In making an argument for the New York School in 1948, Barnett Newman invented a European painting tradition that never existed in order that there can be a manly American one that would have none of that stuff about beauty (Newman in Shiff 1990, 179-173).[2] Plainness and a lack of artifice were superior, frontier, values even or especially in New York City. In 1965 Donald Judd rewrote the same script—now starring British Empiricism in the rôle played by Burke in the Newman version—in order to displace the New York School (Judd 1975, 181-189).[3] His language was ethical in tone and connotation. Not only beauty but expression and composition were bad. Judd railed particularly against art being involved in illusion.

That was the order of things until recently. The avant-garde used ethical-sounding language in transgressing against the aesthetic, in an art world, it should be noted, in which ethics were a tacit component of art but for the most part ignored—excepting, on the commercial side of things, with reference to the oxymoron 'business ethics'—and aesthetics taken for granted but ill- or un-defined. This was true at every level of production and the differences between then and now have reverberated throughout art's social infrastructure. When I was an art student no one ever told me what aesthetics was—this was before the reforms of the mid-1960s—but when I found out I realised that half of the discourse in the life class was Kantian, the other half being technical and of ultimately Renaissance provenance. No one could teach art in that way now. It was because learning to draw did not require much interrogation of the terms in which it was discussed that it ceased to be the unarguable basis of art education, and

Kantian judgement is nowadays not an implicit if unacknowledged point of reference but an explicitly disreputable way to think about art. Once almost nameless while constantly challenged, the aesthetic is now prominent as an object of permanent abolition.

If art's founding criteria were once technical skill and a vaguely Kantian idea of perfection, their subsequent fates illustrate the differences between then and now. Painting and sculpture have survived by exacerbating the critical dimension that the idea of technical skill has always possessed in these fields. The pre-history of the avant-garde is filled with acts of skill as negations of itself (for example, Courbet's *Internment at Ornans*). The immediate past is filled with practices in which skill is skilfully resisted (for example in many kinds of both representational and non-representational painting, from Pollock to Elizabeth Murray or Mary Heilman or beyond to Fiona Rae), and, elsewhere than in those media, as skill in choreographing complex arrangements of awkwardness (for example in Cunningham, Yvonne Rainer, and many kinds of performance art since). As was not the case once, it is now safe to say that one involved with contemporary art (dandyism aside) is either intimidated or irritated by technical skill. Everybody is quite settled most of the time regarding what are good deployments of bad drawing and what are uninteresting, deficiently deficient, bad at being bad, ones. So settled indeed are we that, especially in the electronic media sometimes felt to have replaced painting and sculpture, skill has recently been able to re-emerge as a very traditional version of itself (as in a great deal of video art, both single channel and projected). A visitor to the contemporary art world could reasonably infer that it was unfashionable to be able to draw but *de rigueur* that one be amazingly fluent in cybernetic techniques. She might almost think that a very old-fashioned delight in smooth transition had been transferred to the electronically photographic, where it was now permitted, from the hand-made where it continued to be viewed with suspicion. Being indispensable, the idea of skill has been reinvented, its capacity to produce meaning reinsured through critically broadening its scope.

Kant's fate has been settled quite differently by the art world. Neither artists, nor art dealers, nor historians can make do without the idea of skill, which has therefore been rehabilitated and expanded so as to include the exploitable potential of its own bankruptcy as well as its more conventional associations with inventiveness. In contrast, the contemporary art world shows no interest in rehabilitating Kant, who is retained only so that his alleged bankruptcy may be exploited through an inventiveness that has no use for his subject. This is because Judd's Minimalism (or Eva Hesse's or

Anne Truitt's) was the end of something which the intellectual and commercial administration of the art world (a partly voluntary and partly involuntary symbiosis of parallel interests) has spent the past twenty years or so reinventing in terms of an anti-art model of production (Duchamp), and theory (predominantly Foucault's) that was not Kantian to begin with and has been rendered more, and differently, determinist than it ever meant to be by being reconciled first with Duchamp and then with the Frankfurt School (Gilbert-Rolfe, 1999). This has permitted the art object to remain historical, and therefore commercially viable for art dealers and intellectually within the purview of art historians.

This is why I say that the question of ethics is complicated by the facts of contemporary art. Usually, contemporary art is described in terms which suspend the question of *art* in favour of *art after art*. That suspension, or repression, indicates a preference for art which is read rather than seen which is shared by a great deal of art after art itself. 'Art after art' turns out to be a kind of social documentation, anthropological in content and form in that it is a matter (connoisseurship) of recognisable discourses presented in manners generally approved, both the art and its accompanying theory, as noted, predicated on substituting a kind of reading for seeing, intellectual recognition (the episteme) for visual perception (the retinal). A new historicism foregrounds the ethical as the grounds of the historical, and at the expense of the aesthetic, but since it is a type of art its popularity turns ethics into a commodity in quite a new way. There is nothing new in its claiming, inter alia, to be founded on a critique of the institutions which support it and on which it depends. What is new is that the ethical is now no longer a volition for art, but what one has instead of art.

In such a situation, one might at first think that the most ethical position would be to withhold from an ethical position. This is unsatisfactory because it is absurd. It could never describe how a work actually worked in the world at large, although it does have the virtue of returning the origin of the work of art to the work of art. There is, moreover, no obvious reason why people should not fill galleries up with objects which immediately raise ethical issues if that's what they want to do. I do not wish to lose sight of that point in discussing the administration of the art sign which has followed Kant's fall from favour. There seem to be several reasons for it, of which his having been *in* favour for so long might be one. The desire to irreversibly replace aesthetics with ethics is, though, by far the most important. Others would have to do with Kant's idea of the autonomous subject and the uses to which it has been, and continues to be, put, and it is these which have provided most of the evidence at the post-mortems. [4]

This is the environment in which Kant survives as a ghost, his aesthetic now often or generally supposed to have been surpassed, either wholly obviated or at the least discredited. At times he is a Canterville ghost too, his credible existence as a tangible force denied on the grounds of logic by criticism which, (like the friendly Americans in Wilde's story, who refuse to believe in the ghost but nonetheless helpfully offer him oil with which he may quieten the clanking of his chains) wants it to be understood that he is not there and if he is he's harmless. Both hear the chains (which are in Kant's case historical), and treat their clanking as a present sound which must really be absent. The Canterville ghost will be tolerated by his guests but is encouraged to be quiet; aesthetic judgement will be accommodated as long as it is understood to be a minor aspect of the work's appreciation and meaning. The part, for example, that has to do with the 'merely' beautiful. As long, that is, as it is understood to be an ultimately dispensable component. But it is not, except for a logic which necessitates replacing the aesthetic with an ethics. It is with the popularity of this urge in mind that I am interested here in the indispensability, as a presence which must be denied because logic requires its absence, of Kant's ghost in the generally non- or anti-Kantian context which is the contemporary art world.

Spectral (Partriarchal) Kant

My discussion of Kant's current status as a ghost was of course prompted by Jacques Derrida's of Marx as a spectre. Francis Fukuyama teaches in a business school, likes capitalism while describing himself as an Hegelian, and argues that Marxism has now become pointless insofar as it proposes a future now definitively precluded by capitalism's global ubiquity, which he interprets as its perpetual success. Derrida demolishes this argument for capitalism as the ultimate economic model and final stage of historical and social development by demonstrating how Fukuyama has to preserve Marx as a visible ghost in order repeatedly to confirm his death. Fukuyama's argument depends on his own description of contemporary capitalism as a system perpetually founded on a present maintained through promises of a better future, which must therefore of necessity be constantly proving to itself that that other futurity (more clearly founded in Hegel) which Fukuyama repeatedly declares to be now permanently foreclosed really is dead.

It may be that all political systems live off a promised future, what they claim to have left behind being the significant question, and in the *Spectres of Marx* (Derrida 1994) Derrida shows how it is that Marx has a rôle to

play as a ghost in Fukuyama's market paradise once he has been denied an engagement with both history and the present as a living force. It is the ghost that is preserved in order to be exorcised that continues to matter, to be immaterially bothersome—*i.e.* it is the promise of Marx which must be shown to be dead, the logic, the subjunctive which has to be precluded. In theorising the spectre, Derrida makes use of Shakespeare, not only of Hamlet's father—the ghost as witness to his own death—but also of Harry Percy's caustic response to Owen Glendower in *Henry IV, Pt 1*. Glendower claims to be able to summon spirits at will, but Percy, pitting Yorkshire practicality against Welsh mysticism, allows us to ask anyone may do that. The question, he says, is whether the ghosts will come when called. Derrida's treatment of Fukuyama extends this sceptical point to show that one's credibility may also suffer if the ghosts one calls forth do not resemble the bodies whose spirits they are supposed to not-embody.

Marx haunts Fukuyama not because of what he got wrong but of what he got right. None of the contradictions he observed to follow from the capitalist mode of production has proved resolvable. He haunts Marxism too. His posthumous murder by Stalin (Marxism's Claudius, but in this case a bad consciousness without the bad conscience) is an issue between him and the living. So too, as Otto Werkmeister has observed, is the ineffectuality (another kind of betrayal) of Western Marxists in keeping his theory up to date. Werkmeister says that Marxism's failure to provide a serious account of (and therefore response to) the multinationals follows from Marxists' refusal to be Marxists about historical facts, preferring instead to lose themselves in wondering what Benjamin actually meant regarding a long-vanished historical moment (Werckmeister 1999, 5-6 *et alia*). Perhaps feminism could be compared to capitalism and Marxism in that it too uses its ghosts, like any mass movement, as sources and signs of authority (power as the reward of mastery and daring). Feminism regularly recalls two ghosts, the mother's in order to show that she was murdered and the father's to show that he's dead. But, unlike Fukuyama's treatment of Marx, feminism preserves the ghost of the patriarch so as to further interrogate the corpse and it does so knowing, as do Marxists in regard to the failures and bankruptcy of a nonetheless triumphalist capitalism, this death to be less complete in practice than in theory. Furthermore, or ultimately, capitalism is haunted by what it conceives as an other, but feminism and Marxism each has its own ghost, whom neither would deny but whose chains they would prefer to rattle only on command. Marx is Marxism's ghost, while within political feminism is the ghost of the feminism which used the word patriarchy before the world at large did.

Ophelia does not return as a ghost. Having withdrawn herself from the competition she becomes the image of what cannot be recalled, as does Gertrude in the opposite way. In participating in disinheriting Hamlet, who did not inherit his murdered father's throne, Gertrude in effect deprives herself of her own legacy. Likewise Ophelia, who in murdering herself pre-empts her own legacy while expunging her mother's, and who rather than being mourned gets blamed by Hamlet in a rather laddish way for adding to his travails. She has no revenant to enable her to say anything in her own behalf after the fact, while the old man's ghost is always there to goad him towards duty. If Gertrude represents what can be partially undone—her dithering son could regain the throne—Ophelia is irretrievable. Moreover, in contrast to Gertrude's adultery, Ophelia's death is caused by the father's death, but she has to do it to herself and gets precious little thanks for it. There may be no room for an Ophelia ghost within feminism considered as a political movement, as there is little for her in the play, because her story cannot be resolved by a readjustment of the dynastic facts. It is, then, her political ingenuity that dooms her to exclusion from any spectral pantheon: hers is a result of the father's death but it is an internal argument beyond the horizon of politics, it does not negate anything or enlarge the original crime. About feminism I am not sure, but there could be an ethical question here regarding art which resisted master narratives while being inextricable from them, not least in regard to origin, through being driven by a logic or teleology irreconcilable with that with which it was otherwise engaged —in Ophelia's case literally.

If one grants the logic of Ophelia's death her absent ghost might be heard to ask why some symbolic withdrawals are more equal than others.

The answer would be because you can only do withdrawal once, but art develops, in the interest of which feminist art has used negation in a way directly continuous with its employment by modernism and its successor/s in the art world at large: not exemplary withdrawal but exemplary refusal, communicated through inversion as assertion—although irreversible withdrawal is not a plausible option in art, symbolic withdrawal is its life blood.

In New York in the nineteen-seventies, for example, feminist art, conceived as art about its being made by women, defined itself through what its own description of what it was not going to be (any more). It was not going to be about pure form, which is what it took Judd's Minimalism to be, and (which is not to agree that any art had ever been that) that was the ghost that American feminist artists of the seventies such as Joan Snyder, Miriam

Shapiro, and Judy Chicago invoked in order to exorcise. For materials they turned towards ornamental and decorative forms that had been overlooked as well as to the most established art of the time, and where that was concerned they would find a beginning in Hesse's rather than Judd's Minimalism. Hers was hand-made and sometimes even rough and lumpy, where Judd's was smooth (a quality aesthetics traditionally associates with the feminine) and industrially fabricated (smoothness associated with impersonal power). Hesse's sculpture was soft where Judd's was hard (a formalism of the informal that would come to be linked iconographically to the domestic rather than the institutional). Encumbered by the obligation to be more like what it replaced than the latter had ever been itself, a great deal of seventies art was heavy-handed, and suffered from being more macho than macho. Within it the patriarchal was conceived and presented as a ghost so that its feminist inversions or intensifications could be seen to be livelier than its production had ever been. In simplicity as well as savagery the seventies were, in art, the archaic period of the anti-patriarchal era. Ghosts had to be named, a legacy to be retrospectively constructed. No Ophelias, but some Gertrudes by default, women artists declined to be identified with a legacy perceived to be wholly patriarchal.

The next generation tends to be severe and heroic as the former was archaic, with the father more clearly ghostly: what is constantly to be exorcised is art before feminism. Once again, however, one finds inversion and intensification—described as appropriation—and on occasion within the same practice. Sherrie Levine, for example, has sought to use Duchamp's idea of the readymade to undermine a fundamentalist patriarchal property of the art work, namely its authority as embodiment of origin—although what she has deoriginated, through demystification or its rhetoric, remains unclear—but has subsequently come to make works that Duchamp, originary deoriginator, never made. This is a complex relationship to a legacy which preserves the Kantian ghost in order to support its own claim to power (authority) through seeking to keep the legacy of his exemplary debunker alive. Others, of whom Cindy Sherman would be a good example, could possibly be said to work in terms of the presumptively achieved, beyond the need to invoke ghosts because they are so thoroughly, or authoritatively, there—the difficulty being that they are so thoroughly instituted as to have become images of certainty, which is to say of banality.

Other women artists have gone elsewhere, for example towards a feminine sublime, to which I will return.

The point of this brief recital of some main currents in art in the United States and everywhere else since the seventies has been to demonstrate that art by women lives comfortably within a general institutional discourse in which, as with Marx in Fukuyama's capitalism, Kant's rôle in contemporary art is to be ritually exorcised. To say that capitalism is not Marxist and the post-modern is not Kantian is to define both through recourse to what they are not, as with at least elements within earlier feminisms in the arts. Anti-formalist formalism initiates what its own formula cannot, or should not want to, sustain: the first generation struggles with the ghost, the second uses it—the question being how to use it without mistaking the signs of struggle for struggle, but that is a problem common to art regardless of its origin or intent, and perhaps also to ethics.

Within the economic domain on the one hand, and the economics of the (hypothetically post-) aesthetic on the other, Marx and Kant are constant witnesses to their perpetual murders, present not to say who murdered them but to demonstrate why that was and continues to be a good idea. At the same time, Kant is constantly invoked in that judgements about art continue to be Kantian, although in a way that reverses the relationship between the aesthetic and the historical that Hegel recommended, in order to achieve a more total historicism than his, an Hegelianism beyond its originator.

The Subject in the Aesthetic

The artist (and art dealer) and the critic call Kant forth at crucial moments: the first to draw attention to how a work may be said to be purely historical or anthropological (and in that, far too hip to invite questions about form, having instead managed to become an entirely discursive text, albeit one that requires an art gallery) and the second to begin somewhere other than with Kant's subject.

That is to say that a great deal of contemporary art and its theory requires that Kant be a ghost in order that being post-Kantian may be defined as a state in which one has seen through the art object because one has through Kant, a principle that works in reverse and in parallel. At the same time it must be possible to summon him at will because the subject he describes continues to be a problem—incredibly active, then, in both senses of the word, active without credibility and alive after death—in a way that goes beyond its capacity to cause the post-Kantian to be experienced as a perpetual, or at least on-going, state of disentanglement rather than an epoch following a new beginning, as with Derrida's description of Marx's

place in Fukuyama's ubiquitous and irreversible capitalism, which is similarly based on a rhetoric of futurity. But where capitalism seeks to use futurity to maintain a permanently imperfect present, art at least seeks the reverse. The Kantian subject is a problem insofar as it is a ghost called forth in order to be contested, involuntarily as well as voluntarily, by all works of art, or of art after art, including, or in this context most importantly, works preoccupied with the present's social imperfections.

It is further problematic because what is contested is Kant's excessive sense of freedom. The notion that subjective judgement is driven by an intuition which derives obligation from perception predicated, in part, on freedom from obligation is found to be unsatisfactory because of its reliance on indeterminacy rather than determination. In addition to dissatisfaction with disinterest as an idea, and to the traditionally recognised puzzling bits in Kant's thought, there is the flawed disinterest of Kant the historical figure to contend with, and the doubt this casts on what he meant. That part of Kant which is mysterious if not ephemeral adds to the spectral uncertainty which comes with his historical contradictions. To adapt Derrida's Shakespearean example to the contemporary art world, it is as if Percy and Glendower—who were never in disagreement as to ghosts' existence— both call forth the same ghost, disagree about what it says—which is to say do not see the same ghost—were to end up not even agreeing that it *was* a ghost. If Kant could be made entirely historical, he could be kept altogether in the past. There are of course many Percies and Glendowers, and I shall suggest that it is around questions having to do with the idea of the subject to be found in disputes around the concept of the sublime that they are frequently most interestingly quarrelsome, which is to say free of restraints.

The Kantian subject is a problem because of its autonomy. In the art world no one wants the art object to be about autonomy, despite everyone wanting it to be about people thinking for themselves. This is because the internal history of the art world since the seventies, for example, has very largely consisted of debunking, demystifying, or otherwise discrediting Greenberg's version of Kant's idea of autonomy, in which the means that characterise the form provide the grounds for it as experience and for that experience's judgement. This argument has an interest for artists who, as many have been in the twentieth century, want to know what one could do if one worked entirely with those aspects of, for example, painting without making a painting. Greenberg's argument could be described as preoccupied with either the aesthetic or since the aesthetic is there to be dialectically extended by being transgressed against—with a not necessarily exclusively aesthetically referential conventionality. This, as I

have noted, has been replaced with a basically realist argument in which the work is treated as a straightforward reflection of a discourse. As noted, contemporary art is a generally dominant theory that grafts Peter Bürger's conflation of Duchamp's notion of the readymade, together with the Frankfurt Institute's idea of 'exemplary practice', on to a version of Foucault's epistémé which has been rehabilitated to it. (One might think here also of such parallels as might be drawn between Foucault's epistémé and Fukuyama's end of history.)

Paul Guyer has pointed out that in Kant art works are clearly intentional objects and could therefore never be autonomous in the way that Greenberg claimed, which leaves the actual Kantianism of Greenberg's argument in some doubt (Guyer 1993, 264). Recently, though, Rhonda Shearer has raised the possibility that Duchamp's readymades were never anything of the sort, thus undermining the supposedly anti-Kantian demystification of authorship attributed to them. In the art world's intellectual-commercial economy, however, neither modification of received belief is allowed to matter. Greenberg's Kant is left untouched, to be ritually exorcised by acts of nonoriginality which are in practice obliged to be original—and thus subject to the kind of use of Kant one finds in Hegel, returning one to Greenberg, actually, by a rout circuitous but symmetrical (Gilbert-Rolfe 1999). This, the most obvious sense in which the contemporary art world maintains the ghost so that it may be seen to have been banished, just requires an agreed-upon version of the ghost. Anything else the spectre has to say is ignored, along with the possibility that there never was a readymade and Greenberg did not know what he was talking about.

This is a ritual celebration of successful exorcism which in truth only masks the exorcism's actual lack of success, while in any case being only an attempt to scare the ghost away rather than to encounter it. As with Marx in Fukuyama, in contemporary art discourse Kant is summoned to show that he has been left behind but also to be the spectral body—embodiment of the problematic—that must still be left behind afresh, over and over again, through, as with Fukuyama's cheerful capitalism, an exorcism that needs to take place every day for the foreseeable future. As noted, most contemporary art is anthropological rather than aesthetic in its appeal, in that it seeks to address social and political questions without being confined to the strictly historical. In this it perhaps redraws Lyotard a little. It is not (as in his version) that it is post-modern in aspiration but becomes modern after it has been made, when it is sucked back into the history of modernism, but that it transposes (an instituted version of) modernism through inversion which claims to be negation: anti-formalist formalism

remains the strongest unifying current in contemporary art as a whole. Within this context it might be worth observing that insofar as art by women may be related to feminism as a political movement, if post-modernism were, as Lyotard describes it, a thinking of a way out of a modernism that afterwards retrieves it, feminist art would be engaged in thinking a way out of a patriarchal history of a sort that would preclude its being retrieved. Henceforth it would do its own retrieving. Since for administrative (intellectual-commercial) reasons history is at any one time always one thing in the art world, this would mean that it would be committed to a rhetoric of contestation to the extent that it was explicitly political, by which I mean that official history's exposure as a falsehood was the discourse that the gallery was made to display. This could be extended, and I think has been, into a more subtle contestation which is no less political but involves a more elaborate politics and, which calls into question the nature and definition of the patriarchal status of that which it contested. The women artists of the seventies took the rhetoric of the New York School and the Minimalists literally or on its face value, and fashioned an equally blunt counter-argument to it. But a lot of women's art that is engaged in thinking a way out of the archaic period proceeds from a position that finds the argument and the counter-argument too simple. This work, which I think moves ethics from the surface to the structure of the work of art (after art), however defined, contests an original definition and replaces it with one from which the original cannot retrieve itself.

But 'to contest' is not necessarily to reason away, and while to preserve in order to contest could be a kind of collusion it could just as well be an attempt at reform, or, as one says in intellectual as opposed to juridical life, at revision.

Conjuring the Sublime

This 'revisionist' possibility is found in uses of Kant which are less exorcisms than conjurings-up, attempts to engage rather than banish, and to proceed from or through acknowledgement of his ghost's persistence, while being sensitive to its unexpected appearances. The identification, description, or invocation of feminine sublimes, although potentially missing the question of whether *the* sublime was not feminine to begin with, sustains the bits—wisps—of Kant which will not go away as opposed to declaring that they have and then refusing to see them. Instead the ghost's interrogators seem prepared to be Kantian in respect of the possibility—in Kant, the necessity—of a subject capable of grasping that

the idea of the ungraspable is therefore not wholly an idea, and moreover can find its own autonomy in that thought, which follows from Kant's definition of the sublime. That is to say what is conjured up for another look rather than exorcism is what few want to exorcise—save implicitly—but surely all want to problematize, namely Kant's idea of an autonomous subject. (As ever, it seems suggestive that, as Derrida points out, Kant raises the question of the *parergon*—the limit and meeting with the outside—not in the *Critique of Judgment* but in a work called *Religion within the Limits of Reason Alone* (Derrida 1987, 56).

In respect of the question of autonomy and of the sublime within (its apprehension of) which it finds itself, it seems to me that the ghost must in principle have become doubly spectral: at once the ghost of an 18th century Pietist, and the ghost of a differential once regarded as prior but now conventionally regarded as a cultural effect of wholly accountable origin elsewhere - behavioural, genealogical, historical, ideological. The limits and circularity of the latter reduction themselves reduce the proposition's own credibility, causing that ghost to thrive in the face of unconvincing exorcism, but the Pietist's ghost is exasperating because it attributes beauty to the feminine while simultaneously insisting that women cannot themselves be thought of as beautiful as, say, flowers are: This last is at once self-evident but at the same time objectionable surely in that it both attributes a quality and then takes it away, while making (the idea of) woman subject to a social order in which she does not have equality but which is supposed to define her and be realised by what was said to be hers in the first place, to subordinate itself not to reason—which is what Schiller and Kant insist beauty has to do and why they regard the sublime as a higher state of consciousness than the beautiful—but to a rôle reason has decided to impose upon it. As Penny Florence has pointed out to me there is a degree of parallel self-immolation in theories which, having constructed the idea of a feminine subjectivity, then seek to reason away the idea of the subjective.

That aside, however exasperating Kant the Pietist's ghost may be, terminally so one would think, I have not noticed anyone who wants to exorcise that ghost. No one wants beauty to not give way. It is as if no one wants to take responsibility for it. Dispute is instead focused on reconceptualizing the sublime to which the beautiful is meant always to give way. There is a general agreement that the gendered opposition between the beautiful and the sublime inherited from the eighteenth century, perhaps most perniciously—or perhaps one should just say forcefully— expressed by Burke has to become something more suited to

the twentieth century if it is to continue to be useful. I have suggested that the alternative to a masculine sublime is an androgynous sublime, *i.e.* one made of the intransitive as well as the transitive—which condition of complementarity I prefer to that between the passive and the active as there seems to be an insufficient difference between these. Indeed, that there can be passive-aggression suggests there is in effect none excepting differences of degree and deployment (Gilbert-Rolfe 2000).

Others accept the original formulation but look within it for a feminine sublime, hitherto repressed by the claims of what has been said to be a 'wholly' masculine one, in doing so expanding or changing the sublime while keeping its relation to beauty the same. I mean by this that to say that the feminine sublime 'is neither a rhetorical experience nor an aesthetic category but a domain of experience that resists categorisation' (Freeman in Kelly 1998, 332) is to say that the sublime's relationship to everything else remains what it always was but has exceeded its original formulation as a logical consequence of that formulation's implications. It has expanded the idea of the ungraspable sublime by pursuing (and here one could speak of Adorno) its implicit capacity to be an aesthetic category which was at the same time the category of that which was beyond, or framed, the aesthetic.

If the ghost of the masculine sublime is, in principle—although of course not in practice—easily abolished 'woman's' responsibilities are contested and the exclusively masculine an absurdity in the twentieth century, appropriate only to zones of acute distension such as sports or the military—this conjuring up of the otherwise proscribed Kantian sublime in order to find what it has to say now suggests that aesthetics continues to provide the terms through which works of art may do something other than perform acts of historicist confirmation—may, for example, engage history without being reduced to it. In this arena Kant's ghost is summoned not to disappear but to speak. This is because the subject which can grasp the idea of the ungraspable, and for that reason is autonomous as objects are not, remains Kantian, whether or not from there to be problematized in terms of a feminine sublime whose appeal is 'not to a specifically feminine subjectivity or mode of expression, but rather that which calls such categories into question [...] [and which] is one name for what cannot be grasped in established systems of ideas or articulated within the current framework in which the word *woman* has meaning' (Freeman in Kelly, 1998 333). The differential between the beautiful and the sublime on which the however disputed subject depends remains credible because of an –as the economists say, perceived—need to find a theory of meaning-production which is not entirely grounded in transitive force, and because it

is the concept of the sublime provided by Kant (or Schiller) that makes possible a discussion of what Ginette Verstraete has described as 'a confusion of "scribe" and "seer" (that) embraces a mode of graphic visibility [...] that belongs to the radical outside of writing: to Joyce's invisible night [...]' which can 'bring about this—feminine—outside [...] a new kind of invisible discourse' (Verstraete 1998, 207).

One might, in discussing the ungraspable, seek to provisionally combine Lyotard with Kristeva (temporarily leaving aside those other questions that might be raised by the ghost's obligatorily constant diminution in comparison to Hegel in Kristeva's writing). I have in mind bringing together Lyotard's discussion of an indeterminacy which is not a presentation of the indeterminate as a concept (*i.e.*, as determined but in a special way) with Kristeva's notion of the *chora* as the pre-conceptual because pre-semantic: Lyotard throwing into doubt the legislative language of the ungraspable (as unpresentable); Kristeva providing a model in which the idea cannot be the origin of what it seeks to name—to overcome by naming, *i.e.*, to make give way to it—because by definition it comes after it, both eroding or erasing the subject founded in reason but in that proposing another reasoning (another use for that reason, another subject capable of another kind of speculation on the limits of autonomy, or of the latter's internal organisation).

If one accepts that (Romantic, Realist, Modern and Post-modern) art objects are quintessentially historical—*i.e.*, that if without Kant one cannot have an art grounded in aesthetic judgements, without Hegel one cannot have art history, and therefore without both one cannot have modern art which is about being modern art—then it follows that without aesthetics (or a quarrel over aesthetics, which is almost the same thing) the work of art cannot be a place where one finds a subject which is the product of questioning the constitution of the subject. Like the subject which, even if, as I suspect, better described through its heteronomy than its autonomy, is still one subject, works of art can only pass beyond aesthetics—or propose to do so, since one might dispute the possibility of any such thing being realised—by remaining within it. As with Lyotard's post-modern that precedes the modern as well as following it—a way out of the modern that immediately becomes a part of modernist art history—the sublime's capacity to expand (infinitely because of an inherent indefinability) seems to preclude its being exceeded. Instead it is reinvented, and it would be there—in however unspoken a manner—that one could say that the work of art had also reinvented itself, or been reinvented by a subject which may not have noticed this aspect of its own reinvention. In this regard one

might note the work of artists who have come after those I have mentioned already. Roni Horn, for example, who began her career in the eighties with sculpture which extended minimalism by undoing it (two objects instead of Judd's one, a sheet of folded gold rather than Richard Serra's ton of steel, an embossed mark instead of Robert Smithson's whole lake) but whose recent work cannot be returned to those beginnings. Or an even younger artist, Diana Thater, whose work, like Horn's, directly uses the language of the sublime but began after it had to be wrested away from its once presumptive associations (Fig. 1 and Plate 1).

I have mentioned elsewhere how the fact that painting is a medium or practice predominantly identified with boys but at the same time traditionally and by definition dependent on a space which precedes whatever is put into it is suggestive in the light of Kristeva's analysis of the precedence of the syntactical over the semantic, figuration being in both cases a retrospective agent of control, but also that through which what precedes it leaks or may even be actively rediscovered or at least sought. The model is in practice invaginative but always described as penetrative, and in that provides the conditions for its own reversibility. I should say that it has always practiced its own reversibility to the extent that its necessary androgyny has always implied it. I recognise that 'androgyny' is a problematic term for feminists in that its dualism returns it to a model they interrorgate, but want to preserve that dualism here (as elsewhere) because the point I want to make is that the simple fantasy of pure power which it enshrines relegates to passivity what is better describes as another activity: space has always been as active as the figure in painting, as has silence in music—its erasure or exclusion in prose an ominous if inevitable feature of the exclusively discursive, its retrieval in speech or writing a confirmation that poetry is what prose is not. (Also, there may be ten thousand sexualities, but there is either form or formlessness—and ghosts—and only nothing can start nowhere. The wind is not a dispersed or negated form—in fact it is never an object until objectified.)

Within the art world, then, Kant's ghost, like Marx's in Fukuyama, is ritually exorcised on an ongoing basis—the present maintained by a tradition of moves beyond or otherwise away from the Kantian object and its assumptions and criteria, and towards, alas, anthropology—but in the more general discussion of the subject it is brought forth to be interrogated in a way that itself resists, or obviates, such exorcism. I think the contemporary's general acquiescence in beauty's—theoretical—traditional subordination is revealing as to the conservatism built into methodologies of negation, and I am unconvinced that the best way to retrieve the sublime

from Burke is to posit a counter-Burkean sublime in the sense of turning him upside-down nor, although I am obliged by my faith in irresponsibility to suggest that to wrest the concept of woman away from Kant by similarly inverting his set of terms would at least be a laugh, insofar as it would cause the beautiful when found in a woman to be subordinated to the opposite of social obligation.

These preservations of an artificially simple spectre seem insufficient to their goals, not least because of the indisputably Kantian continuities between art objects regardless of their appropriation by or of ideologies for or against Kant, whereas it seems to me that both the art object and the subject it produces are illuminated by an approach such as that through which Verstraete finds fragments of the feminine sublime in neither Schlegel and Joyce being able to escape a tradition 'which is nothing other than representation as a tradition' but within which therefore 'repetition presents itself not only as itself but also as what is already different' (Verstraete 19, 217). (Which could return one to Deleuze's ten thousand sexualities.)

Hamlet's dad is dead before the play starts but keeps popping up all the way through. Likewise Kant must have become a ghost if not before the post-modern, certainly—also like the play—in order that it might proceed. Unlike Claudius, Kant's murderers are likely to take care of themselves. The always already different is what the work of art is. For this reason it is more interesting, to me, to theorise the possibility of a heteronomous subject—moving freely but involuntarily between nature and technology - than a reactive subject. (The conscious limits of its freedom are the two incompatible models through which it imagines itself, and I am not clear as to whether these are gendered or whether 'growth' and 'communication' do not, respectively, come before and after gender.)

As to the ethics of the heteronomous subject, Joanna Hodge notes that Heidegger felt Marx had a better grasp of history than Husserl 'not because Marx's materialism is not simply the view that the basic component of reality is physical... (but) rather that what there is results from the human capacity to transform materiality' (Hodge 1995, 97). She finds the interest in the ethics that Heidegger said he rejected fully developed in his insistence that the Greek word 'ethos' originally meant habitation rather than destiny, and to be synonymous therefore with place and home. The ethics of the heteronomous subject would be of the affirmatively homeless, inverting Heidegger but in that realising him (or his worst nightmares) rather than negating him. Materially speaking, its heteronymity would

doom it to be never totally embodied—dualism as the unchoosable—so much as called forth provisionally in the pursuit of a specific discourse or interest of the moment, but this seems more plausible than its alternative, whose autonomy seems suspect because of its unity, a reaction being a concept limited by its stimulus. In that the ungraspable is the work of art's subject in both senses of the word—its origin and its topic, being and reason for being—what might be required is a theory of the subject which is not a theory of a fractured whole but of (more than ten thousand) interactions, at once one and many movements. It would be in these terms that I should suggest that Kant's subject, as one that has long since become at once indebted and indifferent to Kant, is multiplicitously present in art in which other kinds of movements cut across historical ones, and that this could not to be an inverted Kant, or unthinking of Kant, except to the extent that both were recognised to be inevitable extensions of Kant. Perhaps the issue may not best be conceived or imagined as one of the fragmentation of the subject imagined as an entity, so much as of an (impossible) assemblage of what are at the same time fluid and other kinds of movements. This is why I think one should, regarding space as the subject of painting (considered as an affair of seeing rather than of telling) consider the possibility of a sublime found in nature but feminine rather than masculine to begin with.

One is, for example, surrounded by the wind. One may be caught in or up, or be blown or even flattened by it, but one's encounter with it is not like being hit by a spear. It is not quite right to talk of it as having a trajectory although it is as often as not clear that it is prevailing in a particular direction, an insubstantial force experienced as an entity. I am aware that Luce Irigary has written about what Heidegger did not, the air rather than the ground, for instance, but have not yet read what she has to say and can only comment that there too one would not be starting with either a form or force. With that in mind I would suggest there is a question here (or as it were in the wind) also raised implicitly by Freeman in the essay to which I have referred, of what Kant and Schiller might have ignored through their predilection for form rather than formlessness.

This would be one sense in which Kant persists by being impossible to leave behind. His corpus indispensable to any image of the incorporeal, which could only be of a subject since it would have no where else whence to derive, and would have to be intuited. Elsewhere or in general Kant's is the ghost of a corpus that persists in rituals of denial require its constant return. Or in affirmations of it, however sceptical, where, as spectral

witness to the consequences of his ideas, he disappears and becomes instead the ghost of the post-Kantian.

Notes

1 I have elsewhere associated Mothersill's point with beauty's capacity to exceed reason (Gilbert-Rolfe 2000, 12-13).
2 Originally published in *Tiger's Eye* (1948).
3 Originally published in *Arts Yearbook* (1965).
4 In addition to what I have said above about technique it is worth noting that its appreciation has been replaced by a connoisseurship of idea-deployment that is pre-Kantian in aspiration, if not wholly in practice, in that it depends on a theory of art—meant to be one of art after art—in which the medium is almost transparent (*i.e.* irrelevant, its putative transparency is not meant to signify) and, though sensitive to the evolution and mutation of signs (particularly within the context of the rapid change characteristic of things in general in the twentieth century) which insists on an hierarchy of important subjects or themes which is remarkably reminiscent of the 18th century Academy: works about history (*i.e.* ideology) at the top, works about the cosmology of contemporary culture second (substituting exactly for the Academy's second tier of difficulty, mythological and Christian art).

Chapter 4

Aesthetics in the Gaps – Subverting the Sublime for a Female Subject

Rachel Jones

Once imagine that woman imagines and the object loses its fixed, obsessional character. As a bench mark that is ultimately more crucial than the subject, for he can sustain himself only by bouncing back off some objectiveness, some objective. If there is no more 'earth' to press down/repress, to work, to represent, but also and always to desire (for one's own), no opaque matter which in theory does not know herself, then what pedestal remains for the ex-sistence of the 'subject'? ... The Copernican revolution has yet to have its final effects... (Irigaray 1985, 133)

Aesthetics in the Gaps

The 'Copernican revolution' to which Irigaray is here referring is Kant's transcendental turn, which grounds a philosophical modernity where neither the (transcendental) subject nor the (transcendental) object of experience is 'given' (Irigaray 1985, 133). Instead, it is only via the synthesising work of the faculties that an objective world comes into being. This objective world functions as the necessary other against which, and as a correlative of which, the transcendental subject can be posited as a kind of stable reference point for perception, thereby securing its (self)-identity through time. Irigaray charts the ways in which woman has herself been objectified within the history of Western metaphysics, such that she has repeatedly fulfilled the role of this necessary 'other'. Indeed, as we will see, woman's status as a human subject is problematised by Kant's suggestion that it is only proper for her to remain part of the phenomenal, natural world—the realm of 'opaque matter'—which the fully-developed moral subject will seek to transcend.

However, Irigaray also suggests that the constitutive role attributed to the object by Kant has effects beyond the control of the rational Enlightenment subject. The very necessity of the external 'object'/'other' against which the subject is positioned as a unity of consciousness accords a potentially excessive power to the material realm of nature with which woman has been culturally, socially, and philosophically aligned. Indeed, even within the Kantian system, the aesthetic of the sublime invests external nature with a power that ruptures the spatio-temporal forms via which the subject attempts to grasp and contain the world. The sublime is provoked by powerful or apparently boundless natural phenomena—raging seas, vast mountains—which threaten the physical and imaginative limits of the self. By overcoming its terror of such potentially overwhelming natural forces, the subject is capable of imaginatively transcending both nature within (that is, its own fear) and without (the might of the phenomenal world). Thus, although nature must retain its boundless power within the phenomenal realm if it is to serve as a provocation to transcendence, its excessive materiality is ultimately mastered by the subject, who thereby feels a strengthened sense of its own rational and moral potential.[1] In the end, the feeling of respect [*Achtung*] generated by Kant's sublime is for the transcendent potential unlocked in man through the aesthetic encounter with nature's might.

Despite appearances, then, it is in the sublime that the very structures of Kant's transcendental subject make themselves most deeply felt, as man's phenomenal and material aspects are transcended via an imaginative striving towards infinity, the unconditioned and the absolute. Hence the far-reaching implications of Kant's exclusion of women from this mode of aesthetic feeling: it is not that women cannot but rather that they *should* not experience the sublime.[2] In the post-critical *Anthropology from a Pragmatic Point of View*, this exclusion stems from Kant's insistence that women have a duty to the species which entails that they should retain their instinctive fear of nature, rather than being educated into modes of transcending the phenomenal realm (Kant 1974, 169 [7:306]; Battersby 1995, 96). However, as we have seen, the dynamic confrontation with nature in the sublime provokes an affirmation of man's supersensible destination. Thus excluding women from the sublime also bars them from developing both the reverence and awe that mark the fully developed moral identity of 'civilised man', and the capacity to transcend the limits of human experience which is essential to genius. As Christine Battersby

has commented, Kant's critical and post-critical writings align women (uncritically) with instinct and nature "even though the gendering of human excellence disrupts and disturbs the whole of his critical system" (Battersby 1995, 93).

Battersby responds to the disturbing effect of women on Kantian thought by mobilising this critical blindspot as an opening which makes it possible to question the transcendental conditions of aesthetic experience. Rather than seeking to "add women in" to the Kantian model, she asks what the sublime would become if reworked from a 'female' perspective which, in Western modernity, has been socially and culturally aligned with matter, embodiment, affect, and 'nature'. The emphasis is thereby placed on transforming aesthetic tradition by thinking a "response to the infinite and overwhelming [that] involves immanence, rather than transcendence" (Battersby 1995, 97).[3] This shift in focus makes it possible to recognise transformed modes of the sublime in work by past women writers and artists, work that can aid us in re-imagining the structures of aesthetic experience together with models of the self.

In this paper, I aim to contribute to the collective feminist project of reading in the gaps of dominant philosophical and literary frameworks. Such a project forms a necessary counterpart to Irigaray's critique of the phallogocentrism of Western philosophy: reading for the female voices absented from the history of philosophy, literature and art entails looking for the gaps within those histories where women's otherness has become *productively* disruptive.[4] Hence I will not retrace here the reasons for Kant's exclusion of women from the sublime; rather, I will explore the possibilities for a feminist re-appropriation of the sublime suggested by the poetry of a much neglected German woman Expressionist: Claire Goll (1890-1977). The paper will begin by siting German Expressionism as a crisis of the Kantian subject characterised by the dissolution of the oppositional structures orienting both subject and object. Goll's absence from most accounts and anthologies of Expressionist literature can be seen to stem from the ways in which her work does not fit with the dynamics of the posthuman sublime charted in the poetry of many male Expressionists. More importantly, as I will show, it is precisely through this lack of fit, through her exploration of the gaps and spaces in an

already disruptive genre, that Goll's work encourages the 'imaginative or theoretical adjustments' (Battersby 1998, 56) that help us to philosophically reinstate a sublime for female subjects.

Expressionism: Dissolving the Subject

In the Kantian system, the stability of the constitutive subject–object relation depends jointly upon the schematisation of the transcendental object, the 'something = X' which marks only the formal unity of the manifold in intuition (Kant 1933, 268–71 [A250–253]); and on the schematisation of external matter as inert substance whose underlying permanence is the necessary counter-balance to an enduring transcendental subject.[5] Although the relative position and the appearance of such matter might change, these alterations—at least in terms of their extensive magnitude—are not a sign of agency or animation, but can always in principle be mapped out in terms of the obedience of objects to universal mechanical and causal laws of production. As Irigaray notes, this entails that the subject's stable identity is only guaranteed as long as the material 'other'/'object' against which it is positioned remains silently acquiescent in its own repression (Irigaray 1985, 135). By contrast, many key texts of German Expressionism, particularly those of the early Expressionist period (c.1911–c.1922), depict an ever more animate and threatening environment where the objects of the city, nature and, increasingly, the landscape ravaged by war, refuse to passively comply with the causal laws that would allow the subject to order the world and secure his place within it. Jacob van Hoddis's 'Weltende'—often positioned as the first archetypal Expressionist poem—depicts the collapse of propriety and order as natural and inanimate objects cease to behave as they should:

> Dem Bürger fliegt vom spitzen Kopf der Hut,
> In allen Lüften hallt es wie Geschrei.
> Dachdecker stürzen ab und gehn entzwei,
> Und an den Küsten—liest man—steigt die Flut.
>
> Der Sturm ist da, die wilden Meere hupfen
> An Land, um dicke Dämme zu zerdrücken.
> Die meisten Menschen haben einen Schnupfen.
> Die Eisenbahnen fallen von den Brücken.
> (Pinthus 1993, 39)

From pointed pates hats fly into the blue,/ All winds resound as though with muffled cries./ Steeplejacks fall from roofs and break in two,/ And on the coasts—we read—flood waters rise.// The storm has come, the seas run wild and skip/ Landwards, to squash big jetties there./ Most people have a cold, their noses drip./ Trains tumble from the bridges everywhere. (Hamburger 1977, 83)

In this poem, the possibility of schematising the manifold of sensory intuition so as to produce objects that remain stable in their relation to the perceiving subject begins to disintegrate. The spatial disorder evoked by seas that hop onto the land is matched by a collapsing temporality: with the advent of modern technologies of communication, no sooner does one read about the rising floods than the storm arrives.

The lack of logical or narrative connection between the events described in each line of this poem suggests a world which refuses to cohere into an ordered whole. Furthermore, the poem makes no evaluative distinction between natural disasters, train crashes, and the common cold, but treats them as equally important events in a detached tone which only adds to the sense of a world where hierarchical order has broken down.

This discontinuous style (*Reihungsstil*) characterises many texts by early Expressionists, which often convey a sense of the overwhelming absurdity of a world where objects are disturbingly alive. In Alfred Lichtenstein's '*Die Dämmerung*' (Twilight), people, animals and objects are treated as equally and indiscriminately active: a fat boy plays with a pond, a horse tramples a woman, prams scream and dogs curse. Whilst wind and sky are treated as if human subjects ('Der Himmel sieht verbummelt aus und bleich, /Als wäre ihm die Schminke ausgegangen'; 'The sky looks run-down and pale, /as if all his make-up had run'), most of the humans in the poem are either mad - a blond poet seems to be losing his mind—or maimed: 'Auf lange Krücken schief herabgebückt/Und schwatzend kriechen auf dem Feld zwei Lahme' ('On long crutches, crookedly stooped/ And prattling, two cripples crawl on the field') (Pinthus 1993, 47).[6] Like van Hoddis, Lichtenstein juxtaposes these descriptions to form an incongruous series of disjointed events. Both poems articulate a grammar of a-causality and disconnection which extends its indifference to

the demise of man's ability to generate order and meaning through his rational powers, focussing instead on the chaotic materiality of a disturbed and disorderly world.

The literary critic Silvio Vietta has stressed the double-sidedness of the perceptual crisis figured by such Expressionist texts (Kempner and Vietta 1975, 42).[7] As objects assume more power, man becomes dehumanised and displaced; as they become active, he becomes more passively open, caught up in power-relations and forces beyond his control, in which he figures as an object himself. In poems such as those by van Hoddis and Lichtenstein, subject and object are simultaneously transformed: the activity of the animated object-world refuses the stability that would allow the perceptual subject to orient itself securely. Not only is individual human identity attacked and trampled on, but, as Lichtenstein's poem '*Punkt*' (Full-stop) makes painfully clear, the unified consciousness of the subject is finally emptied out altogether as man is caught up as just one more object in a flux of powerful material forces:

> Die wüsten Straßen fließen lichterloh
> Durch den erloschenen Kopf. Und tun mir weh.
> Ich fühle deutlich, daß ich bald vergeh—
> Dornrosen meines Fleisches, stecht nicht so.
>
> Die Nacht verschimmelt. Giftlaternenschein
> Hat, kriechend, sie mit grünem Dreck beschmiert.
> Das Herz ist wie ein Sack. Das Blut erfriert.
> Die Welt fällt um. Die Augen stürzen ein.
> (Lichtenstein 1962, 69)

Through the extinguished head goes a blazing flow/ Of desolate streets. Hurting me./ I know I'm not long for this world— /Briarrose of my flesh, don't prick so.//The night is mouldering. Bilious lamplight/ Has smeared her with a trail of green filth./ The heart dangles like a sac. The blood freezes to death./ The world comes tumbling down. The eyes cave in.

The light of the desolate streets here flows through the head of the perceiving subject until it is burned out. However, the permeation of the subject by this intensity of light does not merely lead to a reversal of the roles of subject and object; rather, as the object-world becomes a flux of

creeping luminosity, the gaze of the subject is extinguished, and objective reality itself collapses. The poem reflects the Kantian insight that there can be no subjective centre of perception if the world ceases to fit within the spatio-temporal limits that would enable such a subject to orient itself, but equally, that there can be no objective world without a subject to construct it. The undoing of the perceptual subject thus mirrors the collapse of the external world.

Expressionism is replete with such images, which figure the breakdown of reality as the boundaries between subject and object, self and world dissolve. Nonetheless, Vietta argues that what is at stake in such images is not a simple disappearance of subject and object, but their reciprocal and simultaneous transformation:

> The subject is objectified, [...], but the world of things is dynamised and 'animated'. Hence the conditions of being, and thereby the integrity of reality itself, are attacked by dissociation. Persons are no longer persons, things are no longer things.
>
> (Kempner and Vietta 1975, 42)

Expressionism does not merely depict a world dissolving into chaos, but charts the dislocation of a specific mode of 'reality', namely, that underpinned by the constitutive opposition of an active subject to the dead matter of an external world which this subject organises and regulates. For Vietta, the collapse of this subject–object relation in Expressionism implies that subject and object are reconfigured together as a different ordering principle comes into view. People are no longer people and things no longer things because both are transfigured by a dynamics of flux. Understood in this way, Expressionist texts which depict the emptying out of the subject through its subsumption in a dynamised exteriority become legible as the simultaneous mapping of both the disintegration and the radical reconfiguration of reality.

Such a movement of disintegration and reconfiguration is powerfully charted in several poems by Alfred Wolfenstein, where the subject is eaten into by an aggressive urban environment that permeates not only his private domestic space, but also his bodily interiority. In one poem, the

sights and sounds of the city-street burst into the poet's room ('Wieder schon ins Zimmer platzt die Straße'; 'Into the room, again, bursts the street'), which is simultaneously filled with noises that well up from within the building, as others are heard undressing, washing, gargling water and preparing for bed (Kempner and Vietta 1975, 42). The possibility of delimiting the realms of public and private, self and other, collapses: the walls and rooms of the teeming building no longer provide a protective barrier or shell. In both this poem and the following extract from '*Städter*', Wolfenstein deploys skin itself as a key trope of the fragile and permeable. No longer a boundary sealing the body as a container for the soul, skin becomes a porous surface allowing a threatening seepage between 'inner' and 'outer' realms until this very distinction breaks down:

Ineinander dicht hineingehakt
Sitzen in den Trams die zwei Fassaden
Leute, wo die Blicke eng ausladen
Und Begierde ineinander ragt.

Unsre Wände sind so dünn wie Haut,
Daß ein jeder teilnimmt, wenn ich weine,
Flüstern dringt hinüber wie Gegröhle
<div align="center">(Pinthus 1993, 45–6)</div>

The two façades of/ People, tightly meshed in one another,/ Sit in the trams, where glances spread narrowly/ And desire rises in each other.// Our walls are thin as skin,/ So when I weep, everyone has a share,/ Whispers come over like bawling

In the city, bodies become inseparably enmeshed: desires surge between them, producing an intensive flow where individual identity is lost. Wolfenstein's poems turn interiority inside-out: domestic spaces and bodies alike are determined neither by enclosing boundaries, nor by the self whose integrity they should protect, but by forces filling them from outside until everything is subsumed into a de-individualised flux where subject and objects of perception become indistinguishable.

Wolfenstein's poems hover between fearing and celebrating this liquefaction of organic boundaries. In ways that conflict with the verses quoted above, where no separate self remains, later in the same poem he

returns to a more humanist frame of reference, suggesting that people still feel utterly isolated and alone in the city. In contrast, and despite its title, '*Verdammte Jugend*' (Doomed Youth) celebrates the feeling of being 'schön allein' ('wonderfully alone') in the teeming metropolis, which is depicted as a bubbling, hissing stream of people, light and noise. Intrusive homely and human relations are finally escaped as the individual is plunged into the dehumanised flux of city life (the 'Entmenschlichte') which seeps through everyone and belongs to no one (Pinthus 1993, 54-5). Paradoxically, it is a poem which evokes primordial nature, and which may thus appear utterly removed from the Expressionist cityscapes, which most fully expresses the desire buried within the imaging of the latter:

O daß wir unsere Ururahnen wären.
Ein Klümpchen Schleim in einem warmen Moor.
Leben und Tod, Befruchten und Gebären
Glitte aus unseren stummen Säften vor.
(Benn 1960, 25)

Oh that we were our primal ancestors,/ A little lump of slime in tepid swamps./ Our life and death, mating and giving birth/ A gliding forth out of our silent sap. (Hamburger 1970, 338)

The first stanza of Gottfried Benn's '*Gesänge: I*' epitomises the Expressionist longing to melt the rigidified form of the human subject into a flowing, pre-human life, into an external world that is no longer formed and re-presented for a conscious, knowing subject, but dumbly seeping matter.

Such texts offer a radical challenge to the Kantian model of identity which privileges the persistent, unified and autonomous subject. Excessive materiality is no longer to be mastered, organised or transcended, but instead dissolves subject and object into an infinite flux of luminous life. The limits of the Kantian Enlightenment subject are broken down by the intensive forces of animate matter. Nonetheless, the ways in which this overcoming of limits provokes both anxiety and exaltation recalls the complex interrelation of pain and pleasure, attraction and repulsion that characterises Kant's account of the sublime in the *Critique of Judgement*.

Indeed, the dynamisation of the external world that both precipitates and characterises the violent undoing of the subject–object relation in Expressionist poetry recalls the excessively forceful matter of the dynamic sublime. However for Kant, as noted above, the terrifying sight of nature's power is recuperated as it inspires man to transcend his phenomenal limits and reaffirm his supersensible destination. In many Expressionist poems, there is no such reinscription of the subject in a position of mastery. On the contrary, Expressionism maps the annihilation of the subject by an aggressively encroaching environment. In Lichtenstein's and Wolfenstein's threatening cityscapes, there is no sign of any transcendent consciousness. Not only is the subject made to suffer, but the very possibility of individuated perceptual consciousness is extinguished, emptied out into the excessive forces of an exteriority whose ceaseless flux consumes the constitutive split between subject and object that held both in place in a Kantian world.

Nonetheless, these Expressionist poems do not merely figure the annihilation of the individual. In Kant's sublime, the conflict between the subject and excessive natural forces provides a point of release for man's capacity to strive beyond the phenomenal world, for what Gilles Deleuze has called 'a non-psychological life of the spirit' (Deleuze 1986, 53-54). In *Cinema I*, Deleuze positions the jagged and zigzagging movement of light in German Expressionist films as releasing just such a life, but in ways that go beyond Kant by turning the Kantian emphasis on the necessary interdependence of subject and object against itself. On Deleuze's reading, in Expressionist cinema—as in Lichtenstein's poem *'Punkt'*—all possibility of mapping an objective Nature or organic exteriority burns up through light's intensity, along with the very possibility of positing a unified point of consciousness. However, in ways that echo Vietta's insistence that Expressionism does not merely dissolve but reconfigures both poles of the subject–object relation, this posthuman sublime does not open onto undifferentiated chaos.[8] Rather, the reciprocal meltdown of subject and object serves as a point of release for a dynamic life of transindividual intensive forces, unlimited by the organic boundaries of phenomenal nature or psychological unity:

> intensity [...] is raised to such a power that it dazzles or annihilates our organic being, strikes terror into it, [...] *the non-organic life of things* culminates in a fire, which burns us and which burns all of Nature [...] But this latter, by the ultimate sacrifice which it demands

of us, unleashes in our soul *a non-psychological life of the spirit*, which no longer belongs either to nature or to our organic individuality. (Deleuze 1986, 53-4)

Expressionism keeps on painting the world red on red; the one harking back to the frightful, non-organic life of things, the other to the sublime, non-psychological life of the spirit. (Deleuze 1986, 54)

If this doubled transfiguration can still be called a mode of the sublime, this is not only because it produces both suffering and exaltation, but because of the way in which it doubly culminates in transcendence: in the non-psychological life of intensive forces which transcend the very conditions of organic being, as well as in a world characterised by a perpetual and immanent overcoming as both subject and object are plunged into flux.

Claire Goll: Somersaulting Through the Sublime

For the Expressionists I have discussed thus far, who figure the permeation of human being by an aggressively animate materiality, the disintegration of the subject–object distinction entails the disintegration of the very possibility of individualised identity. The latter dissolves not into chaos, but into a posthuman flux where, as objects cease to behave like objects should, so the subject ceases to be a subject. Whilst this dissolution ruptures the history of the modern subject, its significance is transformed if viewed from the sideways perspective of those who have not been historically positioned as fully constituted subjects. For those who have been aligned with, rather than constitutively opposed to, both materiality and the object, the sublime dynamisation of the external world and the breakdown of stable boundaries between subject and object holds open the possibility that identity itself might be differently configured. If materiality is no longer positioned as the passive 'other' of the subject, then to be a stubbornly material nexus of forces and intensities might no longer entail being that which constantly threatens the specificity of form and individualised identity. On the contrary, the activities of animate matter might become that through which identity is formed without needing to

oppose subjects to objects. It is just such a possibility that is explored in the work of Claire Goll.

Although better known in literary history as the wife and literary executor of her husband, Ivan Goll, Claire Goll was a prolific author in her own right, publishing novels, political and pacifist essays, poetry, and an infamous autobiography over a long career. Her earliest poems belong with Expressionism, as the following text indicates, although she gives an imaginative twist to the dynamics of dissolution previously outlined.

> Spitäler klammern sich wild an die Erde,
> Mansarden schlagen mit zerbrochenen Flügeln
> Und Schreie fallen klirrend auf die Straßen.
> Jetzt brechen blutige Tulpen drohend auf
> In buckligen, vergrämten Vorstadtgärten.
> Jetzt öffnen Mütter ihren Leib wie Muscheln,
> Draus Sterne fallen an den Strand der Welt:
> Rote Signale einer neuen Zeit.
> Die Sonnenuhr schlägt dreizehn von den Himmeln.
> (Studer 1918, 18)[9]

Hospitals cling ferociously to the ground,/Garrets beat shattered wings/ And screams crash tinkling onto the streets./ Now bloody tulips threateningly break open/ In troubled, hunchbacked suburban gardens./ Now mothers open their bodies like mussels,/ And stars fall out onto the beach of the world:/ Red signals of a new time./ The sundial strikes thirteen from the heavens.

The title is ironic: humanity is no longer in the ascendant here. Rather, images of a nightmarish city chart the now familiar breakdown of the subject–object relation: inanimate, man-made or natural objects become violently active and develop forceful and unpredictable trajectories of their own. The threatening materiality that provokes the sublime is once again mobilised to figure the disintegration of the Kantian binary fixing the human subject on the side of willed, autonomous activity and the object-world as a realm of inert, causally ordered matter.

However, though this poem does not reaffirm the subject, its focus is not so much on the dissolution of the human individual as on its displacement. The image that most strongly evokes the absence of any human life

simultaneously evokes the persistence of a specifically sexed, female identity: man disappears as mothers birth stars which pulse to a new time. These female bodies which open like mussels no longer give birth to human subjects; nor do their glittering offspring need to transcend or separate themselves from the fluxing materiality of their birth for their own singularity to take shape. Rather, these stars fall from the maternal body into the sand, becoming embedded in the beach-world to which the mussel's regenerative capacities already belong. These red signals belong to the same material realm as the maternal body from which they emerge without simply reduplicating her material form. In this posthuman world where mothers are mussels birthing stars, generation is no longer the reproduction of the same; instead, glowing newness and difference also emerge through a generative materiality.

In this poem, we have left behind the world of the male Expressionist poets, where the dynamisation of objects entails the destruction of distinct identity, culminating in Benn's poetic invocation of what Deleuze calls 'the vital as potent pre-organic germinality, common to the animate and the inanimate, to a matter which raises itself to the point of life, and to a life which spreads itself through all matter' (Deleuze 1986, 51). Whereas the vitalism of Benn and the male Expressionists foregrounds life as de-individualised, pre-organic flux, in Goll's poem, the potency of the life that is spread through all matter is expressed as a power to generate specific new forms. Thus although meaning is no longer given to the world by a human subject, the emerging stars signal the birth of a new time, where order is generated through a capacity for material production which both encompasses and produces difference. For the female matter already positioned on the side of the animal, the non-rational and the passive, the collapse of an oppositional subject–object relation does not entail the collapse of all differentiation between self and other. Far from melting away as the split between subject and object dissolves, in Goll's poem, a female materiality comes into a time and a life of its own. Within this non-human temporality, a body that can multiply itself allows singular forms to emerge, such that sameness and difference remain intertwined.

Several other poems by Goll similarly refigure maternal and material productivity. The poems avoid an essentialist reduction of woman to her

organic reproductive body by privileging a birthing of identity generated between mother and daughter in an imaginative space of play. '*Schlaflied*' (Lullaby), for example, uses uncomplicated, concrete language to depict a magical domain where the usual restrictions on movement are lifted. Mother and daughter run into the Milky Way to catch stars and the child waves to her mother from the rim of the sky, playing on the edge of a world whose boundaries are no longer securely delimited. In a fantastic universe where the moon is also a lollipop tasting of honey, mother and child do not just play amongst the stars, but play at being the sun itself: instead of opposing themselves as subject to object, they become part of a realm of celestial bodies by playing out material transformations.

> Morgen wollen wir Sonnenaufgang spielen,
> Mit unserem Lächeln,
> Mutter schüttelt den Sonnenbaum,
> Da fallen goldne Blätter in dein Bett.
>
> Aus den Traumbecken hängen noch Flöckchen
> In meines Vögelchens Gefieder.
> Morgen zwitschert es wieder
> Hundert neue smaragdne Lieder.
> > (Studer 1918, 17)

Tomorrow we will play at being the sunrise,/ With our smiles,/ Mother will shake the sun-tree,/ And golden leaves will fall into your bed.// Little flecks from the basin of dreams still hang/ In my little bird's feathers./ Tomorrow it will twitter again/ A hundred new emerald songs.

This apparently simple, song-like poem explores an imaginative space where material becomings are the norm, unlimited by a fixed subjective horizon. The final stanzas, quoted above, suggest that the remnants of this dream topography seep into the child's waking world, enabling the daughter to sing in a glittering language of colour. The remembered realm of play here seems to provide an alternative, synaesthetic model for the production of meaning. Even though this child's body remains unlimited by fixed organic functions—her voice resounds in the visual medium of colour—neither is it an inchoate, sensory chaos, for it is from this body that song emerges. The child's not-quite-human voice does not articulate the world through a purely conceptual language, however, which would

strive to solidify experience into fixed categories or disembodied 'truths'. If its song produces abstractions, these are the abstractions of colour which remain inseparable from the affective, intensive qualities of saturation, tone and hue; this shimmering language emerges from and is embodied by the mobile resonances of a jewel-like, multifaceted voice.

For Goll, the imaginative space played out between mother and daughter is not a site to be ideally left behind as the child enters the 'reality' and order of adult identity. On the contrary, in this poem and others, Goll emphasises that this imaginative space of play already allows for a mode of ordering where both self and world are articulated together through patterns of movement and transformation. In the first stanza of '*Die Erwachsene*' (The Grown Woman), for example, Goll again positions the material realm of nature as a site of infinite potentialities, where a child's world grows and takes shape.

> O Kindheit, da in meinem Angesicht
> Zwei Wunder brannten
> Voll unbegriffener Welt.
> Hymnen schliefen im wachsenden Mund,
> Geschwister war man mit allen Engeln
> Und hörte Gott im weißen Lied
> Sich sehnender Lilien.
> Im Hollunder wuchsen blaue Märchen
> Und reiften an den großen Dämmerungen,
> Da man zum erstenmal wußte,
> Daß Knabe und Stern dasselbe sei,
> Da, Liebe, deine heiseren Mittage
> Mit dem Wind vorbeirauschten.
>
> (Goll 1922, 32)

O childhood, when in my face/ Two wonders burned/ Full of ungrasped [unconceptualised] world./ Hymns slept in a growing mouth,/ I was related to all the angels/ And could hear God in the white song/ Of longing lilies./ In the elder trees blue fairytales grew/ And ripened towards the great twilights,/ When it was known for the first time,/ That boy and star were the same,/ There, love, your hoarse middays/ Rushed by with the wind.

The poet here celebrates a childhood existence where the world was not grasped via conceptual processes of ordering.[10] Instead, the world filled the child with a burning intensity that, far from extinguishing her gaze, was a source of abundance and growth. Hence although permeated by her environment, this child was neither overwhelmed by the violent matter characterising the poems of many male Expressionists, nor simply absorbed in a de-individualised flux. Rather, the world transformed the child with wonder, and her sense of order emerged slowly through a plenitude of potentiality: hymns slept in a growing mouth, waiting to take shape like the stories which grew out of the elder trees.

Far from dissolving identity, this generative materiality produces the imaginative structures that shape the child's world. This childhood realm cannot be equated with a preconceptual *lack* of differentiation, to be necessarily abandoned as the child matures and accessed only as a carefully circumscribed imaginative resource—the very resource of excessive matter that provokes and permits the aesthetic of the sublime. Nevertheless, the tales ripen towards a privileged identification of boy and star, therby hinting that the processes of growth and becoming may be oriented by a more fixed and phallocentric horizon. This foreshadows the second stanza of '*Die Erwachsene*,' which emphasises that the adult world has grown cold and dead because this generative material realm has been left behind and can no longer be accessed at all. Goll's poem can be read as an allegory for a Western metaphysical history in which, as Nietzsche reminds us, the world of being cuts itself off from the very processes of becoming out of which it grew (Nietzsche 1990, 45–7), and, as feminist theorists have reminded us, what gets forgotten above all are the maternal processes of gestation and birth (Battersby 1998; Cavarero 1995; Irigaray 1985). However, Goll also challenges the necessity of this history, by positioning the imaginative childhood site where the self is immersed within an animate materiality not as a temporary stage of maturation to be overcome, but as an alternative and lost mode of ordering. Instead of a constitutive cut opposing a disembodied subject to the material realm of objects, and separating either the child from the maternal body or being from becoming, in the childhood realm Goll's poem mourns, self and world unfold together, the fecund growth of the imagination entwined and embodied in material processes.

The need for an imaginative return to a temporality shaped by somersaulting interrelations of play that chart the possibilities of a mobile materiality is powerfully expressed in '*Gedicht*' (Poem):

Vorgestern spiegelte ich dich,
Sonne.
Nachts spielten wir Stern,
Fingen Wind,
Nachtigall sang uns näher zu Gott.
Gestern regnete es schon,
Aber heut ist es erdkalt.
Meine Augen frieren zu,
Oede Weiher,
Scherben auf dem Grund,
Rostige Nägel
Und ein ertrunkenes Herz,
Zerstoben,
Stumm.
Nichts rauscht mehr von dir,
Sonne,
Wind,
Stern.

<div align="center">(Goll 1922, 33)</div>

Before yesterday I mirrored you,/ Sun./ At night we would play at stars/ Caught the wind,/ Nightingale sang us closer to God./ Yesterday it was already raining,/ But today it is earth-cold./ My eyes freeze over,/ Desolate pools,/ Shards on the ground,/ Rusty nails/ And a drowned heart,/ Splintered,/ Silent./ No more rush of you,/ Sun / Wind / Star.

The opening image suggests the specular ontology that has informed Western metaphysics, and its ancient origins in Plato: long ago, the self reflected the light of the sun, that traditional symbol of truth and enlightenment. But in a playful subversion typical of Goll's poetry, the next lines undermine this specular logic: poet and sun together played at being stars and at catching the wind. No longer trapped in oppositional

reflection, sun and self are as if on the same side of the mirror, where, as mobile objects playing in space, neither can serve as a fixed point of origin for an economy of reflection.

The fact that reflection does not here allow for the stable orientation of subject and object, but is inherently playful, does not entail a loss of the very possibility of coherent experience: on the contrary, reflection becomes another game played out between sun, self and stars, mapping out a spatiality through relations and transformative becomings. Despite its philosophical history, the image of the sun is not here deployed to invoke a stable origin of truth; neither is reflection the specular work of a subject on inert and manipulable matter. Instead, reflection becomes a dynamic process, shared between sparkling objects as they take shape through play. Once again, however, this magical transformative world has already been lost—the present is 'erdkalt', the 'I' of the poem is trapped in a frozen realm where change and becoming are barred. The playful immersion of self within the external world is destroyed: its eyes freeze over, and together with the shards on the cold ground, they figure the fragmentation of a once animate materiality into a frozen sea of surfaces. In ways that look forward to Irigaray's 'Une mère de glace', and back to Plotinus, Goll's poem mourns the reduction of a dynamic materiality into the 'dead matter' of Western metaphysics (see Irigaray 1985, 168–79).

Nonetheless, the play figured in several of Goll's poems where selves and objects take shape and shape a world together provides an imaginative access to the 'Vorgestern' she invokes. Such imaginative, preconceptual play both echoes and can be usefully contrasted with the role of play in Kantian aesthetics, where play is associated with the beautiful. According to Kant, in judgements of the beautiful, the imagination is freed from having to match the world to determinate concepts, and instead plays over the spatio-temporal forms it is able to map within a particular perception, without unifying these forms into particular objects. This preconceptual 'free play' of the imagination intensifies the subject's sense of its capacity to order the world, as well as the way in which the world appears to lend itself to such ordering.

However, this 'free play' is in fact far from free: it reflects the ordering capacity required to structure a world of unified objects against which the persisting self-identity of the individual subject can be posited. By contrast, for Goll, imaginative play no longer reflects the perspective of a

stable individual oriented *against* an inert and external materiality; rather, it is generated between subjects who are also material objects, and animate objects capable of agency and action. Together they organise space in ways that it is impossible to ground in any one subject. Such play generates continual transformations which traverse a space that is no longer simply external to (and potentially hostile towards) the self, but the material site within and across which its potentialities unfold. The animation of the world of nature and materiality does not lead to the disintegration of embodied individuality and singular identity, but to a different model of identity, one grounded in connection and (inter-)change rather than opposition and permanence.

Goll's poems refuse the limits that characterise the beautiful for Kant, where play is associated with soft, bounded and easily contained feminine forms, by relocating play in the infinite reaches of the Milky Way more usually associated with the sublime. As we have seen, for Goll, such stellar spaces no longer constitute an abyss in which the imagination fears to lose itself (Kant 1987, 115 [5:258]), but are instead the site of unbounded relations which orient those who are both active subjects and material objects via a ceaseless play of (self-)transformation. Her texts thereby confound the very distinction between the beautiful and the sublime by exploring an imaginative play that is no longer linked to the contained spatiality of a self-identical Kantian subject, but that takes sublime risks with both self and world.

By leading the imagination outwards, towards the limitless stellar spaces more readily associated with the inorganic strata of the planets, the burning intensities of the stars, Goll's poems, like those of her male counterparts, more strongly prefigure Deleuze's non-organic, intensive life than they recall Kant's turbulent nature. However, for Goll, if the dynamic forces of an animate materiality are no longer a threat the subject must resist and overcome, neither do they annihilate the specificity of all bodies— including but not exclusively sexed bodies—by decomposing singularity into formless flux. Instead, Goll seeks to recapture a fluidity of movement and generative force through which the possibilities for difference are multiplied and singular identity might itself be differently imagined as a temporal patterning shaped by shared becomings. Materiality is seen from

the side of the object as a manifold potentiality allowing specificity to unfold in ways that defy the binary logic that would stage a choice between identity grounded in static self-containment and oppositional separation, or no identity at all. Goll's poetic selves and the stars with which they play are never opposed as subject and object but take shape together as distinct entities held within a web of interrelation and imaginative transformation/s.

Perhaps unsurprisingly, the key figure in one of Goll's most effective poems ('*Junge Akrobatin*' – Girl Acrobat), and an appropriate concluding image, is that of an acrobat flying over herself through time:

Bunter Vogel du, der zwischen Welten
Über Abend, Stadt und Staunen schwebt
Schwing dich auf dem Trapez
Über dich selbst durch die Zeit.
Deine Schenkel flattern zittern von Zweig zu Zweig
Und dein Herz von Mensch zu Mensch.
Goldne Flitterlibelle, deine schwebende Sehnsucht
Fällt nie durch die gierigen Augen ins Herz.
Armer Stern, der allnächtlich aufgehn muß
Am kleinen bezahlten Himmel der Gaukler.
Der jeden Abend abstürzt in die Arme roher Athleten,
In den giftigen grauen Zigeunerwagen,
Der dich gefangen durch das unendliche Leben fährt.
 (Studer 1918, 16)

You, brightly coloured bird, that hovers between worlds/ Over evening, city and astonishment/ Swing yourself on the trapeze/ Over yourself through time./ Your thighs flutter tremble from branch to branch/ And your heart from person to person./ Golden sequin-dragonfly, your hovering longing/ Will never fall through greedy eyes into the heart./ Poor star, that nightly must rise / Into the little, paid-for sky of the illusionist;/ That every evening falls back down into the arms of raw athletes,/ In the poisonous grey caravans,/ Which carry you trapped through unending life.

This acrobat is a hybrid creature, a golden, sequinned dragonfly, part heavenly, part natural, part tinselly, who moves between different spaces and times. Her somersaults embody a dynamic of becoming, and although

her trembling materiality seems always under threat, at the beginning of the poem the acrobat moves freely, generating a temporality of change. As she turns over and over herself, she allows movement to flow out of movement, mapping out space through the relations traced between her body and the air through which she flies, unfolding time in tumbling patterns of repetition wherein both sameness and difference are marked.

It is this acrobatic space-time which Goll seeks to recover through her poems, a playful space-time full of sublime risk and potential. Indeed, the risk involved in Kant's sublime is not lost from Goll's poems, but is in turn transformed. The danger is not that it might be impossible to secure the boundaries of the self against a manifold materiality, but that the material site of the transformative encounters which generate and sustain identity might not be recoverable, or, once recovered, might be all too quickly recaptured by the waiting arms of a more oppositional metaphysics. I would suggest that Goll's poems encourage us to take the philosophical risks required to think and sustain modes of the sublime that allow female selves to be the subject of aesthetics. In the interplay between her images and the structures of philosophical modernity, we might find the material allowing us to rework the structures of both self and sublime.

Although the defining body of Expressionism is constituted by a crisis of the (male) subject of modernity, the breakdown of the subject–object relation opens a space where other modes of constitutive relationality can be reworked. Goll's work indicates that Expressionism functions differently for those who write from the side of woman, the side of the 'other' and the 'object'. Her poetic texts rechart the sublime to map the possibilities for a self grounded in a non-oppositional logic inclusive of difference and change, from the perspective of one who is *both* material object *and* active subject. Her work reminds us of the importance of looking for those who thread their way between the voices that have so often dominated accounts of Western modernity, for it is in their interweavings that we may find some answers to Irigaray's now famous question: 'what if the "object" started to speak?' (Irigaray 1985, 135) Threading our way through modernity with Goll, we find the 'object'– 'woman' has not only already found a manifold emerald voice, but has begun to move in glittering somersaults.

Notes

1 See especially *Critique of Judgment* (Kant 1987), sections 28 and 29, 119–126 [5:260–66]. All references to Kant give the date of the translation and the page numbers, followed by the reference to the *Akademieausgabe* in square brackets, except in the case of the *Critique of Pure Reason* (Kant 1933), where standard A and B numbers are used.

2 The precise reasons for women's exclusion from the sublime change between Kant's pre-critical text, *Observations on the Feeling of the Beautiful and Sublime* (1960 [first published: 1764]), and the transcendental aesthetics of the *Critique of Judgment*, also discussed in *Anthropology from a Pragmatic Point of View* (1974 [first published: 1798]). For a careful discussion of the gendering of Kant's account of the sublime, see Christine Battersby, 'Stages on Kant's Way: Aesthetics, Morality, and the Gendered Sublime' (Battersby 1995).

3 In particular, Battersby has shown how the eighteenth-century German poet, Karoline von Günderode, and the contemporary British artist, Evelyn Williams, differently deploy the antinomies that structure female identity, together with an ambivalence towards the individuated self, to generate alternative modes of the sublime. See Battersby 1994b and 1994a, respectively.

4 Although Battersby's philosophical position is partly inspired by Irigaray, she also critiques Irigaray's tendency to homogenise the history of Western philosophy as 'the expression of a seamless masculine imaginary' (Battersby 1998, 56).

5 Kant 1933, 217 [A189, B232]: 'Permanence is thus a necessary condition under which alone appearances are determinable as things or objects in a possible experience'.

6 All translations of German texts are my own unless otherwise indicated.

7 References to Vietta's argument are to *Expressionismus,* which was co-authored with Hans-Georg Kempner; all material used here, however, is from the section written solely by Vietta.

8 On this point, Deleuze's analysis of the burning intensity of light in Expressionist film can be productively compared to his analysis of Turner and catastrophe. See James Williams, 'Deleuze on J.M.W. Turner: Catastrophism in Philosophy?'. As Williams argues, for Deleuze, chaos is not simply valorised but rather 'catastrophe has to be controlled' (Williams 1997, 244).

9 Claire Studer is Goll's name from her first marriage.

10 'Unbegriffen' contains the German '*Begriff*', or concept, implying that which is ungrasped and non-conceptualised.

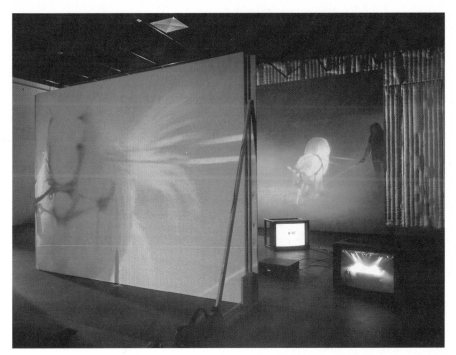

Plate 1. *The best space is the deep space* 1998. Diana Thater. Video Installation.
(See also Fig.1.)

Plate 2. *June Painting. Ultramarine and Yellow* 1996. Wilhelmina Barns-Graham.
Oil on Canvas. 137.2cm x 216cm. (See also Fig. 3.)

Plate 3. Barbara Freeman. See Fig. 5 for details.

Plate 4. Lubaina Himid. See Fig. 7 for details.

Plate 5. Jo Hsieh. See Fig. 8 for details.

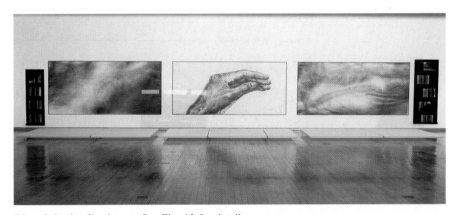

Plate 6. Lesley Sanderson. See Fig. 13 for details.

Plate 7. Partou Zia.
See Fig. 17 for
details.

Plate 8. *Burn* 1999. Barb Bolt.
Oil Stain on Canvas. 180cm x 120cm.
(See also Fig. 35.)

Chapter 5

Living Dialectics, *Aufhebung* and Performance Art

Petra Kuppers

Aesthetics is concerned with questions of art and value. In this paper, I want to query the values of performance art: what can performance mean to its society? I am therefore not interested here in an historical overview or even a fixed definition of the term performance/art (even at the level of label, performance becomes complicated), but in its specific materiality (or the materiality of each specific instance). For the purposes of this argument, I am focusing on performance art because of its relationship to language: performance art complicates the full presence of its subject in identity and language categories – it embodies the effects of language on bodies. Performance artists have inserted their and their audience's bodies (and their absences, traces and debris) into the discourses that categorise them into 'female' and 'male', into 'periphery' and 'centre', 'nature' and 'culture' or into other binaries and differences. The sensuality, the semiotic and phenomenological richness of the living body, its vehemence, violence and passion are the material with which artists such as Yoko Ono, Carolee Schneeman, Karen Finlay, Marina Abramovic, Rudolf Schwarzkogler or Ron Athey construct their work. Performance theorist Peggy Phelan points to the axis of absence and presence which complicates performance art's 'hold on the Real'.

> Performance art usually occurs in the suspension between the 'real' physical matter of the 'performing body' and the psychic experience of what it is to be em-bodied. Like a rickety bridge swaying under too much weight, performance keeps one anchor on the side of the corporeal (the body Real) and one on the side of the psychic Real. Performance boldly and precariously declares that Being is performed (and made temporarily visible) in that suspended in-between. (1993, 167)

The play in the realm of the bodily, the psychoanalytic and the semiotic, never finds its utopian place of fullness, but points endlessly to longing, and the invisibility of the Real. This provisional, liminal, in-between character of performance is reflected in its materiality: it is unable to exist outside its specific time, space and bodily encounter.

In this paper, I want to see how a re-reading of a specific passage of Georg Wilhelm Friedrich Hegel's *Phenomenology of Spirit* can help me to continue work on the aesthetics of performance, and on the issue of suspension. By sketching out a tentative intervention into an aspect of this work, I am opening up small spaces which allow me to see beyond the main critical exegesis which reads Hegel as the foundation of the modern subject's alienation.

My work with Hegel's text, like the work of many performance artists with theory, is characterised by physical encounters, an erotics of reading which plays along surfaces of texts and bodies, and witnesses the effects of these meetings. Thus, when I started my work on the text, I remembered vividly the 'staging' of Hegel for us pupils at school – I was introduced to a Hegel writing his grand project while hearing Napoleon's cannons echoing through the streets of Jena. My teachers painted for me a vivid, dramatic vision of Hegel's dialectic and his analysis of the struggle between master and slave. Their reading was derived from Alexandre Kojève (1958). To encounter Hegel again and again, in changing forms and in different disciplines, prepared me to see my own writing within the purview of a dramatic encounter. Hegel and his project are 'unfamiliar' to my contemporary sensibilities, but I re-visit his strangeness in my search for generative, rather than forbidding, difference.

In order to arrive at this point, I read Hegel's foundational analysis of the emergence of master and slave. This 'Independence and Dependence of Self-Consciousness: Lordship and Bondage' chapter is a small part of Hegel's phenomenology, though, and my reading takes it out of its context and inserts it into mine. I then continue by questioning Jacques Derrida's reading of the Hegelian *Aufhebung* in specific pages of *Glas*, and sketch out a different interpretation of the dialectics of 'the negation of consciousness' as a living process, rather than a deadly division. Finally, I will bring my readings of Notion, nature, labour, product, language and the specific to bear on the performance encounter. Within this paper, I am refraining from analysing specific performances – this pleasurable task can be taken up elsewhere.

I understand an aesthetic to be necessarily contextual - bound by historically specific definitions and understandings of subjects. In this paper, I focus on the tradition of defining the subject derived from Hegel's analysis of the partial constitution of the subject through antagonistic struggle, through fight. This fight appeals to me as a performance theorist because of its visceral, kinetic quality, its spatial and temporal encounters, its reference to the flesh - my history and story intertwines with Hegel's analysis, and new meanings can emerge.

Performance theorist Rebecca Schneider addresses a utopian project, the wish to find a redefinition of Hegel's premise of unavoidable misrecognition:

> ... Hegel's premise (is) that recognition must always involve a battle to the death – only one can be recognized when two are involved. But is antagonism the only mode of conceiving of difference between one and one? Or is there something imaginable as satiable in a mutual gaze, double vision, a hybrid pass, a two-way street, or even a 'trivialis'? (Schneider 1997, 178)

I intend to follow her trajectory, to develop my own ideas of how to (mis)-read Hegel for a more hopeful outcome. Like her, I believe that

> Performance, a medium of mimesis and exchange, has become a terrain well suited to this exploration because performance acknowledges the present moment of exchange between embodied participants, embedded in cultural codes. (Schneider 1997, 178)

Schneider's emphasis on exchange in performance will be my way to rethink the disavowed exchanges in the encounter between master and slave.

This notion of 'exchange' and 'meeting' needs to be read against the understanding of performance art as the rehearsal of the subject's constitutive longing, unfulfilled but fuelling the gaze structure of performance in Peggy Phelan's *Unmarked.* She uses the Lacanian concept of the subject trying to find recognition in the gaze of the other: a concept which is at the heart of the lord/slave relationship in Hegel's *Phenomenology of Spirit.*[1]

Phelan is interested in that which evades the gaze, that which is unmarked in a strategy of active vanishing, that which destabilises any one conception

of the 'real' by being its nagging blind spot. The traumatic nature of subjectivity, rehearsing again and again its unrepresentable myth of origin, is the drive that places Phelan's spectator in the position to desire performance. This play with absence and presence, troubling self-identity, is at the heart of my reading: I am trying to locate in the specific instance of the performance art encounter and in the historic persistence of performance as an art form a subversive potential, destabilising the character of identity as Notion.

I am returning to Hegel, who formulated the traumatic scene of a consciousness never able to fully find itself, in order to find another entry point into the contemporary feminist impasse of thinking essentialism together with respect for the other (or, alternatively, finding ways of dispensing with the thinking of self and other). This problem is the problem of the general and the specific: thinking together the category (or genre) of (for instance) 'woman' as concept with the specific, material, embodied lived experience of different beings. My entry point lies with the 'real-ness' of autonomous self-consciousness: (how) can a specific performance destabilise the divisions between self and other, and therefore also the boundary between 'woman' and specific woman?

In order to approach this question, I want to read through the specific constellation of self-consciousness, of autonomous being-for-self, as Hegel conceived it. In my account, I am keeping to the original, the masculine him and he: Hegel's relation to the female is too problematic for me to collapse into gender neutrality.[2]

Lord and Slave

> The lord is the consciousness that exists *for itself*, but no longer merely the Notion of such a consciousness. (115)

The consciousness of the lord is thus an embodied being: a thing in itself. It cannot be thought as abstract (merely a Notion), but it is in each instance specific. This concept of the Notion is important in its specificity: in the German original, the word is 'Begriff', a term which points more strongly to the language character of the concept. The abstract is the abstraction of language, and the other to it is lived embodiment. This embodiment is not specified as outside or inside.[3] But the concept of an abstract self working through contradictions is much closer to Hegel's journey of the consciousness to a 'purity' of idea than my late 20th century reading for an

integrated human subject. Judith Butler reads Hegel as concerned with bodies not as

> objects of philosophical reflection, much less a site of experience, for bodies are, in Hegel, always and only referred to indirectly as the encasement, location, or specificity of consciousness.
> (Butler 1997, 34)

Hegel's concept of self is under discussion within the subject and in the encounter with other subjects, but the language that Hegel uses is never fully 'interior' or 'exterior': it is always poetically alluding to 'Befindlichkeiten', specificities. In any instance, consciousness is shaped by embodiment.

This embodiment of consciousness means that it is specific in its location (and therefore consciousness is indivisible from history), something which is only accessible through the separation from an other, but an other who is also equally embodied, perceived as a 'thing':

> Rather, it is a consciousness existing *for itself* which is mediated with itself through another consciousness, i.e. through a consciousness whose nature it is to be bound up with an existence that is independent, or thinghood in general. (115)

The possibility of consciousness in the 'real', in the lived, embodied experience, is therefore always already dependent on the other. But this other is not the same: the other is related to 'thinghood in general'. It is this dynamic, the need to define thing and being, which is at the heart of the fight that characterises accession to the subjecthood of master and slave.

> The lord puts himself into relation with both of these moments, to a *thing* as such, the object of desire, and to the consciousness for which thinghood is the essential characteristic. (115)

So how does a consciousness, for whom thinghood is the essential characteristic, come into being?

In order to answer this question, I have to go back to the first moment of encounter: two consciousnesses together. Hegel worked through this encounter first in the abstract, talking about Forces, and now applies his insight to two consciousnesses meeting.

Self-consciousness is faced by another self-consciousness; it has come *out of itself.* This has a twofold significance: first, it has lost itself, for it finds itself as an *other* being; secondly, in doing so it has superseded the other, for it does not see the other as an essential being, but in the other sees its own self. It must supersede this otherness of itself. (111)

This superseding of ambiguous otherness is necessary in order to hold on to the core of consciousness: the certainty 'of itself as the essential being' (111). The fulfilment of this call to the self to see itself is in the moment of recognition:

It is aware that it at once is, and is not, another consciousness, and equally that this other is *for itself* only when it supersedes itself as being for itself, and is for itself only in the being-for-self of the other. Each is for the other the middle term, through which each mediates itself with itself and unites with itself; and each is for itself, and for the other, an immediate being on its own account, which at the same time is such only through this mediation. They *recognize* themselves as mutually *recognizing* one another. (112)

But this moment of recognition is never fully realised. The encounter staged above is a 'pure Notion of recognition' – abstract, not lived. What happens when it enters the embodied world of the self is the tragedy of self-consciousness:

Self-consciousness ...will exhibit ... the splitting-up of the middle term into the extremes which, as extremes, are opposed to one another, one being only *recognized*, the other only *recognizing*. (112/113)

In the struggle that follows from this mis-recognition of recognition is a fight to the death. At the core of the fight is the attempt to return to the impossible state of consciousness as Notion: as abstract rather than embodied. This tension between Notion and Being is the source of violence. The two consciousnesses are for each other

(o)rdinary objects, *independent* shapes, individuals submerged in the being (or immediacy) of *Life* – for the object in its immediacy is here determined as Life. (113)

But as long as they are Life rather than Notion, the self cannot see the other as the same as itself:

(t)hey have not as yet exposed themselves to each other in the form of pure being-for-self, or as self-consciousness. (113)

And, as we have read, the Notion of recognition relies on the moment when

(e)ach is for the other what the other is for it, only when each in its own self through its own action, and again through the action of the other, achieves this pure abstraction of being-for-self. (113)

Thus, the Notion of recognition is not possible: instead of mutual recognition, the two parties attempt to prove to each other (and themselves) their own pure abstraction:

The presentation of self, however, as the pure abstraction of self-consciousness consists in showing itself as the pure negation of its objective mode, or in showing that it is not attached to any specific *existence*, not to the individuality common to existence as such, that it is not attached to life. (113)

This means, then, a fight to the death: to give up before one is dead is to value life too much. But death itself is self-defeating.

For just as life is the natural setting of consciousness, independence without absolute negativity, so death is the natural negation of consciousness, negation without independence, which thus remains without the required significance of recognition. (114)

If one is dead and the other is alive, the middle term which mediates the extremes is gone:

(t)he two do not reciprocally give and receive one another back from each other consciously, but leave each other free only indifferently, like things. (114)

Thus, being together and being apart becomes impossible for two consciousnesses. The dialectical movement of extremes meeting has to drive life. If one were to kill the other, or they were to live without knowledge of each other,

Their act (would be) an abstract negation, not the negation coming from consciousness, which supersedes in such a way as to preserve and maintain what is superseded, and consequently survives its own supersession. In this experience, self-consciousness learns that life is as essential to it as pure self-consciousness. (114/5)

Hegel describes here the dialectic movement as necessity for growth, and for a recognition of difference in the incorporation and memorisation of it. He also introduces here not a dialectic of unity and teleological development (if I read this paragraph by itself, outside the elaborate ascendance to the Idea), but the idea that the way to growth is through lived experience of difference.

This paper leaves Hegel at this point, thereby breaking the master-slave fight out of its coherent framework. Peter Dews sums up how the master's story goes on:

The master-slave relation, in other words, represents the maximum disequilibrium of self-consciousness, and it is from this point that the long peregrination of consciousness towards an adequate concept of itself will begin. Clearly, such as concept can only emerge when full reciprocity becomes possible, when consciousness can 'recognise themselves as mutually recognising one another', without coercion, and without abandoning their individuality in futile imitation. For Hegel such recognition involves the abandonment of total autonomy as a possible goal. Full reciprocity is only attained when human individuals cease to cling to the punctuality of self-certainty, and recognise themselves and each other as common participants in the partial unity of a social world, in that 'I which is We, and We which is I', which Hegel refers to as *Geist*. (Dews 1987, 54)

Aufhebung

By putting forward my own positive reading of a Hegelian dialectical moment (rather than *the* Hegelian dialectic), I am putting my writing into difference: difference from the readings of Hegel that fuelled the dramatic stage my old schoolteachers set for me. It is time to set the scene for encounters, haggling over words and meanings, to find spaces of generative difference between Derrida's reading of the Hegelian *Aufhebung*, and an intervention through a reading of one small passage, but a passage which I

read on a human scale: I relate the difference of the word to the difference of the embodied self.

Derrida writes about the dialectic in relation to gender difference:

> When sexual difference is determined by *opposition* in the dialectical sense (according to the Hegelian movement of speculative dialectics which remains so powerful even beyond Hegel's text), one appears to set off 'the war between the sexes'; but one precipitates the end, with victory going to the masculine sex. The determination of sexual difference in opposition is destined, designed, in truth, for truth; it is so in order to erase sexual difference. The dialectical opposition neutralizes or supersedes [Hegel's term *Aufhebung* carries with it both the sense of conserving and negating. No adequate translation of the term in English has yet been found, translator's note] the difference. However, according to a surreptitious operation that must be flushed out, one insures phallocentric mastery under the cover of neutralisation every time. These are now well-known paradoxes. (Derrida 1995, 149)

But the well-known is questionable. In the passage which I quoted above, concerned with dialectic in action, the German last sentence reads:

> Ihre Tat ist die abstrakte Negation, nicht die Negation des Bewusstseins, welches so *aufhebt*, dass es das aufgehobene *aufbewahrt* and *erhält* und hiermit sein Aufgehobenwerden überlebt. (Hegel 1996, 336)

I can find no equivalent to 'neutralizes', 'superseding' and 'negating' in this passage: Hegel's words 'aufgewahrt' and 'erhält' approximate 'keeping/conserving/keeping alive'. But let me concentrate on the one word which has achieved a similar status to Derrida's untranslatable, fleeting 'différance' – *Aufhebung* (in the Hegel translation given as supersession). Etymologically, the word contains the words 'up' and 'lifting' – 'heben' means to lift, to elevate. Granted, the metaphorical meaning of 'negation' is part of the word's German meaning, but in a desperate struggle for hope, a more literal=pictorial meaning can be seen: 'uplift'. And does it not fit well? I remember learning about the dialectic as a school child, watching the chalk create a diagram of umbrellas on the blackboard, staggering upwards in generous strides.[4]

And Derrida is not always so fast with the *Aufhebung*. When he engages in
ice-skating and reflection (*Glas*) rather than stage dancing and responding
(*Choreographies*), he teeters more on the edges of words. *Aufhebung*
becomes aligned with other Derridean concepts, to (the law of) genre, and
to the enframing (parergonality), by exactly that movement of 'one-up' –
an elevation which always bears the traces of its spatial path, being
implicated by what it 'supers', overcomes, walks on:

> Nevertheless, by reason of the structure of language's internal
> development, what is elaborated there destroys itself in that very
> elaboration [*as the Notion of family 'overcomes' the Hegelian
> 'natural' family, the site of the singular (Einzelne) and the non-
> labour (and therefore non-logos), my elaboration*] or rather submits
> itself to the process [*procès*] of the *Aufhebung*, relieves itself. In
> positioning itself as a system of natural signs, as existing in
> exteriority, language raises itself to the concept (ideal interior
> signification) and from then on denies itself as a system of natural
> signs. (Derrida 1986, 8)

It is the logos, the labour, which disrupts the self-presence of language, just
as in parergonality the frame always is troubled by the outside of the frame
(see Cornell, 1991, 104ff for the performative implications of style
questions).

> The thing (the referent) is relieved (*relevée, aufgehobene* (sic)) in the
> sign: raised, elevated, spiritualized, magnified, embalmed,
> interiorized, idealized, named since the name accomplishes the sign.
> (Derrida 1986, 8)

Aufhebung becomes naming, begets the name, labours on the natural to
create the product of the name. But the name is thereby not the nature, not
the thing. In the master-slave dynamic it is exactly that labour which brings
the slave to freedom: the overcoming (*Aufhebung*) of nature. But the labour
belongs to the master, not the slave. Nothing can be owned – the naming,
that transformation of nature, always keeps traces of the nature which
cannot be acknowledged by its owner, the master, and the slave cannot be
without the master (and own his own work, naming it). It is this sense of
scraping raw on the *différance* of naming, on the non-realisable self-
presence of labour(er), that I understand Derrida's statement to mean:

> The dialectic of language, of the tongue [*langue*], is dialectophagy.
> (Derrida 1986, 9)

We choke on language, erasing the (thing/*parole*) tongue through *langue* – cannibalising ourselves. Thus, as feminist writer, I choke on the language of Derrida's *Aufhebung* – I am trying to wrestle my own 'specific' out of 'his/their' master's definition, which reads *Aufhebung* on and on, out of (my) control, in moments such as the erasure of sex difference (Derrida 1986, 111, 125).

But for Derrida in the first pages of *Glas* (to arrest the runaway definition), the oscillating other narrative/drama (printed on the other side of the page, in a different script, in a different genre) to *Aufhebung* is death:

> 'The executioner follows close behind me, Claire! The executioner's by my side. ... They'll all be wearing crowns, flowers, oriflammes, banners. They'll toll the knell [*glas*]. The burial will unfold its pomp. It's beautiful, isn't it? ... The executioner's lulling me. I'm being acclaimed. I'm pale and I 'm going to die.' At the moment of the glas, let oneself be lulled, verily be given the breast [*sein*] by an executioner: by the one who, do not forget, enabled having a name. The name is given near the scaffold. The one who gives the name and the *seing* brings his blade next to your neck [*cou*]. To divide you. And with the same gesture, he transforms you into a god. (Derrida 1986, 12/13)

In Saint Genet (and Saint Derrida) you die as you are named, the mother's breast (Derrida's image of beginning) is the scaffold, you are being chopped up into godhood, into 'generic' 'man'. The ascension erases being. But is that all there is?

The *Aufhebung* as it becomes the terror instrument of Derrida is not the same as the one I quoted in Hegel. Genet and Derrida are sliding into a death which would be fatal for Hegel's slave and master: the absolute negation. How can one hold on to Hegel's distinction between lived and absolute negation? Back to the small, minor case of the verb 'aufheben': collecting the debris.

The 'negation coming from consciousness', the lived, experienced creation of negation, can potentially open up to the traces of the 'aufgehobenes' – the traces which complicate the self-presence of the new term, embedded it in its own genealogy. In the passage quoted, this processual, unfinished, leaking conception of the synthesis is expressed in Hegel's noun: 'Aufgehobenwerden' – the process of becoming 'aufgehoben', not the end,

the 'sein' of it. The 'werden' translates as becoming, a meaning lost in the 'supersession' translation which designates a completed act.

The reading in these pages is already marked by being conceived within the horizon of the death of metaphysics – the collapsing of the binaries of languages, the uncertainty of the realm beyond the horizon - and therefore, the *Aufhebung* moves closer to the historically more recent partner, différance. When Gayle Ormiston writes,

> To be certain, différance disrupts the mastery and confidence of the Hegelian *Aufhebung*, the sovereignty of a certain philosophical heritage oriented by desire and mastery of consciousness to comprehend itself. Différance conditions and betrays the very delivery of this lineage. (Ormiston 1988, 41)

The *Aufhebung* is already marked by différance, as is différance by the Hegelian movement through the desire to be: it/ça writes on, we read on, the I marks itself on the page.

Living with Difference

The dialectic of non-abstract difference splits up the two consciousness, with one independent consciousness, whose essential character is 'to be for itself', and one dependent one, who essentially 'lives or is for another'. 'The former is lord, the other is bondsman' (115): The way out of the dilemma of encounter is the introduction of another dilemma: a game of *fort-da*, of disavowal and fetish. The two consciousnesses split up into master and slave, but in a relationship of mutual dependency. The slave becomes all thing, and the lord all Notion: an impossible state only held in place through mis-recognition. For the lord to need the slave would be to acknowledge the corporeality of the lord, and for the slave to need the lord is to acknowledge the need for (indirect) recognition. The disavowal of Life and Notion respectively is enacted through the materiality of the encounter: the thingness of the slave is realised through a mode of production which splits the product from its issuing source.

> [...] the bondsman, *qua* self-consciousness in general, also relates himself negatively to the thing, and takes away its independence; but at the same time the thing is independent *vis-à-vis* the bondsman, whose negating of it, therefore, cannot go the length of being

altogether done with it to the point of annihilation; in other words, he only *works* on it. (116)

'Relating negatively' is here the dialectical moment: to be the other to something. The bondsman cannot be rid of the thing, it is incorporated into his being, and creates the endless chain of dialectical movement. But this movement never transcends either bondsman or thing: instead, a product, bearing signs of each, is produced.

Thus, the slave can see himself in the traces he leaves on the product, but has to give up that product to the lord, whereas the lord has to receive products whose thing-ness he has to disavow, since to accept them he would lose his absolute notionness and would have to accept his own dependence on the 'material' slave.

This play of disavowals, creating two dependent subjectivities, rests ultimately on the distinctiveness of product and bondsman. It is their dialectical difference which both constitutes the thingness (and obvious dependency) of the slave, and the second order dependency of the lord (who has to acknowledge and disavow his separation and difference from the slave).

Performance

I want to see what happens when the mode of production shifts. I am going to read the disavowal of the utopian Recognition in the embodied encounter of master and slave by considering the mode of production which occurs in performance art situations. In what ways can performance art destabilise the disavowals, and excavate (the longing for) Recognition as a viable encounter? Can performance art activate different modes of production, resulting in different subject-relations? I propose that an aesthetic of performance art needs to address a different aesthetic of the subject: an encounter not (only) marked in commodity production and separation, but an encounter as destabilisation, opening up within language the horizon of the impossibilities of recognition.

The *Aufhebung* of the dialectic was 'located' (by Derrida, in one place) in the name: in the mark of that which is other to the thing, and therefore frames the thing (or the subject) but points back to the other of the framing. It points to that which is excluded by the frame, and this includes the possibility of full self-presence. In Derrida's oblique shift into Genet, the

Aufhebung results in death. The name is so distant from the subject that it fully supersedes the materiality (specificity) of the subject – the subject is superseded. As I have shown, death is *not* Hegel's solution. Living, growth, experience are the words that Hegel associates with the 'human scale' negation – the negation at the level of embodiment, not abstract Notion. The Derridean jump from instance to genre, from image to frame, is present in the tension of the dialectic, but it is not so far executed that death on the scaffold of abstraction results.

At the beginning of this paper, I hedged my bets about the definition of performance: I wrote about specific instances and their materiality. Performance art: even the generic term is problematic, and is constantly written and re-written in the academic field. The undefinable nature of performance art is exactly its inability to present itself in language. The production of a performance relies on a temporal and material presence – if not a self-presence of the involved persons, then a coincidence of spectator and performer in time and space (or, at least, a faulty memory of the possibility of that coincidence, as for instance in Hannah Wilke's art works). Performance art often does not split between performer and audience, between those audience members who willingly acknowledge themselves as part of the event, and those that try to maintain the safe fourth wall of theatre. All are drawn into the risk of the experiment, loosing their safe definitions vis-à-vis one another. The hysteria surrounding these leaky boundaries are played out in artist Franko B's blood presence, where one form of play with risks and labile boundaries is enacted.

Documentation has always been a problem of performance. Performances vanish – not only are they never the same, marked by difference in each repetition, they are always liminal to the realm of the specific and the general: the Notion and the material presence of the witnessing bodies. Performances are metonymic, never giving up the partial character in their unsuccessful supersession by the whole. As Della Pollock claims for performative writing, the performative element destabilizes the relationship between the laboured-over product and its materiality:

> In the metonymic display of its own materiality, writing underscores the difference between print-based phenomena and the corporeal, affective, processual temporalities in which they operate, thus actually featuring what they aren't. (Pollock 1998, 85)

Similarly, performance art troubles the edges of absence and presence – no 'absolute', no full presence or full absence can take hold of the performing

body. Hegel's misrecognitions do not work here – they cannot maintain their separation. Just as performer and audience member positions are made labile and provisional in the performance encounter, Performance art can rehearse non-self-presence without the safety of the conceptual other – in this way, performances are lodged on the limit of the Notion and the specific.

Metonymy refers to the relationship between part and whole. The binary nature of the concept is always fragile: the whole is only referenced through the part, and only has existence through it. The 'part' or specific can never be 'superseded' – to do so would lose the ground of the whole. This ability of the dialectical binary to remain, to survive the *Aufhebung*, is what fascinates Judith Butler, as well:

> Within the Hegelian framework, the subject, which splits itself off from its body, requires that body in order to sustain its splitting activity; the body to be suppressed is thus marshalled in the service of that suppression. (Butler 1997, 59)

In my discussion so far, the whole is the 'Notion', Derrida's 'language'. The part is Hegel's 'nature', in Derrida the being led to the scaffold. Hegel's slave works on nature and produces the product – in Derrida, language. It is this mechanism, the slave's 'transcendence' of nature, that makes him Hegel's carrier of futurity/history (in the Kojèvian reading of my philosophy teachers). But the slave's products are separate from him (and therefore separate him from nature: if they were to remain with him, they would be implicated in the 'natural' from which no history can emerge). The products are for the lord. The lord accumulates them, but again, he cannot use them 'bodily' since to do so would shatter the fragile disavowal of his own nature.

Performance disrupts this economy. In performance, the part which is constitutive for the whole is never separable from the physical, bodily production. Once the performance is over, no product remains. The slave's transcendence of himself out of his 'thinghood' (or, for Derrida, his death by ascension to language) does not occur: the Notion never purely materialises, but remains linked to nature. The lord, the other, cannot wholly take possession of the product: it remains in tension, in touch with the two subjectivities of producer and consumer, through being between them. This touch can be used to inform the pleasure of performance which might be located in its transgressive nature: not (immediately) transgressive on the level of notion, but transgressive in its psychic/social implications,

on the interpersonal level of encounters between self and other, slave and master.

Performance art can rehearse the uncertainty of the self 'of itself as the essential being' (111). It can open up a traumatic moment, a rupture, in which the dialectic is seen in its 'holding up' moment rather than in its 'synthesis' moment. The 'touching' of the unknowable (and therefore non-binarized) other across the dialectic can be used to think onwards the search for respect for the other. If the division into master and slave cannot be wholly realised, the dividing lines between self and other may be contaminated by the traces of the living dialectic, as well, as the necessary boundaries are not fully in place. Maybe performance might not bring about the recognition of the other – but performance might just present movement traces, absent presences realising on the limit of the concept and the physical.

Let me revisit:

> It is aware that it at once is, and is not, another consciousness, and equally that this other is *for itself* only when it supersedes itself as being for itself, and is for itself only in the being-for-self of the other. Each is for the other the middle term, through which each mediates itself with itself and unites with itself; and each is for itself, and for the other, an immediate being on its own account, which at the same time is such only through this mediation. They *recognize* themselves as mutually *recognizing* one another. (112)

This 'pure notion of recognition', the utopian moment, is not the moment of performance – the embodied, specific nature of self stands in the way of a Notional resolution. Thus, as we have seen,

> Self-consciousness ...will exhibit ... the splitting-up of the middle term into the extremes which, as extremes, are opposed to one another, one being only *recognized*, the other only *recognizing*. (112/113)

Performance, with its liminal *in*ability to split up, to create the product that allows the *fort/da* game of disavowal to be played, illuminates the playground of the dialectic. Performance insists on the traces, the ground, the secondness of the concept. Drucilla Cornell sees the value of deconstruction for feminism in the opening of the infinite into the concept character of justice: likewise, my reading is driven by the infinite non-

arrested *Aufhebung* which lifts into witnessing view the specific in tension with the Notion.

The desire to split and not to split, simultaneously, drives onwards the search for the other: the dialectic/touch is not just the longing for self-presence, but a longing that can only be materialised through the eyes of the other. Therefore, notions can change, as well. The embodied specificity of the encountering subjects do not merely question all notionality, but drive the notion onto its own dialectical path: covering its own fight towards encompassing meaning, appropriate to the specific subject. In this way, the intervention of the performance encounter does reverberate beyond the melancholia of language's limits.

An aesthetic is a project of hope: it throws into relief what art could be. In this paper, I have charted a partisan course, strategically reading Hegel for a new understanding of encounters in performance art: encounters which lead away from nomadic subjects encased in identity politics and towards other possibilities of recognising non-recognisability, troubling productively the edges of identities. I do not wish to say that Hegel identified the leakiness of the lived dialectic – although I am quoting his passage to 'ground' my reading. What I do wish is that contemporary projects which aim to read performance art as an interesting and important intervention into the economy of the sign as Notion retain exciting new spaces to move in. This movement will not rest in an either/or: body/mind, physicality/language, but will engage across the landscape of the living dialectic.

Notes

1 In the following, I am reading section B.IV. A.: Independence and Dependence of Self-Consciousness: Lordship and Bondage in the translation of A.V. Miller, 1977, all page numbers refer to this edition. I am also using the German original, collected in Günter Schulte's *Hegel*, 1996, to point to dissonances between the English and the German.

2 For a recent discussion of feminist interventions into Hegel's discussion of woman in the *Phenomenology of Spirit*, see the 'Antigones of Gender' chapter in Christine Battersby's *The Phenomenal Woman*.

3 This issue, whether Hegel is to be read as concerned with history or psychology, has been worried for a century by exegists such as George Armstrong Kelly (1965/1973).

4 The graph on the blackboard was not the same that I imaged when I read Derrida's image of the stairs. The arching umbrellas linger more, lean more, are more in the spaces before and after than the stairs. For me, dialectics were never a straight staircase.

Fig. 19. *Masha Bruskina* 1989. Nancy Spero. Typewriting, hand-printing and Xerox collage on paper. 10" x 42".

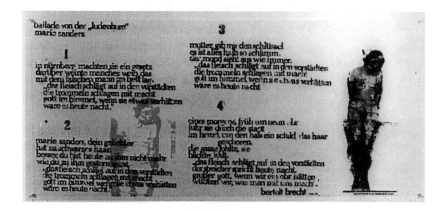

Fig. 20. *Ballade von der Judenhure Marie Sanders* 1991.
Nancy Spero. Lithograph. 21" x 48".

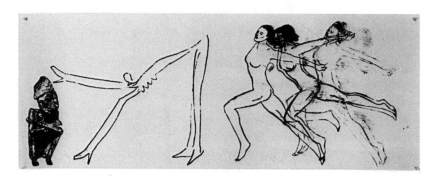

Fig. 21. *Sky Goddess and Fleeing Figure* 1988. Nancy Spero.
Handprinting and printed collage on paper. 20" x 54".

Chapter 6

Nancy Spero and Woman in Performance

Judy Purdom

Woman in process, never fixed or stable identity, woman as a continuous presence, woman in motion—gesture and movement being the earliest forms of human communication—woman warrior, woman victim. (Spero 1988, 105)

Spero's Exhibitions: Undoing the Identity of Representation

Nancy Spero's work celebrates women, but as her parades of figures leap and dance, fly and tumble she breaks away from the beaten path and reworks the aesthetic in order to undo the conventions of representation. Each new exhibition or installation—exhibitions with evocative titles like *Let the Priests Tremble* ...1998, *To Soar* 1991 and *Vulture Goddess* 1991— finds another configuration of eclectic images as they are assembled, connected and articulated to form new lines of association. Each show works a different topology and a new construction. Each show is a new composition of woman. There is a vast cast of characters: victim, whore and goddess; Artemis, African dancer and Sheela-na-Gig; clichés and archetypes; found figures and mythological ones; historical and commercial images. Women stream along paper scrolls and across the walls. Acrobats swing alongside a running Gorgon; dildo dancers jostle with a fertility symbol; Egyptian musicians parade towards a suited character from the 1930s; a Dionysian dancer leaps towards a posturing teenager Spero uses her portfolio of images of women to create rhythmic friezes of figures; laughing, dancing, fleeing and parading women.

Spero adopts two different media: either long paper sheets are pasted together end to end into long narrow scrolls, as in what is perhaps her most well known work *The First Language* 1979–81 and in *Black and Red III* 1994, a work most recently seen at the Ikon Gallery in Birmingham, England (21 March–24 May 1998); or the images are printed directly onto

the walls, ceilings and architraves of the gallery or exhibition site, as in *Wall in Bogside, Derry* 1990 and in *Let the Priest Tremble* ... 1998, an installation made for the inaugural exhibition at the Ikon Gallery last year. The first approach obviously has a permanency that the last does not but both paper and wall work are really temporary installations because the structure of the work shifts and changes so that even the paper works are presented differently at each showing. For instance, the installation of *The First Language* depends on the architecture of each gallery, and the scrolls of *Black and Red* are shown either as a frieze or a block; hence *Black and Red* 1983, *Black and Red II* 1985, and *Black and Red III* 1994. Each version is complete but each is a new performance with a new title and date.

Spero's appropriation of images can easily be read as an exploration of the myriad and conflicting representations of women and as a chronicle of the multiple role of woman as the malleable other—virgin and whore, goddess and demon. However, her interest in the French feminists of the 1970s and 1980s gives that eclecticism a philosophical inflection and points to the more radical quest for a specific identity for women. In her article of 1987 'Nancy Spero, Images of Women and *la peinture féminine*' Lisa Tickner draws a parallel between the *écriture feminine* of Hélène Cixous, with its notion of a feminine writing that would free women from a language with a masculine bias, and Spero's work. I would add that her myriad yet repetitive images also have an immediate resonance with Luce Irigaray's method of *parler-femme* where the emphasis is on mimesis and repetition—'to play with mimesis' and 'to make "visible" by an effect of playful repetition' (Irigaray 1985, 76).[1]

Like Cixous and Irigaray, Spero recognises both that women do not have a distinctive voice, and that their identity is unstable, but she does not stop with what she calls 'the castration of women's tongues':

> ... in reading the French feminists, I decided that this tongue business that I had used had something to do with language and castration, the castration of women's tongues, their language ... I still use the tongue but it's more blithe: it's a running woman, she's sticking her tongue out at the world, but she's blithefully running by.
>
> (Spero 1987, interview with Lisa Tickner)

Spero looks to gesture and movement in order to experiment with an alternative language for women. She looks to the power of the body, performance and dance; indeed the inspiration for the title and dancing

figures in *The First Language* 1979–81 came from a book on pre-historic art and the phrase '*Peut-être la première langue—c'est la danse*' [perhaps the first language is dance] (Harris 1994, 30). It is a language in which woman is indifferent to the determined identities of representation bestowed on her: 'she's sticking her tongue out at the world, but she's blithefully running by.' This move to the body and movement has radical implications for the notion of aesthetics as a theory of sensation because it goes beyond a concern with what can be represented to experiment with the power of the concrete text or image, to ask what the image can do, not what it signifies.

In an interesting double articulation, Spero's pieces work at two levels. She uses real and important images of women borrowed from documentary photography, as well as from more popular sources and from history and myth, but those images are dislocated and problematised in the structure of the work where the images are played off against one another to create a theatre where meaning and identity is thrown into chaos. Woman is warrior, angel; *Sky Goddess, Egyptian Acrobat* ... (Fig. 19), but this is not necessarily to propose an infinity of representations of Woman (Spero 1988). Rather it affirms woman without the coherence of identity, as unlimited. The very profusion and diversity of images in Spero's work is itself perplexing, and it is that very perplexity that is the work's strength, so while I want to be careful not to diminish the acuity with which Spero selects her figures, particularly the difficult and sensitive documentary material which she uses, it is clear that the power of the work arises from its complex structure rather than from the individual images.[2]

In the whirl of conflicting figures that Spero creates, no single 'image of Woman' is possible; they are comic, tragic, erotic and rude; degraded, glorified and shamed; flaunting, mocking, cowering At the micro level Spero gives us a fascinating and delightful parade of individual women, but while individual images are often repeated they are always varied, appearing at different angles, in different colours, defaced or deformed, and in juxtaposition with different images. At the macro level what becomes important are the patterns and rhythms built up by the tensions between the figures as they are repeated and overprinted, lined up, crowded or isolated. As they leap along walls and across panels the figures form heterogeneous series, where each series tells a different and divergent story but where each of those stories exists simultaneously and has an independent validity. The

dynamic and indefinite composition of the work clearly situates it as experimental and experiential rather than representational. Further more, many installations are impermanent because they are painted directly on to gallery walls and, like *Let the Priests Tremble* ...1998 which uses the lofty roof space of the Ikon Gallery, tailored to the architecture of the building. There is therefore no given art object but only a chaotic, vertiginous movement of dancing figures. Furthermore, in order to see the work, the viewer must compound Spero's already complex construction by actively selecting and connecting the fragments of the work, experimenting with different intersections and new compositions, and even creating the space of the work as it unfolds. With figures dispersed along the scroll or around the gallery there can be no completion to the work and no point of view: there is no beginning and no end, start where you like and finish where you like. The permutations are infinite. The figures are in performance and the work is continuous. Far from being a multiple representation, which would presume the possibility of convergence on a definitive story, here there is a burgeoning complication of internal relations and the image of woman remains unformed. The logic of the narrative collapses because, like the cinematic montage, the images are not linked by rational cuts but by more inventive linkages; interruptions, gaps, flashbacks, metamorphosis; 'irrational' cuts which disallow any totalising integration of the work and which set up the work only as a system of relationships.[3] The bewildering and defiant incoherence of the work confuses and denies representation. It is not a case of what can be represented in the work of art, but of what can be sensed. The resonance of the material configuration produces and affirms a power that does not work at the level of thoughtful recognition but as an encounter. Rhythm takes over from narrative and performance from meaning. Sensation takes over from representation. Women, it seems, just will not be stilled.

The Limit Case of Sensibility

With her profusion of images, and her turn to dance, rhythm and movement Spero refuses any fixed notion of Woman, and despite her utilisation of mythological, historical and political images her work is not illustrative or descriptive. In fact, I argue that by working through rhythm and movement Spero mobilizes the image and, by keeping signification in abeyance, moves beyond any generalised notion of Woman as a lived experience to show Woman in flight from formalisation, as always incomplete and always becoming. As such Spero develops an aesthetic that works through concrete and yet variable images to create Woman as a composition that

exists only in performance. Here the work itself is undoing the conventions and habits of the representation: victims run, whores dance, weeping women crawl away ... and Woman breaks through the stasis of signification and representation, to remain always becoming.

Spero's move to the work of art as performance is a radicalization of aesthetics that has a strong resonance and affinity with philosopher Gilles Deleuze's project of 'thought without image'; that is, to think beyond the structural restrictions of the pre-formed, the mediated and the representational—a structure of thought that is governed by the hierarchical and patriarchal oppositional system that denigrates Woman (Deleuze 1994, 276).[4] As his writing on art demonstrates—Part Two of *What is Philosophy?* (1994) and *Francis Bacon: Logique de la sensation* (1981) being the most sustained discussion on the work of art—Deleuze himself insists on the power of art in breaking through representational norms and his work is seeped in references to painters, musicians and writers. Indeed Deleuze recognises that philosophy can take many forms, a sentiment reiterated most succinctly by Brian Massumi in his foreword to *A Thousand Plateaus* (1988) where he notes that one of the aims of that book is to demonstrate the eclecticism of the philosophical task: 'Filmmakers and painters are philosophical thinkers to the extent that they explore the potentials of their respective mediums and break away from the beaten paths' (Deleuze and Guattari 1988, xiii).

I want now therefore to turn to Deleuze in order to explore what is at stake in this radicalisation of the aesthetic and in Spero's consequent disruption of the order of Woman. One short quote from *Difference and Repetition* (1994) will serve to support my interest in Deleuze here. Talking about the importance of Kierkegaard and Nietzsche in bringing new means of expression to philosophy he writes: '... it is a question of making movement itself a work, without interposition; of substituting direct signs for mediate representations; of inventing vibrations, rotations, whirlings, gravitations, dances or leaps which directly touch the mind' (Deleuze 1994, 8). Spero immediately springs to mind as an artist who works within a parallel aesthetic.

In *Difference and Repetition* Deleuze gives particular attention to the work of art as experimentation, finding in modern art an abandonment of representation that resonates with the task of philosophy. What Deleuze

identifies, and what I see in Spero's work, is precisely that aesthetic which defies representation in order to function as a 'science of the sensible', by which he means, it is work which functions at the level of that which can only be sensed. Deleuze's interest here is in literary procedure, and the 'unformed chaos' of Joyce's *Finnegans Wake* in particular, but we can see the same chaotic constitution—internal resonance, permutating series, decentring of circles, abundant movement—in Spero's series of women as in Joyce's use of words. Each artist plays with the components of the work—words or images—to create displays that, at the structural level, defy the exterior or transcendental totalising identity crucial to meaning and representation and instead favour expression. Here it is the work of art itself that is productive because the power of the work arises from the complication of the internal configuration and its effect is generated in the rhythm and movement of that composition. As such, Spero's pieces, with their repetitions, multiple layers, and unexpected combinations, break through the representational coherence of individual images and work only as performances that, in the dance of pattern and rhythm, impact at the level of sensation, and it is this move to sensation that links Spero's aesthetic to Deleuze radical understanding of the work of art as a being of sensation.

In a critique of the Kantian model, Deleuze finds it strange that traditional aesthetics could be founded on what can be represented in the sensible (sensible being) when, if it is to be a science of the sensible, it can only truly be demonstrated in that which can only be sensed (the being *of* the sensible) (Deleuze 1994, 56). Deleuze questions the association of aesthetics with representation and reworks the aesthetic as a theory of sensation that refers to that which can only be sensed. 'The work of art', he says, 'leaves the domain of representation in order to become 'experience', transcendental empiricism or science of the sensible' (ibid). Instead of aesthetics being concerned with what can be represented in the sensible, aesthetics is demonstrated 'when we apprehend directly in the sensible that which can only be sensed' (ibid). That sensation is a real experience that is produced in the internal movement of the modern work of art. It is affirmed at the level of the empirical without recourse to any exterior conditions that would constrain the real within the parameters of possible experience. The interest in the work of art then moves from what it is representing, to what is actually happening in the work and to what it is doing. What becomes important are the principles of composition and the structure of the work of art as the condition of sensation.

Deleuze argues that the move to a transcendental empiricism, or as he otherwise calls it, after Schelling, 'superior empiricism', brings together the

'wrenching duality' of the Kantian aesthetic which, on the one hand, is concerned with the theory of sensibility as the form of possible experience, and which therefore captures the real only so far as it is in conformity with possible experience; and on the other hand, designates the theory of the beautiful as a conditioned, thoughtful reflection on real experience. What Deleuze identifies in the work of modern art is the limit of sensibility. His interest here complements feminist thinking because it is in conditions of real experience and not with the form of identity or with representation, and because he does not recognise any transcendental conditions of understanding 'larger' than the conditioned. The only conditions of experience are the genetic or immanent conditions of real experience. In the case of the work of art, the only conditions or principles of sensation (the experience of the work) are the genetic principles of composition. In short, it is the structure of the work that is productive of experience, and the only conformity of the real is to the practices of that composition. There is no recourse to representation. This radical aesthetic therefore reunites the possible and the real because, rather than denoting a reflection on the real, it is demonstrated precisely in the empirical as that which can only be sensed or apprehended. The conditions of that empirical are the principles of its material composition; thus Deleuze makes the transcendental project an issue of immanence.

Without transcendental conditions, the work of art appears as experimentation; while at the same time the sensible is revealed in the movement immanent to that unformed performance (Deleuze 1994, 68). Deleuze's insistence on this 'superior empiricism' and its chaotic movement takes aesthetics beyond the form of identity (and therefore beyond the model of recognition and the criteria of sameness and difference), and the domain of representation. It is, as Deleuze puts it, 'a complicated, properly chaotic world *without identity*' (57).

Whilst this move seems to be resolutely anti-Kantian, both because of its adherence to the radical materialism of the sensible and because of its refusal of a separation between possible and real experience, it is not entirely because there is already the suggestion of a 'chaotic world without identity' in Deleuze's reading of Kant's sublime. In the section the 'Analytic of the Sublime' in Kant's *Critique of the Faculty of Judgement* the imagination is forced to confront its limit and, because there is no harmony of the faculties, the boundlesness of the ocean, or the violence of

the volcano, are sensations which are apprehended 'in mere intuition (by the eye)' *but not understood as an object* (Kant 1973, #26). As Deleuze understands it, the immensity and power of nature is encountered but not recognised; it can only be sensed and therefore cannot be understood as a sensible being but presents as 'the very being *of* the sensible' (Deleuze 1994, 57). What we have here then is a glimpse beyond the representational.

For Kant, the failure of the imagination to bring apprehension within an estimable unity, or to make a coherent sensible being, elevates the imagination to present those cases where the mind confronts its own limit. It then produces the admiration and respect that Kant sees as the negative pleasure of the sublime—the satisfaction in the extension of the imagination by itself. Nature is therefore not judged sublime because it is great or because it excites fear, but because it confirms the power of the human mind which remains true to its fundamental principles even when faced with Nature's might. The Kantian sublime brings us to the very limit of representational thought, but while Kant steps back from that precipice to reassert the centrality of the human and of rational judgement, Deleuze finds in the sublime the opening for his transcendental empiricism. What is it, he asks, that prompts the judgement of a thing to be sublime? He concludes that, what is presented to the mind is the very fact that there is a limit to sensibility, and that which it is not adequate to nevertheless exists. It exists in sensible nature—in the lightening flash and the lofty waterfall.... The sublime 'being of the sensible' is not therefore the unrepresentable or unpresentable, but the limit case of sensibility.[5] As there is no common human representational standard adequate to a judgement of the sublime, it has no status as an object or thing. It makes no sense to ask the question of identity and recognition, 'What is it?'. We are returned to what can only be sensed, to the composition of the 'thing' itself and the question of how it works. How does the work of art make sensation visible?

Spero and Experimental Aesthetics

How do Spero's pieces work? Clearly as I have said there is no art object as such: the dynamic composition shoots across walls, down staircases and over ceilings; it is chaotic and fragmental, but this is an incompletion that has never been a single whole. It is the relationships between the figures that is important, not its illusive coherence. Recognition is kept at bay by the perpetual movement and the unformed chaos intrinsic to the structure of the work, a structure that works more like a musical composition than a

representation. Its rhythmic power evolves from the patterns of figures or 'notes', as in musical composition, but the power of the piece arises only when its rhythmic cadences are followed. It is therefore the composition and the intense differential relation of its components that produces its effect. There are no exterior conditions. The conditions of sensation are at the same time the principles of the composition. What are productive are the techniques of composition and what happens on the canvas to make a synthesis of disparate notes or elements. Inevitably then each piece is singular production with its own peculiar material and composition.

What we see here are very specific images of women working at the level of the differential and producing effects that take them beyond their representational or symbolic reality. Far from diminishing Spero's important use of documentary photographs of individual women victims, this is to emphasise the seriousness of, for example, her work of the 1970s such as *Torture in Chile* (1974) and *Torture of Women* (1974–76) in which she uses reports by Amnesty International; or her more recent engagement with the abuse of Jewish women under Nazism, *Ballad of Marie Sanders, The Jew's Whore* (1990) (Fig. 20) which uses Brecht's poem; or *Masha Bruskina* (1993) (Fig. 21) where text from a *New York Times* article is interspersed with photographs and mythical figures and lots of white space.

What becomes clear is that, far from denigrating the political and personal importance of sensitive material, setting them against other images whose relation to the real is less direct gives them a force that disrupts and goes beyond the often glib and predictable generalisation of women's representation as 'object'. Even in this work which engages with specific political issues and situations, the assessment - point of view, opinion and cliché - of women as victim or whore is resisted and the work finds a political force precisely in the resistance to such representations that the play of the heterogeneous series affords. Spero's work does not converge neatly into narrative form. The story is told but always disrupted by the topology of the composition—by the connections and disconnections, conjunctions and disjunctions, transformations and manipulations that Spero makes at the level of the composition. Transformed by these novel and irrational intersections, the power of the figures goes beyond their subject positions to interrogate the status of the fictive and to assemble a new type of reality.

The connections, tensions and resonance that are built up within the work as new complications evolve and have an unsettling power which distorts and decentres the significance of component images precisely because the viewer cannot make sense of its tangled lines and variant movement. While audiences may admire individual motifs, it is their differential relation that is of fundamental interest because it produces an effect or sign quite beyond the distinct representational figure. This effect remains immanent to the complex unformed chaos of the composition and points to an aesthetics which cannot be contained within what can be represented in the sensible but which we apprehend directly as the effect of differential relations.

Differential Relations: Repetition and the Documentary Image

Using Leibniz, Deleuze explains the differential relation through the example of the noise of the sea, the murmur of a crowd, and of colour. Just as the hubbub of the crowd is produced by the discordant relations of individual voices, so green is actualised when yellow and blue enter into a differential relation; and like the murmur which exceeds its elemental voices, green is seen only when yellow and blue become indiscernible. Green is therefore a difference engendered as a mixture or variation which remains coexistent with yellow and blue (and their own constituent colours and relations). Correspondingly, white would integrate the genetic elements and differentials of all the colours.

While it would be false to suggest that particular figures used by Spero might become indiscernible (as constituent colours do), applying this theory of the differential to Spero's work enables us to see how the mixture of figures works, keeping the component figures in play but producing an effect that goes beyond their generalised significance. Each figure is a genetic element in a differential relation, and what is productive is the varying kinds of differences between those figures. The total effect presents woman, not as a generic concept abstracted from or summing up a plurality of images, but as a variation which embraces women's diversity and that implicates real experiences and real struggles. The power of the work is a direct effect of its internal complication, a complication in which documentary photographs play a key part. These images often entail a problematic representation of women; it is profoundly unsettling to insert documentary images of the suffering of actual women into new and challenging contexts. Spero acknowledges this, keeping that difficulty in play by making new and often unexpected connections which put the images in original differential relations and which disrupt and transform the

representational in order to affirm a quasi-synthesis of woman in continuous variation.

One way that Spero effectively deforms representation is through her use of repetition where as each figures is repeated it is at the same time altered. In *Difference and Repetition* Deleuze contrasts the notion of repetition as duplication of the same with 'repetition in itself'. This he defines as 'the formless power of the ground which carries every object to that extreme 'form' in which its representation comes undone' (Deleuze 1994, 57). Reading Spero after Deleuze, we can see how her use of repetition works to undo representation by undermining the sameness that repetition as proliferation demands. Far from multiplying a standard representation, there is no original model in Spero's parade of women.

Printing, stamping or collage; printing, overprinting and reprinting; Spero transfers figures, taken from her huge archive, onto the white or beige blank and indefined space of the paper or wall. There is repetition but never duplication. Though from the point of view of recognition the same images recur over and over again, they are always disguised; colours and tonal values change, some figures are faint, some bold, there is fragmentation and cropping, warm tones and bright colours. Rhythms build up as figures are repeated, as they darken and fade, and as the scale changes. Figures are selected, manipulated and transformed. Always the same, always different. There is always, as Spero herself explains, 'a carnival of frenzied, dancing figures', always movement, always transformation (Spero quoted in Harris 1994, 14).[6] The repetition of figures is crucial to the build up of rhythm in the work and, at the same time, displaces and disguises the fixed representation. This is the movement of the process(ion) not progression or proliferation. Repetition as displacement is not only characteristic of the composition of each work but also to the changing re-presentation of pieces when they are reworked at new venues.

This echoes the changes in time and place in Spero's compositional montage, where the action moves from the real to the mythological, from the ancient to the modern, from Egypt to Japan making inexplicable combinations, as if each scene were being played out at once, contradicting, adding to, obliterating and complicating each other. In a further twist to the complex intersections of the composition, the work extends up the walls and over the ceiling, around corners, and up stairs and confounds the

formal distinctions between canvas and frame, work and exhibition space, image and structure. As the figures work their delirious dance, architectural connections between wall, window, rafter and ceiling are reworked in defiance of the conventional space of the gallery, and a new space is constructed, one peculiar to each show, even to each viewer. The work, the gallery and the viewer are all connected. Look up, to the left, to the right, bend down, peer, walk on, double back. Move with the rhythm of the images, travel to Africa and Greece, journey through your memories and dreams. In Spero's shows, the viewer has to keep moving, with the result that there is no unitary image, but the 'whole' is a non-accumulated assemblage rather like white noise where each sound or figure is distinct but where the work is a cacophonous uproar, and where the synthesis, such as it is, is made by the viewer who is drawn into the network of intersections. Indeed, Spero makes a mockery of the conventional distance between work, gallery and viewer. All are interconnected, but all relations are ephemeral. Viewers go home, gallery walls are whitewashed and scrolls rolled up. No trace remains but in memory and discourse, the name and date in the gallery calender and records recalls not only the materiality of the work, but her refusal to fetishise it.[7]

Instead of the identity that demands sameness, a picture of woman emerges as a product of the disparity between figures and in the peculiar inclusion that is made between resonating series. The model of identity here is one that emerges 'bottom up' from a material configuration characterised by difference rather than sameness; one that is in accord with Deleuze's maxim that 'only differences can resemble each other' rather than the formula 'only that which resembles differs' (Deleuze 1990, 260). Whilst the latter formula allows only the difference that refers to a previous resemblance or identity, 'only differences can resemble each other' makes identity a product of internal difference and the differential relation.[8] In a system where the conditions of production are internal to that system, and that we see in the complication of Spero's parades of women, the production of an 'identity' comes, not from recognition that defers to conditions outside the system but from the resemblances that emerge in the patterning within the work; resemblances that challenge and undo the representational references that haunt the work at the micro level.

In blithefully running by, Spero's figures parade in abstract lines and make irrational intersections that work against the 'laws' of representation. Their frenzied dance dissolves meaning in the movement of dislocation—decentring and diverging, displacing and disguising—and the conditions of real experience are opened to experimentation. The power of the work

comes not from the image being a carrier of meaning or an object of represented reality but from the function of the image as a vehicle of real experience. As such, it is not only a plane of dislocation which upsets or confuses representational norms but is a performance which undoes that convention in order to stand up on its own as a monument to the sensible. It is not a question of reflecting on the work but of going with the movement of the images and developing a thinking that resonates with that performance. In Spero's work, art is experimentation and, if philosophy is to work alongside art, philosophy must find that same indefinition and break through the strictures of representation.[9] The challenge is for thought to be as experimental, inventive and as pragmatic as art, and that it engage, not with meaning, but with the work of images. This is the task of a radical aesthetics.

Notes

1 Cixous calls for an *écriture feminine* in 'The Laugh of the Medusa'; Irigaray advocates speaking (as) woman [*parler-femme*] in *This Sex which is not One* (Marks and de Courtivron (eds) 1980, 245; Irigaray 1977, 222). For a discussion of the concept *peinture féminine* see Bird 1998, 79–80.

2 The work that engages with the treatment of Jewish women under Nazism, such as *Masha Bruskina* 1993 (Fig. 21) and *The Ballad of Marie Sanders* 1993 (Fig. 20), exemplifies the political sensitivity of Spero's material. The *War Series* in which images of women who have been ravaged, raped and tortured are employed is another such work; *Christ and the Bomb* 1967 for instance includes images of women disfigured by nuclear fallout and images of disintegrating bodies.

3 In *Cinema 2* (1989) Deleuze discusses the importance of the irrational cut as a disruption of narrative and of linear time, and argues that the image as a system of relationships—the "image itself"—must not be confused with what it represents. He references Antonioni, Ozu, Godard and Robbe-Grillet, among others, as masters of a new practice of images that constructs its own 'objects'. Susan Harris and indeed Spero herself, draw an analogy between painting and film; Spero draws attention to how the various scales of the images work like the zooming in and out of a camera; and Harris makes two observations, firstly that following the scrolls is like watching a play unfold, and secondly that viewing the work is an active experience (Harris 1994, 13/37). Spero's point supports that Deleuzean analysis of dislocation above, but I would, of course, dispute Harris' inference that there is a story to be discovered in Spero's scrolls, however her emphasis on the viewers involvement is interesting.

4 For Deleuze's theory of the aesthetic, see: Deleuze 1990, 260, and Deleuze

1994, 56–7 and 68–9. See also: Smith, Daniel W, 'Deleuze's Theory of Sensation: Overcoming the Kantian Duality' in Patton 1996.

5　In an important footnote to his own explanatory article on Deleuze's theory of sensation, Daniel Smith points up the difference between theories of art developed by Deleuze and Lyotard. Briefly Lyotard works from an analysis of the imagination and the sublime and develops a conception of postmodern art which presents the unpresentable; Deleuze works from an analysis of sensibility and its limits to theorise modern art as an art of pure sensation. While Lyotard remains caught in the idea of a transcendental imagination, Deleuze's work is radically materialist and explores the immanent configuration of the sensible. See: Patton 1996, 51.

6　See: Susan Harris' essay 'Dancing in Space' in the catalogue for Nancy Spero's exhibition of 1994 at Malmö Konsthall, Sweden. Talking about Spero's vision of the empowered woman she argues that: "The poetic choreography of expressive movement, gesture and space was more than enough to assert the body as carrier of meaning" (Harris 1994, 30).

7　The completion and coherence of representation eludes such installations. Such repetition accords to Deleuze's description of the repetition as "completed and unlimited" (Deleuze 1994, 57).

8　In *Difference and Repetition* Deleuze characterises the work of 'difference in itself' (briefly, the difference that is produced by the differential relation) as divergence and decentring, and the power of 'repetition for itself' as displacement and disguise. See: the Conclusion to *Difference and Repetition* a summary of the work of difference and repetition in undoing representation (Deleuze 1994, 288, 292).

9　In an interview with Herve Guibert in *Le Monde*, 6 October 1983, Deleuze comments that: "It is not a question of reflecting on the cinema, it is normal that philosophy produces concepts that are in resonance with the pictorial images of today or with cinematographic images etc." (Deleuze 1986, xi). Editors Penny Florence and Nicola Foster take up this point about the intersection of philosophy and art in their introduction to this volume.

And There Shall be (Polyvalent) Beyond

Penny Florence and Nicola Foster

Introduction

Subjectivity remains central to considerations of the aesthetic in most essays in this section, and so does the issue of ethics. However, ethics is understood – following Levinas' articulation of ethics and most famously developed by Irigaray - as the ethics of sexual difference. Unlike the previous Sections, this one introduces essays whose central philosophical reference point is the work of female philosophers, or essays which seek to establish female perspectives which make less reference to traditional male philosophers (though not necessarily to males as such). Some writers, including Barb Bolt, Marsha Meskimmon and Bracha Lichtenberg Ettinger are to some degree exploring philosophical issues in relation to their own artistic practices, which they then employ to further develop their own practice and theory. Their philosophical reference point is thus not purely textual (philosophical and visual), but involves their own bodily practice, which extends to the materials, personal and physical experiences and even the climate in which they work.

Before referring in turn to the essays in this section, it is necessary to take a little time to set out the context of the first of them, by Bracha Lichtenberg Ettinger, who is an artist, psychoanalyst and art theorist. The challenging way her approach, including the texture of her writing, derives from combined practices and theories in differing arenas of psychoanalysis and art is of particular interest in the context of this book. Lichtenberg Ettinger's project requires some contextualisation in relation to Luce Irigaray's, since it differs from it in important respects, and since the latter's work is referred to explicitly or implicitly by most essays in this collection.

There is by now considerable - and well established[1] - feminist scholarship on Hegel's account of Antigone,[2] as well as on Lacan's readings of Hegel's

account. The best known is in the work of Irigaray. In 'Transgressing with-in-to the Feminine' in this volume, Lichtenberg Ettinger offers an independent interpretation of Lacan's account of the aesthetic in his interpretation of Antigone and Tiresias. Lichtenberg Ettinger's work is still relatively little known in Britain and the USA, although she has a powerful advocate in Griselda Pollock. However, she has developed a body of artistic and theoretical works in which she offers a positive development of Lacan's account of (male) subjectivity. One reason that psychoanalytic theory has been of interest to feminists since its early days is that it offers an account of subjectivity which is always already sexed.[3] However, the psychoanalytic theories of Freud, and Lacan's 'return' to them, have also been the central point of criticism for their refusal to allow for positive female forms of identification. Irigaray and her readers have been prominent in this.

While most (though not all) feminist scholarship that utilises psychoanalytic theory today is critical of Lacan, Lichtenberg Ettinger suggests that his work can indeed be read as productive for women. In contrast to Irigaray, she reads in the later Lacan an account that would allow for the emergence of a possible psychic space of traces which is heterogeneous and relational. She calls this 'hybrid feminine instances "between centre and absence"' the matrixial sphere. She suggests that in this matrixial 'space' relations of 'rapport' are 'poietic' (sic) processes that carry aesthetic knowing. This process she calls metramorphosis. Metramorphosis, she says, 'is both action, perception, inscription and memory of borderlinking and of distancing-in-joining'. The matrixial sphere, or 'space', allows for 'partial-subjects and partial-objects' as well as their linkage. Like several other authors in this collection, Lichtenberg Ettinger is interested in the possibility of a subjectivity which is not stable and fixed. Her artistic work explores the potentiality of gaps, for example in her series *Means of Transport: Family Album* (1986). A more recent artistic exploration into a space of subjectivity which is neither stable nor fixed and which can call for affective relations can be seen in her *Woman-Other-Thing no.11* (1990-1993, (Fig. 22), *Mamalangue no.1* (1992, Fig. 9) – for both works, the interaction between text and image is central – and in her *Eurydice no.16* (1994-1996, Fig. 23).

In France, there has been considerable feminist scholarly interest in Tiresias,[4] the mythical male figure who experienced being transformed into female for seven years. This is not so in Anglophone feminism.[5] Moreover, while there is a developed feminist scholarship on Hegel's reading of Antigone, as well as Lacan's and Irigaray's, the focus of this feminist

scholarship[6] is very different from the focus of Lichtenberg Ettinger's. Lichtenberg Ettinger is interested in Lacan's discussion of Antigone and its relationship to his discussion of Tiresias primarily because in this discussion she says:

> Lacan re-animates a mythological relation that traverses cultures and centuries - the relation of death to the feminine - and locates the aesthetic effect of 'the passage to the second death' in the domain of the feminine as the beautiful ... both 'woman' and death are bearing witness to, that which is 'impossible'.

For Lichtenberg Ettinger, Lacan's account is not very different from her own articulation of the matrixial sphere. Hence, she goes on to argue that 'it is in the domain of the aesthetic that the frontier that separates the human being from death converges with the frontier that separates the human being from the feminine'. Moreover, in Lacan's discussion she sees both Tiresias and Antigone as figures that 'represent transgressing with-in-to the feminine', and this transgression is tragic. Since it can only 'bear fading-out and fragmentations', it is tragic because it is an impossible rapport.

Lichtenberg Ettinger's artistic work and her theoretical work should not be seen as two separate projects, but as two aspects of the same. Moreover, her interest in mythical and tragic personae that can be described as 'in-between' borderline figures, or figures 'between two deaths', have also informed one of her series of artistic works: the Eurydice series. According to Ovid, Orpheus' wife Eurydice died from a serpent's bite to her ankle She was called back from the dead on condition that Orpheus did not look at her till they reached the surface of the earth. But Orpheus the artist lover did look at his beloved, and Eurydice 'slipped back into the depths [...] dying a second time' Ovid, 1955, 225-6).[7]

In conversation with Emmanuel Levinas – whose articulation of ethics is central to her work – Lichtenberg Ettinger says the following:

> The fragility of Eurydice between two deaths, before, but also after the disappearance [...] the figure of Eurydice seems to me to be emblematic of my generation and seems to offer a possibility for thinking about art. Eurydice awakens a space of re-diffusion for the traumas which are not reabsorbed. The gaze of Eurydice starting from the trauma and within the trauma opens up, differently to the gaze of Orpheus, a space for art and it incarnates a figure of the artist in the feminine. (Lichtenberg Ettinger and Levinas 1997a, 30)

Lichtenberg Ettinger's evocations of Eurydice are enigmatic and behind a veil. They are images which invite a re-assessment of our understanding of the role of visual (and affective) space in art. Her images invite us to re-think our position as viewers and the space offered by the image, visually, but also as an affective and relational space in which the artist and viewers can participate. Lichtenberg Ettinger's work has several layers in different media from photograph fragments to photocopied fragments, fragments of texts as well as actual bright coloured paint. These multiple layered works give the work a texture and a textuality, but also intertextuality, since her work always alludes to other works and other ghostly spaces, while providing a meeting space for affective vision, a vision which is also a touch.[8]

A different approach to art, which also utilises psychoanalytic theory, can be seen in Hilary Robinson's essay 'The Morphology of the Mucous: Irigarayan Possibilities in the Material Practices of Art'. And yet, while Robinson's approach is very different, there is considerable similarity between Lichtenberg Ettinger's articulation of the aesthetic and Robinson's. For both of them, the aesthetic is a relational space, which allows for interchange and development.

Robinson focuses on Irigaray's articulation of morphology. She argues that morphology for Irigaray, is 'the site where [...] a spacing between body and signification, can be an instance of *différance* at work (play): both as a producer of gendered subjectivity [...which is] between body and language, between empiricism and text, preceding any distinction between the two, and as productive of structure and transformation in that relationship'. Robinson then goes on to adopt Irigaray's utilisation of the metaphor of 'mucus'. Robinson is interested in this articulation both because it ties the discussion to the physical body and the female body more specifically, and because it operates to counteract the solidity through which subject and object are understood within the philosophical tradition. Robinson applies Irigaray's articulation of the morphology of the mucus towards an interpretation of the aesthetic space as transformative. Her focus is on painting, and she seeks 'to understand the processes of painting as one site of mediation within the morph-logic of the mucus'.

In her essay 'The Gendering of Allegory: Mary Kelly's *Post-Partum Document* and Benjamin's Melancholy Dialectics', Christine Conley argues that 'the procedures Mary Kelly devises to articulate the mother's loss in patriarchal culture and to effectively deconstruct the mythic status of

the maternal feminine are allegorical procedures'. Moreover, she argues, 'allegory – which has been recuperated for contemporary art criticism by the revived interest in the work of Walter Benjamin - is of particular significance for feminist aesthetics' (See Figs. 25-6).

Film rather than painting is the focus of the next essay in this section. Catherine Constable examines where feminist thinking both relates to and diverges from the postmodern by demonstrating the potential of Judith Butler's work to elucidate a differential account of power relations rather than acceding to postmodern nihilism in the face of the annihilation of power and meaning, as typically found in Baudrillard and his advocates. The transgressive power of the parodic is examined in relation to the film *To Die For*, presenting an argument for affirmative re-readings through the text's use of hyperbolic mimicry and citation.

Sean Cubitt's essay 'Cybertime' also revisits film history in a particular sense, working through it to make some wide ranging and illuminating connections. He writes at a pace that embodies his thesis: that the digital revolution has changed and differentially accelerated the nature of time, thus requiring that the 20th Century be viewed through it as another layer of a palimpsest. On the basis that there is 'no such thing as instantaneous communication' (or as he also puts it, 'All mediation takes time') Cubitt probes the 'ontological turn' of the 1990s. Reviewing the new time/s proper to the digital, he leads the reader through an invigorating network of relationalities, including those involved in the computer crash, 'real time' cinematic and experiential, QuickTime and the loss of the 'full zero' – all involving possibilities for differential aesthetics, or in his terms, aesthetics that can embrace undecideability. Postcoloniality, feminism and the ecological movement are all cited with the digital as 'ecological models' that 'point towards an aesthetic of mutation and evolution'.

The remaining three essays almost constitute a sub-section of their own in that they all place the material at the centre of their various inquiries into art as both practice and theory, and in that they examine paint and paintings as *matter*. They are also all to an extent reflexive, since they examine their own work as cultural practice. As a group, they afford an international perspective, since Betterton is British, Meskimmon is American, but working in the UK, and Bolt is Australian.

Rosemary Betterton's essay positions itself in relation to art history as a discipline, re-evaluating the writer's own (considerable) contribution to the debates. She argues the continuing relevance to feminism of painting as a

'set of practices', especially in rethinking embodiment. This applies in general terms, but it is particularly as 'an analysis of the relations between embodiment in painting and my position as an embodied viewer' that Betterton elaborates her argument. After a brief examination of Hesse's piece *Hang Up* and its reception, Betterton moves surely and swiftly through modernist abstraction to focus on two pre-modernist works, the first from the later Renaissance and the second from the early seventeenth century: Titian's *Diana and Acteon* (1559, Fig. 29) and Poussin's *Rinaldo and Armida* (c.1628, Fig. 30). The re-embodiment of the eye through which she makes her readings produces not only fascinating interpretations, but also a critique of the notion of 'pure visuality' on which so much art history has relied. Concluding with Susan Hiller, Betterton draws her argument together as an 'aesthetic of abstract painting which differs from the modernist claim of "no before and no after"'. In this we are never allowed to lose sight of the intersubjective relations embodied in the encounter between the work and the sexed spectator.

Marsha Meskimmon examines the epistemological implications of understanding matter as a process, exploring in her own work in practice-related theory how corporeal theory impacts on the implied subjectivities at play in aesthetics. Her use of the 'micro-history' provides necessary specificity and locatedness, inserting enactment and dialogue into critique, while her probing of matter and pattern as gendered offers ways beyond the logic of sameness in which aesthetic understandings easily become mired. Meskimmon's work recalls some of the collective practices with which feminists have engaged since the 1970s, significantly extending such work and implicitly resituating it by placing her thought-practices not only within the exhibition space (in a manner in some ways analogous with Mary Kelly in particular) but also within current theorisations of the body. Her examination of 'the matter with words' provides new insights into the 'processes of aesthetics between word/theory and image/object' which is a valuable contribution to the current debate in the U.K. about 'art practice as research'.

As we pointed out in the general introduction, Barb Bolt uses both her own and Indigenous Australian practices in painting to interrogate the dominant Western assumption, that representation is always mediated (Fig. 35 and Plate 8). Her essay conveys a strong sense of the processes of making in her work, through it revising underlying conceptualisations of matter as inert. The art practice that results as 'co-emergent rather than mastering' clearly has considerable implications for an aesthetics that truly recognises its interrelations with the practices it produces, and through which it is

produced. On this basis, Bolt elaborates a necessary qualification of Butler's notions of performativity, clarified and developed through the work of Vicky Kirby. In this and in its *rapprochement* of Indigenous Australian thought and practice with European and American theoretics, it is a particularly good example of the international, yet located, outlook of differential thought.

Notes

1 See the collection of essays with references to earlier feminist scholarship work, in Mills, Patricia (ed) (1996) *Feminist Interpretations of G.W.F. Hegel*, Pennsylvania: The Pennsylvania State University Press. See also Chanter, Tina (1995) *Ethics of Eros: Irigaray's Rewriting of the Philosophers*, London, New York: Routledge. See also Stella Sandford 'Feminist Philosophy and the Fate of Hegel's Antigone' in Morwenna Griffiths and Margaret Whitford (eds) (1996). *Women Review Philosophy: New Writing by Women in Philosophy*, a Special Issue of Women's Philosophy Review, University of Nottingham. See also Christine Battersby's (1998), discussion in *The Phenomenal Woman: Feminist Metaphysics and Patterns of identity*, Oxford: Polity.

2 In the *Phenomenology of Spirit*, not only does Hegel offer an account of the structure of subjectivity - the master/slave dialectic - he also offers a historical account of the emergence of subjectivity. He analyses this in a work of art: the Greek tragedy by Sophocles, *Antigone*. Hegel's analysis of the emergence of subjectivity has been of particular interest to feminists since he identifies this moment in an act – under an ethical double bind which applies only to women WHICH IS? – made by a female character in the play: Antigone.

3 Joan Rivière's essay 'Womanliness as Masquerade' dates back to 1928, and is still of interest to feminists today, (Burgin, Donald and Kaplan 1989).

4 See Nicole Loraux (1995) *The Experiences of Tiresias: the Feminine and Greek Man*, Princeton: Princeton University Press.

5 Perhaps they are inhibited by Eliotic associations. While Tiresias is not central to the article, Penny Florence uses the figure in her *The Daughter's Patricide: the miss's missing myth*. (Florence 1995) as part of an interrogation of how Oedipal narrative maintains the hero's position as structurally impossible for daughters. 'What does it mean if there is a gap in mythology? ... how might any such gap provide a locus for intervention in language and the symbolisation of power?' (186).

6 See the collection of essays with references to earlier feminist scholarship work, in P. Mills, ed. (1996) *Feminist Interpretations of G. W. F. Hegel*. See also Tina Chanter (1995) Ethics of Eros: Irigaray's Rewriting of the Philosophers. See also Stella Sandford 'Feminist Philosophy and the Fate of Hegel's Antigone' in M. Griffiths and M. Whitford (eds.) *Women Review Philosophy: New Writing by Women in Philosophy*. (1996). See also Christine

Battersby's (1998) discussion in *The Phenomenal Woman: Feminist Metaphysics and Patterns of Identity*.

7 See Florence and Pollock 2000 for Pollock's essay on this.

8 For a discussion of vision and touch see Vasseleu (1998) *Textures of light*. For a different discussion of vision and touch see N. Foster's article 'Boundaries of Sight and Touch: Memoirs of the Blind and the caressed' (Foster 2000) in J. Mottram ed. *Drawing across Boundaries*.

Fig. 22. *Woman-Other-Thing no. 11* 1990-93. Bracha Lichtenberg Ettinger. Mixed media on canvas. 29.3cm x 39.8cm. Photo: Jacques Faujour, Centre George Pompidou, Paris, France.

Fig. 23. *Eurydice no. 16* 1994-96. Bracha Lichtenberg Ettinger.
Mixed media on canvas. 51.7cm x 22cm.

Fig. 24. *Stadium A* (detail) 1987. Bracha Lichtenberg Ettinger.
Mixed media on canvas. 38cm x 94cm.

Chapter 7

Transgressing With-In-To the Feminine[1]

Bracha Lichtenberg Ettinger

Tiresias: The 'Impossible' Knowledge of/from Feminine Sexuality

'A conference on feminine sexuality is not ready to burden us with the threat of the kind of Tiresias' fate' says Lacan (1958, 728), meaning by this that we are not in any way getting closer to understanding feminine sexuality.

Tiresias is a male mythological figure transformed into a woman for seven years and then back into his original sex. As a male who had experienced female *jouissance* he could be seen as master of its knowledge. Tiresias is famous for replying to Zeus and Hera, that if ten parts of love's ecstasy - or *jouissance* - were given to human beings, women took nine parts and men only one. Hera, furious that the secret of her sex was revealed, punished Tiresias with blindness, while Zeus endowed him with the gift of prophecy. It is Freud who associates the punishment of blindness with the idea of castration connected to male's fear of the feminine (Freud 1919, 217-252) and we can add that the gift of prophecy hints at the link between feminine and the time of the future.[2]

Fourteen years after this brief reference to Tiresias, Lacan mentions Ovid's version of that myth again, in order to say that we cannot incarnate such a figure. Knowledge of feminine sexuality is impossible because the structure of language itself, and the structure of the Symbolic - and therefore of the Unconscious - makes what would be a knowledge of heterogeneity impossible. This impossibility is what makes a woman 'not all' while man is the prototype of 'the same' and its reflections, of the *semblant*. He is 'hommosexuated'.[3] Lacan considers knowledge of femininity inaccessible to women no less than it is to men. For feminine sexuality bears an 'impossible' *rapport*: a relation, which is beyond human relationships.

> To say that a woman is *notall*, it is this that the myth indicates for
> us, in that she is the unique whose *jouissance* passes beyond [...]
> What one calls sex (indeed the second, when one is an idiot) is
> properly, in supporting itself by the *not-all*, the *Heteros* which
> cannot arrest itself up with a universe [...] It is the logic of the
> *Heteros* which is to be made to depart [...] from the incompatibility
> of the One with Being. (Lacan, 1973, 24)

The *heteros*, Lacan continues, 'erects the *man* in his status which is that of
the *hommo*sexual' while the *not-all* cannot recognise herself in the parades
of truth, seeming (*semblant*), enjoyment (*du jouir*) and excess (*d'un plus
de*) in man's universe. In 'the absence (*ab-sens*) of relation (*rapport*)' man
is guided 'toward his true bed (*couche*)' as he is 'resituated by the return of
the sublime phallus.' (Lacan 1973, 24) (This translation by Jack Stone).

We recognise here an earlier, and somewhat clearer claim, which carries a
similar meaning but an opposite conclusion, in the sense that for the late
Lacan the woman partly escapes the phallic structure while for the early
Lacan the libido is marked by the sign 'male' and woman must totally
assume it and recognise herself in man's universe, the only one
symbolically available[4] (Lacan 1958, 735).

Knowledge of/from the feminine-beyond-the-phallus is considered by
Lacan impossible, in agreement with Freud's conception of femininity as
either derived from the masculine Oedipal complex and its mechanism of
'castration', or a mysterious 'dark continent' of which we know too little.
In this Freudian-Lacanian account, a difference that is not structured via
the couple: phallus/castration is foreclosed from the Symbolic. Such a
difference would be either absent, or present in fragments of nature,
composing pure events of *jouissance*: the feminine is 'pure absence' or
'pure sensibility' (Lacan 1958, 733). Lacking with regard to masculinity,
or a surplus to it, she is the Other-Thing, an excess with no proclaim on
subjectivising desire. Woman here is a subject of course, but by virtue of
her participation as an object in what I have relativised as the *phallic
subjectivizing stratum*[5] which regulates sex difference, and where she can
mark her resistance only by incarnating a masquerade,[6] while some
obscure 'femininity' still hovers behind it like a phantom, forever
enigmatic. Glimpses of/from such a *phantom of the subject* are considered
mystical or crazy when appearing in the phallic domain.

Non-phallic psychical phenomena appear toward the end of Lacan's teaching in terms of the topological sphere, the Moebius strip, Klein bottle, cross-cap, and these terms join the feminine 'heterogeneity', 'not all' and 'no sexual *rapport* (relation)'.

It is the spherical topology of this object called (*a*) which is projected on the other of the composite, *heterogeneous*, that the *cross-cap* constitutes. [...] a Moebius strip, that is the putting in value of the a-sphere of the *not-all*: It is which supports the impossible of the universe, that is, to take our formula, that which encounters the real. The universe is nowhere else than in the cause of desire, the universal no more. It is from there that proceeds the exclusion of the real [...] of this real: *that there is no sexual rapport*. (Lacan 1973, 30) (This translation by Jack Stone).

With no proper symbolic apparatus to encompass and repress these inscriptions, with no process beyond-castration to in-form human desire, and with no passageway beyond metaphor and metonymy to deliver their potential meaning, they remain inaccessible to knowledge.

Whether a Woman-Other-Thing, a product of the Real's non-sense, whether a radical Other, whether dangerously bordering on originary repression of the Thing, whether equated with an elusive almost-nothing (*objet a*) - even when described as 'not all,' the concept of woman as defined in the Lacanian psychanalysis is always automatically reinforcing the Phallic structure because 'woman' is perceived as the holes in this structure, its scraps, rests, excess or surplus. If 'there is no sexual *rapport*' (Lacan 1975, 17 & 35) and 'a woman is *not-all*, there is always something of her that escapes discourse' (Lacan 1975, 34). She experiences in excess to the *phallic jouissance* a *supplementary jouissance*, but Lacan insists that she knows nothing about it.

From the woman's side, a sexual *rapport* - not organ, not essence, but some kind of relation - could have been elaborated into knowledge, had such an elaboration been possible, but, even a woman, says Lacan, cannot know anything of her own sex, and cannot report on a *rapport* that would

have been feminine-Other if/where it does occur, because, precisely, what could have been qualified as heterogeneity escapes the Imaginary and the Symbolic by definition, and what can be included inside these domains is already phallic. In this conception, Tiresias' position of both experiencing feminine different sexuality *and* knowing it - is out of reach.

Yet, in departing from elaboration of the *not-all* and *supplementary jouissance,* it is difficult to clarify feminine *heterogeneity* in a way that would be independent from the *all* to which it is related and from the experience to which it is *supplementary.* Only a departure which should not derive at all from the phallic structure would allow to account for hybrid feminine instances '*between* center and absence' (Lacan 1972, unedited)[7] and their twilight zone. I propose departing from a difference which is feminine from the onset, from a *rapport* of *borderlinking* in an originary psychical sphere that I have named matrixial. In the matrixial sphere, *not-knowing the feminine difference* is impossible, inasmuch as this difference is in itself a *co-naissance* (knowledge of being-born-together). A feminine in-between instance of '*rapport*' is a poietic process that carries in itself aesthetic knowing, a process I have named metramorphosis. Metramorphosis is both action, perception, inscription and memory of processes that I have titled 'borderlinking' and 'distance-in-joining'. A mental swerving-in-borderlinking with the other[8] - opening a distance-in-proximity while separating-in-jointness with/from the other, or borderlinking while differentiating - is a feminine matrixial process. My *encounters* in the Real with my others are swerved to register traces coming from me and from others concerning the *Thing* as a traumatic event.

These psychical traces witness and account for co-emergence or co-fading of several subjects, partial-subjects, partial-objects and of their links with one another and with the traumatic *Thing-event.* A non-cognitive mode of knowledge that reveals itself in such an ontogenetic witnessing-together, in *wit(h)nessing,* is what I call *co-poiesis,* where *trans-scription* occurs. It is here that following intimate encounter between several partners, that affects in different ways each *I* and *non-I,* traces of the affected events of my others are unknowingly inscribed in me and mine are inscribed in others, known or anonymous, in an asymmetrical exchange that creates and changes a trans-subjective matrixial alliance.

Such a trans-scription is a dispersed subsymbolic and affective memory of

event, paradoxically both forgotten and unforgettable, a memory charged with freight that a linear story cannot transmit, a memory that carries dispersed signifiers to be elaborated and affects as sense-carriers. It is not the story inscribed for reminiscences that I carry in place of a non-I. Rather, fragmented traces of the event's complexity carry fractured and diffracted memory, memory of oblivion itself and of what could not be inscribed in others, even though it 'belongs' to a memory which is theirs, but only trans-scribed for/from them in me. Affected traces of a matrixial encounter echo, in the present, earlier matrixial encounters while modifying older traces and being modified by them. Traces of past metramorphic processes and matrixial events will in their turn modify the processing of further, future encounters.

Under the matrixial light, the transgression in the figure of Tiresias between man and woman is not a transgression of a frontier between known maleness and unknown femaleness. Rather, since the matrixial *I* carries traces of experiences of the matrixial *non-I*, inasmuch as *I know in the other* and my other *knows in me*, non-knowledge of the feminine, in the matrixial borderspace, is impossible, by virtue of the transgression itself. This cross-inscription is vehicled by matrixial effects like empathy, awe, com-passion, languishing, horror and maybe telepathy. *However, the transgression itself is a bridging and an accessing to the other already in the feminine.* It is inscribed in a psychical matrixial channel opened to begin with between a future-mother and a prenatal subject-to-be, where it is only by joining the maternal's psyche that the subject-to-be will achieve separation, and where through differentiating-in-coemergence the m/Other caringly knows her *non-I*. Such transgressions transform the frontiers themselves, so that even though *my non-I*(s) are never entirely cognised they are not entirely cut away from me either. Transgressing with-in-to the feminine with-in borderlinking with-in-to the other is in itself a kind of knowledge, transcribed.

Antigone: Beauty and the Impossible Knowledge of/from Death in Life

Before taking this idea of the matrixial feminine difference further and drawing out some of its aesthetic consequences, I would like to add to the

picture the figure of Antigone from Lacan's seminar on *Ethics* in 1959-60 (Lacan 1992), an addition inspired by a strange allusion Lacan is making to her when he mentions Tiresias once more in 1972. There, the impossible transgression of the frontiers between maleness and femaleness, and the impossibility of extracting knowledge of/from/on the feminine, are associated with another transgression and another impossibility: the transgression of the frontiers between life and death and the impossibility to know of death in life. Let us first make resonate together two brief passages where Lacan briefly and enigmatically links the tragic transgression to death both to the mystery of the feminine and to the aesthetic experience:

> You have satisfied me, little man. You have understood what was needed. Go on, from being stunned (*étourdit*) there is not too much, for it to return to you in the afternoon and after being half-said (*après midit*).9 Thanks to the hand that will respond to Antigone who is called the child, you call it, the same that can tear you apart from what I – feminine and sphinx like – prophesy (*sphynge*) as my *not-all*, you will even be able toward evening to make yourself the equal of Tiresias, and like him, from having been made the Other, to divine what I have said to you. (Lacan 1973, 25).

The second passage is introduced by Lacan's claim that 'the question of the beautiful can only be found at this level as operating at a limit. Even in Kant's time it is the form of the human body that is presented to us as the limit' (Lacan 1992, 298). Lacan then asks:

> [...] is it this same image that constitutes a barrier to the Other-thing that lies beyond? That which lies beyond is not simply the relationship to the second death [...] There is also the libido [...] the only moment of jouissance that man knows occurs at the site where phantasms are produced, phantasms that represent to us the same barrier as far as access to jouissance is concerned, the barrier where everything is forgotten. I would like to introduce here, as a parallel to the function of the beautiful, another function [...] a sense of shame. The omission of this barrier, which prevents the direct experience of that which iss to be found at the center of sexual union, seems to me to be at the origin of all kinds of questions that cannot be answered, including notably the matter of feminine sexuality, (Lacan 1992, 298).

What associates Tiresias and Antigone together is a conjunction of beauty that blinds, the limits of feminine sexuality, the limits of death, and the impossibility of inscribing the transgressions of these limits as knowledge - an impossibility which in fact turns death-drive itself into a feminine *not-all* issue. Both figures have transgressed the frontiers of the laws of nature - transgressing the natural corporeal limit between the sexes in the case of Tiresias, and choosing death upon life in the case of Antigone. Thus, in associating such a transgression into death with the enigma of the feminine, Lacan reanimates a mythological relation that traverses cultures and centuries: the relations of death to the feminine, and locates the *aesthetic* effect of 'the passage to the second death' in the domain of the feminine as the beautiful. This also qualifies the relationships that both 'woman' and death are bearing witness to as 'impossible'.

The aesthetic dimension arises in *The Ethics of Psychoanalysis* 1959-1960 (Lacan 1992) via the question: what is the surface that allows the emergence of 'images of passion'? The extra-ordinary passion which transports death into life and impels life onto death arises, says Lacan, from some contact with that which *is*, the unique, the irreducible and irreplaceable, with what has no substitute and can not be exchanged. Beauty enters the picture through the idea of relations to the irreplaceable. A disappearance in appearance creates the beauty's effect. The effect of beauty results from the *rapport* of the subject to the 'horizon' of life, from traversing to 'the second death'. From Antigone's point of view, life 'can only be lived or thought about, from the place of that limit where her life is already lost, where she is already on the other side. But from that place she can see it and live it in the form of something already lost' (Lacan 1986 [trans. 1992, 318, 280]). This limit, detached from historical time, is a source of creation *ex nihilo*.

If the surface of passion captures such a unique value to make an image of it, this image creates a barrier that blocks from traversing to the other side, and 'The effect of beauty is the effect of blindness'- blindness to the other side, blindness as a castrating schism. The function of the beautiful is precisely 'to reveal to us the site of man's relationship to his own death, and to reveal it to us in a blinding flash only'. (Lacan 1986, translation

modified). The beautiful is a limit of a sphere that we can only approach from the outside, a phenomenological limit which allows us to reflect on what is behind it. 'Outrage' is the term that carries, according to Lacan, the crossing of some invisible line which allows to join beauty with desire. 'Outrage' whose meaning is 'to go out or beyond' ('*aller outre, outrepasser*', is the aesthetic effect of Antigone). This 'most strange and most profound of effects' arises in the limit zone *in-between*-life-and-death, where 'a fate' is enacted and a death is 'lived by anticipation, a death that crosses over into the sphere of life, a life that moves into the realm of death The glow of beauty coincides with the moment of transgression'. The aesthetic question engages the beauty-ideal, which operates at a limit materialised and represented in art by the human body. The human body, 'the envelope of all possible phantasms of human desire' is that barrier which transports 'a *rapport* of the human being with its second death' (Lacan, 1986 [1992, 281, 295, 298]) and in doing so blocks the passage to it. Beauty, in form and image of the human body is the last barrier from the Other-thing 'beyond' - to be understood as a 'second death', but also as 'supplementary femininity', because this barrier is also what keeps us from a direct apprehension of 'sexual *rapport*', which as we have seen, is feminine.

It is in the domain of aesthetics that the frontier that separates the human being from death converges with the frontier that separates the human being from the feminine. In the phallic structure the figure that transgress them is sacrificed to death or blindness. I am suggesting that from a matrixial angle we cannot speak, in the dimension of the feminine, of separation, but rather of separation-in-jointness, whose risks and wonders are beyond the phallic scope where the act of creation concerns the individual with its presence/absence subject/object and interior/exterior dichotomies. A matrixial transgression operates in a co-poietic psychical borderspace shared with several others from the start. Thus, the human body with-in the feminine is not the last barrier from the Other-beyond, but is the passage to a matrixial other. Therefore, the question of sacrifice moves to the margins in the matrix, to make place for the question of witnessing as withnessing: wit(h)nessing.

Antigone incarnates the death-drive, and Lacan adds that she incarnates the desire of the Other linked to the desire of the mother which is the origin of every desire, 'the founding desire' which is also 'a criminal desire' for it was in this case incestuous. Transgression is thus fatally linked to and

binding with death-drive, incest, and the desire of the mother. Antigone's transgression is a fate in the sense that it is a result of 'the crime', to be understood as the infliction of death or incest by one's ancestors, by someone else on someone else, played at the horizon of the subject's existence and thus being a part of what allowed the subject's coming into life.

At the center of Lacan's argument lies his interpretation of Antigone's idea concerning 'having been born in the same womb [...] and having been related to the same father', an interpretation that leads him to saying that the heart of the matter is the uniqueness of the brother (Lacan 1986 [1992, 279). In my view, in so referring to Antigone's hinting at the maternal womb, Lacan is folding the womb into the phallus/castration stratum. Being born of the same womb is equated with being of the same father and leads to paying the price of the parental crimes of incest or killing by traversing beyond the human chain of exchange. The specificity of this conjunction results in Lacan's representation of the brother, for whose memory Antigone is willing to die, as an incarnation of the idea of the unexchangeable One. The matrixial prism conveys a different interpretation to Antigone's referring to the womb, and a supplementary value to the figure of the brother. Transgression is still linked to death-drive, incest, and the desire of the mother, but this linkage itself is transformed, and with it, the meaning of each of these concepts in the feminine. To elucidate that I will first elaborate further the matrixial sphere. This will allow me to locate another conjunction between Tiresias and Antigone, in the *transgression with-in-to the feminine*.

The Impossibility of Not-Transgressing in the Matrixial Sphere

Matrix is an unconscious borderspace of simultaneous co-emergence and co-fading of the *I* and uncognized *non-I* - or partial-subjects, or unknown others linked to me - neither fused nor rejected, which produces, shares and transmits joint, hybrid and diffracted objects via conductible borderlinks. The matrixial is modeled upon a certain perception of feminine/prenatal borderlinking, where the womb is conceived of as a *shared* psychical *borderspace* in which *differentiation-in-co-emergence,*

separation-in-jointness and *distance-in-proximity* are continuously reattuned by metramorphosis created by, and further creating - together with matrixial affects - *relations-without-relating* on the borders of presence and absence, subject and object, among subjects and partial-subjects, between me and the stranger, and between those and part-objects or relational objects. Co-emerging and co-fading *I(s)* and *non-I(s)* interlace their borderlinks in metramorphosis.

Metramorphosis is a process of intra-psychical and inter-psychical or trans-individual exchange, transformation and affective 'communication', between/with-in several matrixial entities. It is a passage-lane through which affected events, materials and modes of becoming infiltrate and diversify onto non-conscious margins of the Symbolic through/by sub-symbolic webs. In a joint and multiple-several marginal trans-subjective awareness, perceived boundaries dissolve to become new boundaries; forms are transgressed; borderlines surpassed and transformed to become thresholds; conductible borderlinks are conceived, transformed and dissolved. Contingent transgressive borderlinks and a borderspace of swerve and encounter emerge as a feminine sex-difference and as a creative instance which engraves traces that are revealed/invented in *wit(h)ness*-in-differentiation. Relations-without-relating transform the uncognized other and me and turn both of us into partial-subjects - still uncognized but unthinkingly-known to each other (prior to thought) and matrixially knowing each other - in subjectivity-as-encounter, where no other is an absolute separate Other.

Metramorphosis is a co-poïetic activity in a web. It 'remembers' swerves (originary differentiation in the realm of affects echoing on Merleau-Ponty's *écart* in the realm of sensibility and perception) and '*rapports*,' bifurcations and relations. It remembers operations of borderlinking that inscribe affective traces of *jouissance* and trauma which are taking place in encounters, transferring the knowledge of these events with-in-to the feminine. Via art's metramorphic activity these traces are transmitted into culture and open its boundaries.

The matrixial designates a difference located, in its originary formation, in the linkage to female corporeal invisible specificity, to the archaic enveloping outside that is also an inside: the womb. However, by matrix I do not intend an 'organ' or an 'origin', but a complex apparatus modelled upon this site of female/prenatal *encounter* that puts in *rapport* any human

becoming-subject-to-be, male and female, with female bodily specificity and her encounters, trauma, jouissance, phantasy and desire.

Through metramorphosis, each matrixial encounter engenders its jouissance, traumas, pictograms, phantasms, affects, and channels death-drive oscillations and libidinal flow, and their affected traces, in *several* partners, conjointly but differently, in com-passion. Traces circulate in a trans-subjective zone by matrixial affects and non-conscious threads that disperse different aspects of traumatic events between the *I*(s) and *non-I*(s). Thus, as I cannot fully handle events that concern me profoundly, they are fading-in-transformation while my *non-I*(s) become wit(h)nesses to them. It may happen that because of their highly traumatic value I cannot psychically handle 'my' events at all. In the matrixial psychical sphere, 'my' traces will be trans-scribed - pluri-scribed and cross-scribed - in others, thus my others will process these events for me. Thus, female bodily specificity is the site, physically, imaginatively and symbolically, where a feminine difference emerges, where a 'woman' is interlaced as a figure that is not confined to the one-body, but is the 'webbing' of matrixial webs and metramorphic borderlinks between several subjects, who by virtue of such a webbing become partial. Metramorphosis, as a carrier of such originary difference and of its transforming potentiality, induces instances of co-emergence and co-fading *as* meaning and trans-scription as unforgettable memory of oblivion. In the matrixial borderspace a specific aesthetic field comes into light, with metramorphosis as an aesthetic process with ethical implications.

The feminine/prenatal incest is here a necessary transgression. Not at all measured by, or compared to perverse or genital-phallic Oedipal incest. The feminine/prenatal one is a primordial psychical field of trans-scription and of transgressions between trauma and *jouissance*, phantasy and desire *in severality*: between several partial-subjects - of trans-subjectivity. Unlike the incest Lacan makes allusion to in Antigone's case (the Oedipal/paternal), in the matrixial sphere all mothers are incestuous in a non-phallic and non-oedipal sense, inasmuch as the intrauterine relations between future mother and future subject are by definition incestuous. Because of the highly psychotic potentiality of this prebirth non-prohibited incest for the phallic subjectivizing processes, this m/Other-incest was

deeply silenced, not even excluded from the Symbolic (from which it could have returned as its repressed and produce an-other desire) but marginalized as unthought of and foreclosed. Whatever of the matrixial twilight zone that did get elaborated in the phallus was subjugated to its order, where it was regulated as a question of bringing children into a heterosexual framework where objects-women are exchanged in 'the Name of the Father'.

Julia Kristeva believes that giving birth must emerge as psychosis in culture.[10] I suggest that this is so only in a Symbolic articulated within the phallic paradigm. Evocations and irruptions of the feminine/prenatal encounters are not psychotic. They only become psychotic when they have no symbolic access. Already before birth, the subject-to-be aspires in phantasy, and contacts 'traumatically' a woman in whose trauma, phantasy and desire s/he already participates.[11] The *jouissance* that spurts on the level of prebirth non-prohibited incest, and the links between the trauma and phantasy of the becoming-subject-to-be (*I*), male or female, and the trauma, phantasy, and desire of the 'woman' as its becoming-archaic-m/Other-to-be (*non-I*), both of them in their status of partial-subjects *and* partial-objects for each other constitute a feminine cluster borderlinking *in-between several* participants while the link to the phallus is however always maintained through the woman's desire that is both phallic and matrixial, and where archaic traces of contact with female body are inscribed as archaic trauma and jouissance, and are revealed in the phantasy of both participants of the encounter (males and females).

Female subjects have a double access to the matrixial sphere in the Real, since they experience the womb both as an archaic out-side and past site, out of chronological time - which is true for males as well - *and* as an in-side and future site, whether they are mothers or not - that may (or not) become present. While the out-and-past-side/site is both female's and male's, the in-and-future-side/site belongs to the female and the male the in-and-future-side/site is the female's. Male subjects are more radically split from this archaic time-and-space of inside and future, since their *rapport* with it in the Real stays forever in the archaic *totally outside* and *too early* that is forever too late to access. *Female subjects have some privileged access to a paradoxical time of future-past and a paradoxical space of outside-inside.* Males however are in contact with this time and space, as women are too, by compassionate matrixial jointing-in-difference with others and with particular art presences – whether art-objects,art-

actions, art-gestures, music. i.e. *as an aesthetic filter, the matrixial apparatus serves both males and females*. Various non-conscious lanes, that are opened toward and from femaleness, are not limited to women only, though they do carry a special resonance for women when they treasure and screen their bodily traces.

It was Freud who, in The 'Uncanny' (Freud 1919, 244, 248) suggested that prebirth experience and womb phantasms participate in the aesthetic experience. In *The Matrixial Gaze*, (1995) I have isolated these phantasms and developed the idea of a matrixial complex as a specific non-phallic psychical apparatus. Even though Freud himself did not fold the earlier phantasy inside the later, in psycho-analytic literature the phantasy of the maternal matrice is generally *excluded* from any particular considerations by *inclusion* within the 'castration' complex, and it doesn't stand for any different psychical mechanism. In my view, these two complexes (matrixial and castration) constitute different psychical dimensions, heterogeneous to one another, whereby feminine difference does not stem from masculine difference.

Matrixial awareness engenders a disturbing desire for jointness *with* a foreign world, with the unknown other, the uncognized, with a stranger who by definition is never a total stranger in the feminine when unthinkingly known in a non conceptual way. Matrixial awareness channels the subject's desire toward the beauty and the pain, the phantasy and the trauma of others. My awareness can't master you via your traces in my psyche, there is no joining without separation nor separating without joining. The desire to join-in-difference and differentiate-in-co-emerging with the other doesn't promise any peace and harmony, because joining is first of all joining with-in the other's trauma that echoes backwards to my archaic traumas: joining the other matrixially is always joining the m/Other and risking a mental regression just until the maternal matrice. A matrixial desire can generate dangerous encounters, it can become pathological, it proposes no fixed settlement, no homogenous mixture but returning and hybridity, im-pureness, a continual contemplation of unabolished difference in jointness. A matrixial love is care-full and emphatic, yet painful because of inevitable processing of the other's trauma and because of inevitable participation in transformation and

opening of boundaries for transmission or reception, fragmentation, contracting and withdrawal, and of what I call 'severalization': dispersal and sharing of the *already* joint-several yet partial and fragmented trans-subjective memory of oblivion. A matrixial loss by definitive cut is, in this psychical zone, a horror beyond its scope. This is the horror experienced by Antigone in her reference to the womb that carried both herself and her brother: it is the matrixial prenatal incestuous co-emergence in different times with the brother that is fatally traumatized. And this trauma has no common measure with the effects of the paternal incest.

Thus, putting the feminine beyond a schism and out of reach for the masculine figure is in the matrixial borderspace an impossibility, and likewise, a total disjoining of living death by anticipation from the meaning of life itself is another kind of impossibility, because life from the onset is linked to non-life. This impossibility of not-transgressing life and non-life in the matrixial sphere demands its price and originates its beauty; it has its solaces and moments of grace, but it is profoundly tragic. I therefore propose to locate Lacan's claim, that we are far from approaching Tiresias' position, in the phallic zone. I propose that, on the contrary, we have never been so close today in the domains of aesthetics and ethics to such a position, inasmuch as we are carrying in this second half of the twentieth century enormous traumatic weight of/for the other in wit(h)nessing, and certain contemporary art-practices are clearing the path to a better apprehension of the matrixial alliances that confront the limits of shareability in trauma and *jouissance*.

Meaning as a Transgression with-in-to the Trauma of the Other

We can now suggest to understand Tiresias as an evocation of the possibility of transgressing between male and female with-in a matrixial feminine dimension where Other and Outside are fatally engaged with *I* and inside, with no symbiosis nor foreclosure, where Other and Outside are knowable in/by *com-passing* between me and inside with others and outside - others of either sex, alive, not-yet in life or dead. In other words, transgression between male and female is not a passage to the radical Other nor transcending to the ultimately exterior, but a metramorphosing with-in-out of selves with-in-to the feminine that passes along the threads that turn, like a Moebius strip, the inside into the outside and the outside into the inside.[12]

Transgression with-in-to the feminine is not a jump beyond a frontier but an access to the surplus beyond, and thus, a transformation of the limits themselves with regard to my affective access to the question of the death of the other, and the death of my other's Other. Metramorphosis opens the frontiers up and turns them into thresholds. Transgression becomes an ontogenetic memory and meaning of sharing in distance-in-proximity with-in the trauma of the other. Meaning becomes a transgression with-in-to others via borderlinking. Both partial-subjects transform and are transformed by one another differently, in a reciprocity without symmetry, creating joint compassionate and eroticized aerials, to be further shaped by following traces of their further affective irradiation.

We know about the crimes at the source of Antigone's desire, we know who are their authors, we know who suffers for them and who scarifies herself, but we don't know *whose trauma it is*. If we rethink Antigone with the notion of trauma, and we ask the question where hides its ineffaceable affected traces, the matrixial perspective takes us onto further new turns. What is at stake here is the trauma of others with-in myself: by force of their matrixial alliance with the *I*, the *non-I(s)* are already, from the outset of any encounter, traumatic to the *I*. I am a wit(h)ness to traumas I didn't witness, like that of the death of others I was not in direct contact with - a death that, however, have traumatized my *non-I*(s). The beautiful, accessed via artworks in our era, (and I emphasise again our era since we are living through massive effects of such a transitive trauma, captivated by some artworks) carries and produce new possibilities for affective apprehending of such a proximity of a double-distance wit(h)nessing. We are experiencing the uncognized *non-I* by/in its difference, as traumatized and traumatizing. I propose to understand Levinas' enigmatic claim, that the Other in its vulnerability is traumatic to me, in such a matrixial prism.[13] Ethical first, but also aesthetic, therapeutic or wounding, is therefore the experience of reaching out to the affect-activity of the trauma of others in each encounter. The aesthetic is therefore, but indirectly ethical, the experience of reaching out to the affect-activity of the trauma of others via artworks. The aesthetic is the trauma's transformed affectability in wit(h)nessing in/by art, beyond time and in different sites and spaces, yet it has ethical and therapeutic consequences. Both the aesthetical and the

ethical are therefore a healing potentiality offered by wit(h)nessing. The beautiful is that which offers whatever succeeds – as object, subject or event – to suggest reaffectation-as-redistribution of traumatic traces of encounters with and of one's *non-I(s)*.

Matrixial transgression of affect creates instances of aesthetic trans-subjectivity, with-in-to the feminine inasmuch as it is inseparable from its archaic form. There is in it an originary prebirth incestuous encounter-Thing with-in the m/Other that is non-criminally incestuous. An archaic *wit(h)ness-Thing* is capsulated in this encounter. The archaic encounter, usually considered inaccessible to symbolic knowledge, is hereby considered the prototype of trans-subjective knowledge. Painting captures in producing, or produces in capturing knowledge of the wit(h)ness-Thing. A possibility of ethically acknowledging the Real emerges in transferential wit(h)nessing, when someone else apprehends in place of the subject the subject's own non-conscious matrixial sites.

Suddenly, in metramorphosing with the artwork, you might find yourself in proximity to a possible trauma, as if you have always been potentially sliding on its margins. You are threatened by its potential proximity yet also compelled by a mysterious "promise of happiness" (Nietzsche's expression concerning beauty), a promise to re-find in jointness what faded away and got dispersed, on condition of matrixially encountering the *non-I*, since your own desire is the effect of others' trauma no less than of your own. By such an effect of beauty, the feminine borderlinking does not qualify as dwelling beyond a barrier, a frontier. Rather, in-between pure absence and pure sensibility, it is a surplus of fragility embedded with-in co-affectation and it makes sense as a transformation on the level of the limit. The artwork extricates the trauma of the matrixial other out of 'pure absence' or 'pure sensibility', out of its time-less-ness into lines of time, and the effect of beauty is to allow wit(h)nessing with non-visible events of encounter to emerge inside the field of vision and affect you.

Metramorphic beauty is co-affectation's obscure trail, skirting on sensation's edges and becoming visible when a passion based on marks of shareability becomes transgressive *again* and labors anew in com-passion. When a world, internal and external, from which the artist has to transfer and to which she has to transmit, is shared with-in-difference via artwork, this world is being brought into presence at the same instant that the work awakes its strange beauty and pain. A potentiality to make a difference

with-in-for others becomes beauty when the artwork vibrates - and the spectator attracts to itself and transmits, back to it or onwards to others - availability for co-affectation. No content, no form and no image can guarantee that an event of co-affectation will take place via a particular artwork for particular viewers and that beauty will arise to attract a matrixial response. But when beauty arises, a matrixial co-affectability hides behind the form and the image and we can think of it as sprouting, overflowing and proceeding from shareable eroticized antennae of the psyche, acting all over the synaesthetic field and channeled by the scopic drive inside the filed of vision.

The matrixial aesthetic effect attests that imprints are interwoven between several subjects: that something that branches off from others engraving traces in me and relinquishing me, (or mentally unbearable to me) is yet accessing others, that we are sharing erotic antennae but processing different re(a)sonating minimal sense from them. These erotic antennae register what returns from others as traces and transmit a centerless matrixial gaze.

The process of making art involves sensing a potential co-emergence and bringing into being objects or events that sustain it and transmit its inscription. Art evokes further instances of trans-subjectivity and makes almost-impossible new borderlinking available, out of elements and links already available in part, but that need to be transformed in ways that can't be thought of prior to the process of art itself. Trauma determines the trajectory of what is, out of art, a forever no-time. The beautiful links the time of too-early to the time of too-late[14] and plant it in historical time. Metramorphosing a traumatic encounter is extracting times of too-early and too-late out of indifference on-to with-in-visibility with-in-difference, when new affects wake up archaic ones from beyond the walls of foreclosure. Aesthetical that is bending towards the ethical is the transform-ability of the no-time of archaic encounter, between several *I(s)* and *non-I(s)* in new co-emergence and co-fading.

The female body makes a sense based on knowledge of/from a body different to the male body. This in-body difference as sub-knowledge was undoubtedly neglected by Lacan when he claimed that knowledge of the

'supplementary' femininity is out of reach for women just in the same way as it is inaccessible for man. That such a difference in body induces an originary feminine difference was perhaps somehow perceived by 'authors' of mythologies and of the Bible, when they have chosen to appropriate and incorporate *symbolic* potentialities of the female body, and mainly the womb and its procreating forces, the breast and its nourishing forces, but even female genitals and sexual pleasure, and plant them into male God-figures or into the monotheistic misericordial and Almighty God.

In the Hebrew Bible, one of the many names for God is *El Harahmim* translated as 'God full of Mercy' or compassion, and also as *misereri, misericordiam, caritas, pietas, gratia* and so forth. These are indeed the figurative meanings of *Rahamim*. But the literal meaning, the signifier, is: wombs, uteruses, Matrixes. The text literally signifies a 'God full of wombs' or (in Latin) full of 'matrixes'. Another name of God is *Shaddai*. In *Exodus* (6, 3) God reminds Moses that it is under the name of *Shaddai* that he established the Covenant, the alliance with Abraham, Isaac and Jacob. Indeed, each time that God appears in the Pentateuch as *Shaddai* it is in the context of the Covenant and the blessing of fertilization, procreation, and transmission to further generations. 'I am the *El Shaddai* [. . .]' says God to Abraham, 'and I will make my covenant between me and thee and will multiply thee exceedingly [. . .] and I will make thee exceedingly fruitful' (*Genesis* 17; 1,2,6)[15] *Shaddai* is interpreted by Rashi as 'the one who is sufficient for himself' and is translated as: 'Omnipotent,' or 'Almighty', yet the Hebrew signifier rhymes with: 'my breasts' 'my nipples.'[16] When we read in *Genesis* 43,14: 'and God Almighty gives you mercy' we hear in the Hebrew: 'and God's Breasts give you wombs/matrixes'. These meanings are abolished in all classical translations of the Bible.[17]

The abolition of the wombs and the breasts from God's name in translations from the Hebrew constitutes, in my view, not only the elimination of conventional feminine imagery from God's Image, but also a foreclosure of a matrixial-feminine symbolic dimension of alliance.[18] No less astonishing is the association between God's name: *Hessed*, and female genitals and sexual pleasure. *Hessed's* most common meaning is: mercy, kindness, compassion, pity, grace (*Genesis* 24,12; 24,14; 47,29; *Exodus* 34,6; *Numbers 14,18*; *Psalms* 103, 4; 86,15;145,8; 106,1), but it also has, in the Bible, this feminine sense, more hidden and metaphorically

hinted (*Jeremiah*, 2,2) or more bluntly in the context of Incestuous iniquity (*Leviticus* 20,17). I have suggested to see in the choice of such signifiers for symbolic Names of the God a potential meaning of the Covenant or the Alliance between God and human-kind, whereby the ethical idea of responsibility to the unknown Other is expressed with signifiers of the feminine.19 Matrixial articulation and comprehension of such a confronting-and-connecting between signifiers and the Real of the female body opens the Symbolic's frontiers, so that it may further account for this body, still in difference, but not in total Otherness.

Even though the matrixial filter transgresses the boundaries of the body-in-identity as male and female and provides meaning to a variety of shifting traces with-in feminine borderlinking beyond gender identifications, and even though the matrixial alliance concerns any human being, the specific reference to the female body remains pertinent. The trail of co-affectivity transgresses the affective individual limits not to become another quality but as an access to others and through forms that will *follow* and will temporarily 'capture' the excess, if a matrixial alliance will be in-formed.

The effect of beauty indicates for us, then, not only the place of relationships to one's own death - but also the *rapport* of the *I* to the matrixial partner before life and to the death of unknown others, a death that traumatized either myself or my others and for whom, through care-full com-passion, I am processing affective memory they can not process alone, and I am digesting and transforming mental traces or inscriptions. When something that can not be looked at, that blinds us, arises at the horizon of visibility - a form of death-drive is embodied in the phallic zone, so that any apparition of a point of emergence can only be represented as a 'want-to-be'. But we can discuss now, in this same experience, the representation of the point of emergence as a co-poietic birth as well, when with every metramorphosis, inter-connected traces of the encounter with the archaic m/Other as a point of emergence are re-evoked-in-transformation, leading within the aesthetic field, through *sharing of trauma and phantasy,* to the ethical position of *co-response-ability with-to* uncognized others. An *impossibility of not-sharing* comes forth in the transgression with-in-to the feminine, what holds some ethical implications: I have an alliance with others *even before* any full cognizing

of difference is possible. In the feminine-matrixial, *there is an Other of the other*.[20] But this other is an other-in-jointness. Antigone's brother who is the unique One in the phallic dimension is the partial-subject of a *unique Jointness* in a matrixial transgression. This is attested by the reference to the womb in the text.

The transgression with-in-to the feminine allows us to think the phenomenon of unconscious transmission between the sexes and between different generations and periods, beyond life and presence in time and place.[21] The matrixial gaze conducts traces of *events without witnesses*[22] and passes them on to witnesses who were not there, to what I have called *wit(h)nesses with-out events*. The viewer, and this partially includes the artist in its unconscious viewer position, is the wit(h)ness with-out event par excellence. The viewer will take in traces of the event in continuing weaving metramorphic borderlinks to others, present and archaic, cognized and uncognized, future and past.

Borderlinking to the Other Sex by a Feminine-Matrixial Differential Potentiality

I can now draw further guidelines for reading-together the myth of Tiresias and the tragedy of Antigone. Both Tiresias and Antigone represent transgressing with-in-to the feminine. In the phallic stratum of subjectivization, if death and the feminine are the enigmas of which we can know nothing, the transgression to the other side via the process of art has a particular aesthetic effect because the artist bears witness to a process otherwise inaccessible: to its 'own disappearance from the signifying chain', and she can articulate such 'non-knowledge' of/in the Real as a 'dynamic value' (Lacan 1986 [1992, 295]). In the matrixial stratum the artist positions herself on an-other's sides, joining-in-difference the others' traumas and webbing passage lanes from this wit(h)nessing. We can now view the tragic quest of the figure trespassing into 'second death' as fatally linked not only to the One and Unique brother, but also as having to bear an unbearable total subtraction from a joint matrixial configuration that can't bear such a substraction, for it can only bear fading-out and fragmentations but no total cuts. A subtraction, (rather than contraction yet not just separation), of *non-I* from shareability, and an extinction of possible borderlinking to the other in a matrixial borderspace, must be paid in 'your body' (Lyotard 1997, 109) as the body of the artist in which other

bodies are cross-inscribed.

What in Antigone's argument is waiting to be heard and com-passioned, is the suffering from tearing apart of her principal partner-in-difference up till now separated-in-jointness from her into total separateness. If the almost-impossible knowledge of the Thing-Event concerns the originary feminine *rapport*, it is not death in itself that inflicts the horrible cut in the matrixial web, but the passage to a bestiality that threatens to blow up and explode this sphere all together into separate pieces. For life and death are constituted in the psyche as already human even when beyond reach of human-symbolic exchange or communication, even at the corpo-real level. Human body is not animal body. Non-human bestiality inflicted on my *non-I(s)* diminishes, and can also abolish, the capacity of the matrixial web for reabsorption of loss, for transference of memory and for processing mourning. Antigone's private death is less a price for her to pay than living through an irremediable explosion of the matrixial borderspace. She literally acknowledges the corpo-real source of this psychical space: the shareable maternal womb.

Why is Tiresias related by the 'feminine impossible *rapport*' to Antigone? What in Tiresias is waiting to be comprehended is, that passing into the female and back again is not either imposing on her a male's filter, mastering the experience by masculine knowledge, confusing it, or totally foreclosing **a** femaleness, but a specific kind of superposition-in-difference, or trans-position of maleness and femaleness. Such a superposition enables to extract hidden sub-knowledge of the other-sex into shareable co-poietic meaning. Tiresias delivers a promise of a behind-appearance access to the other-sex body. We might tune-in-difference our body with-in the corporeal sub-knowledge of the other sex, in keeping to our own sex, with no relation to gender identification.

If feminine originary sex-difference is an enigma of which we can know something though the matrixial prism, and if this prism opens to us the contact with spaces of non-life, the transgression with-in-to the feminine via the process of art has a particular aesthetic effect because in transmitting sub-knowledge from a site of transgression, in a borderspace that contacts the surplus by borderlinking, the artist can bear wit(h)ness

and articulate sub-knowledge of/from the sex of the other. 'The kind of Tiresias' fate' which is 'impossible' for us in the phallic stratum is also a matrixial 'promise of happiness' even if such a beauty is tragic. The artwork is a promise to deliver what up to the appearance in a specific artwork of a particular encounter was a non-knowledge concerning the transposition with the other. Tiresias reveals-while-hiding the other sex in a superposition only as long as distance-in-proximity is kept, difference is held in suspense within jointness, and the access to a surplus is captured for a while. But what I would like to emphasize is that this kind of transgression between the sexes is a transgression with-in-to the feminine - in a matrixial borderspace - whatever its direction is.

Thus, the function of the beautiful is to reveal instances of co-birthing and co-fading and articulate their sub-knowledge when an-other surplus is suddenly distinguished out in the artist's matrixial borderspace. What is captured and given form to at the end of such a trajectory with-in the time of 'too late' as time of a traumatic encounter with-in the other and with the other's Other, is no other than what have always been experienced as such in the time of the 'too early', waiting for an almost-impossible articulation in a time of suspension-anticipation. Thus, a dynamic which indexes a difference in the Real is co-knowledged in with(h)ness, to become shareable, again on some levels and for the first time on other levels, via the process of art.

It is Henry Maldiney who, in speaking on forms of ambivalence in Leonardo's painting, succeeded in isolating an aesthetic dimension fit for describing the superposition of maleness and femaleness in a matrixial androgynous figure. Maldiney speaks of

> a double issuing less from a behind-world than (from) Leonardo's before-world which remains the absolute past of his early childhood, not anterior but subjacent to his present world [and of a communication] on a single-same plane of emanation which is tied to the global schema of (their) crossed forms [... where] the occult in withdrawal bears that which is manifest. The latent meaning underlies the immediate meaning. But these two meanings, without excepting the occult, are immanent in the two visible images - one subjacenting the other. (Maldiney 1970)

Ambiguity here is not con-fusion, separation is kept in single-same plane

of union as in distance-in-proximity. It communicates a subjacenting borderlinking that incorporates without exclusion and without fusion, where an absolute 'before' world is, in the same breath, once again and for the first time available.

Notes

1 This paper was presented at the symposium Leonardo's Glimlach (The Smile of Leonardo), Gent University, Belgium, 16.12.1997.

2 For Emmanuel Levinas, future time is feminine. See Lichtenberg-Ettinger & E. Levinas (1993) & (1997). I have discussed elsewhere the feminine-future dimension, and the foreclosure of the feminine from culture through the foreclosure of the future dimension from God's name in the translation from the Hebrew Bible (God's name 'I Will Be/Become that I Will Be/Become' is translated in classical biblical translations as: 'I am that I Am'). See Lichtenberg-Ettinger (1994).

3 A word play on the word 'homme' – 'man' in French. The second 'm' is therefore intentional.

4 According to Lacan, women in their sexuated position vis-à-vis the phallic universal split between 'pure absence and pure sensibility'. While men make of the phallic referent the universal supporting ground for their phantasm, built to make up for the deficiency of a primordial lack, a split from the Real, from the body and from the Other, for women there is an extra-territory beyond the phallus.

5 Thus reducing the domain of the Phallus in the determination of the Subject. See Lichtenberg Ettinger (1992).

6 Behind 'the mask of womanliness', she is 'either [...] castrated (lifeless, incapable of pleasure) or (as) wishing to castrate', said Joan Rivière (1928) 54. Rivière's concept of 'masquerade' concerns hiding female 'factual' castration and her castrating wishes, and is therefore considered by me as a phallic concept.

7 Lacan is quoting the poet Henri Michaux.

8 For more on this idea see: 'The With-In-Visible Screen' in de Zegher (1996).

9 'Etourdit' and 'apres-midit' are word plays in French. The first expression is laying on: 'étourdir' - to stun, to daze, to make dizzy or giddy; to astound, to stagger, to divert one's thoughts, to deafen, to try to forget, be thoughtless, commit thoughtless act - on the one hand, and 'dit' - said - on the other hand. The second expression is playing on 'after-noon' and 'after being half said'.

10 J. Kristeva (1980). Among the psychoanalysts who elaborated on prenatal life we can mention R. D. Laing *The Voice of Experience* (1982) and S. Ferenczi *Thalassa* (1929).

11 This point is necessary for the understanding of women's claim over their pregnant body and their legitimate rights to keep or abort their foetus. It makes no sense, from the point of view of the matrixial, to speculate on a foetus' 'needs' separately from the mother-to-be's desires, as some anti-abortion militants are doing when trying to oppress women and limit their rights by means of the phallic imaginary. This imaginary posits the foetus mistakenly as a 'separate' entity with separate desires which they then pretend to defend against the mother's desire. I emphasise that the feminine-matrixial configuration supports woman's full response-ability for any event occurring with-in her own not-One corpo-reality and it disqualifies phallic regulations of it. The foetus is not a separate entity. It differentiates itself only in co-emerging with a woman's body-phantasy-desire complexity, and its 'fate' is inseparable from this complexity.

12 I have presented Lacan's preoccupations with the Moebius strip in relation to the gaze in a catalogue (Lichtenberg Ettinger, 1998). In that essay I have also suggested a possibility for a matrixial rereading of it.

13 Emmanuel Levinas in conversation with the author. Unpublished, 1991.

14 The 'too early and too late', is an expression used by the poet Paul Celan to describe poetry. For Deleuze, the time of 'too late' is related to aesthetics.

15 All Biblical references are to the King James version.

16 Same vocalization though different vowelling, responsible for the enigma of this word 'shaddai' in its biblical vowelling.

17 Chouraki's recent French translation of the Bible mentions "matrix" and keeps *Shaddai* without translation.

18 This paragraph on God's names was fully taken from my early book (1993) where I go into this matter in more detail.

19 See the interpretations I offer to Levinas and his replies in Lichtenberg Ettinger and Levinas (1993) and (1997).

20 Lacan has endlessly repeated through many years of teaching, the idea that 'There is no Other of the Other'. I am suggesting that this is limited to the phallic field, and that in the matrixial sphere, *there is an Other of the Other*. In his very late writing, when discussing Joyce (1975-76), Lacan enigmatically delimits this statement only to the phenomenon of *jouissance*. Saying as usual 'there is no Other of the Other,' he adds: 'at least there is no *jouissance* of the Other of the Other'. I propose that he hereby intends the possibility of certain exceptions to his usual claim. Such exception may concern a beyond-the-Phallus zone, such as the matrixial.

21 The question of the possibility of such a transmission via art, and particularly women's art, is a major theme in Griselda Pollock's recent writings. See for example, Pollock (1996).

22 See Lawb, in: Felman (1992).

Fig. 25. *Post-Partum Document* 1973-79. *Introduction* (1973). Mary Kelly. Perspex units, white card, wool vests, pencil, ink. 4 units. 20.3cm x 25.4cm each. Photo: David Atkins, London.

Fig. 26. *Post-Partum Document* 1973-79. *Documentation V* (1977). Mary Kelly. Mixed media, 3 of 33 perspex units. 12.7cm x 17.8cm. Collection of the Australian National Gallery.

Chapter 8

The Gendering of Allegory:
Mary Kelly's *Post-Partum Document*
and Benjamin's Melancholy Dialectics

Christine Conley

It is as though allegory were precisely that mode which makes up for
the distance, or heals the gap, between the present and a disappearing
past which, without interpretation, would be otherwise irretrievable
and foreclosed.

(Joel Fineman 1980, 49)

In her introduction to *Feminist Aesthetics* Gisela Ecker argues that art is a
privileged area where the 'subject in process'[1] may be studied as a site of
struggle. Art is the dominant field in which gaps in the symbolic are most
likely to occur, and hence where change may be envisioned. Ecker posits a
feminist aesthetics that is necessarily a critical reflection upon the
'feminine', and upon the historically specific contradictions that female
subjectivity generates between desire and social codes (Ecker 1985, 20-21).
Ecker's account of a feminist aesthetics aptly describes the work of Mary
Kelly whose first major installation *Post-Partum Document* (1973-1979) is
my subject here (Figs. 25-26).[2] As a visualization of the mother-child
relation *Post-Partum Document* presents the subjectivity of the mother as a
site of social inscription, of contradictory desires, and ultimately of
politically transformative possibility, thereby contesting the mythic
construction of the maternal feminine as natural and immutable.

Against a history of iconic representations of mother and child that
produces them as *objects* of the gaze, Kelly seeks to produce the mother as
the *subject* of loss and desire within a system of heterogenous signs, a
strategy informed by Julia Kristeva's theory of the semiotic (Kelly 1983,
197). This system comprises six series of documentations representing
significant moments in the child's separation from the mother, commencing
with the process of weaning, and culminating in the child's entry into the

education system. Each series encases the mother's memorabilia of her son's first five years: stained nappy liners, the child's first words, his drawings, a plaster hand imprint with his 'blankie', his nature collection ('gifts' to his mother) and his early writing. As these framed elements are repeated in series they replay the inevitable moments of separation and loss consequent upon the child's maturation.

The mother's mementoes introduce Kelly's thesis: the possibility of female fetishism. Freud understood fetishism as a male perversion arising from the little boy's need to disavow his knowledge of the mother's missing phallus. The little girl's need to negotiate this threat is deferred through the promise of someday having her own child. However, Kelly claims that motherhood forces a confrontation with this lack as the experience proves not to be the phallic one that she imagined. Thus the mother's relation to her child as a substitute for the phallus leads her to fetishise the child, to delay the loss of symbolic plenitude and the ability to represent lack. In *Post-Partum Document* Kelly conveys her own maternal anxiety through displacing this fetishising desire onto the work of art. The internal structure of the fetish as both acknowledgement and disavowal of loss is repeated and extended across the spatial-temporal axis of the *Post-Partum Document*: repetition moves forward to displace and distance the sensuous bliss of the mother-infant dyad even as its recuperative impulse points back to signal the longing for lost plenitude. The maternal subject is thus installed through a dialectical movement of loss and recuperation that simulates the process of mourning.

The intersubjective relation of mother and child is mapped out across and between the surfaces of organic materials (wood, paper, cloth, lead, plaster) in a continual displacement that evades the fixity of the sign. The infant is represented by material traces that are not determinably perceivable as signs: stains, first words, scribbles, a handprint, all highly cathected. The mother is represented by her writing, which foregrounds the material or graphic quality of the letter even as it signals the symbolic purchase of language. Unlike the infant's marks, the mother's handwriting, stamped letters and typewriting are not imprints of her body, not the indexical relation associated with the painterly gesture, but one step removed as signifiers which relay her desire beyond responding to her infant's demand: the desire to be an artist and the desire to have conceptual knowledge of her (ineffable) maternal experience. The necessary distance is provided by a supplementary text that records the artist's concurrent analysis of her experience using psychoanalytic theory. Another indicator of analytic distance is the superimposition of Lacanian diagrams upon the

heterogenous play of the *Post-Partum Document*'s fragments and texts. These are emblems of women's difficult relation to language and the Symbolic, summed up by Lacan's notorious proposition: 'The woman does not exist' (Kelly 1995, 150). The status of these diagrams as 'blazons' of a love-hate relation to the paternal order has been discussed in the book form of the *Post-Partum Document* (Kelly 1983) and in the substantial commentary.[3] They bear a complex relation to both the denigration of the mother in culture and access to conceptual knowledge. Hence, the superimposition of Lacan's diagram for the intersubjective relation, *Schema L*, upon four tiny infant vests (Fig. 25) introduces the antinomies of desire that will play themselves out sequentially, without resolution, in the semiosis of indexical and symbolic signs, marking out the inevitable ceding of the child to the Law of the Father. Their opposition here in the very introduction of the *Post-Partum Document* functions as an *incipit* to mourning.

My argument is that the play of desire in *Post-Partum Document* is the play of allegorical desire, which is first and foremost the desire for knowledge, as Maureen Quilligan puts it, 'the ache to make sense out of the universe' that all allegorists share (Quilligan 1979, 248). Yet such knowledge cannot be simply accessed. The complex discursivity of allegory with its horizontal accretion of meaning demands interpretation. Allegories are elusive and intransigent 'because they are concerned with a highly complex kind of truth, a matter of relationships and process rather than statement' (Quilligan 1979, 226). Likewise, as an allegory of the mother's loss in patriarchal culture *Post-Partum Document* begs deciphering while defying succinct summary. My analysis will focus on how allegory, which has been reintroduced into art criticism at least in part through the revived interest in the work of Walter Benjamin, is of particular significance for feminist aesthetics.

Benjamin's Allegory

In a widely read essay published in 1980 in the journal *October*, Craig Owens argues for the strategic importance of allegory in the postmodernist critique of representation. He identifies allegory as a definitive impulse in postmodernist art (Owens 1992, 52-87). Inspired by Walter Benjamin's recuperation of allegory in *The Origin of German Tragic Drama*, Owens foregrounds both the redemptive function of allegory (the fundamental impulse to rescue the past from oblivion) and its critical capacity (the function of allegory as palimpsest).

Owens notes the derivation from Greek in describing allegory as supplement:

> Allegorical imagery is appropriated imagery; the allegorist does not invent images but confiscates them. He lays claim to the culturally significant, poses as its interpreter. And in his hands the image becomes something other (allos = other + agoreuei = to speak). (Owens 1992, 54)

The 'other' (*allos*) of allegory inverts the declarative or public sense of speaking (*agoreuei*). Allegory always says one thing and means another.[4] This gap between materiality and meaning is central to Benjamin's theory of the allegorical signifier. In his study of the German baroque *Trauerspiel* or mourning plays, Benjamin argues for the allegorical mode of the baroque as a shift, from the mythic structure of classical tragedy to the drama of man's mournful subjection to natural history. Classicism's conflation of appearance with essence, the beautiful with the moral, was inadequate to the crisis of meaning that the politico-religious conflicts of the baroque provoked. Against the mythical unity of sign and meaning in the classical symbol, the dialectical structure of allegorical signification rests upon a profound gulf between 'visual being and meaning' (Benjamin 1998, 165). It foregrounds the materiality of the letter itself: the allegorical image as rune.

This dialectical structure arises from the antinomies of the allegorical, that is, the contradictory nature of allegory as convention *and* expression. The allegory of the seventeenth century, Benjamin argues, was an expression of convention and of authority but was also recognized as a creative form of expression, like holy scripture. These antinomies took plastic form 'in the conflict between the cold, facile technique and the eruptive expression of allegorical interpretation' (Benjamin 1998, 175). The dialectical solution between authority and expression lies in Benjamin's concept of the allegorical image as a form of writing that encodes sacred knowledge.

The vitality and dignity of the 'revealed spoken language' is sacrificed in the strict codification of sacred scripts which, in aspiring to become fixed complexes of words, adopt the form of hieroglyphics. Alphabetical script, while conventional, escapes this fixity and remains on the side of 'profane comprehensibility' (Benjamin 1998, 175). For Benjamin, it is the desire to guarantee the sacred character of a script that produces the excitatory writing of the baroque emblem books, the conscious pattern of the typographical arrangement where 'the written word tends towards the

visual' (Benjamin 1998, 176). In this conflict between 'sacred standing and profane comprehensibility' (Benjamin 1998, 175) the allegorical fragment must be robbed of its vitality so as to be elevated from the world of profane meaning to that of the sacred. Devaluation necessarily precedes redemption. The materiality of the signifier is drained of its literal meaning so as to point to some 'other' meaning that begs deciphering.

It is the elision of the linguistic and pictorial registers in Benjamin's account that Craig Owens finds so rich in discussing postmodernist art, that is, 'the reciprocity that allegory proposes between the visual and the verbal: words are often treated as purely visual phenomena, while visual images are offered as script to be deciphered' (Owens 1992, 57). Owens' essay is useful for imagining how Benjamin's theory might translate into specific procedures in more recent visual art, identifying a number of allegorical aspects within contemporary practices: the appropriation of images, the piling up of fragments as in photomontage, strategies of accumulation, the repetition of forms in mathematical progression or series, hybridity, impermanence, and discursivity. While Owens does not refer to Mary Kelly, her re-presentation of collected memorabilia, the repetition, seriality, and meta-textual structure of the *Post-Partum Document,* all signal her affinity with the textual strategies that Owens identifies as allegorical. Further the 'scriptovisual' nature of the *Post-Partum Document* introduces tensions between different forms of knowledge, between the codified knowledge of science and the mother's experience of infant care, for instance, that are resonant with the dialectic of sacred and profane knowledge, of convention and expression, in Benjamin's theory. Sigrid Weigel observation of the latter, that the field of interpretation that opens out of the gap of the allegorical signifier 'is bound up in the history of power-knowledge-systems' and is the field of 'battle over the control of knowledge' (Weigel 1996, 99) is evocative of the *Post-Partum Document*'s feminist interventions. The conflict between 'cold, facile technique' and 'eruptive expression' that Benjamin ascribes to allegory may be discerned in the austerity of the *Post-Partum Document* as conceptual art and the pathos, so characteristic of the *Trauerspiel,* that its interpretation evokes.[5] In the dialectic of these antinomies then lies the capacity of allegory to defer to authority while critiquing it. What Owens does not of course claim is that sexual difference, which he will later argue forces a reconsideration of postmodernist thinking on the indeterminacy of the sign (Owens 1983, 60-64), might also be significant to a consideration of allegory.

While the critical capacity of allegory alone announces its affinity with feminist interests, my argument for its relevance to feminist aesthetics is

provoked by the recognition that, as Benjamin insists in his *Trauerspiel* study, allegory is intimately related to melancholia: allegory is the melancholic's only pleasure (Benjamin 1998, 185). At the same time feminist analyses suggest melancholia to be a gendered category, not only as a clinical condition but as a creative ethos, for the cultural discourse of melancholia has long functioned to exclude women from the canon of artistic genius.[6] I will now consider how Benjamin's difficulty with the melancholia of the allegorist resounds with the problem of melancholia identified by feminist inquiry.

For Benjamin, melancholia is a function of the problem of knowledge, that is, the problem of the arbitrariness of meaning. Susan Buck-Morss explains: '...the Fall broke not only the unity of Creation, but the unity of the Adamic language of Names. In the latter there is no gap between word and referent, whereas the language of judgment which replaced it interprets nature abstractly as a sign of its fallen state' (Buck-Morss 1989, 235). Knowledge attempts to remedy this breach between subject and object. The allegorical impulse is to recuperate this lost similitude between name and thing. However, such knowledge as the allegorist creates is merely arbitrary and subjective. In the theological sense it is only knowledge of evil, for as Benjamin recalls of the Bible, it was through the concept of knowledge that evil was introduced into the world.[7] The gap then between literal meaning and the meaning assigned by the allegorist becomes the abyss of melancholic contemplation. While the gulf between materiality and meaning sustains the heterogeneity of the sign, the pressure of allegory as a system arrests the continuous play of meanings. Benjamin writes:

In [the allegorist's] hands the object becomes something different; through it he speaks of something different and for him it becomes a key to the realm of hidden knowledge; and he reveres it as an emblem of this. This is what determines the character of allegory as a form of writing. It is a schema; and as a schema it is an object of knowledge, but it is not securely possessed until it becomes a fixed schema: at one and the same time a fixed image and a fixing sign. (Benjamin 1998, 184)

As a form of visual writing allegory's deference to structure counters the continuous displacement of meaning of Derridean *différance*, so that deferral 'becomes not a source of joyful abandonment to the infinite plenitude of writing, but a mournful subjection to the written'. (Pensky 1993, 124)

The intimacy of melancholia with allegory produces a theoretical impasse for Benjamin emanating from the hypersubjectivity of the melancholic, whose assignation of meaning in allegorical construction is necessarily preceded by the devaluation of the object.

> If the object becomes allegorical under the gaze of melancholy, if melancholy causes life to flow out of it and it remains behind, dead but eternally secure, then it is exposed to the allegorist, it is unconditionally in his power. That is, it is now quite incapable of emanating any meaning or significance of its own; such significance as it has, it acquires from the allegorist. (Benjamin 1998, 183-4)

Within the depths of melancholic pensiveness, the allegorist is sovereign over the realm of dead objects. He 'betrays and devalues things in an inexpressible manner. The function of baroque iconography is not so much to unveil material objects as to strip them naked' (Benjamin 1998, 185). Benjamin's account of mastery over the fragments of allegorical construction illustrates the sadistic subject-object relations that preside under the sign of the *Grübler*, the brooding intellectual, who develops a violent relationship to the object rescued from oblivion. In *Melancholy Dialectics*, a reading that embraces the Messianic aspects of Benjamin's interpretation, Max Pensky sums up the contradiction: '[t]he object, lifted from the process of circulation, must be killed to be saved' (Pensky 1993, 240).

Pensky poses the hypersubjectivity of the melancholic as a philosophical-political problem in Benjamin's formulation of a critical methodology. Melancholic contemplation, mired in a hopeless world of dead objects, produces political paralysis. Yet, the theological solution to allegory's antinomies is likewise unsatisfactory. In a leap of faith manifest in the theatrical device of the miracle, the baroque allegorists transcended the transitoriness of nature (the spectacle of the skeleton) to embrace the Resurrection, thus presenting the meaning of the devaluation of the object as a sign for its opposite, redemption. By taking refuge in the spirit, allegory 'deserts both history and nature' (Buck-Morss 1989, 175) and betrays the world of things and of human intervention. For this reason, Benjamin concludes his discussion of allegory and *Trauerspiel* with the pronouncement 'Allegory goes away empty-handed' (Benjamin 1998, 233). For Max Pensky, the theoretical impasse is this: how to retain the messianic insights opened up to the melancholy mind through the dialectical relation to the object without submitting to the despair of the melancholic's 'mournful subjectivity, political paralysis, and contemplative fixity.' He

concludes, 'Overcoming melancholia without losing the redemptive relation to the thing: that is Benjamin's real interest' (Pensky 1993, 140).

Benjamin's difficulty with the melancholy of the allegorist is resonant with feminist critiques that point to the dissymmetry of gender in relation to the object, which is both 'killed' and 'rescued' in this scenario. Feminist analyses of melancholy suggest women have a different stake in the object relations that pertain in the aetiology of what constitutes both a clinical pathology and a mode of expressibility. The second aspect of my argument then concerns the gender politics of melancholia and how this informs our understanding of allegory.

It is women's vexed relation to melancholia as *the* culturally privileged modality for representing subjective loss in the western tradition that interests me here, provoking the question of how allegory might figure in women artists' negotiation of their paradoxical position. While I intend to relate this question back to *Post-Partum Document*, it is necessary first to map out the terms of the paradox, and for this purpose Juliana Schiesari's study *The Gendering of Melancholia* is most useful. In a discussion resonant with the mournfulness of Kelly's project, Schiesari proposes an historically different relation for women to the representation of loss, through a 'language that approximates a mourning for their barred or devalued status within the symbolic rather than a melancholic fixation on the tomb as the imaginary return to the womb' (Schiesari 1992, 75-76).

Daughters in Exile

Schiesari underscores the crucial distinction between melancholia as a *clinical* discourse and melancholia as a *cultural* discourse, arguing that while women have always numbered among the *clinically* depressed, as a *cultural* discourse that capitalises upon the sensibility of loss, melancholia has been the provenance of a privileged male subject:

> [...] as early as Ficino and as late as Freud melancholia appears as a specific representational form for male creativity, one whose practice converted the feeling of disempowerment into a privileged artifact [...] the very nature of the melancholic was to be that of a self split against itself, fleeing the social into a perpetual dialogue with its own Imaginary, to use Lacan's term. (Schiesari 1992, 8)

She contends that the discourse of melancholia has provided a 'topos of expressibility' for men, allowing them to express anguish in a manner that

registers their loss as culturally significant, and hence 'renders them exemplary of the 'human condition'' (Schiesari 1992, 15). The 'feminine' is incorporated as site of representational loss, while actual women are disparaged, absent, or silent. Though privileging phantasmatic loss, melancholic discourse has real social effects, determining whose experiential and subjective loss is attended to and accredited.

Schiesari's analysis is of critical importance here because it broaches the melancholia of Renaissance invention and scholarship and contemporary theories largely informed by psychoanalysis, beginning with Freud's pivotal essay 'Mourning and Melancholia' of 1917. It is then possible to envision, as Schiesari does, both Walter Benjamin and Jacques Lacan as part of a tradition of 'great melancholics' that includes Petrarch, Tasso, and Ficino, but is bereft of women. It is also possible to read the Lacanian schemas that preside in *Post-Partum Document* as twentieth century analogues, in the linguistic-psychoanalytic register, of women's exclusion from melancholia as a means of symbolising their loss.

With 'Mourning and Melancholia' Freud introduced the topos of melancholia celebrated by Renaissance culture into the twentieth century 'science' of psychoanalysis. For Freud, melancholia is distinguished from mourning by the symptom of fallen self-esteem and by the unconscious nature of the loss, whereby the subject may know 'whom he has lost but not *what* he has lost in them'(Freud 1917, 155). It is the task of psychoanalysis of course to solve this enigma through an interpretive process not unlike the work of allegoresis. Indeed, Joel Fineman has argued for the structural alignment of allegory with psychoanalysis: the 'other' of allegorical signification becomes the 'other' of the unconscious, the allegorical desire for knowledge resounds in the investigative impulse of the 'talking cure'.[8]

The shattering of the object-relationship in melancholia results in a regression to primary narcissism, an incorporation and identification by the ego with the abandoned object. The ego is then subjected to the critical judgement of the superego as if it were the forsaken object. This relation to the object is complicated by ambivalence, 'countless separate struggles are carried on over the object in which *love* and *hate* contend with each other [...]' (Freud 1917, 256-57). Freud's cure for the melancholic's self-abasement involves the discarding of the object once it has been rendered valueless through the punitive agency of the superego. At the same time, just as the allegorist's violent relation to his fragments secures the authority of his subjective knowledge, the melancholic's moral masochism lends authority to his truth claims. In his clinical observations Freud remarks

upon the melancholic's self-critical, moralising conscience (the 'hammering' of the superego upon the object) posing the question 'we only wonder why a man must become ill before he can discover truth of this kind' (Freud 1917, 156).

Despite the impoverishment of the berated ego, writes Schiesari, melancholia functions as an empowering discourse:

> The melancholic ego, in order to authenticate its conflicted relation between *innen* and *umwelt*, inner and outer world, is dependent on loss as a means through which it can represent itself. In so doing, however, it derealizes or devalues any object of loss for the sake of loss itself [...] refocuses attention not on the lost *object* but on the loss, on the 'what' of the lost object, whose thingness points back to the *subject* of the loss. (Schiesari 1992, 42-43)

The melancholic transformation of the lost object into a material signifier ('thingness') of indeterminate meaning (the 'what' that has been lost) may be understood here as analogous to the lost similitude encoded in the allegorical signifier, the gap between name and thing. Melancholia is like allegory a perpetual failure of naming that continuously points back to the subject. Hence melancholics are famously loquacious; allegorists revel in textual excess. Perhaps the melancholic's pleasure in allegory lies precisely in the digressions of its investigative impulse.

One might reasonably conclude at this point that the efficacy of allegory for feminism is its capacity as an artistic mode of expression to enable women to become melancholics in the cultural sense. However, the situation is not straightforward. Schiesari turns to analyses of melancholia by Luce Irigaray, Julia Kristeva and Kaja Silverman to reveal the difficulty for women of accessing this 'prestigious neurosis'. Irigaray's response to Freud's essay in *Speculum of the Other Woman* supports Schiesari's distinction between clinical depression and melancholia as a cultural modality. Irigaray points to the chilling correspondence between the melancholic's symptoms of self reproach and abasement and the libidinal economy of the little girl who discovers, through the devaluation of the mother, both her own and her mother's castration. However this double loss cannot be mourned because the *what* that has been lost remains unconscious. Hence, what Freud deemed a pathology of grief in the male subject is endemic to the female's negotiation of the Oedipus complex. Irigaray is clear on the gendering of the object relations that subsequently prevail under 'the moral sanction' of the superego: 'the object of wrath is

the castrated mother, whereas the 'super-ego would represent the "paternal" figure, "providence," 'fate"'(Irigaray 1985, 70).

This asymmetry of gender in relation to the superego is key to the structural absence of women from melancholic discourse. The alignment of the critical capacity of the superego with the law of the father allows the male subject greater access to narcissistic mirroring, suggesting for Schiesari that the cultural/clinical divide of melancholia/depression marks a gendered hierarchy that determines the *ways in which loss may be represented*. By Irigaray's account, women cannot be melancholics in the cultural sense, as they lack access to a signifying economy that could represent a loss that 'radically escapes any representation' (Irigaray 1985, 68). Women are left only with depression as their status of *déréliction* remains unrepresentable, ineffable.

Julia Kristeva likewise interprets women's depression as a problem of signification, emphasising the daughter's insufficient differentiation from the mother. Kristeva's topology in *Black Sun* maintains the duality of the primal mother as either idealised primary narcissism (fusion, plenitude), or the primal experience of abjection. Representations of the mother either fetishise her as inaccessible, as in representations of the Virgin Mary, or else perform an identification with the mother as repressed, unnameable, assuming a position verging on psychosis.

The alternative to psychosis is matricide, the withdrawal of libidinal investment in the mnemonic traces within which the girl finds both the object and herself. However, as Schiesari insists Kristeva's 'cure' of matricide is like Freud's de-cathexis: precisely what *causes* female melancholia. Kristeva's insistence upon the cure of matricide registers most acutely the dilemma that melancholia poses for women: the dual pressures to de-cathect or de-invest in the devalued maternal object yet to also sustain identification.

Kaja Silverman's contribution to these debates introduces the possibility of an oppositional desire that might represent the maternal feminine beyond the poles of psychosis or matricide. In *The Acoustic Mirror* she revives an earlier moment in Freud's formulation of the Oedipus complex, where he accounted for the little girl's erotic investment in the mother. This *negative* moment, which follows the entry into language and hence places the daughter's desire for the mother firmly within the symbolic, was curiously overwritten in Freud's theory in favour of the pre-Oedipal, which precedes

the entry into language. Silverman insists that it is only with the advent of the *positive* Oedipus complex that the little girl is faced with the castration scenario, and the melancholic effects, described by Freud and Irigaray. By situating the daughter's passion for the mother within the Oedipus complex Silverman makes it an effect of language and loss, within the compass of desire, and hence the possibility of representation.

In Silverman's scenario the loss of the mother/daughter (the *what* that has been lost in melancholia) is not the loss of the pre-Oedipal mother, but of the mother as valued within the intersubjective relation of mother and infant. Theoretically this loss could be articulated as a transition between the two moments that Silverman insists structure the Oedipus complex: the negative moment that maintains identification and desire and the positive moment that signals the mother's castration. The process of this articulation would then take the form of a lament, or as Schiesari claims, a mourning for women's barred status in the Symbolic. I suggest it is this process of mourning that produces the maternal subject in *Post-Partum Document*.

Love Among the Runes

The mournful subjectivity of allegory ensues from its structure as both a fixed schema and a field of interpretation, from the dramatic conflict between authority and the critique of knowledge. This conflict is played out in *Post-Partum Document* between the antinomies of desire encoded in the infant vests (Fig. 25). These antinomies are never resolved yet their process within and across the framed elements produces moments of insight, yielding what Kelly refers to in the supplementary text as the possibility of the 'truth of the mother' (Kelly 1983, 189). However, this 'truth' is not exacted at the price of the object in the manner of the melancholic. The mother's mementoes serve as poignant reminders of the inevitable transitoriness of nature, but also figure within the 'drama' that the *Post-Partum Document* 'stages' to point to the mother's loss as a consequence of her devaluation in patriarchal culture.

The antinomies of desire are put into play through Kelly's staging of the intersubjective relation as a linguistic exchange. In *Documentation II* the child's first words are objectified in the form of little blocks, each carved with a letter and nestled in a wooden typesetter's bed. The adjacent typescript documents tape-recorded sessions of the child's early speech, to reveal the mother's critical supplementing role in the acquisition of language. The transcribing of the child's speech into written form may be

understood in terms of Benjamin's study as a transformation of the purely sensuous to the realm of meaning (Benjamin 1998, 209). Within the realm of allegorical intuition, the child's speech becomes a fragment that must be robbed of its vitality so as to be assigned another meaning. This is the price of knowledge: the distance from the immediacy of experience. Yet the 'thingness' of the letters on the little blocks retains a residue of that vitality. The blocks are emblems of the mother's desire, not evidence of the murdered object. In this instance, the knowledge of the mother's supplementing role suggests a more mediated model of language than the one invoked by Lacan's melancholy theory of the subject, where the entry into language is presented as a 'cut'.

The price exacted by the Lacanian subject's entry into language is revealed in Lacan's reading of Freud's well-known story of the *fort-da*. In 'Beyond the Pleasure Principle' Freud interprets his little grandson's play with a wooden reel and string as a representation and 'working through' of the anxiety of maternal separation. Repetition of the unpleasant stimulus in the form of a game, a representation, leads to acceptance of the inevitable separation. By contrast, in 'Function and field of speech and language' Lacan reads the story in terms of the child's mastery of his environment through speech, his birth into language, and announces: 'Thus the symbol manifests itself first of all as the *murder of the thing*, and this death constitutes in the subject the eternalization of his desire' [emphasis added] (Lacan 1977, 104).

This story is important for Kelly too, who claims the *Post-Partum Document* as a maternal version of the *fort-da* game (Kelly 1983, 108). However, from the evidence of the work her interpretation of Freud's allegorical story is quite different from Lacan's. The game's repetitive movements towards mastery and recuperation are evident in the temporal-spatial axis of the *Post-Partum Document*, in the dialectical movement that instills longing for the mutual desire of the mother-infant dyad, even as it moves forward towards the mastery of language. This movement whereby the mother 'comes into her own' performs a memorialising function that approximates mourning rather than melancholia.[9] What is mourned is the loss of the mother as the other of language, acknowledged in the term 'mothertongue', yet overwritten by the Other of the socio-symbolic order.

The status of the objects as mementoes repeats this memorialising function. Consistent with the contradictions of allegory, the fragments are wrested from their everyday context (devaluated) and elevated to a higher meaning within the work of art (redeemed). Yet, they are not 'killed' in order to be

'saved'. *Documentation V* features the gifts of the child to the mother, collected on outings to the nearby Hackney marshes: insects, plants, or the shell of a snail (Fig. 26). Their display is modelled upon the natural history museum, which Kelly sees as 'a vast metaphor for the exploration of the mother's body' (Smith 1982, 29). Hence the handsomely mounted and catalogued specimens are accompanied by transcribed conversations, where the child's impertinent questions demonstrate his curiosity about sexual anatomy and reproduction. Though these artefacts are of no intrinsic value, their aesthetically appealing display conveys their emotional value for the mother. In contrast, the accompanying diagrams from a medical textbook, displaying cross-sections of the pregnant body alongside an alphabetical list of symptoms, censor the desire for carnal knowledge.

The status of the object in *Documentation V* exists in a transition between two narratives that Susan Stewart identifies in her book *On Longing* as the narratives of the souvenir and the collection. The souvenir is the memento. It is a metonymic 'sample of the now-distanced experience [...] which the object can only evoke and resonate to, and can never entirely recoup [...] the souvenir must remain impoverished and partial so that it can be supplemented by a narrative discourse [...] which articulates the play of desire' (Stewart 1993, 136). The souvenir that points back to the experience of its owner becomes 'emblematic of the worth of that life and of the self's capacity to generate worthiness' (Stewart 1993, 139). The collection, on the other hand, 'offers example rather than sample, metaphor rather than metonymy' (Stewart 1993, 151). In contrast to the associative value of the souvenir, the objects in the (museum) collection 'have significance only in relation to one another and to the servility that such a relation implies' (Stewart 1993, 153).

Stewart's narratives of the object of longing correspond to the difference between the motivated indexical sign and the arbitrary sign of written language. Kelly uses these signs in the *Post-Partum Document* to mark out a transition that gradually narrows the gap between materiality and meaning. In *Documentation VI*, modelled upon the Rosetta Stone, the child's markings graduate from a 'pre-writing' that Kelly presents as an anagram of the maternal body (Klein 1923), to a mastery of the alphabet which represses that very knowledge. Kelly's use of allegorical signification reveals this lost similitude encoded in the child's runes. Nevertheless, on the final 'stone' the child writes his proper name, Kelly (the mother's name) Barrie (the name of the father), confirming his inscription into the social order in accordance with the Law of the Father. This prompts the mother's question: What will I do?

Like the melancholic, the mother berates herself: What have I done wrong? Why do I not understand? These self-interrogations punctuate each series of documentation in the form of Lacan's formula S over little s. But like the melancholic's complaints these self-criticisms produce insight and new knowledge. For while the laments signal the mother's 'failure' they also release her, as is proper to allegory, from the essentialism of femininity as maternal and natural, and opens up the possibility of envisioning the mother differently. The mother is redeemed, not by a miracle, but by the hope of political change.

By making the mother's loss visible in *Post-Partum Document* Kelly does not go away empty handed, but counters Benjamin's theoretical impasse, allowing the possibility of a critical practice that overcomes melancholia without losing the redemptive relation to the thing.

Notes

1 Julia Kristeva's notion of the 'subject in process' counters the unified subject of the transcendental ego as a model for the subject of signifying practices. It is a concept which Kristeva associates with the rupturing and transformative operations of the modernist text and the Freudian discovery of the unconscious: '[...] one would then be led to think the history of signifying practices from a starting point that would no longer be that of stability but of the place at which a society produces its subjects as subjects in process, who declare their anxiety in order to transform the discursive ensemble of the community'. J.Kristeva, 'Signifying Practice and Mode of Production,' *Edinburgh Magazine* no. 1 (1976): 73.

2 Subsequent installations are *Interim* (1984-89), *Gloria Patri* (1992), and *Mea Culpa* (1999).

3 See the bibliographies in Kelly (1996) and Iversen et al. (1997).

4 Joel Fineman has argued that the structural linguistics of Lacanian psychoanalysis is an extension of the classical tradition of allegory; Lacan's definition of the unconscious as 'the discourse of the Other' is a direct translation of the etymology of allegory (Fineman 1980, 62).

5 'But is not pathos to some extent the regal natural sound of the Trauerspiel?' (Benjamin 1998, 205).

6 Christine Battersby has demonstrated the historical link of melancholy with a model of artistic genius unrelentingly gendered male in *Gender and Genius* (1989, 84).

7 'But it is said of God after the creation: "And God saw everything that he had made, and, behold it was very good". Knowledge of evil therefore has no object. There is no evil in the world. It arises in man himself [...]' (Benjamin 1998, 233).

8 Joel Fineman argues that the structural linguistics of Lacanian psychoanalysis
 is an extension of the classical tradition of allegory, and that Lacan's definition
 of the Unconscious as the 'discourse of the Other' is a direct translation of the
 etymology of allegory. Fineman discerns a correlation between the double
 register of allegory – its literal meaning and the 'other' meaning that it points
 to – and what Lacan reveals as the split in the psyche when it learns to speak.
 This split (S/s) is the foundation of Lacan's theory of the subject, and his
 dictum: the unconscious is structured like a language (Fineman 1980, 62). See
 also Weigel 1996, 102 for a discussion of modern allegory and the structure of
 the unconscious.
9 Madelon Sprengnether interprets the fort-da story as a memorialization of the
 mother. *The Spectral Mother: Freud, Feminism, and Psychoanalysis*, Cornell
 University Press, 1990, 135.

Chapter 9

Feminism, Postmodernism and the Aesthetics of Parody

Catherine Constable

This chapter will examine the relation between postmodernism and feminist aesthetics by addressing the work of Jean Baudrillard and Judith Butler. Baudrillard's extreme nihilistic position has fed into the popular conception of the postmodern as cynical, indifferent and apolitical.[1] I will demonstrate the ways in which the philosophical model expounded in *Simulations* (1983) would undermine the very possibility of a feminist aesthetic by focusing on the accounts of signification and power. I will argue that Butler offers a way out of Baudrillard's nihilism in that her sophisticated analysis of the generative nature of power structures in *Bodies That Matter* (1993) can be seen to underpin more complex models of signification, subjectivity and social relations. Indeed, the contrast between Baudrillard and Butler is intended to demonstrate that the attempt to develop a version of feminist aesthetics is reliant upon a differential account of power relations. These relations, in turn, construct norms and standards which support and sustain traditional aesthetics. The numerous and diverse projects of feminist aesthetics derive their impetus to theorise from their relations to such norms, offering ways to deconstruct the tradition, or to create new aesthetic paradigms, or to develop different histories.

The vexed question of the relationship between feminism and postmodernism has been explored in detail elsewhere (Nicholson 1990). In contrast to those theorists who are suspicious of the postmodern (Di Stefano 1990, Harding 1990), I am concerned to demonstrate that Butler's version can be used to generate a feminist aesthetic. Both Baudrillard and Butler offer philosophical systems that are imbued with aesthetic concepts and as a result the aesthetic projects that their works sustain can only be understood by addressing their overall positions. I will therefore be

offering an analysis of each theorist's philosophical position before drawing attention to its aesthetic implications. This will ensure that the differences between their deployment of similar arguments are made clear. Importantly, both Baudrillard and Butler make use of the concept of parody, defining it as a key feature of the hyperreal and the performative respectively. I will outline the ways in which Butler's take up of parody differs in *Gender Trouble* (1990) and *Bodies That Matter* in order to argue in favour of a definition that combines elements from both works and therefore conjoins the comic and the subversive.

This essay will begin with an examination of Baudrillard's definition of the postmodern as a mode of capitalist excess which results in the annihilation of power and meaning. I will argue that Butler offers an alternative to this apocalyptic vision in which anything goes because her model of the postmodern uses a Foucauldian conception of power as generative. As a result, the continual play of power in relation simultaneously underpins and undermines the creation of normative standards. For Butler, the unstable and provisional nature of both power and language can be mobilised to create potential sites of resistance. I will argue that her attempt to delineate the possibility of 'affirmative resignification' (Butler 1993, 240) can be seen to rely on a model of re/reading that can be taken up to form the basis of a postmodern feminist aesthetic. I will demonstrate the ways in which this model of re/reading would work by offering an analysis of Gus van Sant's film *To Die For* (1995) in the final part of the paper.[2]

Part One

Baudrillard's presentation of the postmodern as excessive conjoins an analysis of capitalism with an account of signification. In both cases, the move into an economy of excess is related to the rising dominance of the image. In *Simulations*, he argues that the traditional concept of capital destroys the notion of an objective reality by setting up an economy in which all objects become equivalent. 'For, finally, it was capital which was the first to feed through out its history on the destruction of every referential, of every human goal, which shattered every ideal distinction

between true and false, good and evil, in order to establish a radical law of equivalence and exchange, the iron law of its power' (Baudrillard 1983, 43). Capitalism is said to re/create the world as a closed system of signs. However, this annihilation of objectivity is partially concealed by the introduction of the criteria of 'use value' as a mode of regulating exchange. The criteria of functionality are said to sustain the last vestiges of the illusion of referentiality - the usefulness of the object 'itself' (ibid 43). However, the concept of use value is obliterated by massive overproduction of goods and the rise of advertising. The huge quantity of goods and services creates an economy in which goods are sold as image, obliterating any referential reality and re/creating the world as pure simulacrum - the hyperreal.

The loss of objective reality undermines any concept of facticity as well as annihilating the structures of difference. There are no objective criteria for judging the distinction between true and false or good and evil. Baudrillard makes use of the image of the circuit in order to convey the exponential proliferation of meaning that characterises the hyperreal. 'Facts no longer have any trajectory of their own, they arise at the intersection of the models; a single fact may even be engendered by all the models at once. This anticipation, this precession, this short-circuit, this confusion of the fact with its model [...] is what each time allows for all the possible interpretations, even the most contradictory - all are true, in the sense that their truth is exchangeable, in the image of the models from which they proceed, in a generalised cycle' (ibid 32). The overproduction of meaning is both a 'cycle' and a 'short-circuit', both an unlimited exponential movement and a null point. Baudrillard occasionally attempts to present this proliferation as positive (ibid 75 footnote 4); however, the continual juxtaposition of meaning proliferation and the end of meaning that occurs in *Simulations* has the effect of undermining the variety of interpretations available. Ultimately, all readings are the same; they are all interchangeable and therefore meaningless.

Baudrillard argues that the circular discourse of the hyperreal undermines models of difference and therefore extinguishes traditional conceptions of power. 'Thus there is no longer any instance of power, any transmitting authority - power is something that circulates and whose source can no longer be located, a cycle in which the positions of the dominator and the dominated interchange in an endless reversion which is also the end of power in its classical definition' (ibid 77 footnote 7). Within the circuit the

hierarchical positioning of the dominator over the dominated is overturned once the former is seen to be created and sustained through the acknowledgement of the latter. Any attempt to interrogate authority is thus presented as a kind of conversational impasse since the position of the interlocutor (the dominated) is always already contained within the response of the dominator. 'From now on, it is impossible to ask the famous question: [...] 'From where do you get the power?', without immediately getting the reply: 'But it is *of* (from) you that I speak' - meaning it is you who speaks, it is you who knows, power is you' (ibid 77-78 footnote 7). Importantly, the gesture towards a generative model in which the subjugated also create and sustain power is simply presented as the end of the traditional model of authority. Thus, for Baudrillard, once power ceases to be a set of prohibitions imposed from above, it ceases to exist.3

For Baudrillard, the postmodern is created through the annihilation of the real which results in the destruction of meaning and power. The hyperreal is also said to destroy traditional aesthetics in that the re/constitution of the world as image closes the gap between reality and the image that is the basis of traditional models of mimesis and representation. 'This is what Andy Warhol demonstrates also: the multiple replicas of Monroe's face are there to show at the same time the death of the original and the end of representation' (ibid 136). The possibility of serial duplication marks the end of the concept of an original art work as well as the end of an original that is copied. Monroe 'herself' becomes a play of images. This infinite proliferation of images constitutes both the end of traditional aesthetics and indefinite extension of the scope of the aesthetic. 'And so art is everywhere, since artifice is at the very heart of reality. And so art is dead, not only because its critical transcendence is gone, but because reality itself, entirely impregnated by an aesthetic which is inseparable from its own structure, has been confused with its own image' (ibid 151-152).

The ubiquitous nature of the aesthetic is presented as both destructive and comic. In a world become art, an aura of 'non-intentional parody hovers over everything' (ibid 150). The fakeness of the hyperreal is comic in itself. However, the artistic projects that it engenders provide further opportunities for laughter. Baudrillard argues that cinema, along with

other art forms, demonstrates an attempt to break out of the cycle of images by returning to the real. This is said to be 'the maddest of enterprises' in that the attempt to return to the real simply results in the perfect reproduction of the real in the cinematic image and therefore sustains the hyperreal (Baudrillard 1993, 195). The second project is a straightforward continuation of the dynamic of the hyperreal in which current films feed off previous filmic images. 'Cinema plagiarises and copies itself, remakes its classics, retroactivates its original myths, remakes silent films more perfect than the originals [...]' (ibid 196). Both projects operate as a continuation of the hyperreal, yet each offers different opportunities for laughter. In the first, the attempt to recreate the real in itself is seen to be paradoxical and therefore laughable. In the second, the film remake offers a celebration of its own fakeness, mockingly foregrounding its status as a perfected copy in order to signify its own emptiness.

Baudrillard's account of postmodern aesthetics can be seen to be fundamentally inimical to any feminist project of re/reading. While he does not explicitly address the problem of reading texts, it is clear that any practice of critical reading would fall into the same modes of overproduction as the attempt to ascribe significance to events. A diversity of textual readings would simply demonstrate the multiplicity of critical models available. The differences between the readings would be subsumed by their equivalent status as readings, ultimately resulting in a cancellation of meaning. The chain reaction overproduction/ equivalence/ cancellation means that any feminist project of re/reading texts would be rendered useless. Any attempt to mobilise the play of signification for political ends is always already encoded as an empty gesture.

The problems with Baudrillard's aesthetic arise out of his wider philosophical model. The drive towards equivalence which underpins his analysis of both capitalism and power creates a system that is devoid of any concept of difference or inequality. The key move is the loss of an objective reality which is said to render everyone equivalent as simulacra. However, the argument that truth can no longer function as an objective standard, or that power does not work in a straightforwardly hierarchical way is not synonymous with the annihilation of all concepts of truth or power. Baudrillard's nihilism is thus reliant on very traditional forms of definition. Moreover, the loss of objective standards does not mean that normative definitions of what has passed for truth cease to be effective. It

simply means that the efficacy of these definitions is derived in a different way. Creating a space for a postmodern feminist aesthetic can therefore be seen to necessitate more complex analyses of both power and signification.

Part Two

Butler's account of performativity can be seen to utilise a number of similar strategies to Baudrillard's model. Like Baudrillard, she provides an account of signification as excessive and an analysis of the doubleness of generative power structures. She also makes use of the concept of parody, offering different definitions in her early and later works. I will demonstrate the ways in which the sophistication of Butler's position undermines Baudrillard's nihilism and provides a way of mobilising features of the postmodern for political ends. I will begin by outlining Butler's position and will go on to draw attention to the ways in which her use of parody has changed. I will demonstrate the ways in which her work can be used to generate a feminist aesthetic in part three.

Butler's analysis of interpellation in *Bodies That Matter* can be seen to demonstrate her accounts of signification and power. In Althusser's account of interpellation, the policeman (the representative of the law) instigates the process through which the subject is created. The policeman's act of hailing, the call 'Hey you!' is both the moment at which the subject is recognised and the moment in which s/he is positioned as subject to the law and inscribed within a social domain (Butler 1993, 121). Butler comments that the call itself is a performative in that the words perform an action, creating the subject that they address. She goes on to argue that the address 'Hey you' which clearly seeks to incorporate the subject within the structures of the law also generates a range of disobedient subjects.[4] The production of the unlawful through the operations of the law itself show that the structure of interpellation, the mode of linguistic address, is subject to an inherent slippage. 'Interpellation thus loses its status as a simple performative, an act of discourse with the power to create that to which it refers, and creates more than it ever meant to, signifying in excess of any intended referent' (ibid 122). Butler goes on to argue that the structure of interpellation can be seen

to underpin the social designation of gender. The comment 'It's a girl' can also be seen as a performative, it 'initiates the process whereby a certain "girling" is compelled', creating what it purports to describe (ibid 232). The designation of gender, 'girl', can be read as a command to conform to social standards of femininity and can therefore be seen to simultaneously evoke the possibilities of conformity and non-conformity (ibid 237). Importantly, Butler's account of a linguistic excess which ensures that performative commands can have contradictory effects is not a simple celebration of pluralism. She does not enter into the short-circuit of overproduction/equivalence/cancellation that characterises Baudrillard's model. While both theorists recognise the possibility of multiple and contradictory interpretations, Butler retains a sense of legitimate and illegitimate readings or responses.

The distinction between different types of readings is possible because Butler's account of excess is fundamentally different from Baudrillard. For Baudrillard, the move into overproduction creates a surplus which annihilates the economic model. The corresponding proliferation of images and meaning is also mapped as an excess beyond the system and may therefore be said to constitute the hyperreal as a pure space, albeit a negative and apocalyptic one. For Butler there can be no such thing as the excess of excess, indeed the postulation of a pure space is simply said to be naive. Excess is always already a part of the way in which a system functions. As a result, the recognition of a space of ambivalence does not annihilate the law. Instead, that recognition alters the sense of the ways in which the law operates. The law can no longer be seen as an objective reality which is continually imposed on its subjects. It becomes a provisional structure that is always in the process of being made and remade (Butler 1994, 36). On Butler's model the law itself is subject to the subject's response, its continual re/production as law is reliant upon the subject's re/enactments of its commands. The legitimate response may therefore be seen to both legitimatise the subject and the law itself (Butler 1993, 265 footnote 34).

The self-reflexive structure of Butler's account of the exchange between the subject and the law can be compared to Baudrillard's analysis of power as a cycle of reversible positions. On Baudrillard's model, the circuit marks the end of any interaction with authority, the questioning subject receives the reply 'power is you' (1983, 78 footnote 7). The reply presents the subject as the creator of the structures of authority and is said to signal

the destruction of power itself. For Baudrillard, the structures of authority must be absolute or they cease to function. Butler's account of the law as a provisional, historical structure may therefore be seen to undermine Baudrillard's key move in which the collapse of traditional definition simply results in a state of equivalence. Butler undoes the spiral of nihilistic logic by using the first move, the loss of a traditional definition of power, to propel a re/consideration of the nature of power. Her Foucauldian analysis of power as a generative structure may therefore be seen to offer a way out of Baudrillard's nihilism.

Butler's analysis of gender as performative expands her account of the productive interrelation between the subject and the law by linking it with the concepts of the parodic and the fake. This link is expounded differently in *Gender Trouble* and *Bodies That Matter* and I will explore both versions, drawing attention to the changing role of parody. Butler's account of gender as a series of re/enactments of normative ideals remains constant in both works. The social designation of gender creates a subject 'who is compelled to "cite" the norm in order to qualify and remain a viable subject' (Butler 1993, 232). The subject is therefore continuously re/engendered through a 'compulsory citationality' (ibid). While the subject has no option other than to site/cite itself in relation to gender norms, the mode of citationality that s/he mobilises can either reinforce or deregulate the norm. In *Gender Trouble* Butler argues that all modes of citationality can be regarded as intrinsically parodic. She revises this position in *Bodies That Matter*, arguing that parody only occurs within the deregulative mode of citationality.

In *Gender Trouble*, Butler focuses on the ways in which the gendered re/enactments of heterosexual subjects serve to legitimate normative ideals and yet always fall short of those ideals. She argues that this constitutive failure to instantiate the Lacanian ideals of being or having the phallus is the result of their status as discursive positionings. 'Every effort to ·establish identity within the terms of this binary disjunction of 'being' and 'having' returns to the inevitable 'lack' and 'loss' that ground their phantasmatic construction and mark the incommensurability of the symbolic and the real' (Butler 1990, 44). As a result, heterosexuality may be said to reveal itself as both a 'compulsory law' and an 'inevitable

comedy' (ibid 122). In a wonderful riposte to Lacan's analysis of the tragic nature of the structures of lack and loss which undermine the possibility of full identification, Butler celebrates the intrinsic failure of the norms (ibid 55-57). 'The loss of the sense of "the normal", [...] can be its own occasion for laughter, especially when "the normal", "the original" is revealed to be a copy, and an inevitably failed one, an ideal that no one *can* embody. In this sense, laughter emerges in the realization that all along the original was derived' (ibid 138-139).

The account of the loss of original gender ideals which results in every re/enactment of gender being positioned as bad copy can be seen to follow the same logic as Baudrillard's hyperreal in which the loss of the original founds the era of simulacra. This similarity is not surprising given Butler's references to Jameson's definition of pastiche as blank parody in her account of gender (ibid 138, 146). Jameson's concept of pastiche is a re/working of Baudrillard's analysis of the 'non-intentional parody' that is said to characterise the hyperreal.[5] Both Baudrillard and Butler can be seen to use parody as a means of mocking the notion of an original and of celebrating the fakeness that characterises the bad copy. However, Butler's account of gender parody is fundamentally grounded within her analysis of power as generative. As a result, becoming bad copy is not seen to erase differences between copies because normative social structures are still in play. 'Parody by itself is not subversive, and there must be a way to understand what makes certain kinds of parodic repetitions effectively disruptive, truly troubling, and which repetitions become domesticated and recirculated as instruments of cultural hegemony' (Butler 1990, 139).

Butler's later work, *Bodies That Matter*, takes up her distinction between subversive and regulative modes of citationality and positions the parodic on the side of the subversive. Butler's account of the range of disobedient subjects produced by interpellation links parody and hyperbole: 'where the behavioural conformity of the subject is commanded, there might be produced the refusal of the law in the form of the parodic inhabiting of conformity that subtly calls into question the legitimacy of the command, a repetition of the law into hyperbole, a rearticulation of the law against the authority of the one who delivers it' (1993, 122). In this case, parody is linked to the Irigarayan strategy of overmiming, a repetition in excess, which creates space for re/signifying the terms of the law (ibid 124). Butler goes on to argue that this re/signification can result in the re/deployment of terms that have been used to designate the subject as

abject, using the example of the current redeployment of the term queer by gay political groups. 'This kind of citation will emerge as *theatrical* to the extent that it *mimes and renders hyperbolic* the discursive convention that it also *reverses*' (ibid 232). The theatrical nature of the citation exposes a homophobic law that cannot control its own terms.

The subsumption of the parodic within the hyperbolic in *Bodies That Matter* marks an important departure from Butler's earlier use of parody. In *Gender Trouble*, the parodic is used in a classical sense, it is always associated with the comic (Rose 1993, 25). Butler presents laughter as a political tool, commenting in the preface that 'laughter in the face of serious categories is indispensable for feminism'.[6] The re/working of Lacan that underpins Butler's re/presentation of gender in *Gender Trouble* can be seen to make use of the traditional fusion of parody and comedy while also conforming to her later definition of parody as subversive. On the Lacanian model the constitutive failure of identification is said to mark 'a religious idealisation of 'failure', humility and limitation before the Law,' which consolidates the power of the Law and gives the system the structure of religious tragedy (Butler 1990, 56). Butler's use of this failure to sustain a comic appreciation of gender as parody is thus more than an inversion of Lacan because she significantly rewrites the status of the law, reducing it from an imperious Old Testament power to a 'perpetual bumbler'(ibid 56, 28). *Gender Trouble* itself can therefore be seen to significantly re/deploy the terms of the Lacanian system, creating a parodic recitation that is both comic and subversive. The laughter that is provoked by this is more than a mocking celebration of fakeness, it becomes the *joie de vivre* that accompanies the practice of strategic deregulation.

I have drawn attention to the fusion of the subversive and the comic in Butler's early practice in order to retain a sense of the ways in which the re/deployment of the terms of the dominant culture can be both gleeful and celebratory. *Bodies That Matter* repeatedly focuses on the ambivalence that is involved in any deregulative citation in that the subject is always already positioned through the discourses s/he seeks to oppose. 'Performativity describes this relation of being implicated in that which one opposes, this turning of power against itself to produce alternative modalities of power, to establish a kind of political contestation that is not

a 'pure' opposition, [...] but a difficult labour of forging a future from resources inevitably impure' (Butler 1993, 241). While the attempt to 'make over the terms of domination' must be a partial and difficult one, Butler appears to have lost sight of the enjoyment that can arise from the practice of redeployment (ibid 137). This is important because the very concept of 'affirmative resignification' is reliant upon making over terms which have invalidated the subjects that they created (ibid 240). The move from invalidation to validation can be seen to offer a kind of *joie de vivre*, literally a joyful mode of living, that is made possible through the creation of the re/worked spaces.

Part Three

Butler's definition of performativity as a political re/configuration of the terms of domination is reliant upon the possibility of re/reading. In *Bodies That Matter*, she extends her reading strategies into the realm of aesthetics by offering analyses of particular filmic and literary texts. This practice can be seen to create an aesthetics of affirmation in that the reading brings to the fore the ways in which the texts destabalise and appropriate the terms of dominant culture. While Butler does not regard the few Hollywood films that she references in *Bodies That Matter* as subversive (ibid 126), I have chosen to apply her practice of re/reading to a Hollywood product because her system is based on the possibility of reclaiming impure spaces. The films of the Hollywood studios clearly serve to create the 'sanctioned fantasies, sanctioned imaginaries' that reiterate normative gender ideals (ibid 130). Feminist theorists such as Laura Mulvey and Kaja Silverman have analysed Hollywood as a closed system which serves to reproduce patriarchal constructions of gender.[7] I want to use Butler's model of re/reading in order to open up the possibility of exploiting recitations/representations of gender ideals that are excessive, problematic and unsettling.[8] I will demonstrate that Butler's analysis of the provisional nature of subversion as a strategic re/deployment that can occur in a series of moments is an ideal framework with which to tackle Hollywood cinema.

To Die For is a dark comedy about the media saturation of American society. The film is largely set in Little Hope, New Hampshire, and charts the rise and fall of the media obsessed small town blonde beauty, Suzanne Stone. The film begins with a media stampede to interview Suzanne as she

is arrested for the murder of her husband, Larry Maretto. It cuts between a later series of monologues to camera done by Suzanne, media interviews with her family and her in-laws, and flashbacks to reconstructions of past events. In chronological order the events of the film are as follows. Larry Maretto notices Suzanne when she comes into his parents' restaurant. The pair date and marry, going on honeymoon to Florida. While Larry is off deep sea fishing, Suzanne goes to a national broadcasting conference and has an affair with a chat show host. On returning to Little Hope, Suzanne gets a job as a Girl Friday at her local cable station and persuades her boss to allow her to perform on camera as the weather girl. She also persuades him to allow her out with a camera to make a documentary about disaffected youth at the local school. She forms friendships with three pupils who sign up to do her documentary: Lydia, Russell and James. Larry expresses doubts about Suzanne's career prospects and she begins an affair with James, persuading him and Russell to murder Larry. The lads commit the crime and are instantly arrested and Suzanne is later charged with murder. She eludes conviction and goes free until she is murdered by an assassin who has been hired by Larry's parents.

The format of the film juxtaposes Suzanne's monologues with interviews with her family and in-laws, creating a multiplicity of different perspectives. Suzanne's video diary does not operate as the voice of truth. In it she styles herself as a member of the professional media whose husband was very supportive of her career, a version of events that is clearly at odds with the flashbacks. The multiple perspectives give rise to inconsistent descriptions of Suzanne. She becomes the intersection point of a variety of sanctioned fantasies of femininity: from pure virginal daughter to scheming seductress. What is important is that all her roles are reliant on concepts of beauty and appearance, clearly feeding off the normative ideal in which woman is defined as desirable object.[9] My reading of *To Die For* will examine Suzanne's roles in more detail and will consider how far she succeeds in making over patriarchal definitions of femininity.

The first fantasy of femininity that Suzanne plays out is that of the pure blonde woman as icon of desirability. Janice sums up Suzanne's appeal to her brother Larry saying: 'He coulda had anybody, basically that's what I'm saying - but I dunno - Suzanne - blonde - I dunno.' There are two

flashbacks of Larry's first meetings with Suzanne during the course of Janice's interview. The second flashback consists of a medium long shot of Suzanne standing in front of a beige car wearing a blue and white check dress. This is followed by a long shot of Larry in his black jeans and black leather jacket revving his outsized black and silver motorbike in front of his parents' restaurant. The use of costume in the two shots references the 1950s and the hackneyed sexual iconography sets up a parody of the traditional pairing of the nice girl and the bad boy from the wrong side of the tracks. The juxtaposition of shots also feeds into the Hollywood iconography of romance. The desirable female is presented as a vision of light: Suzanne's blonde hair and pastel clothing; while the desiring male is represented through the use of darkness: Larry's black hair, jacket and jeans.10

The overt nature of the 1950s references and Hollywood tropes of romance means that the second flashback can clearly be seen to conform to Baudrillard's conception of parody. In this short sequence, cinema plagiarises and copies itself. The film foregrounds its status as a Hollywood film by overplaying the tropes that it references. The multiple constructions of Suzanne's blondeness also sustain other cinematic and literary references. Larry positions Suzanne as fragile and innocent, comparing her to the 'porcelain figurines' that his mother collects. He also comments that her pure exterior conceals depths of desire, thus referencing the famous Hitchcock blonde: icy exterior and volcanic interior. Janice's impression of Suzanne is different. She describes her as: 'Four letters beginning with 'c' [...] cold!' The joke line indicates that she meant to say the word 'cunt' and therefore conjoins a slang reference to sexual availability with a lack of emotion. Her other title for Suzanne is 'The ice-maiden', constructing her as a younger version of the Snow Queen.

Within Baudrillard's system, the different readings of Suzanne simply display the diversity of models available, ranging from Hitchcock to fairy tales. The multiplication of perspectives through the film's use of media interviews indicates that it can be read as a parody of the very process of interpretation. While the Baudrillardian reading recognises the comic aspect of the endless proliferation of perspectives, it fails to consider a central issue namely: why should this parody of interpretation centre around the figure of a woman? Larry's and Janice's perspectives can be seen as fundamentally interrelated, they expose different aspects of the cultural equation of blondeness and desirability. Larry follows the norm,

the blonde is seen to be the most desirable because she represents ethnic and moral purity.[11] Janice's perspective skews the sanctioned fantasy of the blonde, transforming her 'purity' into a cold, manipulative aspect. The excessive proliferation of perspectives is based on the continual making over of cultural definitions of femininity and can thus reveal instabilities within the normative definition.

I do not want to suggest that all the parts that Suzanne is seen to play are equally radical. Her presentation in the second flashback to the national television conference constructs her as a 'dumb blonde', a sanctioned fantasy of desirability that clearly reiterates the norm. Suzanne attracts the attention of the main speaker at the conference, a chat show host, who gives a speech on the importance of television in global communications. Later, he tells Suzanne an apocryphal story about a small town weather girl who had made use of an introduction to him in order to break into national television. The story goes that the girl had dressed up in her 'best Donna Karen dress-for-success knock-off', done her hair up in a French twist and produced a letter of introduction from her imitation leather briefcase. The letter described her as moderately intelligent and able but extolled her skills at giving oral sex. On testing her ability, the speaker recommended her for her first job and she went on to become famous. Years later, he met up with the local station boss who wrote the letter, only to discover that it was a forgery. Suzanne's wide-eyed incomprehension as to who could have written the letter sets her up as the dumb blonde and the chat show host has to spell out his punchline, telling her that the weather girl had written it herself.

The apocryphal story is clearly designed to get Suzanne into bed. However, the scenario is given a further comic twist in that she responds to the story as though it were serious career advice. Suzanne arrives for an interview at her local cable station dressed in a yellow and white check Chanel knock-off, with her blonde hair in a French twist and carrying a pale blue imitation leather briefcase. She also toys with a letter throughout the interview, eventually deciding not to hand it over to the obese station manager. As she is departing, there is a cut to a medium shot of her and she launches into a reprise of the end of the speech she heard at the conference. There is a slow zoom into close up as she intones the tribute to

the global importance of television and the movement of the camera clearly underlines her blissful lack of awareness of her surroundings. Suzanne's grandiose delivery of the speech is clearly parodic in that it is utterly out of place in the context of the tiny office with two staff members. The parody is constructed through Suzanne's mimicry and the laughter arises from the blonde's inability to see that her speech is inappropriate.

Suzanne's mimicry sustains a multiple mode of citationality that is integral to the parodic structure of the film. Her video diaries display her attempts to style herself as a member of the professional media and her stunning pink lipstick and purple eye makeup are clearly a homage to 1980s power dressing. Suzanne explicitly references the female presenters that she copies and her overt mimicry may be said to foreground the imitative nature of subject construction. However, her status as bad copy cannot be mapped as straightforwardly radical. Butler's distinction between non-subversive and subversive forms of repetition in *Gender Trouble* is clearly played out in *To Die For*. Suzanne's status as bad copy is not subversive when it is subsumed within the dumb blonde persona. This can be seen in her mimicry of the chat show host's speech which is seen as an inappropriate re/citation and therefore serves to display her lack of competence.

The possibility of a subversive form of parody comes into play when Suzanne's imitations become multi-layered. This hyperbolic play of citationality begins in the flashback in which Suzanne gets James to offer to murder Larry. The film cuts from an interview with James in his cell to a scene in which the lovers have a conversation in a car during a thunderstorm. The film cuts between close ups of Suzanne's face and reverse shots of James' face. The conversation flows over the pattern of the editing until particular key moments. Suzanne tells James that Larry is abusive to her and she remains in shot as she unwittingly reveals the source of her story which is the Sally Jessie Raphael show on abused women that she has just seen on television. James suggests that she get a divorce and she refuses arguing that Larry will take everything. There is a cut to James as he says: 'A guy that does that to someone like you doesn't deserve to live'. This is followed by a close up of Suzanne's tear stained face. She looks intently at James, her pale face side lit from the right, creating dark shadows on the left side. The conversation has been accompanied by occasional chords of extra-diegetic music and the sounds of the storm. The

sound changes abruptly to guitar music which is presumably playing on the radio. There is a cut back to James looking utterly perplexed as Suzanne responds to the song with glee and flings herself out of the car. This is followed by a medium long shot of Suzanne dancing in the rain, taken through the windscreen of the car. She flips the edges of her purple dress, her skin made even whiter by the glare of the car headlights. There is a cut back to a medium close up of James smiling at her which forms a retrospective POV and the film then cuts between shots of the pair of them ending with a shot of Suzanne turning around, arms outstretched as the rain falls.

Suzanne can be seen to play a series of roles during this complex flashback. She begins by performing as the abused wife, an overt imitation which is clearly designed to get a response from James. Suzanne's use of performance to inveigle her lover into offering to murder her husband mimics the actions of at least two famous *femmes fatales*: Phyllis from *Double Indemnity* (Wilder 1944) and Cora from *The Postman Always Rings Twice* (Garnett 1946). The use of the harsh side-lighting also reinforces the noir references. The flashback juxtaposes the *femme fatale's* manipulative use of her sexual allure with the dumb blonde's innocent enjoyment of her own desirability as Suzanne dances in the rain. The abrupt transition between the two roles cannot be seen as a return to her true character. The three POV shots of Suzanne dancing are replayed later in the film and clearly form the basis of James' memory of their relationship. Suzanne's whiteness in the car headlights and the purity suggested by the falling rain also feeds into James's repeated description of her as 'clean'. The flashback can therefore be seen to end with James' view of Suzanne while exposing his perspective to be partial and limited.

Suzanne's later actions re/present her as a hyperbolic construction in that she plays the dumb blonde mimicking the role of *femme fatale*. Her reprise of the *femme fatale's* subtle use of sexual wiles occurs in a scene in which she suspends giving James oral sex in order to motivate him into getting the gun! The blatant display of her methods and motives results in a *femme fatale* who is far from enigmatic. However, Suzanne's parodic reprise of the role has a further comic twist in that her utterly transparent attempts at manipulation are successful and James, Russell and Lydia conspire to commit murder for her. This success is important in that it changes the

context of the bad copy, the joke is no longer on Suzanne. Moreover, the hyperbolic construct of the dumb blonde as *femme fatale* operates as a subversive parodic construction in that it constitutes an illegitimate mobilisation of the normative definition of femininity as objectification. The designation of woman as the attractive object of desire is meant to sustain her subordination within the subject/object hierarchy. Suzanne's excessive mimicry serves to positively spell out the ways in which she mobilises desirability to undermine the power structures of the traditional heterosexual unit.

To Die For offers another way of making over the normative ideal of female desirability through references to narcissism. During the interview with Suzanne's family and in-laws there is a cut to some black and white home video footage of Suzanne as a child. The clip consists of a single shot which begins with Suzanne sitting in front of the television, her face turned away from the camera. As her father calls to her saying 'Who wants to be on T.V.?' she turns towards the camera and her movement is replicated on the television screen. The screen image is not a mirror, it is linked up to the video camera. Moreover, the television screen is a series of three screens, each inside the other, giving the impression of Suzanne's endless refraction into image. As the child looks back at the television her mother's voice can be heard approving her gesture. The home video footage clearly links Suzanne's aspirations to be on television with a childish narcissism. The parental voices clearly function as the mode through which a kind of 'girling' is compelled. They are seen to set up and approve of Suzanne's creation as a beautiful image. While the set up clearly plays into the normative definition of femininity as spectacle, Suzanne's recitation of femininity is also illegitimate in that she responds to the image as an end in itself. The illegitimate sense of becoming spectacle sustains her pursuit of a media career. Suzanne's repeated catch phrase: 'You're nobody if you're not on T.V. cos what's the point of doing anything worthwhile if nobody's watching', clearly shows her embracing the ideals of femininity while at the same time subverting the ultimate purpose of the display. This subversion reaches its comic climax at her husband's funeral. Suzanne chooses to play the song 'All by myself', using the funeral as an opportunity to steal centre stage.

At the end of *To Die For* the hired assassin murders Suzanne by drowning her in an icy lake. Janice is seen later, skating over the frozen surface, displaying her glee at having vanquished the ice maiden. The finale is

clearly comic, the joke being that the Italian family do conform to the Hollywood stereotype after all in that they are seen to have Mafia connections. The ending could be seen as a kind of containment in which Suzanne is finally brought under control by the patriarchal family unit. However, this closure does not negate the moments of subversion that are offered along the way. Indeed, I would argue that the violence of Suzanne's containment attests to the extent to which she succeeds in undermining patriarchal definitions of femininity. Suzanne's hyperbolic *femme fatale* and her narcissistic pursuit of media fame constitute deregulative citations of the normative definition of femininity as objectification. These moments are both comic and subversive in that they offer a parodic take up of the norm that pushes the definition to its logical limits and implodes it from within.

Butler's concept of affirmative resignification can be seen to sustain a feminist aesthetic that deploys the technique of re/reading in order to open up spaces of subversion using textual resources that are always, inevitably impure. What is important is that the model of reading that is offered is fundamentally non-teleological, enabling the articulation of a series of moments that have subversive potential, rather than being bound to a traditional holistic model of the text. Interestingly, Jeanine Basinger's feminist readings of classical Hollywood cinema and Jackie Stacey's analysis of female viewers' memories of female stars also address the text in terms of momentary fragments.[12] Butler can therefore be seen to provide an aesthetic model that supports and sustains these readings while simultaneously attesting to their social importance. The practice of re/reading holds open points of affirmation that resonate within the world text extending the possibility of validation to other readers/viewers. This gesture is always partial, subject to further readings and interpretations, yet it is important because it is also a movement towards the creation of different kinds of communities and social values.

Filmography
Garnett, T. (1946) *The Postman Always Rings Twice.*
Van Sant, G. (1994) *Even Cowgirls Get the Blues.*
Van Sant, G. (1995) *To Die For.*
Wilder, B. (1944) *Double Indemnity.*

Notes

1 See *Parody: Ancient, Modern and Post-Modern* in which Rose provides a table of negative and positive constructions of the postmodern. Among those listed on the side of the negative are: Baudrillard, Lyotard, Habermas and Jameson (1993: 198-205).

2 This paper will analyse *To Die For* as an example of a Hollywood film because it was made for Columbia studios and is seen to mark van Sant's transition to mainstream film making after the failure of *Even Cowgirls Get the Blues* (1994).

3 Probyn argues that the drive to equivalence that characterises Baudrillard's hyperreal is a form of epistemic violence that eradicates the other (1990, 183-184). My argument follows a parallel trajectory in that I am arguing that Baudrillard cannot map differential power relations.

4 Butler also comments that Althusser mentions the possibility of creating disobedient subjects but does not explore it (1993, 122).

5 (Baudrillard 1983, 150). Rose argues that Jameson's account of pastiche is heavily indebted to Baudrillard (1993, 216-217).

6 (Butler 1990, viii). She also discusses Foucault's analysis of laughter (1990: 102-104).

7 See Mulvey (1989, 14, 15) and Silverman (1988, 24, 31).

8 There are numerous examples of radical readings of Hollywood texts, such as Jeanine Basinger's analyses of the contradictory presentation of female protagonists in classical cinema (1993). However, the mode of re/reading that Butler can be seen to facilitate is significantly different to Basinger's in that the practice arises from an overarching aesthetic framework. I would suggest that Butler's feminist aesthetics could be taken up as a framework which provides a means of accounting for a number of the feminist re/readings that are available.

9 For a detailed analysis of the importance of appearance in cultural definitions and representations of femininity see Stacey (1994, 65-67).

10 Dyer provides a detailed analysis of the sexualised iconography of darkness and light in *White* (1997, 122-142).

11 For a detailed assessment of the racial connotations of the blonde as the paradigm of the beautiful and the moral see chapter 2 of *White* (Dyer 1997, 70-81). Stacey also addresses this issue (1994, 88-89).

12 (Basinger 1993, 10-13). See also Stacey's account of viewers' memories of female stars as a series of frozen moments (1994, 67).

Chapter 10

Cybertime: Towards an Aesthetics of Mutation and Evolution

Sean Cubitt

Cyberspace: at least we know what we're talking about. Cyberspace is a territory, Gibson's 'consensual hallucination', entered through portals and gateways, viewed through Explorers and Navigators, a dimension with its own geography of datastreams, homes, firewalls; where cybernomads roam the electronic frontier, whose orientations are back, forward and deeper. It is also, in the language of philosophical sociologies like those of Kittler (1990, 1997, 1999) and Virilio (1995, 1996, 1997, 2000), as in the technoboosterism of cybergurus, instantaneous or about to become so. The network universe only seems infinite from the inside: seen from Mozambique right now, I imagine it has shrunk smaller than the mosquito's larva that carries river blindness. But not all digital media are connected to the network, and not all outcomes are effectively spatial. This paper is a what-if scenario: what if the cybernetic media are not instantaneous? What if instantaneity and immediacy are ideologically fraught denials of time? What if the aesthetics of the new media were rethought as temporal evolution in a digital ecology, rather than the colonial discourse of a spatial frontier?

Although space has become a governing topos of cultural studies since the influential work of Harvey (1989) and important geographical and geopolitical work by scholars such as Massey (1992, 1993; see also Lury and Massey 1999) and Sassen (1991, 1994), time has been getting its fair share of attention outside the cyberculture zone in recent years. Julia Kristeva's best-known essay is probably 'Woman's Time' (Kristeva 1986), where she argues that women occupy both 'cyclical time' and 'monumental time', as opposed the time of history which she calls 'linear time'. Since the early 90s, a number of key studies have appeared, including Peter Osborne's *The Politics of Time* (1995). For film studies Deleuze's cinema books (1986, 1989; first pubished in 1983 and 1985), their commentators

and critics (among them Laura U. Marks 1994, Jonathan Beller 1995, 1998; David Rodowick 1997), Jonathan Crary's recent book on attention and reverie in late 19th and early 20th century France (Crary 1999), Lorenzo Simpson's work on time and technology (Simpson 1995), Virilio's dark forebodings about the end of human scales of time perception (for example Virilio 1998): all of these and others are rethinking the nature of time in cinema and cognate areas. I would like to add my two cents worth with a suggestion first that time in the digital era is different again from the times of the pioneer cinema or of classical film addressed by Crary and Deleuze (1986, 1989) – so much so that it is worth going back once more to rewrite the history of cinematic time from the standpoint of the moving present, not in the interests of proving a better system, but to add to the palimpsest of film history another layer whose codes are pixels, cuts and vectors rather than the photographic codes that Metz taught us to foreground before the digital invaded. Far from jettisoning the 20th century, I want to learn from it, but to do so in the spirit of an accelerated modernity which does not allow scholars, activists and creators the luxury of fossilising conceptual frameworks. Time is changing as the times change, and the nature of that change has something to do with our machines. Unless you believe that history ended with the non-appearance of the Y2K bug, the fatal crash that was not and did not, talk about cybertime is necessarily historical talk.

That is one cent. The second concerns the claim that there might be something ontological about the nature of time, or about an interest in it in the first years of the 21st century. I put into play here a vague schematic I pencilled out a few months ago, according to which the 1960s was the last era of ontological media speculation. MacLuhan as *maître-à-penser* for example took the media as ontological entities, and applied an informational paradigm that spread from its 1940s scientific base into the art and practice of makers and theorists as an enquiry into the reality of its objects. In the wake of the May Events of 1968, the turbulent specialisms of 1950s structuralism spilled into the general culture as an epistemological question concerning what and more specifically how we know. In the 1980s, where things begin to get fuzzy, a phenomenological turn shifted us towards an enquiry, tempered in the fires of cognitive anti-psychologism, into the cinematic body and the nature of experience. My sense, wilful perhaps, is that by the mid 1990s there was a return to the ontological questions raised in the 60s. In some key feminist works of the 1990s, notably those by Sobchack (1992), Morse (1998) and Hayles (1999), issues of embodiment and mediation become the core questions for a rethinking of information paradigms in terms that place the historicity and mediated nature of gender and communication centrally in the functioning of

communication. Unlike MacLuhan, this time instead of taking communication as object, communication is taken as premise, and the core concern is with the processes of mediation through which we construct and inhabit our realities.

That reality is constructed does not alter its reality. Symbolisation structures the real – by exclusion. So the real is left out, a remainder, unspoken and unspeakable. There is a politics to this of course, as to any exclusion, and it is all the more urgent for occuring in a newly globalised network of symbolisation that now entirely embraces the world's financial transactions as symbols in a universal currency from which the poor are expelled into the hell of the real. But the real is not synonymous with reality. There is nothing immaterial about symbolic effects of global finance markets and their excluded real (see Castells 1996: 106-147). The ontological turn of the last few years is an enquiry into how we arrived at our communicative world, what it looks like now we are here, what it can become. Temporality is only one aspect of the reality that we confront, but it is a telling one, I think, and can maybe lead us towards some interesting questions.

The preamble now preambulated, we can turn to some novel modes of time associated with the new media. First and foremost - in fact this may be the only thing I have to say which is worth remembering - there is no such thing as instantaneous communication, at least not in my species. The question for the digital media is no longer about how media represent or misrepresent the world. That is a question for the photo-mechanical era, and one that leads all too easily towards the dead-end nihilism of Baudrillard's recent writings (especially Baudrillard 1996). The purpose of media is not to picture or describe an external universe but to mediate. Mediation is the materiality of communication. It describes the necessary interposition of some physical process in the commerce that binds us as a species. There is no immediate communication except telepathy: only in sharing another's mind could we communicate without mediation. Such, for example, would be the dream of sex without gender, since gender is the unnerving mediant between partners in the act of love, the material of their understandings and negotiations. The theme of disembodied sex associated with the anonymity of networked communications is then a dream of telepathy, parallel to the instantaneity ascribed to computer-mediated communication, and like it a dangerous mirage. The immediacy that Negroponte (1995) dreams and Virilio fears is a will o'the wisp. All mediation takes time.

There is a measurable duration to physiological processes in the nervous system and the brain that intervene between perception and cognition. There are physical constants that govern the maximum speed of the promulgation of electromagnetic waves. More importantly perhaps there are limits to the attentiveness of the contemplating mind that place constraints on the speed of thought. In communication, it is not enough to receive (that word belongs to the 1960s paradigm of communication analysis, not to the ecological imaginary of emergence that now gives us our model for both neural processing and global communication: see Dennett 1991 and Mosco 1996). We have to understand, which implies interpretation, which in turn implies weighing alternate interpretations. Often enough it implies misinterpretation in the processes of translation which are to the new ontological paradigm what transmission was to the old. Across and between cultures and subcultures, across the differences of sexuality and gender, misinterpretation leads to negotiation and dialogue, the only grounds we have available for a radical democracy. Democracy too lies counter to efficiency. All of this takes time. The idea that an image, let us say, can be transmitted instantaneously, that an eye can take it in instantaneously, that in the same instant a perfectly receptive mind can receive the image as pattern, recognise it as an object and provide it with a name: this is simply too much. Mediation can be fantastically rapid but it can never be instantaneous. Most of the time it is pretty slow, even on a person to person basis. If we take into account the industrial timescales of production and the activities of interpretation and enjoyment that entertain fan cultures, to take a simple and familiar example, we are not discussing a Husserlian *Augenblick*, the blink of an eye in which perception matches the velocity of the world: we are talking about processes that accumulate in time, acquire their specific characters as temporal events in and of time, and whose reality, in short, is temporal.

There is a philosophical question here, as to whether this kind of time is intelligible. Actually there is a question as to whether time itself is intelligible. I was interested to read in the 26 Feb 2000 issue of *New Scientist* that a theory of the emergence of the universe from random noise proposed by two Australian researchers is the first to offer a physical account of the present (the idea is that since this random generation is ongoing, the present is the moment at which we do not know what happens next). It seems the humanities are not alone in this dilemma. The physicists of course work on the principle that if time exists as a property of the physical universe, then it remains to science to render it intelligible. My proposal is slightly different: it is that time exists as a raw material, but that in different epochs we have learnt to manipulate it in different ways. Just as

we have learnt to make art from the irreducible drives of sex and hunger, arts of love and cuisine, of desire and satisfaction, so that today neither lust nor hunger can be experienced as they might have been by our distant ancestors or even our most recent forebears, so time is no longer the raw aggression of mortality that the early Heidegger tried to retrieve from the ancients, but a complex and to some extent biddable quality of life that we have altered and continue to remake, albeit not under conditions of our own choosing (Marx was speaking of history, of course, but what is history if not the raw material of time?). In the same way that fire and clothing altered eating and fucking, so, as the form of our mediations alters, the temporalities we have both to use and to create alter too.

What then has the digital era brought us? One characteristic experience is render time – seen from the other end of the production process we can call the same phenomenon download time. You build a wireframe model on your desktop, a process which the verb already describes in terms inherited from the time-based work of traditional modelling with physical materials. You select surfaces, lighting effects and camera positions, try a few options, select a view and render it as a bitmap. Even to load this onscreen can be a time-consuming experience. Happy with the result, you dump the frame, or a sequence based on it, to digital video. You sit back. You make a cup of coffee. You saunter next door and see what they are up to. You check the render progress. You decide maybe this is a good time to make a few calls, perhaps catch a bite to eat. The hard drive is still whirring when you get back.

Some days later, after the sequence has been uploaded, your chums log on to see what you have produced. Even a Firewire connection is not going to stream your video in real time. The remote machine begins a download. A dialogue box appears telling them what progress is being made, how speedily it is doing its task, how much time remains. On my machine, the Time Remaining line is the most entertaining, jumping from three minutes to less than a minute to two minutes and then up to four If we are to believe the halcyon cry of push media - the televisualisation of the web - download time will become a thing of the past. Shame, I say. This is the last redoubt of labour time, the time that speaks of the time of making. The delay is itself an integral part of web traffic and file transfer protocol and has been since the early days of mainframe time-sharing. The staggering speeds of even desktop machines and the ubiquitous impression that Moore's Law (which states that processing doubles in power and halves in price every eighteen months) is to all intents and purposes a law of physics rather than an observation of economics. Both lead to the idea that there is a

zero of instantaneity toward which we advance by approximation. Of course, the calculus should have shown us that this is a very poor method for arriving at immediacy: Zeno's race between Hercules and the tortoise already tells us that the number of points between here and there is infinite. Sometimes, waiting for the download, you feel as if you have entered that bizarre temporal universe that Zeno constructed in the attempt to prove that the world was static and complete. It was a strange twist of history that led those same paradoxes towards their uses in the description of a universe without discretion. It lasts while the download lasts, unless we become too impatient. It is always worth savouring time: there is a limited supply in any life. Rendering and downloading are aspects of the time of digital production which are there for contemplation. In the rush to finish, we risk losing the duration of process. If finishing is all we want, then the thought of the journey is lost to us, the movement of data from here to there. That journeying belongs to a machinic time to which the waiting room of download time gives us a privileged access (I recommend tuning a shortwave radio to the Mhz frequency of your processor so you can hear its actions too). That time is, from our perspective, Zeno's paradoxical time of stasis; but it is also the time of the machines as aggregations of dead labour, the time taken up by the process of bringing all that congealed history back into life. Not even the flickering of the pioneer cinema that Burch (1990) celebrates is as convincing a display of the obduracy of work in the apparently dematerialised world of information. Slowness and its artefacts, like the stagger and jump of downloaded QuickTime movies and RealPlayer files (see Sobchack 1999), are not flaws but materials.

A second new time proper to the digital is the crash. Again, the ideal description of computer media never includes this most universal of experiences. Computers crash. Certainly, like everyone else, I have driven machines to freezes, bombs and software loops and watched the screen die, taking with it hours of unbacked-up work, and I have cursed the machine and myself, yeah from generation unto generation. But as time goes by, you learn to make provision for the inevitable, mainly by proliferating copies. But in the end we all know that the magnetic media are not reliable storage, even in the short term. A server is safer than a floppy, but as anyone knows who has lived through a major server crash or worse, a transfer between servers, even they are no guarantee. The crash is not a contingent drama that has nothing to do with the machinery: it is inherent in digital media. So what is it, in temporal terms?

The crash itself is an event, with a duration, and a subject position (we can refer to it as the Oh-no position). For the more perverse among us, there is

even a certain delight to be extracted from the event itself. More significant is the aftermath of the crash, its longer duration as the beginning of a process of recuperation and retrieval, but most of all of coping with loss. Where a crash deletes files, usually the ones you are working on, you find yourself trying to reconstruct them in a process which involves two memories: yours and the machine's. One of the things you learn swiftly is that machines are far better at forgetting than their users. This is amnesic time: the time of forgetting, which has become an integral part of computer culture and one of its most important additions to the aesthetics of contemporary media.

The purpose of most media forms since the invention of the alphabet has been preservation. People have sought to preserve their traditions, philosophies, mathematics, science, stories and likenesses in mediated forms for millennia. While the weak carved their names on trees to share their own growth with the green world, the masters built monuments to demonstrate their mastery of time. As monumentality gives way to proliferation (from Stonehenge to the printed ephemeris), the same tenet holds, save only that proliferation spreads sovereignty in space as well as time. What emerges onto the centre stage of culture in the digital, especially in the kind of retrospective history that I am proposing that we need, is the countercurrent of ephemera: the self-consciously timely products of the hour or the day that have no purpose to continue beyond their brief moment. With the computer crash, ephemerality enters the domain of the monumental. It provides us with a compulsory opportunity to erase and start again. It renders every document as ephemeral as the news. Where erasure is a constant option, accidental erasure, like unconscious forgetting, is a constant generator of random cultural mutation. The fixed form of textuality is lost in the possibility of erasing -- an erasure which lies at the heart of the possibilities for interactivity that network communications bring with them, since to rewrite someone else's files, you have to overwrite and so erase their input.

Moreover, the constant presence of the possibility of absence alters the nature of the present in digital time. The omnipresent awareness that what is onscreen at any moment may not be accessible in the next makes the present indefinitely valuable and indefinitely malleable. Fixity is not a teleology of digital media: erasure is. Every computer file balances over its own deletion with infinite fragility but also infinite possibilities for its remaking. That balance is not, however, a matter of existence versus the void, but of the equilibrium promised by the first law of thermodynamics, the zero sum of all forces in a universe in which energy can neither be

created nor destroyed. What is at stake is not nothing but a zero composed of all interactions across the history of a system, a system like a computer file. All its permutations are at once summed and absented in the equilibrium it attains in the face of erasure. Digital presence is then premised on a non-presence of perpetual permutation. Forgetting becomes an art, an amnemotechnic that places every existent in a fraught relation with all its other possible forms.

Implicated in this immanence of forgetting and permutation is a further distinction which we can draw on to clarify the temporalities of the crash. On the one hand, there is memorised time: the durational quality of the memory we try to restore (or try to erase) while on the other stands the memorial time in which that memory is brought to mind. That distinction has held good for several centuries, perhaps more. But under conditions of digital temporalities, there is a new factor, a continuity brought about by the difficulty of absolute forgetting in machine memory. The condition arises from the foregrounding of mediation in digital media. In representational media, forgetting is always a forgetting who, or what or where. In digital mediation, the process is far purer, in the sense that there is only a mediation to be forgotten, but also less definite since the fact of mediation remains when the mediated has been mislaid. Viruses, fragmentation, crashes and erasures as well as magnetic damage to portable media all construct the digital as a realm of contingency, and differentiate its present from the present of the photogram.

In Vivian Sobchack's account, the still photograph

> exists for us as never engaged in the activity of becoming [...] it never presents itself as the coming into being of being [...] when we experience the 'timelessness' that a photograph confers on its subject matter, we are experiencing the photograph's compelling emptiness; it exists as the possibility of temporality but is a *vacancy* within it. (Sobchack 1992, 59)

Films, by contrast, she argues,

> [...] share it. Unlike the still photograph, the film exists for us as always in the *act of becoming*, does not transcend our lived-experience of temporality but rather it seems to partake of it). (Sobchack 1992, 60)

What digital mediation brings to this 'fullness' is the instability of a primary

differentiation. Like Deleuze's concept of the interval, Sobchack's fullness recognises the absence of absence, but not the changing status of zero in all this. In the metaphysical mode of cinematic thought, zero is still equated with the void. But in digital media, 'zero' is rather precisely 0.7 volts, while 'one' is usually about 5 volts. Crudely, there is no empty place, but a reference signal, itself a waveform. We are then not dealing with presence and absence but with reductions and expansions of presence. In cinema we can take two moments as synchronous: the run time of the projector and the real time of the audience. But when we are dealing with remote machines, for example in web delivery of QuickTime trailers or satellite delivery of feature films, the equivalence is no longer supported. The orders of mechanical and human time apparently united in a stable and integral whole in the cinema are disunited and dispersed in the digital. We can see some aspects of this already in the different temporalities inhabited by computer generated images (CGI) and photographic elements in composite shots, most obviously in *Forrest Gump's* manipulations of familiar TV images. Not only are the figure-ground relationships that earlier matting techniques established as the horizon of cinematic action rendered fluid, so that the possession of the spatial foreground is moot (for example in the addition of imitation emulsion scratches to reconstructed footage), but the two components of the image conflict in their temporalities. So the CGI crowds in the Vietnam demonstration occupy a time other than that of the photographed Tom Hanks, just as he occupies a different time to the archive footage of Nixon and Kennedy. The digital image is at once delayed and premature, occupying the zone of the real numbers -- the infinitesimals, constantly approaching but never touching the full zero of cinematic presence.

I take my sense of zero from Frege, and from a definition that resonates particularly with the concept of the priority of relations over identities in both the political and the gendered subject: 'Since nothing falls under the concept "not identical with itself", I define nought as follows: 0 is the number which belongs to the concept "not identical with itself"' (Frege 1974: 87). This zero is not nothing but the productivity of a state which is at once the origin of the number series (as self-differentiating) and its goal (as the zero sum of total activity). The filmic 'fullness' constructed in the congruence of film time with subjective time is broken in the digital media through the constant flickering of the digital file between existence, erasure and permutation. Though still not absence, this is not presence in the phenomenological sense. It is a subjunctive mood of being, a moment in which subject and object are as like as not to go their separate ways or to integrate into one another. The destiny of film, increasingly seized upon as

a theme in Hollywood films of the 1990s (*Titanic, Good Will Hunting, Phenomenon, The Matrix*) is to exist as a prerecorded event whose unfolding we can guess about, but which in any case pre-exists the viewing moment. In digital media, that certainty no longer obtains. Because we can crash, willingly, accidentally or through external circumstances, the digital is ephemeral. The Apple philosophy – an uncrashable machine – and the Windows NT philosophy – a fast-recuperating machine – are equally misguided: aesthetically, there is no reason to avoid the crash and every reason to embrace it as intrinsic to the toolbox of digital techniques, as is happening increasingly among the new generation of digital artists. Attempts to foreclose or marginalise the crash belong to an alien and outmoded aesthetics, one that gave birth to the desktop computer in the second office revolution, but to which we no longer need to adhere: the aesthetics of efficiency. The various normative cinemas of the mid twentieth century – total film, realist film, classical film – were indeed efficient in this sense: reliably teleological. The digital media, considered in their temporalities, are no longer so. Nor are they entirely 'zero' media, in the sense of the invisible principle of motion as difference that Vertov (1984) described as the interval, the principle of Lyotard's acinema (1978). We are dealing here with the infinitesimal as a principle of cinema, itself a permutation of the forgotten origin of cinema in the animated cartoon: not zero as foundational difference, but the infinitesimal's difference from difference.

In number theory, zero produces one, or unity, and unity produces multiplicity. That interplay of unity and multiplicity is the grounds for the temporality of film as it is played through in the codes of cutting – framing, compositing and editing. The animated line however is a vector. It has momentum and direction rather than the coordinate space of the interval and the cut. Its freedom to mutate endlessly is analogous to the weird mathematics of infinity. In Cantor's hands, set theory, the foundational theory of modern mathematics, confronted the multiplicity of infinities, and arrived at the problem of undecideability. The undecideable in turn would lead to Gödel's theorem, Turing's halting problem and Cohen's extension of undecideability to all mathematics. Undecideability is at the heart of the logic driving the digital computer, as it is a quality of the fantastic metamorphoses of the line in the kind of animation that Emile Cohl undertook in *Fantasmagorie* (1908; see the frame-by-frame analysis in Crafton 1990). Like algorithmically generated CGI, Cohl's art is produced by subordinating human to mechanical creation. The result is an unforeseeable evolution, even if it is guided by a human hand towards a particular line of development. As Gertrude Stein said of Oakland,

California, there is no there there. Read, process, write: there is no still point of presence in the digital, only the miniature times of the machine's internal clock, ticking at rates far beneath human perception. Where Benjamin saw in high-speed photography evidence of an optical unconscious, we can point in the digital image towards a horological preconscious whose ticking disturbs the presentness of the image's presence with its promise that the initial state of the system can never be determined with sufficient precision to allow complete foresight of its outcomes. In every digital frame the future has already bifurcated and is in full cascade. That is why it takes every effort on our part, from protected mode (see Kittler 1997) to browser windows, to curb the tendency of digital machines to plunge into reckless and chaotic productivity. The dialectic of emergence and constraint is the heart of the new media arts: the machines, after all, need our sense of form.

The juxtaposition of render time and the time of forgetting suggests further aspects of digital temporality. Forgetting is a labour too, as memory was. As Langdon Winner wrote, technology 'allows us to ignore our own works. It is a *license to forget*' (1977, 315). Expanding on Winner's thesis, Lorenzo Simpson proposes that

> To time, the contingency that it bears, the loss that it brings, and the irreversibility that it insures, technology responds with a feverish will to surpass, ever haunted by the spectre of insecurity, of undomesticated time. (Winner 1995, 66)

Simpson's theme is that technology is a striving against mortality, his example in the immediate context word processing as 'a species of functional immortality' (Simpson 1995, 66). I think he is wrong, but for interesting reasons. Certainly historically technology has been haunted by the terror of the future into which nonetheless it has thrown itself in the pursuit of some control. But that description fits historical technologies, especially 19th century technologies like the cinema, far better than it does the electronic media and digital media especially. My contention is that the preeminence of forgetting as a mode of time in digital media is exactly such an 'insecurity of undomesticated time'. In foregrounding the labour of technology itself, rather than simply human labour, as download, and at the same time privileging the duration of the crash as a mode of immanent erasure, the digital, it seems to me, inhabits mortality, far more so than the attempts to overcome it typical of the photomechanical media encumbered with Bazin's (1967) mummy complex and Burch's (1990, 6-22) Frankensteinian ambition.

As undomesticated time, surpassing human perceptibility in their workings but nonetheless demanding that we wait for them to do their tasks, engines of immense productivity that also wipe, corrupt and otherwise mutate our files, the digital media open up the infinity of the very small for us, placing us not precisely in a mythologised phenomenological present but rather in an ontological state that is neither metaphysical Being nor epistemological paradox of the knowing subject with no unmediated knowledge. Within this ontological present are infinite gradations, samples so fine we cannot distinguish them as such but only as the continuous becoming of otherness, a bézier curve whose 'handles' are always in motion, the present as sine-wave whose next motion is entirely unpredictable.

I want to distinguish this mobility of an unstable present in the digital media from another phenomenon that more closely recalls Simpson's thesis of a technological temporality set against mortality, the sublime time of a certain form of special effect which I wrote up in the introduction to a special issue of *Screen* on special effects cinema (Cubitt 1999). That sublime time is the evacuation of a moment of time, an annihilation of time into a dimensionless non-Being which, I argue, is effected in moments like the spectacular explosions that punctuate films like *Independence Day* and *Armageddon*. Here the teleological time of narrative is interrupted by a fetishised time of spectacle, a duration without movement whose emblematic content is destruction, and whose thematic is the inhabiting of the time of mortality itself, the ahistorical and a-linguistic time of death. In a way, this is a monumental time established within the perishable (but repeatable) moment, an unchanging time abstracted from time's linearity in the discipline of cinema.

'Sublime' time because of the difficulties I have with the ascendant Kantianism of Lyotard's later work (most importantly in Lyotard 1994), its readiness to go beyond the confines of the social, language, in favour of a direct connection with the great beyond. For me, that task is taken up not only in certain vanguard art practices but also in the blockbuster movie, and we should be wary of fetishising it again in media theory.

Instead I want to place a small plea for the understanding of digital time as inherently ephemeral. To embrace ephemerality is to accept the changing nature of the world, the limits to our time in it, the common brevity of life and technology. In place of fetishising a death we have, since Heidegger, identified as utter and unnameable emptiness, we should address the fullness of a life that incessantly generates difference and change, and in

which we have the task of forming and informing. Moreover, to embrace beauty rather than the ephemeral is to embrace the social nature of a digital world. Harping on mortality belongs to a deeply selfish culture: it is always my death that I mourn. Seeking and constructing the sublime as a monument to that unspeakable *béance* is an act of determined (and overdetermined) solipsism. The beauty of the digital, beauty caught on the froth of the daydream, is always already social: it belongs to the sociality of the human-machine interface, the new community of the cyborg planet.

I do not want to deny what I have argued elsewhere (Cubitt, 1998: 133-9), that the actually existing cyborg is the transnational corporate network with its human biochips. But neither do I want to surrender the fight in a sublime suicide pact with the Grim Reaper. These reflections on cybertime lead me towards another mode of aesthetic thought, one that emerges from the third of the great political movements to have arisen since World War Two. Beside post-coloniality and feminism, the ecology movement has brought profound alteration to our perceptions of the world, so that economies, polities, societies, cultures and media all appear today as ecologies: as networks of flows that constitute their nodes as objects, rather than objects that enter into relations with one another. The emergent digital temporalities described here are among the many phenomena in which the ecological model enters the realm of work, and work begins to supersede function and pleasure as the best way of understanding the tasks of media, culture and art. The networked nature of digital media, their ephemerality and their preference for beauty over sublimity all point towards an aesthetics of mutation and evolution, and a communicative post-rationality of mutual dependence and invagination. The price of the digital ecology is the loss of the autonomous art object, but then, the world is bloody enough, and even Adorno's hard-won refusal of it is not enough today, when the processes of globalisation have produced, in multiculturalism and planetary-scaled communications networks, the foundations for a new form of social expression and a new mode of intercultural connectivity. The loss of the sublime, of objectality and autonomy are a small price to pay for the whole of the future.

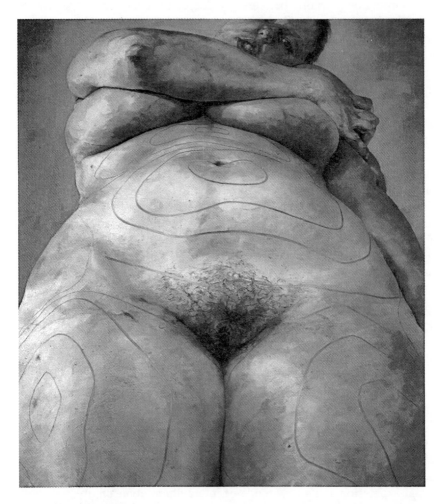

Fig. 27. *Plan* 1993. Jenny Saville. Oil on canvas. 274.5cm x 213.5cm.
The Saatchi Gallery, London.

Chapter 11

The Morphology of the Mucous: Irigarayan Possibilities in the Material Practice of Art

Hilary Robinson

In her important introductory text on feminist cultural theory, Toril Moi provided an influential gloss on Luce Irigaray's use of the term 'morphology': 'Irigaray's theory of "woman" takes as its starting point a basic assumption of analogy between woman's psychology and her "morphology" (Gr. *morphé,* 'form'), which she rather obscurely takes to be different from her anatomy' (Moi 1985, 143). This summary set a tone of subtle misunderstanding for subsequent discussion of Irigaray's work. In this essay I want to retrieve the term 'morphology' as Irigaray uses it from a reduction to anatomy. I will examine its potential for making legible certain material practices in art, not to position such practices as illustrations of an Irigarayan morphology, but to allow for the play of a morpho-logic as prior to, and providing for, the production of what Irigaray terms a 'syntax' in the Symbolic (Irigaray 1985, 132-135).

Although the term 'morphology' is indeed from the Greek *morphé,* meaning 'form', it does not automatically imply an anatomical reading. In biology it does not refer to deterministic analysis of forms in themselves, but to a method of discerning patterns of relationships between forms (in horticulture the explanation as to why flowers as superficially dissimilar as buttercups and delphiniums are in the same family: they share a morphology). 'Morphology' is also a term within linguistics (the subject in which Irigaray presented her first Doctorate [Irigaray 1973], where it names a method of studying the component parts of words and of language. So while there is a biological implication in the term 'morphology', reducing it to the anatomical as Moi does restricts its possibilities. Furthermore, when Irigaray uses the term we are always also in the realm of linguistic structures.

Despite Moi's suggestion, therefore, Irigaray does not structure a relationship of 'analogy' between woman's psychology and her anatomy. Rather, she uses 'morphology' precisely to evoke a distinct relationship. 'Morphology' names the site of a discursive and dynamic relationship between a subject's empirical living in the body and in the Symbolic, where the understanding the subject has of the body is significant in determining an appropriate syntax in the Symbolic; and where in turn the subject understands - or reads - the body through that syntax. The subject then 'sees' anatomy according to the signifiers of that syntax. The 'objectivity' granted this understanding is thus determined in a dynamic relationship with a language inflected subjectivity.

Irigaray clearly states that this is not a matter simply of anatomy: 'I think we must go back to the question not of the anatomy but of the morphology of female sex' (Irigaray 1977, 64). She later reiterated:

> Going back to historically dated anatomico-physiological arguments is obviously out of the question, but we do have to question the empire of a morpho-logic, the imposition of formations which correspond to the requirements or desires of one sex as the norms of discourse and, in more general terms, of language. (Irigaray 1991, 96-97)

A particular morpho-logic - phallomorphism - is imposing its formations of language. Questioning this morphology does not mean retreating to anatomy, but breaking the tautology where only men's sex is spoken - a repetitive, mirroring, mimesis. A different morpho-logic might represent both sexes differently.

'Différance'

In 1986, Margaret Whitford placed the empirical ('biological and social') in a relation of difference with the textual – 'the "female", "feminine" or "other", where "female" stands metaphorically for the genuinely other in a relation of difference' (Whitford 1986, 7). Maggie Berg indicates a problem with this distinction:

> Far from being a trap, however, some sort of identification between 'woman' as a discursive construct and woman as a 'biological and social' entity is absolutely necessary and is central to Irigaray's

work. Had Whitford recognized that masculine and feminine are in a relation of '*différance*' rather than 'difference' in Irigaray's work, she would not, I maintain, also have made the misleading split between empirical and textual women (Berg, 1991, 55).

'*Différance*' is a concept developed by Jacques Derrida. He defines the term as:

> the systematic play of differences, of the traces of differences, of the spacing by means of which elements are related to each other. This spacing is the simultaneously active and passive [...] production of the intervals without which the 'full' terms would not signify, would not function. (Derrida 1981, 27)

This spacing is both active and passive as it is the combination and confusion of differing and deferring. In this play identity becomes possible, rather than identity prefiguring difference. An opposition of presence/absence (i.e. difference, or a master-discourse) would be a product of fixed structure, while the play of *différance* produces transformation and structure together. *Différance* is not produced by something beyond itself; it is necessary before any distinctions in seemingly circular relationships (for example, speech-language-speech) can be made (Derrida 1981, 28).

Thus morphology, in the site where it is, a spacing between body and signification, can be an instance of *différance* at work (play) - both as a producer of gendered subjectivity, and indeed (in that very space between body and language, between empiricism and text, preceeding any distinction between the two), productive of structure and transformation in that relationship. Irigaray writes:

> Thus, for women, the issue is to learn to discover and inhabit a different kind of magnetism and the morphology of a sexualized body [...]. Whether as prime matter or as creation's reject, woman has yet to find her forms, yet to spread roots and bloom. She has yet to be born to her own growth, her own subjectivity. The female has yet to develop its own morphology. Forced into the maternal role, reduced to being a womb or a seductive mask [*parure*], the female has served only as the means of conception, growth, birth, and rebirth of forms for the other. (Irigaray 1993,180)

In a phallocentric morpho-logic, Woman (as Other to man's Same) has been denied the play of *différance* that will give women access to becoming sexuate subjects and which will be productive of an appropriate syntax; denied this, because the *différance* made possible by women's morphology cannot be recognised by a phallic economy.

Through bringing women's morphology into play, phallic morpho-logic will have to shift:

> What this implies is that the female body is not to remain the object of men's discourse or their various arts but that it become what is at stake in a female subjectivity experiencing and identifying itself. Such research attempts to suggest to women a morpho-logic that is appropriate to their bodies. (Irigaray 1993b, 59, translation modified)

Women's bodies will no longer be available as objects for men, nor be Other to men's Same. Once their subjectivity in/as *différance* with/from men's subjectivity is recognised, so too the necessity of inter-subject relationships will be recognised. This will be aided by the deployment of a morpho-logic appropriate to women, in play between women's bodies and their syntax, productive of that appropriate syntax and of appropriate cultural representations of women's bodies.

Lips

The terms that Irigaray uses most often to mediate the play of women's morphology are 'the lips' and, increasingly through her writings of the 1980s, 'mucous'. 'The lips' is a term of ambiguity. Women's morphology produces a site for itself in this term: not the lips of the mouth, not the lips of the genitals, but at the same time both of these: 'the lips', as a term, is the site of a play between them. The lips are at least two in at least two ways: both in the play between the (not)mouth and (not)vulva, and also in the internal morpho-logic of such (non)references. This morphological always-plural (i.e., which is not a one + one + one +) is distinct from phallomorphism, which does count in ones. Noticeably, Irigaray does not produce a name for this morpho-logic of women, but we can recognize that she works with it in her writing. The lips' lack of one-ness means that they do not have a graspable, unitary form; to give this morphology a name at present would be to revert to phallomorphic practice, to place it in patriarchal limits.

Irigaray refers frequently to this lack of form. In an often quoted passage (part of her accounting for phallocentric vision and phallomorphic syntax's inability to see woman's sexuality) she writes:

> This organ which has nothing to show for itself also lacks a form of its own. And if woman takes pleasure precisely from this incompleteness of form which allows her organ to touch itself over and over again, indefinitely, by itself, that pleasure [*jouissance*] is denied by a civilization that privileges phallomorphism. The value granted to the only definable form excludes the one that is in play in female autoeroticism. The one of form, of the individual, of the (male) sexual organ, of the proper name, of the proper meaning [...] supplants, while separating and dividing, that contact of at least two (lips) which keeps woman in touch with herself, but without any possibility of distinguishing what is touching from what is touched. (Irigaray 1985, 26)

This passage shows a constant slipping between the lips of the bodily vulva and the (not)vulva of women's morpho-logic - and gives a reading of the vulva through the means of that morpho-logic. The words 'jouissance', 'phallomorphism', 'definable', 'meaning', and 'at least two' remove it from the realm of the simply anatomical. The non-form qualities of the genitals is in play with those of women's morpho-logic; which, in its play of *différence* between women's body and language, is the birth place of the imaginary. Women's morpho-logic, which has its own material practices, is the necessary precursor to the distinction of a syntax appropriate to women in the Symbolic (this point is crucial). And without this syntax, women remain in a state of immediacy, without access to their subjectivity, since subjectivity is entwined with signification. The only way to mediate what would otherwise be an immediable, distanceless proximity, the morpho-logic of two lips touching, is through the morpho-logic of Mucous.

The Mucous

Irigaray says:

> However, it is possible that the mucous corresponds to something that needs to be thought through today. For different reasons and imperatives:

- any thinking about the female has to think (through) the mucous
[*doit penser le muqueux*].
- No thinking about sexual difference that would not be
traditionally hierarchical is possible without thinking (of) the mucous
[*sans pensée du muqueux*]. (Irigaray 1993a, 110, translation
modified)

The realization of the morpho-logic of the mucous is crucial for women's
relationships with others and for their relationship with themselves: their
self-mediation through an appropriate symbolization. The morphology of
the mucous is that which mediates a woman to herself, and also mediates
her, in her difference and specificity, to her lover. It is the mark of her sex,
and it is the mark of mediation. The lips are, morphologically, a threshold;
ajar, but touching;[1] not skin (surface closure), not flayed (internal made
external), not a unitary form of flesh (non-mediating); but rather, mucous:
the site of mediation.

In 1991, Margaret Whitford refered to the mucous as bodily, and suggested
that what is needed is 'to symbolize the mucous' (Whitford 1991, 106).
This indicates a slippage between the adjective and the noun, an over-literal
reading of Irigaray's use of the adjective 'the mucous'. Instead of
symbolising the mucous, we need to recognize in it the play of *différance*
and its morphological patterns, and develop from that site morphologies of
mediation and, contiguously, of another syntax in the Symbolic. As
Irigaray says, 'of course no woman has the morphology of another'
(Irigaray 1991, 112). To 'symbolize the mucous' (being reductive in turn,
this could collapse into inventing symbols of it) would be to take from it
with 'a gesture which involves a sort of capitalization of the mucous
membrane, an exteriorization of what is most inner' (Irigaray 1991, 112),
and in so doing, revert to a phallomorphologic of metaphor. However,
recognizing its morphology involves relinquishing such control: 'these
mucous membranes evade my mastery' (Irigaray 1993a, 170).

Intersubjectivity

I read the morphology of the mucous as one which allows for both the
relinquishing of control and the presence of the subject demanded by
intersubjectivity and its requisite attentiveness. What Irigaray calls a 'return
to the possible of intimacy' (Irigaray 1993a, 200), can be found in the way

the mucous marks the limits of the subject as it performs a mediation between subjects.

Articulating the limits between women is problematic: 'the very openness [*l'entreouverture*] of their bodies, of their flesh, of their genitals makes the question of boundaries difficult' (Irigaray 1991, 112). What is necessary, then, is a site of a 'third term' - a site that is neither subject, and thus prevents each woman reducing the other to herself; and which is not abstract: what Irigaray describes as a 'sensible-transcendental - a female transcendental against which each women can measure herself rather than progressing only by taking the place of the mother, the other woman or the man' (Irigaray 1991, 112). In discussing how this may be achieved in the psychoanalytic transference between a woman analyst and a woman analysand, Irigaray uses the morpho-logic of the mucous to furnish an understanding of the processes. Without the morpho-logic of the mucous in play in the analytical process, resolution would be impossible: the (non)object would remain the over-valued Object of phallocentrism; possibly, a symbolizing of the Mucous in a phallocentric syntax. The (non)object that is created, however, is something more like a fluidity of creation itself: the work of creating a subject is a co-creation in the analysis. This must start not from the premise that one woman is the subject and the other is her object, but that both are potentially subjects in a relationship of intersubjectivity (Irigaray 1991, 114-115).

In this way the transference takes place as a relation of intersubjectivity: two subjects, women, realizing their boundaries, relating through the play of the morpho-logic of the mucous. Its (non)form, its other-translucency, its resistance to being mastered by either subject, its specificity to each woman, and its mediation of the woman to herself, provide a pattern for the morphology of the mediation between the women.

Rebuilding the Symbolic

Various commentators have attempted to describe Irigaray's use of the morphology of lips and the mucous within extant grammatical formations. Consequently, most fall short of the way in which she herself uses such a morpho-logic and thus fail to provide ways in which we might rethink practices of making art, and the development of an appropriate syntax. This indicates an interesting problem with Irigaray's writing itself: how, at present, can we work simultaneously with and against the structures and

tropes of the Symbolic currently operative? How does one produce the element of mediation - the third term, the appropriate syntax - and its representations, without capitalising? How do we self-represent without reproducing (to ourselves or to others) the phallomorphic representation, 'woman'?

It is crucial that we understand the function of the morpho-logic of 'the lips' and of the mucous, and locate a morphology which can account for mediation through materials - an enunciation which is legible and productive of discourse - in an appropriate syntax. What we can see Irigaray practising is not in a reductive sense 'speaking as a woman' but rather speaking in the morpho-logic of 'the lips' and the mucous. Thus, our task in reading Irigaray is to read the play of *différance* between the language which is spoken and that which is said within that language and its morphology. This would then allow us to approach, develop, and be attentive to the motifs within her enunciation without capitalizing them as a result of our use of the language, without returning them to metaphor or phallomorphic object. Irigaray has hinted at this, commenting upon her motifs such as 'self-touching':

> But of course if these were only 'motifs' without any work on and/or with language, the discursive economy could remain intact. How, then, are we to try to redefine this language work that would leave space for the feminine? Let us say that every dichotomizing - and at the same time redoubling - break, including the one between enunciation and utterance, has to be disrupted. (Irigaray 1985, 79-80)

The play of the morpho-logic (including its play through the media of the artwork) precedes the distinction of the syntax appropriate to women: the motifs and representations occurring within it - that which we wish to say in it - cannot be anticipated in advance; nor can the degree of contiguity between the two. Continuous vigilance regarding the play of the morpho-logic in the structure of the Symbolic is required: in a constant multiple movement we have to work with and through the language (material and representations) to hand, back to its informative morpho-logic, and return again to language.

What is at stake here is the morpho-logic informing both our making and reading of artworks. In recognizing the morpho-logic of the mucous and the lips, the whole approach of thinking through metaphor would need to be undone; the recognition and privileging of metaphoric elements before

other elements would be opened for question. This does not mean that metaphor would be expunged: rather, that its role in producing phallocentric representations be recognised, and the prior workings of a phallomorphologic be disrupted by its need to recognize its own limits. This returns us to the materiality of art making, and to the problem of approaching a medium and working with it as that element of mediation in which enunciation in an appropriate syntax is possible. Thus, 'representational practices' in artworks are in an interdependent, discursive relationship with the practices and processes the artist engages with in her use of media. The medium, then, can be read by the artist and the attentive audience as an element in a discourse productive of representations which remain without capitalising - as one set of signifiers among others in artworks as non-capitalized objects.

Approaching paint

The medium recognized historically as the one privileged among art practices is paint. The legacies of Romanticism and more recently of high modernism have created structures whereby the male subject artist and the painterly gesture have their legibility secured in direct relation to each other through the dominant discourses of criticism. Griselda Pollock analyzes the critical structures which capitalize the medium, Paint, and the practice, Painting, as product of the Artist within high modernism:

> The purity of the visual signifier, seemingly emptied of all reference to a social or natural world, is still loaded with significance through its function as affirmation of its artistic subject. Abstract Expressionism is a celebration of the 'expressivity' of a self which is not to be constrained by expressing anything in particular except the engagement of the artistic self with the processes and procedures of painting. Thus 'painting' is privileged in modernist discourse as the most ambitious and significant art form because of its combination of gesture and trace, which secure by metonymy the presence of the artist. These inscribe a subjectivity whose value is, by visual inference and cultural naming, masculinity. (Pollock 1992, 138-176)

The task, then, is to shift from a discourse of paintmarks-as-metonymy-for-the-artist (a discourse which can only fetishize the painting-as-object), to a discourse which recognises the processes of painting as processes of

meditation in a two-way, intersubjective exchange: to find other ways in which paintings by women might become legible.

The moment of modernism, its structuring of 'the Artist' and privileging of paint, has been massively disrupted by post-modernist and feminist critiques and practices by artists such as Barbara Kruger, Lubaina Himid (Fig. 7, Plate 4), Martha Rosler, Jo Spence and Mona Hatoum (Pollock 1992,154). Despite this, some feminist critics have simply enacted a reversal upon the modernist emptying of all meaning other than 'the engagement of the artistic self with the processes and procedures of painting', instead emptying paintings by women of all meaning other than that discerned in their images.[2] If Painting (as capitalized act) is left undisrupted by feminist theorizing, then feminists who are painting will remain marginal, their strategies reduced to choice of medium, and, crucially, any feminist interventions into the practices of painting will remain broadly illegible, even to other feminists. Thus, painting will not be read as having mediative, intersubjective, potential for women. The images produced in a painting might be read in such a way but the processes of producing those images will not (though it is more likely that images in this context will be be read as metaphor - a reading which is also likely to return to a phallocentric discourse of process). Both because of its historical signification, and because of some of its material potentialities, the practice of painting could prove a major testing ground for the development of an appropriate syntax for women. However, I am not arguing for a return to formalism. It would be easy to capitalize mucous by capitalizing paint, understand 'Paint' as a metaphor for mucous (just as an image might be read as a metaphor) rather than processes of painting and attending to paintings as processes of *différance*. Therefore, I want to try to understand the processes of painting as one site of mediation within the morpho-logic of the mucous.

Two recent articles address the materiality of paint (and in one work discussed, plaster) in a manner that works at undoing phallomorphic understandings of paint. They suggest new possibilities for women engaging with the practice of painting, as subjects who paint and as subjects attending to paintings. I was struck by the way in which each writer (both painters) attended to the experience of being in the same space as the art works and to the presence, substance, and make-up of the works they were discussing. Although neither writer theorises it as such, both attend to the particular medium of paint or plaster as if they were sites through which Irigarayan mediation is occurring.

Riley, Whiteread

Joan Key analyses her experience of seeing Rachel Whiteread's *Untitled (Airbed)* (1992) and Bridget Riley's *Arrest II* (1965) exhibited together (Key 1997, 185-197). Whiteread's sculpture is a plaster-cast of the space above an inflated airbed. Riley's painting is an acrylic on canvas of black, grey and white wavy lines. Exhibited by themselves in the gallery, a space of dialogue had been created between the two works, uncluttered by curatorial interpretation other than a label for each. In this space there is room to contemplate surface, fluidity, skin, absence, closure, openness, masking. Key's description of the two works suggests conflicting morphological structures. The work by Whiteread does not claim authenticity by indexing the artist through her gestural trace: there is no mark to be presented as metonomy of the artist. Rather, any claim to authenticity rests in its indexing of the technical process of its making. In particular, the once-liquid state of its material (plaster), and the flexible, nature of its matrix (the air-bed) (Key 1997, 186).

In contrast, in Riley's painting, knowledge of the original fluidity of its materials (paint; canvas) is suppressed. Any trace of the gesture of the artist's hand is removed to provide a perfect closure: the smooth, flat skin of the paint surface. The canvas is stretched taut; its trace in the finished painting seems incidental to the artist's intention, but proves crucial. Suppressing its fluidity of material and process, the work instead simulates or masquerades fluidity in the image it carries (Key 1997, 186).

Alongside the differences between the works are a set of resonances between the two works. Both employ what was originally a fluid medium which has, in particular ways, coagulated to form a pristine surface. Both artists employ techniques which suppress any signatures in mark-making, but in both instances the maker of the works are instantly identifiable. Both works contain imagery of waves - the painting in the pattern painted, the sculpture in the undulations of the airbed (Key 1997, 191).

The morphology informing each begins to differentiate them, and to form their differing significance in the Symbolic. The painting has a surface which is closed, suffocating, described in a manner which suggests that it was produced in mimesis of a phallomorphologic. The sculpture is more ambiguous, asserting its presence through processes of reversals - the bed and its absence; authentic presence with no visible trace of the artist; apparent solidity displaying originating fluidity, and so forth. More

ambiguous still is the 'reserve' of each work, that which is always already there during any reading of the works as being informed by a phallomorphologic: the potential presence of a morpho-logic of the mucous. In both works this can be found in the artist's touching of cloth through the once-fluid medium of paint or plaster. Key does not use this terminology at all, but her description of the works allows for such a reading:

> Both the Whiteread and the Riley share a reference to the potentially mobile surface of cloth. In both the sculpture and the painting this reference seem to have the status of an incidental detail, but it imposes on their form with unexpected force, since in both, the image of the cloth is embedded in another surface (plaster or paint) to the point where it nearly disappears. (Key 1997, 191)

This 'incidental detail' can be perceived as a determining detail for the audience. Even though the flow of plaster and paint is stilled (closed), the memory of it is carried in the material of the plaster as a reserve, and in the material of the differently tinted paint as masquerade (Key 1997, 191-192). Also of interest is Key's identification of a third term created by the works, elements of which they bring individually to the encounter. In this we can discern a non-phallomorphic logic at play between the materiality of the artworks and their imagery - and between the artworks and Key. Thus, while Key's reading of the painting suggests phallomorphic closure within its processes and materiality, her reading of the plaster by Whiteread suggest more mediative potential, a space of *différance*, complemented by her overall attentiveness to the two works productive of intersubjectivity, rather than producing in her text only a closure for her own subjectivity.

Saville

Alison Rowley's essay on Jenny Saville also takes as its starting point a gallery experience (Rowley 1996,88-109) (Fig. 27). In a long and complexly layered essay, Rowley compares Saville's technical choices (in particular, handling of paint, viscosity of paint, size of canvas, and figure-ground scale) with those of Helen Frankenthaler and Dorothea Tanning. She also analyses the context into which Saville's work was placed, and how she was represented by newspaper critics at the time of her 1994 Saatchi Collection exhibition (in a nutshell, Saville was generally compared with Lucien Freud, with at best, any feminist intent in her work

acknowledged and then ignored). Rowley encourages closer concentration upon the manner in which the handling of the material substance of paint and the configuration of imagery in paint touch upon each other. Her shifting of terminology from 'formal' qualities to 'technical' procedures (Rowley 1996, 92), would seem initially to hold image and material apart; instead, the term 'formal' insists that issues arising from the relationship between the image on the canvas and anything which lies beyond the canvas be discarded in favour of abstract discussions of, for example, 'composition'. Distinguishing technical procedures from configuration of imagery (and by extension, matters of representation) allows us to attend anew to their touching upon each other.

One memorable passage, worth quoting at length, acts as an index for reading processes of *différance* and intersubjectivity in the process of Painting. Here Rowley articulates both a relation between paint and image and a relation between artist and audience:

At my height of 5'7" if I stand at painting distance from the canvas (by the size of the marks this is closer than arm's length as these are manipulations of the brush by fingers and wrist, not swings from the shoulder), I have in my focused vision a group of oblongish marks of flesh tones modulated to simulate the play of light over a smooth but slightly uneven surface. Into this surface break some small brownish black curved marks of raised paint which I can imagine as have been made by gently laying a fine, long-haired brush loaded with colour onto the surface of the canvas and quickly lifting it off again. The memory from my own experience of manipulating paint, of the controlled combination of amount of paint, weight of hand, movement of fingers needed to execute marks like these is very pleasurable. At this distance from the canvas I'm lost in the memory of the tactile pleasures of paint application. And literally lost in the space of the canvas with nothing to locate myself, I cannot see any whole shapes or the edges of the canvas. How does this area of painted marks relate to those on the rest of the canvas, and to construct what? To find out, I have to pull a good way back from touching distance before I have the whole canvas within my field of vision and can see that what the marks make is where the pubic hair peters out into the smooth skin of the stomach. But at this distance my memories are of another order, in another register: they are memories of other images of women without clothes, from other paintings and photographs with which I begin to compare *Plan*. By

moving back to hold the whole canvas within my view so that I can
see how the marks coalesce into the bounded shape I look for as
standing for the human figure in the conventions of western painting,
I have to forfeit the tactile pleasure of an imaginary application of
marks to the surface of *Plan*, the memory of my own body in contact
with a canvas. But I can move in and back again at will. (Rowley
1996, 92)

But while this passage is produced from a morphologic which resists a
phallic closure, certain possibilities in Saville's painting are missed.
Rowley cites Freud's work as highly problematic, but does not give it the
close reading afforded Saville, Frankenthaler, or Tanning. However, there
are a number of instructive differences between the two, both at the level of
technical procedures and of configuration of imagery, which I would like to
dwell upon as I think they can take us even further than Rowley does
already.

Few of Freud's paintings are as large as many of Saville's; the figures
imaged in them are not only thus relatively smaller, but also the relation of
the scale of the figures to the size of the canvas is usually more
conventional: they 'fit' into the picture. In terms of figure-ground relation,
they are more bounded. Their object-like status is increased by Freud's
common view-points, higher than seated or lying models, distanced from
standing models. Saville frequently has a view point looking up at the
figures from a position of closeness. Thus we are invited into an intimate
relation with their flesh, both by the scale of the figures (and the potential
'loss' of the boundaries that Rowley suggests) and by the way the scale of
the figures fill and exceed the field of vision in the painting, provoking
memory of proximity in order to make sense of the image. Even when we
are beyond touching distance of the canvas, the memory is of being within
touching distance.

It would be hard to experience in a Freud painting the loss of mastery of the
figure Rowley experiences close to the Saville painting, or the 'memory of
flesh [...] not yet [...] born into language' evoked by Irigaray (Irigaray
1993a, 215). Freud's paintwork (particularly of skin) may look creamy
from any distance, but it is also usually shiny, with a hard, repulsing
surface, giving us phallomorphic closure and rigidity. In his painting of
limbs and bodies, large brush strokes, while 'moulded' in effect, often
work against the architecture of skin, muscle and bone. It is an activity
which displays a fear or hatred of, or revulsion from, flesh, and which

certainly resists intersubjectivity or any mediation of the other's subjectivity. In that close-up activity of painting, I extrapolate Freud interrogating his models visually, delineating the object on canvas - the over-production of an Object at the expense of subjectivity.

Saville's paint work differs. Her paint has a matt, but not 'dry', surface, and in relation to the scale of the figures imaged, both brush and brushstrokes could be considered very small. When close up to the canvas, she is not delineating the object; its borders are not in her visual control. She is, through a series of small touches, building the image. There is also, as Rowley indicates, an identification between Saville and the body she is painting, whether as self portrait or not: the image of the woman she paints can thus never fully be her object.

I think something else is happening here, something akin to love, which is important not to miss. Rowley quotes Saville as saying 'I'm not painting disgusting, big women. I'm painting women who've been made to think they're big and disgusting [...] I haven't had liposuction myself but I did fall for that body wrap thing where they promise four inches off or your money back' and wonders 'Does Saville, then, worry about her own size?', (Rowley 1996, 95). But Saville's comment was in the past tense, not the present: I read her act in painting as she does, as a gesture of attending to the interrelation of subjectivity and body, and of restoring touch to sight, through the mediation of paint. Rather than being 'surplus paint, and highly unpleasurable' or using paint as a 'modelling material' in simulating flesh (more likely to be found in a Freud painting), Saville is restoring beauty to *that which has been regarded* as surplus substance by returning through the imaging of that body and that subjectivity; making a gift-space/object necessary for intersubjectivity and for mediation between women. There is a non-phallic morpho-logic at play between the technical application of paint and the deferral between the surplus substance of the paint and the surplus substance of the image, which pivots upon the qualities that Saville has required of the paint and the countless touchings.

These two articles alert us to practices of using the materiality of fluid media as artists, and of attending to the implications of this materiality as an audience. Irigaray wrote in an early work 'now if we examine the properties of fluids, we note that this 'real' may well include, and in large measure, a physical reality that continues to resist adequate symbolization and/or that signifies the powerlessness of logic to incorporate in its writing all the characteristic features of nature', (Irigaray 1985, 106-107). As we

have seen, this has developed into the suggestion that we need to think through the mucous - not only to 'think it through' as a political and theoretical necessity, but also to 'think through it' as a means of achieving an appropriate syntax in the Symbolic and the possibility of mediation in intersubjective relationships. We can read Key and Rowley as indicating a particular morpho-logic at play and beginning to be productive of its syntax in the Symbolic. This morpho-logic is discernable in the *différance* between the technologies selected and the imagery produced; in the traces implicated therein of the material fluidity of cloth and of the plaster and paint; and in the gaps between the three art works and the two essays. It is discernable also through attempting to develop a practice of thinking through it: attending to the possibility of mediation through the morphology of the mucous.

Notes

1 '*l'entreouverture*' (for example, *Parler n'est jamais neutre*, p. 300; *Éthique de la différence sexuelle*, p. 108) can read as 'the inter-enter-opening'. It is usually translated (rather unsatisfactorily) as 'open'.

2 One example is Peggy Phelan's discussion of Mira Schor's painting in Unmarked: The Politics of Performance (London: Routledge, 1993), pp.51-60.

Editor's Note: Readers may be interested in the work and Artist's Statement of Deborah Robinson in this volume (Fig.11) in the context of this essay.

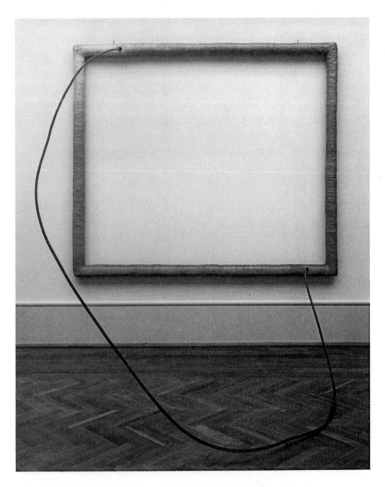

Fig. 28. *Hang Up* 1966. Eva Hesse. Acrylic and cloth over
wood and steel. 182.8cm x 213.3cm x 198.1cm.
Art Institute of Chicago.

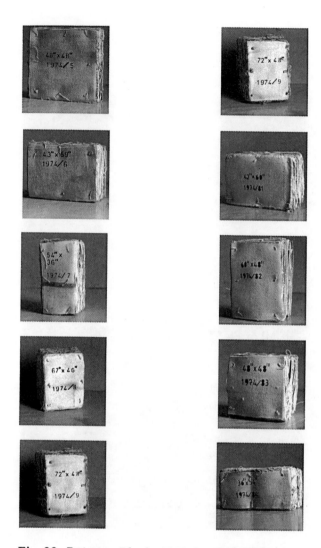

Fig. 29. *Painting Blocks* 1973-81. Susan Hiller.
Oil on canvas. Dimensions as printed on the 10
blocks. Collection of the Artist.

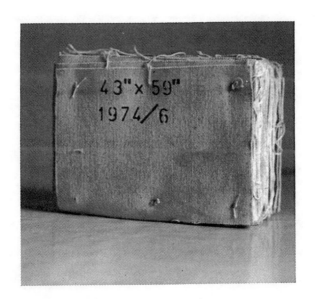

Fig. 30. *Painting Blocks* 1973-81. Susan Hiller.
Detail of Fig. 29.

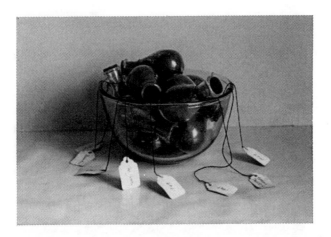

Fig. 31. *Hand Grenades* 1969-72. Susan Hiller.
12 glass jars, ashes of paintings, labelled, bowl.
Collection of the Artist.

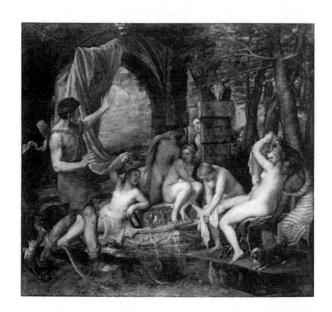

Fig. 32. *Diana and Acteon* 1559. Titian. Duke of Sutherland Collection, on loan to the National Gallery of Scotland.

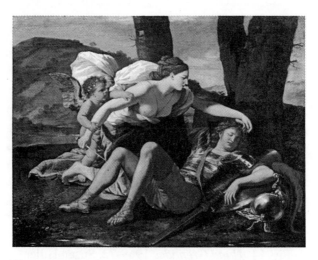

Fig. 33. *Rinaldo and Armida* c. 1628. Nicolas Poussin. Dulwich Picture Gallery. By permission of the Trustees.

Chapter 12

A Matter of Paint:
The Carnal Subject of Aesthetics

Rosemary Betterton

I will paint *against* every rule I or others have invisibly placed. Oh, how they penetrate throughout and all over.

(Eva Hesse, October 28,1960)

Looking back over a decade since the publication of Rebecca Fortnum and Gill Houghton's essay, 'Women and Contemporary Painting: Representing Representation' (1989) which first raised questions of the relationship between women's politics and non-figurative painting, it is evident that there has been precious little further discussion of this subject within feminist critical writing.[1]

In reviewing my own contribution to the debate, I now think I was far too optimistic in imagining that a feminist politics of painting could be articulated through the collective strategies that seemed to be emerging in the early 1990s (Betterton 1996). It simply did not happen, and in retrospect, the lack of a critical audience for women's non-representational painting meant that any such politics would have been hard to sustain. I want to enter the debate from a new direction by developing the idea of an aesthetics which is both embodied and engendered, in order to engage critically with a prevailing orthodoxy that painting has little left to say in the twenty-first century, and in particular, has nothing to say of relevance to feminism. I will argue that painting practice can make a contribution to a central concern within current feminist theory: the rethinking of the sexed embodied subject in ways which undo the separation of mind from body, subject from object, within western epistemology. In Rosi Braidotti's words, 'Whether it goes under the heading of "gender" or "sexual difference", the common project that is emerging is the radical redefinition of female subjectivity from a feminist standpoint' (Braidotti

1991:164). These concerns are evident in the writing on feminist ethics and metaphysics by Elizabeth Grosz (1994) and Moira Gatens (1996) in Australia, Christine Battersby (1998) in Britain and Judith Butler in the United States (1993). I want to explore what is at stake in my own continuing investment in painting as a meaningful practice via an analysis of the relations between embodiment in painting and my position as an embodied viewer. What I will discuss then is this: what is the matter with painting now, why paintings still matter to me, and the idea of painting *as* matter.

A Matter of Paint

I begin from Rosalind Krauss' discussion of Eva Hesse in her book, *The Optical Unconscious* (1994). Here Krauss argues that, rather than Hesse becoming a sculptor in the mid 1960s, as is usually assumed, her work was really engaged in contesting the rules of painting. Krauss describes Hesse's wall piece, *Hang Up (*1966) as 'an enormous, empty picture frame, the site of a painting declared and defied at the same time' (Krauss 1994, 313) which she takes to be evidence of a refusal or an inability by Hesse to abandon painting altogether (Figure 28). From a Lacanian perspective, Krauss suggests that Hesse's work represents the 'optical unconscious' of painting, that which had been repressed within modernism, but continued to trouble, to disturb and to foul up its logic (Krauss 1994, 24). According to this argument, a painting works like Lacan's mirror in offering the viewing subject possession of an ordered and logical visual field which returns to him a (mis)recognition of himself as a unified being. In contrast, *Hang Up* is transgressive, 'burrowing from within the pictorial paradigm to attack its very foundations.' (Krauss 1994, 314). Unlike the 'topology of self-containment' offered by a conventional painting, it describes an 'unformed body without organs' (Krauss 1994, 19) - dispersed, provoking anxiety, potentially chaotic and threatening to the rational, unified self. For Krauss then, Hesse's work operates like the Lacanian unconscious to undermine the symbolic order of painting, but it can exist only as Other to that which it threatens. It cannot signify except in the terms of the symbolic system that it disrupts, in this case, that of modernist painting.

What Eva Hesse herself said about this work was this:

It is a frame ostensibly and it sits on the wall with a very thin, strong, but easily bent rod that comes out of it [...] It is coming out of this frame - something and yet nothing and - oh! more absurdity - it is very, very finely done. The colours on the frame were carefully gradated from light to dark - the whole thing is ludicrous.

(Nemser 1970, 60)

So for Hesse herself, *Hang Up* was absurd, it corresponded to her desire to make work that was 'something and yet nothing', and yet it was meticulously made, framing and unframing space with strength and utmost precision of coloured line.[2] If the function of the picture frame is to maintain the 'conceptual schema' (Derrida, 1987 65) which distinguish form from matter, art from not-art, then here the logic of the frame is disrupted: it is a frame that defines an unbounded space and has itself become the 'body' of the work. My own response to *Hang Up*, which I have seen only in reproduction, is that rather than provoking anxiety as Krauss implies, it makes me want to step inside the released space, as if I have been given permission to enter the frame for the first time. These two elements, the use of a precise absurdity which mimics yet disrupts the rules of painting and the (unspoken) invitation to enter into the unbounded space of the frame suggest a momentous change taking place in painting.

Rosalind Krauss makes Hesse's piece representative of just such a significant moment, not only for Hesse herself but for modernism, a point at which its rules are literally turned inside out and one which marked the beginning of the end for painting. Lucy Lippard, while also identifying Hesse's work as a turning point, saw it as the beginning of something else: the prefiguring of the aesthetic concerns of feminist art practices from the 1970s to the 1990s (Lippard 1995, 4). What is at stake in these different accounts of endings and beginnings which *Hang Up* represents is no less than a seismic shift in the aesthetic grounds of abstract painting. In this context, the critic Michael Fried's account of the painter Frank Stella describing his favourite baseball player in action in the 1960s is peculiarly interesting in its gendered anachronism. As retold by Krauss, this description becomes a metaphor for the aesthetics of modernist abstraction itself: the disembodied eye (I) in the autonomous field of the visual:

In that speed was gathered the idea of an abstracted and heightened visuality, one in which the eye and its object made contact with such amazing rapidity that that neither one seemed to be attached any

longer to its carnal support - neither to the body of the hitter nor to the spherical substrate of the ball. Vision had, as it were, been pared away into a dazzle of pure instantaneity, into an abstract condition with no before and no after. But in that very motionless explosion of pure presentness was contained as well as vision's connection to its objects, also represented here in its abstract form - as a moment of pure release, of pure transparency, of pure self-knowledge.

(Krauss 1994, 7)

Modernist abstraction came to stand precisely for this 'motionless explosion of pure presentness' through which the disembodiment of painting occured.[3] Although Krauss does not remark on it directly, Stella's metaphor is doubly gendered, not only in its evocation of the very masculine game of baseball, but in the concept that self-knowledge is only achievable when, in a state of abstract transcendency, vision is removed from its 'carnal support'. The term 'carnal' here precisely evokes multiple associations of the fleshly, unspiritual, bodily, sexual, that is, of the sexed, embodied subject. It is this carnality that haunted abstract painting until the work of Eva Hesse literally opened it up to admit the female body with all its connotations of temporality, materiality and disorder.[4] In an investigation of what 'comes out of' Hesse's work then, I want to explore the carnal subject of aesthetics outside the limiting frame of modernism.

What is the Matter with Painting?

The rhetorical claim that painting is dead has been made repeatedly for one hundred and fifty years since Paul Delaroche prematurely declared its demise with the advent of photography.[5] Painting has equally repeatedly been redefined throughout the twentieth century. As Yve-Alain Bois has argued, the teleology of modernist painting foretold its own death: both Kasimir Malevich and Piet Mondrian claimed that the end of painting was already in sight as its absolute form, pure abstraction, was developed, 'abstract painting was meant to bring forth the pure *parousia* of its own essence, to tell the final truth and thereby terminate its course' (Bois 1992, 327).[6] This essentialist claim was restated even more powerfully in the generation of American Abstract Expressionism by Clement Greenberg, who saw the logical development of painting as being towards the complete flatness of the picture plane. Without time or space, as in Stella's vision of the baseball player, painting is reduced to a single transcendent

moment of meaning, 'and this in turn, compels us to feel and judge the picture more immediately in terms of its overall unity' (Greenberg 1961, 138). Bois interprets such accounts as both a response to the end of painting and a working through towards that end. He suggests that the genealogy described by Greenberg, and reproduced within the linear conception of modernist art history, might be better replaced by a 'strategic approach (which) deciphers painting as an agonistic field where nothing is ever terminated, or decided *once and for all* [...] if the play of "modernist painting" is finished, it does not necessarily mean that the game "painting" is finished' (Bois 1992 329). But the current state of play within the art world at the beginning of the twenty-first century would suggest that the 'game' of painting is no longer conceptually nor critically dominant. As Tom Crow has commented, painting 'has passed from being a term of technical description into a shorthand code for an entire edifice of institutional domination exerted through the collector's marketplace and the modern museum' (Crow 1996, 127). Painting as a practice - and specifically abstract painting - is not seen as the place where new meanings are made.

If we take this position at face value, it is a depressing one from the point of view of women painters. If painting is no longer central to contemporary art practice and the artistic space allotted to women has historically been on the margins, are women who paint now doubly marginalised? Of the generation of women artists who achieved significant critical and public acclaim in the 1990s only two, Jenny Saville and Fiona Rae, were primarily painters. We might expect feminist critical practice to leap to their defence but, significantly, it is hard to find feminists writing about contemporary painting by women.[7] It seems that, in Britain at least, there has been a loss of connection between feminist critical theory and women's painting, which threatens to foreclose any meaningful debate between the two. But, as Amelia Jones has recently argued, it is important precisely to 'interrogate such moments of interpretative closure' in order to resist an emergent orthodoxy within feminist criticism (Jones 1998, 36). How then are we to resist such closure of meaning, in particular around non-representational painting by women?

One approach taken by Bryony Fer in her book, *On Abstract Art* (1997), is to rethink modernist abstraction beyond the narrow frame of its own definitions and exclusions. While Fer does not explicitly address gender, she does offer a way of thinking about abstraction which invokes sexual

difference, using psychoanalytic readings to explain what she suggests are the 'uncanny effects and fantasies which may be at stake in even the most systematic of pictorial structures' (Fer 1997, 6). When modernist aesthetics embraced purity and economy of means, Fer argues this was always an effect of some kind of repression, a blind spot, exemplified in Mondrian's desire to exclude the 'merely decorative' from his painting. Mondrian named 'corporeality, the three dimensional quality of bodies in space' (Fer 1997, 40) as that which he sought to exclude in order to produce the effect of the pure plane; it was the polluting quality of the feminine which threatened this unity and had to be sublimated to a horizontal principle conceived as an abstract essence. But I suggest that it was not so much the 'feminine' that Mondrian worked hard to repress as the *female*, that is, the sexed subject 'woman'. As Christine Battersby has shown, male artists were always able to incorporate femininity as an aspect of their creative 'genius'; it was embodied women artists that they found difficult to take (Battersby, 1989). Mondrian admitted the feminine principle as a necessary correlate to the masculine within painting, but objected to what he called the 'predominantly female art' of representation on the grounds that women were incapable of abstract thought (Fer 1997, 41). In contrast, Fer identifies collage as one site where what modernist abstraction sought to expel from its system can be identified. In collages by the non-objective artist, Olga Rozanova, there is a tension between an abstract visual order and the tangibility and fragility of materials invoked through its methods of cutting, tearing and pasting, involving as Fer puts it, the 'circuits from sight to touch and touch to sight' which imply bodily presence (Fer 1997, 30).[8] I will explore these ideas of tangibility and embodiment further in relation to work of the artist, Susan Hiller, whose practice marks another strategic move in the 'game' of painting. But, before that I want to say something about what seems to be invested in my own desire to look at paintings. I will describe this desire from the position of a sexed, embodied subject: the carnal spectator.

Why Painting Matters to Me

Two paintings have caused me recently to reflect on my investment in painting and on the viewing process itself.[9] They are both classical paintings, Titian's late *Diana and Acteon,* 1559, on loan to the National Gallery of Scotland (Figure 31), and an early painting by Nicolas Poussin, *Rinaldo and Armida*, c.1628, in the Dulwich Picture Gallery, London

(Figure 32). It is no coincidence that these pictures from the sixteenth and seventeenth centuries absorb me since they were part of my early psychic formation as an art historian.[10] I will not attempt a full reading of the paintings here, nor any account of their historical materiality, but consider what it is about my experience of viewing them that might contribute to an account of contemporary painting practice. The particular elements that I want to address are the relationships between looking, mobility and space, and between paint and touch.

Titian's painting comes out of the tradition of Renaissance image-making which required an ideal viewing point to make sense of it, usually established in relation to a presumed spectator at a set distance from the canvas. Perspective implies a visual mastery of space, a point at which the viewer is spatially privileged and can impose boundaries and discriminate one thing from another. Such knowledge presupposes distance: we can only possess it if we are separated as subjects from the objects of our vision and reduced to one physical sense, the disembodied eye.[11] But my experience of viewing the picture is more complex than such an account implies. While *Diana and Acteon* can be resolved into a visual unity at a certain distance, it constantly threatens to dissolve that unity. As it now hangs in Edinburgh, I approach the painting first at an angle that makes it barely recognisable, and then I am able to move up to it so closely that the optical illusion of the image gives way to the tactile surface of painted marks.[12] This mobility of viewing is a condition of modern spectatorship, as watching the way people look at paintings in any gallery will show. Crucially, it is an experience that takes place over time rather than, as Greenberg suggested, an immediate apprehension of visual unity; it is a procedure that is more akin to the traditional practice of the connoisseur who inspects a picture minutely and then stands back to see it as a whole. It means that the physical relation of our bodies to the painting is probably less like that of Titian's original intended spectator, Philip II of Spain, for whose *camerino* it was executed, and more like that of the artist as he made the painting, as he tried to figure out the world by moving in and out from the surface of the canvas.

The phenomenology of looking at Titian's picture is one of constant slippage between surface and depth, representation and non-representation, between what is displayed and what is obscured: how can a flash of white paint be both a reflection in a glass vase in which the emotional drama of the picture is distilled and yet remain as brushstrokes on the surface of the

canvas? Engaged in this pleasurable process of decipherment, I am absorbed as a spectator between surface and depth, between action and contemplation, in an in-between space, the boundaries of which are not clearly defined. This kind of looking is neither disinterested in the Kantian sense, nor yet instantaneous as Greenberg suggested, but is dependent on the embodiment of the spectator who can move in space. If the painting is seen then, not as an *object*, but as part of an intersubjective relationship which needs an embodied presence, rather than a disembodied eye to complete it, then it becomes a complex phenomenological event involving two beings. Indeed, the art historian and theorist, W.J.T.Mitchell suggests that pictures face us as subjects which confirm our presence: 'Pictures are things that have been marked with all the stigmata of personhood: they exhibit both physical and virtual bodies; they speak to us, sometimes literally, sometimes figuratively. They present, not just a surface, but a *face* that faces the beholder' (Mitchell 1996, 72).[13]

But why is it so hard to walk away from the picture, why does something always drag me back for another look? There is something that just seems to escape my gaze, that pulls at the edge of vision.[14] Looking at Titian's painting involves both pleasure and a certain unease, a sense of something missing that I suggest is part and parcel of the process of looking. This can be related directly to the method of painting in Titian's late work which, as Rebecca Zorach describes, has been consistently gendered as feminine: 'Titian's paintings [...] are not only metaphorically "carnal", exquisite representations of flesh, they are themselves in some sense *carne,* flesh, with all its attendant pleasures and fascinations - but also its attendant risks' (Zorach 1999, 261). Zorach associates this sensation of ambivalence or 'risk' with 'abjection in *looking'* which she argues is closely tied to the abject figure of Callisto who is punished by Diana for her illicit pregnancy in *Diana and Callisto,* the other picture in Titian's pair of *poesie* (Zorach 1999, 248). This is indeed consonant with the narrative of *Diana and Acteon* in which the punishment enacted on Acteon as a consequence of his forbidden sight of Diana's naked body is when, changed into a stag, he will be torn to pieces by his own hounds, presaged in the painting by the antlered skull of a stag on the arch behind Diana's dais. But at the moment at which I encounter Acteon in the painting, he is suspended between advance and retreat, between a desire to see more and a fear of retribution, on the borderline between the masculine world and the dangerous feminine interior marked off by the water at his feet and the crimson curtain held aside by a nymph. His pose, caught awkwardly off balance between

stepping forward and back, appears to mirror my own position as a viewer, a connection reinforced by his positioning at the left edge of the frame, partially turned away from me.[15] Like Acteon, I too am transfixed; caught between staying and going, my desire to enter the frame is counterbalanced by the fear that I will not find what I am looking for. It suggests just that moment of oscillation between desire for a whole self and fear of its loss that Julia Kristeva identifies with abjection (Kristeva 1981). Rather than, as Zorach suggests, an identification with an abject figure, abjection in looking here then seems to be tied to an embodied sense of desire and potential loss, one which I will explore further in relation to Poussin's picture.

Because of its smaller scale and its position at eye level in the Dulwich Picture Gallery, Poussin's painting offers more immediate visual pleasures.[16] These are not purely formal, it is impossible to divorce the delight that I have in the picture from the reversals in gender and ethnicity it effects: the female body of the Saracen princess, Armida, is shown in profile, active and dominant, her white arms forming an arc over the male body of the Christian knight, Rinaldo, who reclines, his body open to the gaze, passive and sensuous. Her skin is as cool and bloodless as her blue and white robe, while his rosy pink flesh glows with the red and yellow tints, his armour gleams, his hair waves extravagantly, his red lips are slightly parted in sleep, his left knee leans out of the pictorial space inviting my touch - which is of course prohibited.[17] This erotics of looking is certainly not unique to painting, but I suggest that it is the particular sensation of vision combined with touch which produces such haptic perceptions.[18] Touch is linked to sight through the materiality of the painting process itself, the colour and brushstrokes barely visible in the picture. Tactile metaphors are used constantly to describe the making of a painted image - the brush 'strokes the skin' of the canvas - in a way which insistently refers to the physical registration of the body. And this painting is all about touch and frustrated desire: Cupid hangs on Armida's arm, she caresses Rinaldo's hand, the point of her dagger just fails to touch his knee. My eyes move around their bodies in a chain of movement. The only disturbance is where the two hands of the lovers meet and it is unclear at first whose hand I am seeing. This makes me pause and then reverse the movement of the gaze back through the arc of Armida's arms to the point of her drawn dagger stayed by Cupid from piercing Rinaldo's body; an oscillation between desire and death. Like *Diana and Acteon,* this painting is all about erotic invitation and prohibition, and the retribution exacted for

transgression - both within the narrative and for the spectator - expressed as looking and (not) touching. The shadow side that haunts every representation, figured here symbolically in the darkened landscape behind the lovers, is the irretrievability of choice (Acteon's, Armida's, the painter's, mine).[19] The outcome of a painting is the summary of such choices, for every mark made there is another lost, obliterated by the next in a process of loss and retrieval which is repeatedly re-enacted by the painter. Whereas the openness of Titian's pictorial methods makes this process of losing and re-marking visible, Poussin effects a closure in formal terms but a sense of loss resonates throughout the whole image: Rinaldo sleeps but his pose prefigures a death.[20] I have discussed my responses these two paintings at some length to try and distil some elements of the experience of looking on the part of a sexed and embodied subject. To summarise, my relation as a spectator to these paintings is clearly not one of pure visuality. I am only too aware of bodies, of bodies in the painting and of my own body as I stand in front of it. I invest them with mixed feelings of pleasure and loss; the ambivalent desire for the what-might-have-been in representation. But what if no image is there? What relationships of paint and touch, desire and loss, space and spectatorship can be mobilised to engage the spectator by non-figurative means?

Painting as Matter

In a series of works called *Painting Blocks* (1973-84), Susan Hiller cut up her own earlier paintings and remade them as ten bound bundles (Figs. 28-30). While Hiller's work is obviously conceptual, it has a strong material quality.[21] Neither painting nor sculpture in the conventional sense but something else, the rough and frayed blocks retain the characteristics of paint on canvas and appear as three dimensional stitched 'books' with the dimensions of the original painting and dates printed on their covers. Hiller comments:

> By moving my own works into another state of being, I allow them to participate in life, instead of curating the work as though it were entombed in a museum. There is also a hidden psycho-political agenda: these works express my interest, at a very deep level, in the tactile quality of vision, in 'touching with the eyes'.
>
> (Hiller quoted in Brett 1996, 16)

What is invested in this transformation from painting to block, and from looking to touching, from tomb to archive? The ideas of duration and 'touching with the eyes' which are implicit in the paintings by Titian and Poussin are made explicit in *Painting Blocks* but, at the same time, the painted surface of the canvas remains hidden. My desire to 'see' them as paintings is frustrated. However much I try and catch a glimpse of their coloured interiors, I can only recover their meaning *as* paintings through the tactile qualities of the rough fraying canvas and the conceptual information given in stark printed details on the surface of each block. As Jean Fisher comments of this series:

> The artist extends some of the procedures and values of an earlier minimalist aesthetic; a rejection of the autonomous, 'ideal' object in favour of non-hierarchical modules; the breakdown of traditional distinctions in painting and sculpture; and an experience of *making* or *duration*, encompassing the act of viewing that reinstates a more interactive relation between art and the body. (Fisher 1996, 62)

The intersubjective relation established between the embodied spectator and *Painting Blocks* involves an active process of decoding that not only requires me to mobilise the senses of sight and touch, but to engage with how the work re-configures these senses in a new relationship. The transformation from painting to 'block' requires the viewer to engage with the process of remembering what looking at a painting is like. It thus actively reinstates the experience of time, which was disavowed in high modernist abstraction. Rather than 'touching with the eyes', I arrive at seeing through a sense of touch in what becomes a complex set of relations between time, space and memory.

Hiller returns painting to something nearer to its performative functions in pre-Renaissance and non-western cultures where it can act as a part of ritual, as a talisman or a manual, conceived as impermanent yet having a material presence and effect in the world.[22] This ritualistic element in Hiller's work is evident in another series of recycled works in which she burnt previous paintings and kept the ashes in a series of glass receptacles with hand-written labels giving their dates and titles, for example, *Collected Works* (1968-72) and *Hand Grenades* (1969-72) (Figure 33). While ashes suggest a death, the title of *Hand Grenades* implies a more violent rebirth; these banal glass jars have explosive potential. Like the act

of cutting up her own canvases, Hiller enacts a violent material transformation of painting. A comparison between Hiller's work and the re-use of her own earlier paintings by Tracy Emin, shows how genuinely transformative Hiller's practice is. In a work entitled *My Major Retrospective* (1982-92), Emin reproduced her early paintings as miniature photographs, which she then exhibited on shelves as a new artwork. Whereas Hiller destroyed and re-made her paintings, allowing them to take on a new life, Emin recorded hers as a kind of *memento mori* to be enshrined on the gallery wall. Yve-Alain Bois associates modern painting with the task of mourning, but suggests that this mourning need not be morbid once we believe in our ability to act in history: 'the desire for painting remains [...] this desire is the sole factor of a future possibility of painting, that is, of a non-pathological mourning' (Bois 1986, 326). By recycling her paintings, Hiller allows her work to make a transition from entombment to 'another state of being'. She refuses to mourn for them and, instead, implies that in such a remaindering, a sense of self can also be re-made.[23] As in the artwork, the subject is capable of change and renewal rather than mere repetition. And, unlike the repeated enactment of loss and retrieval in traditional forms of painting, Hiller's transformative practice does not offer consolation for trauma, but enacts renewal through an aesthetic of unmaking, remaking and reparation. Both indexical and iconic, this work evokes an affective response that is sited in the ambivalent relation between vision and touch.

These concerns are also explicit in the wide range of Hiller's work which combine painting or drawing with automatic writing to explore the unarticulated speech of women. In a work called *The Sisters of Menon* (1972-9), Hiller drew on an earlier project she had done using automatic experiments somewhere between writing and drawing which she later put together in a cruciform layout of four L-shaped panels with additional 'translated' typewritten texts. The modular form of the work seems to relate to the open-ended nature of the 'conversation' between the barely articulated voices of women who are heard and seen through the writing :

> *who is this one/ I am this one/ Menon is (1)*
> *Menon is this one/ you are this one (2)*
> *I am the sister of Menon/I am your sister/the sister of everyone's*
> *sister/I am Menon's sister (3)*
> *I live in water/I live on the air (4)*

Hiller seeks a language to describe the self, or these multiply imagined selves, without resorting to the individual voice or celebrating an imagined feminine 'Other'. In the multiple voices of *Sisters of Menon* - 'I', 'you' 'sister', 'everyone' - there is no separation between the subject or object of speech, but rather a refusal of the fixity of self that is embedded in western epistemology. Unlike paint on canvas, which acts as a skin on the surface, the hand-written and drawn texts are more porous. They enable a viewer to move in and out of the work and to take up other positions: losing a sense of boundaries, 'we are plural' (Hiller 1997 11). Indeed, Hiller has commented: 'My "self" is a site for thoughts, feelings, sensations, not any corporeal boundary. I AM NOT A CONTAINER [...] Identity is a collaboration. The self is multiple.' (Hiller 1996 xiii). Her statement resonates with strikingly similar comments about female subjectivity and embodiment by contemporary feminist philosophers. Christine Battersby questions the notion of the body as a container whose boundaries have to be secured from flowing and flowing out that is prevalent in masculine discourse. In lieu of this sense of a self-contained being within a unitary, autonomous and impermeable body, she proposes a model of '"Self" [...] capable of interpenetration by "otherness"' (Battersby 1998, 38). She suggests that we need to imagine different metaphors of identity that would describe the specificity of women in positive terms and, following Luce Irigaray, takes the maternal body as her model, or rather an individual who can each month think of herself as 'potentially evolving into two individuals:

> We need to think individuality differently, allowing for the potentiality for otherness to exist within it as well as alongside it. We need to theorise agency in terms of potentiality and flow. Our body-boundaries do not contain the self; they are the embodied self.
>
> (Battersby 1998, 57/8)

Hiller redefines the limits of the self in many of her works, often through an exploration of the ways in which unknown or occult phenomena seep into everyday life.[24] In a series of paintings from the mid 1980s, Hiller combined figuration and abstraction to disrupt the 'topology of self-containment' offered by conventional perspective space, suggesting instead a shifting liminal space whose edges and limits are uncertain. In *Masters of the Universe*, 1986, commercial wallpaper intended for a boy's bedroom is partly painted over with black ripolin paint. Inverting the usual metaphor in which the unconscious lies 'beneath' the rational, Hiller

invokes a female presence, which covers and partially effaces the stereotyped masculine fantasy of space invaders. It is the negative spaces left unpainted that appear like a script in an unknown language, from the "outer limits", the unspoken and out of control' (Hiller 1996, xii). A similar concern using very different media is evident in her recent large video installations, *Wild Talents* (1997) and *Psi Girls* (1999), which use fragments from American and European film to represent children who have special powers to move objects by telekinesis. In these works, Hiller goes beyond the limits of the static image using sound and movement, a procedure that enables her to avoid limiting her work within a single frame. In *Psi Girls,* the large scale of the screens that surround the viewer and their changing synthetic colours, together with physical sound, envelops all the senses. The sound track builds to a crescendo using the rhythmic hand-clapping and drumming of a gospel choir and then breaks, followed by the loud electrical buzz of an untuned television receiver, then silence, before the cycle begins over again. As Hiller comments: 'the drumming and clapping of the church choir has a compelling rhythm and what it is compelling you to do is to believe [...] It has that kind of psychological effect: you almost feel it working on your blood pressure and your heart' (Betterton 1999, unpaginated). This synaesthetic use of colour, sound and the movement of flickering images, engulfs the viewer within the space of *Psi Girls,* while the tension in the images builds as each girl begins to move objects through telekinesis. Hiller does not use video as transparent medium, but in a way that evokes both physical and emotional responses and is more akin to the materiality of painting.

In this paper I have tried to delineate a potential aesthetics of abstract painting which differs from the high modernist claim of 'no before and no after'. One of the recurrent thematisations was that of the temporal process of making, unmaking and remaking work which remains deictically in the work itself: Eva Hesse binding her frame like a broken limb; Susan Hiller cutting up, burning and re-making her paintings. Other examples of similar practices include the painter, Lee Krasner, who cut up her old drawings and re-made them as collages in the 1950s, and Helen Frankenthaler who let paint flow and stain unprimed canvas on the floor, emphasising the tactility of the medium. The contemporary painter, Avis Newman, also uses methods that suggest an open-ended process of making and unmaking over time, of touching and re-touching. Newman's *Webs (Backlight)* (1993) use a process of layering and repetition of marks each of which,

while partially obliterated by another layer of paint, remains visible underneath like a material memory trace.

The procedures involved in making all these works anchor them as physical matter which occupies space and with which we become acquainted through senses of sight *and* touch. They can be characterised as material practices dependent on psychic and physical embodiment, which are perceived as taking place through time and always necessarily incomplete.[25] And while, as Susan Hiller's multimedia practices suggest, painting has no intrinsic relationship to the rethinking of female subjectivity and embodiment, I have tried to show that by re-embodying the gaze, it can lend itself to the representation of different topologies of self. I take these topologies to be analogous to - but not illustrative of - new epistemologies of the subject being explored within feminist philosophy. Both painting and philosophical practices invoke the situated ways of knowing and being in the world of the carnal subject.

Notes

1 For example, Griselda Pollock has dismissed women's desire to paint as 'an alibi for female expressivity; that is for seeking women's equal rights to the "body of the painter"' (Pollock 1992, 146), while Katy Deepwell saw the appropriation of French feminist theories of '*l'écriture feminine*' as a misconceived textual strategy to construct a feminine aesthetic (Deepwell 1994). A brief survey of feminist critical anthologies on art published recently in Britain reveals a significant lack of writing on contemporary painting by women. In Deepwell's *New Feminist Art Criticism* (1995), only two essays out of twenty-two refer specifically to painting, both in the context of psychoanalytic theory. In Pollock's collection, *Generations and Geographies in the Visual Arts* (1996), three of fifteen essays deal with contemporary women painters: Jenny Saville, the Korean artist, Ry-Hyun Park, and the Israeli artist, Bracha Lichtenberg Ettinger, while in Catherine de Zegher's major catalogue of the feminist exhibition, *Inside the Visible* (1996), three out of thirteen essays on contemporary art discussed painters: Avis Newman, Ellen Gallagher and, again, Lichtenberg Ettinger.

2 Briony Fer explores the idea of blankness in Hesse's work in Fer (1994).

3 Krauss connects this with the final sentence in Fried's own essay on painting, 'Presentness is grace' (Fried 1968, 147). Although I argue here that the desire for disembodiment is characteristic of high modernist abstraction, Norman Bryson has suggested that it characterises all post - mediaeval western painting (Bryson 1983, 87-131).

4 This is analogous to the claim made by W.J.T.Mitchell that the silencing or repression of language in modernist abstraction was shattered in the mid 1950s by Jasper Johns' *Flags* and *Targets* which marked 'the resurgence of artistic impurity, hybridity and heterogeneity summarised as the "eruption of language into the aesthetic field"' (Mitchell 1994, 239). A similar point can be made about Robert Rauschenberg's combined paintings.

5 The implications of photography for painting have been extensively explored, most notably in Walter Benjamin's essay 'The Work of Art in the Age of Mechanical Reproduction' in Benjamin (1970).

6 W.J.T.Mitchell puts it more succinctly, 'Abstract paintings are pictures that want not to be pictures' (Mitchell 1996, 81).

7 It is significant that while Saville's over-life-sized female nudes have received critical attention from feminist writers (Rowley 1996), Rae's semi-abstract painting has been ignored.

8 Paula Rego makes a similar point about collage in relation to her own practice: 'Touch is important. When I was making collages, paper was pressed into place. These days pastels work extremely well because it's all done with the fingers. The pastels jump to hand when things are going well. It's very physical and that suits me' (Rego 1998, unpaginated).

9 I am grateful to Alison Rowley for sharing the experience of looking at Titian's paintings in Edinburgh in October 1997 and for helping me to think through my own experience of spectatorship.

10 Professor Richard Verdi, a noted Poussin scholar who is passionate about painting, first encouraged me as a student to translate my responses to paintings into words. At that time I was unaware of any gendered implications in the works I was looking at.

11 See John White (1957) *The Birth and Rebirth of Pictorial Space* for an account of the development of perspective vision in Renaissance painting. I am using the term 'viewer' here rather than 'spectator' to avoid this more distanced form of the gaze: 'looker' would be more accurate, but less grammatical. Norman Bryson argues 'glance' rather than 'gaze' implies a less authoritarian viewing position from the margins, but this does not suggest the act of looking over time which I describe (Bryson 1983).

12 The art historian, Ernst Gombrich, associates this balance between illusion and the painted surface in which the brushmark carries the memories of touch and movement with the writing of Adolf von Hildebrand on *The Problem of Form in the Figurative Arts* (1893) (Gombrich 1969 13-14). The art historian, Alois Riegl, also discussed the tactile sense of art in *Spatsromische Kunstindustrie* (1927).

13 Merleau-Ponty's account of the phenomenology of viewing also referrs to the significance of embodiment: 'To perceive is to render oneself present to something through the body' (Merleau-Ponty 1964, 16). See also, Mieke Bal's

'Reading Art' for a discussion of the interactive process of reading images (Ball 1996).

14 In Lacanian terms, this is precisely what the picture cannot show, its 'optical unconscious' or, as Norman Bryson put it, something 'missing, but what it is can never be named because it is precisely, absence' (Bryson 1983, 71).

15 Acteon adopts the position described by Mieke Bal as one of 'focalization: the narrative equivalent of perspectival centering' (Bal 1996, 37).

16 Dulwich Picture Gallery is currently undergoing extensive renovation which may involve rehanging Poussin's picture in a different position from when I looked at it in 1998.

17 I am speaking from the point of view of a white, heterosexual, able-bodied, female spectator, but the 'me' who looks is at the intersection of other possible positions from which different readings might be made, for example, as a lesbian viewer.

18 In her analysis of the visual erotics of video, Laura Marks defines haptic perception as 'the combination of tactile, synaesthetic and proprioceptive functions, the way we experience touch both on the surface of and inside our bodies' (Marks 1998, 332). It is significant that the most persuasive writing on theories of the gaze has been in cinema and photography. This is much less successful when applied to painting where the image is produced directly by bodily action of the subject through a tactile medium and the touch of the artist is usually visible.

19 As the heroine of Jeanette Winterson's novel, *Oranges Are Not the Only Fruit*, comments on leaving home to go to Oxford, 'There's no choice that doesn't involve a loss' (Winterson 1985, 172). My own decision to go to university and study art history rather than to art school and become a painter, signified a different kind of loss. Looking at these paintings involves remembered pleasures, but also recognition of the loss involved in choice.

20 Rinaldo's pose is very similar to that of the dead figures of Adonis and Tancred in two early works by Poussin in Caen and Birmingham respectively. Poussin repeats a passive male figure and the active female pose in other early works, for example *Echo and Narcissus* (c.1629-30).

21 It is somewhat perverse to base this discussion on Susan Hiller's painting, since she is better known for her works in a range of new media including photography, video and installation. See *Susan Hiller,* Tate Gallery Liverpool (1996) for an overview of her work.

22 Susan Hiller used the term 'remaindering' in discussion of her work *From the Freud Museum* at a plenary session of the Association of Art Historians' Conference 'Body and Soul' Edinburgh, 8.4.2000.

23 See Barbara Bolt (2000) for a very interesting discussion of the performativity of painting in the context of indigenous Australian art practice.

24 For example, *Belshazzar's Feast/The Writing on the Wall* (1983-4) and *Magic Lantern* (1987).

25 Both in the sense that the works continue to change physically over time and that their meanings also change: 'reading is a manner of rewriting or repainting' (Bal 1996, 40).

Earlier versions of this paper were given at the symposium, 'Absence of Images' in Bath, September 1998 and at the conference 'Uncommon Senses' in Montreal, April 2000. I am grateful to the organisers of both events for giving me the opportunity to present my ideas and to Penny Florence for her constructive criticisms.

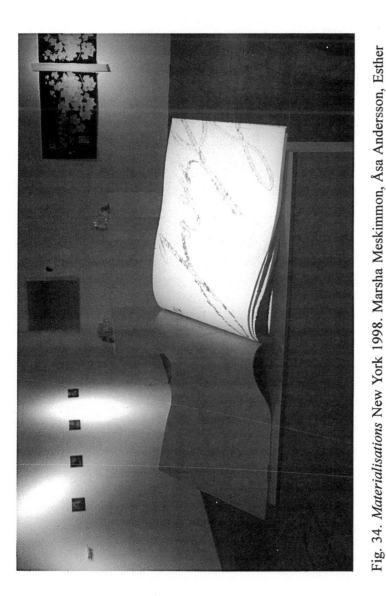

Fig. 34. *Materialisations* New York 1998. Marsha Meskimmon, Åsa Andersson, Esther Sayers. Installation view including: folio volume (foreground); *Writing Water in Its Absence* (series, left); poured glass (background); foliage photogram (background, right).

Chapter 13

From Matter to Materialisations: Feminist Politics and the Aesthetics of Radical Difference

Marsha Meskimmon

'[...] I would propose [...] a return to the notion of matter, not as a site or surface, but as *a process of materialization that stabilizes over time to produce the effect of boundary, fixity and surface we call matter.*'

(Butler 1993, 9)

Corporeal Theory

Matter, materiality and materialisation are crucial terms in any project which explores aesthetics, difference and the articulation of alterity. However, to move from conceiving matter as 'a site or surface' to 'a process of materialization' as Judith Butler suggests, entails a paradigm shift. Epistemological systems underpinned by dualist hierarchies such as subject/object, masculine/feminine and self/other make it impossible to read matter as anything but a mute object, a site or surface, available for examination and interpretation by a knowing subject. As a process of materialization however, matter negotiates the chasm between subject and object reinstating knowledge as a performative activity which takes place between 'knower' and 'known'. To know ceases to be a solitary, abstract encounter with truths underlying the appearance of things and becomes a series of situated actions within the world, each partial and perspectival and each renegotiating the boundaries of the 'self' as much as those of 'others'.

Reconceiving knowledge as an intersubjective process or practice in this way asserts the 'corporeality of theory', a key concept in the work of such feminist scholars as Elizabeth Grosz and Donna Haraway who have explored the potential to think and articulate subjectivity through radical difference (Grosz, 1995:37; Haraway, 1994).

In relation to aesthetics, corporeal theory has been used by Martin Davies to reinvestigate the work of Alexander Gottlieb Baumgarten, arguing that the post-Enlightenment hierarchies which developed between rational knowledge and sensual perception were not necessarily implied by the *Aesthetica.*[1] Davies describes the way in which aesthetics, as a corporeal practice, can reinstate the significance of multiplicity, contingency and location within knowledges systems. Concepts such as embodied subjectivity, situated knowledge and corporeal theory enable us to think past conventional views of authorship and aesthetics without merely negating the significance of material authors and the materiality of ideas.

This is precisely my investment in exploring these theoretical insights. With research centring upon women artists, I am keenly interested in the significance of women's cultural agency and the materiality of art practice. I am thus committed to exploring female subjectivity using concepts of authorship which can accommodate both the specificity of, and differences between, women artists without moving toward universal, essentialised models of the feminine. I am neither convinced that women have been rendered mute by their structural connections with 'woman' (as 'other'), nor that their work can be homogenised and reinstated within traditional, monovocal art historical practices. Hence connections between female subjectivity and aesthetics are crucial to my work, and concepts of 'matter' and 'materialisation' are linked inherently to both. Thinking about women as artists in these terms requires me to challenge the materiality of my own writing to find new modes of enquiry and coextensive praxis.

These modes are multiple and yet particular to their moment; as conceptual micro-histories, they acknowledge visual and material specificity and the location of the critic within the work. Thus, micro-histories are not just specific case-studies of, for example, one artist or one artwork; it is perfectly possible to write one artist or work into a totalising narrative derived from a preconceived universal system. Rather, micro-histories imply an activity through which difference, agency and specificity are not effaced by the questions being asked, the sources being used or the

theoretical framework being fixed. That is, the material under study, such as the work of a particular woman artist, is used to begin a process of materialising possible meanings and theories, rather than to 'prove' or 'illustrate' a predetermined argument about 'women artists' as an homogeneous group. The questions asked of a work shift from what does it mean or represent to how did/does it *make* meanings in conjunction with particular contextual/theoretical constellations. Hence, the micro-history attends to the specificities of difference, enacts an open-ended process of dialogue between the interpreter and the works under discussion and refutes any attempt to find one true meaning or theory underlying all individual manifestations of practice.

Moreover, the idea of the micro-history as a strategic written intervention encourages authors to be more explicit about their positions and more responsible for their methods. The desires and perspectives of the critic are rendered visible by her choice of sources, methods and words, thus countering any sense of pre-given history or objective writing position. Allowing critical insights to emerge from between the texts, images and objects, acknowledges the interaction between the critic/historian and the material she examines as a *practice*; the materiality of writing is involved in this process rather than presenting itself as a transparent medium which carries disembodied ideas and transcriptions of meaning. As Maurice Merleau-Ponty so succinctly put it: '[...] speech in the speaker does not translate ready-made thought, but accomplishes it' (Merleau-Ponty 1962, 178).

In the pages which follow, I want to trace one specific project with which I have been involved over the last two years in order to discuss the development of a particular set of textual practices which were integral to art practice. *Materialisations* (Fig. 34) is a collaborative venture between myself and two women artists/theorists, Åsa Andersson and Esther Sayers, and it began as an attempt to work through some of the more difficult issues being raised in all of our individual practices regarding the interaction between text/word and image/object as well as how an aesthetics of radical difference might be realised in material terms. *Materialisations* was realised in a show in New York during October 1998 and is now being rethought/reworked to open in Wolverhampton in the year 2000.[2] In an important sense, we saw the New York installation (the focus of this text) as one possibility of performing our ideas at that moment, but the collaborative project itself admits of other interventions

and future developments. As an installation, *Materialisations* was unlike the main body of my own work which consists primarily of text (books and articles with 'illustrations') or spoken 'papers' (with slides or, if I am lucky, standing in the same space as the work). However different my 'writing' was in the context of the show, the underlying issues and debates raised by *Materialisations* have had a profound impact upon my thinking in relation to the more conventional aspects of my written production and those ramifications form part of this paper. The move from 'matter' to 'materialisations' in an aesthetics of radical difference can speak to a feminist critical project taking place within the gallery or beyond it.

What is the Matter with Words

The basic insight that difference cannot be articulated within an economy of the same points to the most fundamental problematic facing the art critic/historian when writing about art - reducing the visual and the material to the textual. If an artwork merely is *translated* into text, its potential to produce meanings *differently* and the particularity of its materialisation of ideas are lost, nullified by homogeneity. As a feminist art historian, it is only too clear that the reduction of difference in monolithic histories has occluded the practice of women artists and that in order to explore their production it is necessary to pose alternatives to totalising, masculine-normative art historical methods.

Mieke Bal and Norman Bryson have written eloquently of the difficulties involved in approaching artworks with textual tools arguing that semiotics, as a system which explores the meanings made by signs ranging from the textual, to the visual or material, can overcome the 'linguistic turn' so damaging to art history (Bal and Bryson 1998). As they imply, semiotics as a 'transdisciplinary' system leaves the work of interpreting signs and forming permeable interchanges across multiple material forms to the level of micro-history, where the particularities of enunciation and difference come into view. Here, theory materialises or it fails: the frames and boundaries of a meta-system only serve to occlude the subtle negotiations made by subjects in every act of articulation and every performance of identity. Theory can become corporeal, located in a history and able to change in response to the specificity of the 'others' it encounters, precisely when it does not seek to write them into its own metanarrative. A micro-

historical approach implies an encounter between theory and practice in the 'in-between' where writing can function to keep the tension between objects and concepts open rather than make one into the other. In the words of Nicholas Davey, here writing is not 'something antithetical to any aesthetic experience of an art object but a means to bring such experience to articulation'.3 Writing creates a spatio-temporal context for knowledge-production through aesthetics and becomes coextensive with the performance of meaning, rather than its fixed definition. Within such a space, the matter of writing itself undergoes a materialisation, moving from object to process in response to radical difference.

Materialisations is one such micro-historical intervention into the matter of words and the corporeality of theory. In this light, our first concern was to think about the nature of the collaboration itself, since we wanted neither to operate as isolated practitioners joining together for a 'group show' nor to efface the differences between us and our practices in a form of total collectivity. We operated through dialogues between differences, later finding in the work of Rosi Braidotti these resonant words: 'What is at stake here is how to restore intersubjectivity so as to allow differences to create a bond [...] a new kind of bonding, a collectivity resting on the recognition of differences [...]' (Braidotti 1994, 162). Braidotti's insistent feminist re-working of Deleuzian 'becomings' to admit of material specificity and the political dimensions of difference inspired me to think of the collaboration as itself a form of feminist aesthetic *praxis*.

In practical terms, we brought to the first meetings those writings, art and materials with which we were most fascinated and which we felt engaged with ideas of process and multi-sensorial aesthetics beyond the hierarchy of theory over practice. Each of these first encounters led to stimulating debate, argument and new research for all of us, both individually and collectively. After this initial period, we ran what we crudely termed 'workshops': day sessions during which we jointly explored each others' working methods and learned more about the ways in which our practices were 'materialised' as 'art' or 'text'. These workshops were often studio sessions developing key ideas and materials, such as a day spent experimenting with large format photograms and one using a variety of methods to capture forms of gestural mark-making and writing. Significantly, we also worked through texts and words, doing collective sessions with etymology and theory. Through these sessions, we each came to know more about 'materialisations' which were new to us and to think

differently about our own, well-trodden practices. In the end, we produced work for the show which came from both of these directions: there were collectively-produced objects, such as a large folio volume whose blind-embossed pages acted as screens for multiple projections in the space, and there were individual contributions to the show, made in dialogue with the other practitioners and their works/writings.

For me, this dual approach was crucial: I had experienced making work and had produced a material object for the show, but I had not had my own particular practices as an art historian/theorist subsumed by studio work. In keeping with the process-based corporeal theory with which I was engaged, there was room here to develop the in-between for my own writing. With 'art' residing between the 'texts', 'objects' and 'bodies' making and experiencing the space, my writing, *as* writing, could become part of the process of making 'art'. Within the installation itself, the 'artworks' ranged from the photograms and folio volume to exquisite overlay prints, poured glass objects (striking as both tactile and optical) and fragile, shadow-casting glass shells, all demonstrating ideas of sensual knowing and aesthesis with great eloquence. What then, was the place of words?

As the most textually-confined of all three collaborators on the project, the 'words' in the space of the show were vital to me and were, in many ways, my contribution to the installation itself. Somehow the words needed to engage with the objects without reducing them by 'explanations' or pre-formed theories, they wanted to act in the space, maintaining an open-ended, process-based 'reading' and they wanted themselves to be 'matter', to show their histories and their particularities of form. The textual contribution to the collaboration had not been relegated to the margins as post-facto criticism or comment, yet the conventional uses of text within the spaces of the gallery threatened to do just this by forcing us to write a 'synopsis' or 'statement' or 'titles/captions' to the work. How was it possible to show that the exploration of language and theoretical text had been just as material and just as vital to *Materialisations* as the making of art objects?

This dilemma was in part answered by going back through the material histories of words and theories developed during the course of the collaboration and making these an explicit part of the installation space. In examining text and theory in practice, we had looked at key words and

concepts as matter - definitions, etymologies and the histories of ideas had been plundered to remind us that theory is not a-historical, universal or disembodied. For example, in one specific instance, we had explored 'the book', finding a series of fascinating connections between the folio as a volume, 'folious' leaves, interleaving and the fold, a gestural mark, a chiasmus and the root of the multiple 'manifold'. This, in connection with the histories of folio volumes as the containers of ritual words repeated and performed to move matter toward materialisation, provided ways of thinking about our collaboration, our research and the very substance of the works in the show. The archaeology of our terms, their inflections, connotations and changing historical functions - their materiality - were a key feature of the space.

Attention to the matter of words and the multi-sensorial nature of the installation suggested a need to indicate the experience of words in different forms and so to include gestural marks, writing as drawing (on the very walls of the gallery and on other surfaces), the blind-emboss ('text' on/in the very material surfaces of work), palimpsests, textual fragments (like overheard snippets of conversation) and more formal modes, such as printed dictionary definitions mounted in the gallery as information-bearing titles. The play between these diverse 'texts' reminded viewers of the bodily experience of writing and made any tendencies toward narrative multiple. Yet these disparate voices seemed to have no 'place' within the installation itself while their very interjection was meant to configure a space/time for manifold aesthetic encounters.

Clearly, the spatio-temporal frame in an aesthetics of radical difference permits the coexistence of the 'one' with its 'others'. Such 'places' have been theorised in the past in order to rework static concepts of subjectivity and pleasure and are thus of great interest in aesthetics. For example, Bracha Lichtenberg Ettinger developed the concept of matrixial space in both post-Lacanian theory and art practice while Emmanuel Levinas' thinking about voluptuosity, Elizabeth Grosz's work on the erotic and Luce Irigaray's suggestive term 'porosity' all imply pleasurable encounters with an other who remains different (Lichtenberg Ettinger 1992; Levinas 1969, 265; Grosz 1995, 184; Irigaray 1986, 236). The particularities of these thinkers' arguments are not simply equivalent, but the ways in which each of them point to the corporeality of thought, subjectivity and aesthetics as processes in the 'in-between' of self and other is highly suggestive. To think in these terms implies a web of connections, across permeable

matter, rather than a definitive centre posited as a singular truth underlying the mere surfaces of difference. To cite Grosz on the erotic:

> If we are looking at intensities and surfaces rather than latencies and depth, then it is not the relation between an impulse and its absent other - its fantasies, wished, hoped-for objects - that interests us; rather, it is the spread or distribution, the quantity and quality of intensities relative to each other, their patterns, their contiguities that are most significant. Their effects rather than any intentions occupy our focus, for what they make and do rather than what they mean or represent. (Grosz, 1995, 183)

In *Materialisations*, we were looking for a way of implying the weft and warp of connections across objects and ideas in the installation through words which were themselves material and spatial - which could 'make and do' rather than just 'mean or represent'.

In the end, it was cartography which provided a key through its history: mapping the 'location' of subjects through words and image-making while referencing the western tradition of collecting and displaying books, maps and artefacts together in order to 'know' the world. The kind of mapping which held the most immediate interest for our project was of the sky. Constellation diagrams linked a sense of place with variable connections made across mobile matter, not to mention with the traditions of narrative and exploration dependent upon those configurations. In the gallery space, 'constellation' diagrams, entitled *Aesthetica, Foliosus* and *Undula,* provided perspectival maps of the show and drew conceptual links between objects through various forms of 'text' and 'image'. Theoretically, these plural constellations embodied the process of viewing by connecting works and themes together in one location only to reconfigure these connections in another; the photogram could be thought in relation to the folio volume and ideas of the fold, or, in another constellation, it could work with the glass pieces and the sensuality of perception to rethink the relationships between sight and touch. The viewer was invited to locate their own position in relation to the spaces, objects, images and texts of the show in many different ways and thus to encounter aesthetic knowledges as practices.

Undula, for example, mapped a possible set of connections through text and cartography around ideas of resonance. Resonance had come to be

important to our desire to communicate between disparate practices without effacing them since it indicates flow and movement across individual fragments of matter. Moreover, it is a phenomenon of the surface and its force is enacted through harmonic collectivity - waves become larger when they resonate together at the same frequency, not when they are forced to alter to another band. *Undula* mapped connections between a number of disparate works in the space including the two poured glass objects and slumped glass casts, placed by Sayers in the space with original plaster moulds formed by casting large areas of beach to catch the marks of flowing water. These were linked in this particular constellation with the overlay print series by Andersson, *Writing Water in its Absence.* Materially, these works are diverse and indicate the very different means through which water, flow, presence, absence, narrative, history and archaeology might be thought in objects and images.

Undula referenced the objects only tangentially in the diagram, placing texts and maps in positions according with work. Thus the glass objects became the chiasmus, marked by a transparent film which read 'fluid/solid' as an overlapped shadow while *Writing Water in its Absence*, in which photography made the matter of objects seem insubstantial, was represented by the physicality of a fragment of film. A 'definition' panel for the word wave marked the place of the beach casts and voiced resonance and a fragment of drawn cartography (of the Northwest coast of England, the site of the sand casts) provided a reminder of location and perspective. All of these meanings demonstrated the processes of aesthetics between word/theory and image/object and materialised my theoretical positions at that moment, in that gallery space. The question of materiality and corporeal theory in the wider body of my written work, something with which I have been grappling for some time, now became a priority.

Feminist Materialisations: Critical Writing and the Aesthetics of Radical Difference

The significance of matter and materialisations to a feminist critical project centred on women's art and female subjectivity is reiterated by a brief foray into etymology. 'Matter' is structurally linked to woman; 'mater', 'matrix', and the conception of an opposition between base matter and word, spirit, idea or, traditionally within aesthetics, form, all pose body and

woman as the negative other to mind and man (Meskimmon 1998). The epistemological hierarchies between woman and man have powerful linguistic and aesthetic ramifications, situating theory over practice in the same way that word/text dominates image/object and form (or 'pattern', derived from 'pater') precedes matter. The logic of these dualist hierarchies makes articulation of the other impossible within the language of the same and thus their dismantling is imperative in a project exploring both female agency and art practice. However, the kind of intervention into coextensive 'writing' able to be effected within the gallery space, such as that in *Materialisations*, is not so easily available to feminist art historians and critics in their more usual writing modes. Should the writing of art history simply be rejected as too much a part of a theoretically debased masculinist tradition, or should its forms be manipulated, reworked and reconceived to other ends? This is the kind of question raised by taking an aesthetics of radical difference seriously and trying to enact or perform corporeal theorising in relation to women's art practice.

Corporealising theory enables an important shift in perspective to take place - from the notion that 'feminist content' might reside within works of art or written texts to an emphasis upon activities which produce aesthetic and political engagement. As Grosz argued so strongly:

> [...] no text can be classified once and for all as wholly feminist or wholly patriarchal [...] These various contingencies dictate that at best a text is feminist or patriarchal only provisionally, only momentarily, only in some but not in all its possible readings, and in some but not all of its possible effects. (Grosz 1995, 23-4)

This reinforces the 'in-between' - that particular, located encounters between theory and practice open potential new knowledges without claiming universal truth value. These insights connect micro-history with the concept of knowledge as practice and move from thinking of matter as an object to materialisations, enworlded processes between knower and known. The processes of theory corporealised in this way permit it to be changed and developed in encounters with non-effaced others. For example, in actually exploring the work of women artists, it is possible to renegotiate the theoretical discourses on female subjectivity and articulation in response to the material histories of women and their art practices. Theory loses pre-eminence as an all-powerful and singular tool able to yield fixed truths, but gains by acknowledging difference and

moving beyond subject/object dualism toward becoming a practice. The dialogic interaction between different but not subordinate others speaks to the 'in-between'; this space in my own work is highly political since it unites my commitment to rethinking the histories of women artists with developing contemporary strands of feminist aesthetics which voice female subjectivity through difference.

A few brief examples will suffice here. The work I undertook on women's self-portraiture practices did not produce a survey of self-images by women artists, although their work might have formed the basis of such an additive study if it had been read within a tradition of pre-determined value-judgements. Instead, this amazing body of work enabled me to think through the problems of female subjectivity from a number of different angles, opening my own preconceptions to novel forms of 'self' articulation through difference and materiality. In another project, exploring the historical development of the concepts of the 'monster' and the 'grotesque' provided a method by which to uncover effaced connections between women, creativity, fluidity and deviance toward productive ends. Etymology and the corporeality of concepts themselves helped to foster a processual approach to the research and to the various practices I interrogated.

More recently, I have been developing a body of work centred on finding the means by which to examine the role of women artists in Weimar culture without reducing them to a unified group. This project eventually challenged a number of theoretical premises frequently invoked in studies of women and modernism and thus reconfigured both my approaches to the histories of women in Weimar and to contemporary theory. In all of these ways, and many more, corporeal theory as a practice engaged with the micro-histories of women as artists provided new insights into the articulation of difference. These insights, from the gallery to the printed page, enable us to revisit the past and change the future.

Notes

1 Martin Davies, 'Philosophical Materialism and Situated Knowledge: Baumgarten's Aesthetics Revisited', unpublished paper.

2 For me, these dual international locations mirror my own situation as an American ex-patratiate in Britain and as a feminist art historian whose first introduction to the subject area was decidedly conditioned by an Anglo-

American axis. Indeed, my own recent work draws on far more diverse sources within the geo-politics of feminist thought precisely in order to critique my own, 'Anglo-American' position and the assumptions this entails.

3 Nicholas Davey, 'Writing and the Inbetween' abstract of paper delivered at *The Relationship of Making to Writing: Practice, History and Theory*, University of Plymouth, September 1998.

Fig. 35. *Hyperspace* 1998. Barb Bolt. Oil stain on canvas.
Artbank, Australia. 180cm x 120cm. (See also Plate 8.)

Chapter 14

Working Hot[1]: Materialising Practices

Barb Bolt

I asked Anne-Marie Smith if she would 'sit' for a portrait. At first she had some reservations.

> My first reaction was I thought that at the time I was being asked out of politeness, that nobody would want to do a portrait of me, so I should refuse politely. And then when I was asked again and then I realised there was some real interest there, I felt a bit scared. I was a bit nervous, quite nervous about being pinned down in one place; in one spot and somebody actually getting hold of me. I was giving some of myself away. (Anne Marie Smith)

Ann-Marie's reaction to having her portrait painted raises questions about the nature of representation, particularly the relationship between the visual representation and the represented. For Anne-Marie, the act of sitting for a portrait involved a risk. The danger of being captured in paint evoked the fear of actual capture or of loss. The belief that some trace of her could be taken and transferred into the portrait, that she would somehow *be* in the portrait, suggests that for Anne-Marie an image does not just stand in for or represent her. The portrait comes to embody her being in some way. It could be said that it is an act in which representation 'transcends' its own structures and 'enacts the "mutual reflection" of body and language' (Deleuze in Chisholm 1995 25). If this is the case, and it is in many cultural contexts, the portrait is not just a sign, a representation of the person, but actually becomes them. As Lucien Freud observed to Laurence Gowing:

> I would wish my portraits to be *of* people, not *like* them.
> Not having the look of the sitter, being them.
>
> (Freud quoted in Gayford 1993, 22)

I have painted many faces and I have made many drawings and I wonder what else I have done.

Anne-Marie's fear and Lucien Freud's provocation question a fundamental premise that has come to operate in western visual theory. This premise posits representation as a 'sign', a substitute, that only stands in for or represents its object. It can never be its object.[2] Representation circulates within the social realm of meanings. Its function is primarily communicative.

The influence of literary theory and cultural studies on visual art theory has situated the visual arts firmly as a discursive practice. According to this view, visual representation is conceived of a sign or complex of signs that convey social meanings. The teaching of visual literacy and communication all too often assumes that the visual is first and foremost a language. Linking visual theory to literary theory and cultural studies has had advantages for the visual arts, enabling the mapping of how 'art' emerges or materializes, and comes to mean in a social context. How can we *also* engage the stuff of 'matter', the material production that implicates the matter of bodies, the matter of practice and the matter of the object? What if there was a dynamic relationship between the object and its representation instead of a relationship of substitution? What if the portrait of Anne-Marie was her in some way? How could we figure this?

In Oscar Wilde's *The Picture of Dorian Gray*, the eponymous hero, a young man of great beauty, is asked to sit for a portrait by the artist Basil Hallward. As the story unfolds, a transformation occurs between the materiality of the body of the sitter and the materiality of the painting. This transformation is ushered in by Dorian's performative speech act. Dorian Gray's overwhelming desire to remain young leads him to utter a wish that he should remain beautiful while the painting grew old. He never imagined that his words would effect or enact what he uttered. Yet his rational belief in the separation between the representation and reality was gradually undone:

Surely his wish had not been fulfilled? Such things were impossible. It seemed monstrous even to think of them. And, yet, there was the picture before him, with the touch of cruelty in the mouth.

(Wilde 1980, 34)

Is this is just a story, a moral fable, or is the relationship between 'real bodies' and representation more powerful than customarily thought? Does the speech act or the representative act have the power to bring into being that which it names, that which it represents? Judith Butler suggests that it does in proposing that the performative speech act brings into being that which it names (Butler 1994, 23). But what of visual representation? Does it or can it function performatively? If the function of representation does commit, in Bataille's words, the 'very life of those who take it on' (Wilson et. al 1996, 23), then representation takes on a very different value than currently believed in art theory.

The suggestion that the material practice of art has real material effects – that there could possibly be a mutual exchange between the matter of bodies and the representation of bodies has extremely limited currency in western art history and theory. To argue such a position is to cast into doubt the identity of the sign, since the dominant view is that there is a gap between the sign and its referent, and that the sign can never actually be in a dynamical relation to the materiality of the referent. It questions the assumption that representation is always (and only) mediated, or as Vicki Kirby sees it, 'second-order data removed from an originary source' (Kirby 1997, 113).

Refiguring the relationship between the representation and the object also raises questions about the production of the representation. If there is a dynamic relationship between the object of representation and the representation, what is the relationship between the maker and the work? How do we apprehend the space of interplay between 'artist', materials and technologies of production, the object of representation and the visual representation? How is this dynamism figured in an 'artwork'? How can we theorize about it without reducing it the circulation of signs or reverting to expressionist notions of art?

In his article 'Representation', W.T.J. Mitchell argues that according to the expressive aesthetic, the aesthetic object does not 'represent something, except incidentally; it 'is' something, an object with an indwelling spirit, a trace in matter of the activity of the immaterial' (Mitchell 1995, 16). There

may be another way to conceive the 'revelation' that occurs at the level of what Wilde's fictional painter called the 'flake and film of colour' in which he felt he had revealed too much of himself. I am interested in the suggestion that the aesthetic object 'is' something as well as representing something.3 However, rather than this 'isness' being a trace in matter or an impress on matter, I want to suggest that this 'isness' is a scripturing resulting from the activity of matter itself. Rather than form being imposed on matter, 'matter is becoming more articulate than [...] imagined' (Kirby 1997, 114).

The material practice, the performative representative act, becomes of central concern in rethinking an aesthetics of visual practice. The material practice of art can be conceived, in Paul Carter's terms, as an 'act of concurrrent actual production' (Carter 1996, 84), producing a representation that is both a materialization of matter and a sign. It will be argued that the making of the work is performative, that the labour of making is productive, and that this productivity is materialized as a trace or index in the work itself.

Performativity and Materialization

The two terms that are central to my proposition are performativity and materialization. In *Bodies that matter: on the discursive limits of sex* (1993), Judith Butler argues the limits of social construction, positing an emergent model based on materialization. Materialization emerges through performance. Does Judith Butler's work on performativity and materialization enable me to theorise how the material practice of art is an act of 'concurrent actual production', materializing matter; 'a becoming sign'?

Butler proposes that materialization is a process of sedimentation that results from reiteration or citation (Butler 1993, 15). In her thesis, there is no subject who precedes the repetition. Rather, through performance, 'I' come into being (Butler 1991b, 24). Thus in western art, the avant-garde, and more recently feminist, queer and post-colonial practices have actively engaged in opening up the gaps and fissures that emerge through this process. In an interview conducted by Peter Osbourne and Lynne Segal in London 1993, Butler distinguished between 'performance' and 'performativity'. She proposed that:

(f)irst it is important to distinguish performance from performativity:
the former presumes a subject, but the latter contests the very notion of the subject [...] So what I'm trying to do is think about performativity as that aspect of discourse that has the capacity to produce what it names. Then I take a further step [...] and suggest that this production actually always happens through a certain kind of repetition and recitation. So [...] I guess performativity is the vehicle through which ontological effects are established. Performativity is the discursive mode by which ontological effects are installed.

(Butler in Osborne and Segal 1994, 23)

Whilst Butler's project specifically addresses the way in which sex and gender are materialized, there are some curious similarities with the way in which 'art' materializes. Art practice is performative in that it enacts or produces 'art' as an effect. For her, performativity is 'not a singular 'act', for it is always a reiteration of a norm or set of norms, and to the extent that it acquires an act-like status in the present, it conceals or dissimulates the conventions of which it is a repetition' (Butler 1993, 12). Similarly, 'artists' engage with, re-iterate and question the norms of 'art' that exist in the socio-cultural context at a particular historical juncture. The re-iteration of these through practice, give a 'naturalized' effect which we come to label as an artist's style and it is to this we attribute value. We can identify a work as an 'Ana Mendieta', or a 'John Constable'. Thus Butler argues that the 'process of materialization stabilizes over time to produce the effect of boundary, fixity and surface'. She suggests it is what we call 'matter' (Butler 1993 9). She argues:

(t)hat matter is always materialized has, I think, to be thought in relation
to the productive and, indeed, materializing effects of regulatory power in the Foucaultian sense. (Butler 1993, 9-10)

The regulatory power of discourse shapes what we can think and say about art and yes it has material effects. Foucault's elaboration of the author

function in his article 'What is an Author' (1983), attests to this. However there is another materialization that seems to be excluded from Butler's account. In her concern with performativity as the 'discursive mode by which ontological effects are installed' (Butler 1994, 23), Butler seems unable to account for the materialization that occurs in the interplay between the matter of bodies, cultural knowledges, or discourse, *and* the materials of production. The materialization that occurs in a material practice is far more difficult to access or analyse than is language.

What makes an 'Ana Mendieta' or a 'John Constable' recognizable is not just the materialization of power in a Foucaultian sense (although that produces effects), but also the specificity of the particular material process that produces as its effect, a material work that is also a work of 'art'. Yet even in this stabilization there are variations in energy, differences in the flows and intensities. Dorothea Olkowski designates this, the 'science of the singular'. She proposes that:

> we must be able to address each one in its singularity... it is useless to speak of a 'style' with regard to all the work... of a single photographer, a single artist, a single human being. While... series may resonate in relation to one another, there is no genus or species drawing them together as the unitary style of an integrated person.
>
> (Olkowski 1999, 209)

In Constable's works, for example, the particular energies evident in the plein air study are quite different from the studio studies. How do we explain that some works have a 'life' and 'breath' in them, whilst others are 'heavy' and 'breathless'? Sometimes the process is hot and sometimes it is not. In the interplay between the matter of bodies, materials of production and cultural knowledges, particular energies emerge as an effect of the process. We sense it in the work even as words fail us.

The risk in the privileging of language, is the conflation of 'to matter' and 'to materialize' with meaning or signification. In returning matter to the sign, instead of establishing the facts of matter, 'matter' slips away (Kirby 1997, 108). If we have to return to the matter as sign, what happens to the matter of bodies and the matter of materials in this materialization? Is there a space for an actual concurrent production, a materialization of matter that does not just mean, but has effects? Butler quite clearly admits to the problem. She acknowledges that:

to think through the indissolubility of materiality and signification is no easy matter. If matter ceases to be matter once it becomes a concept, and if a concept of matter's exteriority to language is always less than absolute, what is the status of this outside?

(Butler 1993, 31)

Does this again leave matter unthematized until discourse imposes some form on it? Vicki Kirby finds 'we are only ever dealing with the signification of matter rather than the stuff of matter' (1997, 107). Just when we are getting close to dealing with what happens in the interaction between the matter of bodies and the matter of materiality, it eludes us. Kirby continues:

(o)ur sense of the materiality of matter, its palpability and its physical insistence,
is rendered unspeakable...for the only thing that can be known about it is that it exceeds representation. (Kirby 1997, 108)

A return to the energetic potential of matter is necessary if we are to disrupt the inevitability of the logics of loss, ideality, language or desire as 'lack'.

A Quantum Leap

In *Telling Flesh: the substance of the corporeal* (1997), Vicki Kirby looks to quantum theory to question Butler's insistence on the separation of the 'sign' from 'reality'. She cites Niels Bohr's critique of Albert Einstein's theory separating 'physical reality' from its representations. As Kirby explains, for Niels Bohr, representation is, 'not second-order data, removed from an originary and therefore distant source' (Kirby 1997, 113). Bohr's position is supported by the experiments of Alain Aspect, Jean Dalibard and Gérard Roger, who, in 1982, concluded that:

'particles' are inseparable 'identities' in/of space/time that are both infinite and indivisible, here *and* there, now *and* then

(Kirby 1997, 113)

The implications of these experiments are profound as Kirby points out. It 'ruled out any sense of an enclosed identity of the particle…(a)nd it also ruled out any sense of an enclosed, or local, context within which causality might be identified and contained'

(Kirby 1997, 113).

I would suggest that the discoveries made by quantum physics have direct implications for the relationship between 'reality' and 'representation' in the visual arts. They bring into doubt the separation of sign and referent and suggest that a continuum exists between the process of representation and the representation. Can representation, or the sign, exceed its own structure in a radical performativity that allows it to be or perform rather than stand in for its object? In western philosophy and western art, it is now very difficult to think outside the paradigm in which representation is conceived as involving a gap, an absence or as Kirby says a 'not here' or 'not now'. How can we envisage representation as an act of concurrent actual production? As we have seen, Judith Butler admits to this difficulty. She accepts that 'to think through the indissolubility of materiality and signification is no easy matter' (Butler 1993, 31).

However, this 'difficulty' is not a universal difficulty. Other cultures, such as the Indigenous Australian culture, do not see such a gap. For Indigenous Australians, ritual activities, in particular what they refer to as 'increase rituals', involving dance, song and paintings produce reality. Thus, for example, the performance of fertility rites is not representative, but productive. Indigenous Australian painting rhymes the rhythms of the landscape and the rhythms of the heart beat. The paintings produce a performativity where the 'language' of painting mimes the motions of the body and the landscape. Meaning and reality is constituted in the performance. Paul Carter has termed this productivity *methexis*.[4] Carter sees the productivity of *methexis* as a 'an act of concurrent actual production, a pattern danced on the ground' (Carter 1996, 84). It is, he claims, the non representative principle 'behind Celtic, and Aranda, art, whose spirals and mazes reproduced by an act of concurrent actual production a pattern danced on the ground' (Carter 1996, 84). For Indigenous Australians, *methexis* has real effects in bodies and on the ground. Imaging produces realities.

Viewing representation as an act of concurrent production through which embodied knowledge is produced shifts the terms of the economy of

representation. Meaning arises out of the facts of matter. It supports Vicki Kirby's assertion that if 'there is no gap to be crossed or absence to be filled, then perhaps matter is more articulate than…imagined' (Kirby 1997, 114).

The Signs of Making

In Butler's notion of performativity, like *methexis* there is materialization. However, whilst in Butler's conception this materialization is produced through discourse, in *methexis,* the materialization occurs through matter, in the interplay of culture, bodies, materials and languages. In methektic production there is a causal connection between the matter of bodies, the matter of the object and the matter of the materials of making.

The dialogical and emergent nature of *methexis* resonates with Edward Sampson's notion of the 'acting ensemble'. For him, the acting ensemble presents a dialogical construct that takes into account the emergent quality of creative practice. He would argue that creativity, like intelligence, is the property of the acting ensemble, not the individual. The acting ensemble takes in the totality of the acting environment. We are, Sampson proposes, 'woven together with context'. He speaks of 'embodied interactive emergence', arguing that the acting ensemble is characterized by its emergent property. This removes the focus from the acting individual and places it in the relations between actors. In this shift from the individual artist to the relations between the individual body, the social body and the material conditions of making, the actors include paint, the canvas, the type of support, the weather, the wind and gravity as well as discursive knowledges.

Making a Painting

Not to recreate the world
but to make paintings
to evoke the sensation
of

being-in-the-painting
as
being-in-the-world
Rothko meets Techno
or something like that

but then there is the reality
the making of paintings

I start with the staining of the canvas
(why is it that a stained canvas appears more luminous that a brushed
surface?)
the mixing of paint
the preparation of the canvas
psychic preparation

the first stain is fairly straightforward: an even wash across the canvas
vivid pink
the perfect stain
luminous
and then they arrive
bees, mozzies, insects I have never seen before
they buzz around
dive bomb into the glory of pink
swim in the creamy liquid
and die
a specimen and a speck on the surface of the canvas

being-in-the-painting
but no-longer-being-in-the-world

I start again
a second stain over the first
it's forty degrees Celcius
the sun starts to move across the surface
the paint loses surface tension
starts to spread uncontrollably across the surface
sweats and weeps
the sea breeze comes in
dust, seeds, cat's hair settle in the drying liquid

I weep
I start again
Rothko and techno begin to disappear
I'm making paintings in Australia
under an Australian sun
out in the backyard
not in a studio in America or Europe
or anywhere else for that matter

another story begins to emerge
sunlight, wind, heat, liquids moving in response to heat and gravity
a different mode of working
not mastery
not purely formal
nor shedding light on the matter

but something else

I lay in paint,
watch and wait
allow the paint to move
wet into wet, wet over dry
not total abandonment
but a lightness of touch
kick into the rhythm
respond to how the paint moves, bleeds, blisses
work with the paint, the sun, the heat and the wind
work in the heat of the moment
work hot.[5]

(Bolt 1998a)

In my own practice as a painter I have elaborated this interactivity as 'working hot'. In this state, as Estelle Barrett points out, 'sensory and other bodily responses are fully focussed on the demands of the unpredictable and uncontrollable materiality of paint interacting with the environment. Stimuli arise in the heat of the moment to which the creative gesture

becomes a reaction that is released from conceptual ways of thinking' (Barrett 1999 3). In that state:

> (t)he process of painting is a response to what happens in the interaction between paint, oil, turps, canvas, gravity, sun, heat, the occasional live beast and my body [...] It is working in the heat of the moment. (Bolt 1998b)

This process implicates my body in the process. But it also implicates the materiality of the paint and the environment, processes that have actual causal relations, not merely significatory relations. What this suggests is that the sign is not separate from its production and is embedded in material practices - it emerges in the interactive labour of making. This dynamic relation figures material practice in terms of co-emergence rather than mastery. It is the play of the matter of bodies, the materials of production and matters of discourse in sign work. In a co-emergent practice matter is not impressed upon; rather matter is in process as a dynamic interplay through which meaning and effects emerge. As Andrew Benjamin has observed, 'matter insists' (Benjamin 1996, 51).

Performative Indices

Re-configuring performativity in relation to visual practice requires a momentary return to Butler's account of signification. Whilst for Butler, language and materiality are embedded in each other, 'chiasmic in their interdependency' (Butler 1993, 69), representation is, for her, necessarily a 'language effect'. In this linguistic turn, materiality is disempowered, robbed of its insistence. Representation is reduced to the (Saussurian) sign, the play of signifiers. However, as James Elkin points out graphic marks need to be 'understood as objects that are simultaneously signs and not signs' (Elkin 1998, 45). What is at stake for Elkin 'is nothing less than the pictorial nature of pictures' (Elkin 1998, 13). In other words, visual representation exceeds the sign as it is commonly understood. Pictures 'mean', but also they 'are'; both signs and a materialization of matter.

In a methektic performativity, I have suggested, the sign is not separate from its production. It emerges in material practices as an act of concurrent actual production. How can we figure a matrix in which a work is both a concurrent actual production and a sign? Saussurian semiotics does not

provide that scope. In being primarily concerned with the play of the signifier, Saussurian semiotics omits the process of making, both how signs are made and the relation between signs and their referent. The key term that is missing is that of 'effect' (Fiske 1990, 51). C.S Peirce's semiotics provides this link. (Bal 1994).[6] His notion of the index addresses the Saussurian omission of 'effect'.

Peirce's 'indexical' sign, with its direct causal relation between the 'thing' and its sign, points to a way of considering the 'matter' of things: the matter of the body in process and the matter of the materiality of the work. The index does not produce 'meaning' in the same way that the symbol does.[7] It produces effects. It allows us to 'witness' in a very different way the process of materialization that occurs in the interaction between the matter of bodies, the matter of materials, technologies and the cultural. It is the actual modification of the sign by the object that gives the index its quality (Peirce 1955, 102). It allows us to get beyond the image to the facts of matter.

Peirce first used the notion of the index to theorize the relationship between the photograph and its object (Freadman 1986, 97). In photography, (excluding digital and darkroom manipulation) there is no denying the existence of the referent. Olkowski asserts that:

> (i)n ordinary photographs this remains unremarkable, but in certain photographs,
> those that are loved, the fact that the photograph is literally an emanation of a
> real body, that light is the carnal medium, that the image is extracted, mounted, expressed by the action of light and the body touches me with its rays, attests to the fact that what I see is a reality and not the product of any schema. (Olkowski 1999, 209)

Activating Barthes' notion of the *punctum*,[8] Olkowski argues that it is the *puncti* that provides this expansive force in a photograph. This force becomes 'more than the photographic medium that bears it so that what you see, what is created, what is thought is no longer a sign within a symbolic system but becomes the thing itself'. (Olkowski 1999, 208)

According to Olkowski's conception, could the photo-documentation of Ana Mendieta's work become more than the photographic medium that bears it? Miwon Kwon's claims that the photo-documents are 'souvenirs' is based on a notion of loss – 'the missing body *in* the image and the missing event *of* the image' (Kwon 1995, 170). Following Olkowski, I would argue differentially. I would propose that, rather than being markers of loss, the 'souvenirs' of Ana Mendieta's land/body works can[9] burst the boundaries of their medium and actually become what Mendieta claimed for them; 'after-images'(Kwon 1995, 167).

So what of painting? I would like to return to the question of Constable's paintings and contrast the indexical qualities of the oil sketch for *The Leaping Horse* (1824-5) with the 'exhibited' painting of *The Leaping Horse* (1825). This comparison demonstrates that something quite different is happening in each. The elements (paradigmatic choices) and the organization of these elements (syntagmatic combinations) would, if read using a Saussurian semiotic model, produce similar 'readings'. A reiteration if you like. However there is something else at work.

While the prevailing discursive frame affected what could be thought of as and exhibited as 'painting', the contrast is not the effect of discourse. It is the energy of matter in process. Two different works, two quite different energies.[10] This can be witnessed as an index in the work. John Walker articulates this in observing that the 'horseman in the sketch seems to vibrate with energy' (Walker 1978, 118-9). The work is both a sign, and if quantum physics can be invoked, it 'is'.

In any theorization of visual practice, it is vital that the links back to making are maintained, in such a way as to allow us to consider the 'traces' or 'indexes' of bodies in labour, both human and non-human.[11] The 'causal' link or the effect can relate to the 'index' of the maker's body, the 'index' of the object and the index of the material processes. For Peirce, materialization is an effect that points directly back to the body of labour.[12] It is not an absence that the sign attempts to fill. Rather it is a trace of a productivity, of the interaction between the different bodies of labour, both human and non-human. This productivity is the performativity of methexis.

Conclusion

Theories of representation and theories of the sign in application have not tended to allow matter to matter, to be articulate. An overemphasis on meaning and an inattention to the material practice will, to borrow Vicki Kirby's phrase, lead to substance abuse. We need to allow for a theory of making and not just a representational theory. What I have proposed is a refiguring of the notion of performativity to take account of the 'act of actual concurrent production', the dynamical relation between, discourse or cultural knowledges, the matter of bodies and the materials of production. This expansion of the field of enquiry from what is represented to how images emerge materially, allows us to begin to figure a different politics of practice.

If, as I have argued, matter insists rather than having form imposed on it, we can conceive of artistic practice as co-emergent rather than mastering. In its insistence, matter effects a force that is not reducible to the Saussurian sign. Matter is unruly. At the level of actual practice, mat(t)erialization effects what Olkowski has termed 'the ruin of representation'.[13] It sets the system of visual representation in motion. In Butler's parlance, it is 'to "cite" the law to produce it differently' (Butler 1993, 15).

Notes

1 I want to acknowledge the novel *Working Hot* (1989) by Kathleen Mary Fallon. In the article 'The 'Cunning lingua' of desire', Dianne Chisholm argues that Mary Fallon uses language performatively to produce what it proposes. She links her argument to Deleuze's notion of flexion. Flexion is that 'act of language which fabricates a body for the mind.' It is an act in which 'language transcends itself as it reflects the body' (Deleuze 1990, 25). I have taken this phrase to describe that movement in visual practice where the matter of bodies (both human and non-human) erupt in the work and matter insists. It is both 'language' and body. I would suggest it is a productive turn,

in which the visual image transcends its structure as representation. It is performative in that it sets the system of visual representation in motion. See also Olkowski (1999, 226-230).

2 The notion that a representation is second-order data, or a substitute for things themselves has its origins in the Platonic critique of mimesis. However this 'belief' was not established as lore till much more recently, since the Reformation. The divergence between Luther and Calvin over transubstantiation is critical in this discussion. For a discussion of this schism, see Belting (1994).

3 In Mitchell this 'isness' is a trace of the activity of the immaterial on matter. In Bryson's argument in *Vision and Painting*, it is 'the impress on matter of the body's internal energy, in the mobility and vibrancy of its somatic rhythms' (Bryson 1983, 131). In both cases I worry that matter remains mute, a surface to be inscribed.

4 Paul Carter's elaboration of the theory of *methexis* is derived from his reading of Cornford (1991). For Pythagoras, Cornford argues, *methexis* or participation signifies the relation in which 'the group stands to its immanent collective soul. The passage from the divine plane to the human, and from the human to the divine, remains permeable and is perpetually traversed. The one can go out into the many; the many can lose themselves in reunion with the one'. (Cornford 1991, 204). See Bolt (2000).

5 The above paragraphs were set out as poetry by the author, but are reproduced here in condensed form for reasons of space. They formed part of the performance surrounding the *Technics* Exhibition on 21.2.98 and are not included in Bolt's Artist's Statement in the catalogue (Bolt 1998). [eds]

6 The chapter co-written with Norman Bryson, 'Semiotics and Art History' is especially relevant.

7 Jonathan Culler has renamed Peirce's symbol as the 'sign proper'. In this redesignation there is a recognition that both the icon and index have qualities that exceed the sign as commonly understood. See Culler (1975, 16-17).

8 See Barthes (1981). His notion of the *punctum* resonates with the concept of the *navel* as developed in Miek Bal (1991).

9 Olkowski reminds us that 'not all emanations are for everyone. There will not be... a single desiring-machine defining all desires' (1999, 209).

10 The 'problematic' of the thumbnail sketch exemplifies what happens in a 'conscious' re-iteration. In the translation from these studies into the larger more sustained work, there is often a loss of energy of mark.

11 A painting practice, involves the interplay of body, paint, environment and the technologies of painting. It is a dynamic interplay in which the traces of labour are installed in the work as an index or an effect. It is an interplay that for me parallels the experience of the digital, the human/machinic ensemble. However, whilst in painting the human actant has historically been foregrounded, in this ensemble, the machinic becomes foregrounded. The

deictic marker or index does not just refer back to the human body, but also to the machinic body and its particular qualities, capacities, energies, hardware and software.

12 The materiality and the 'dynamical relation' of the indexical sign is suggestive of Norman Bryson's deictic marker. (Bryson 1983, 87) It is 'utterance in carnal form' (Bryson 1983, 88). The productive turn that I am proposing in this paper brings us closer to Aristotle's understanding of representation - the object, manner and means (Mitchell 1995, 13). While agreeing largely with his view, I would extend his notion of 'manner' to include the dynamics of making as well as the representation itself. 'Manner' becomes the way particular energies, materials and processes come to 'effect' existing signs and create new signs. It is 'a becoming sign of the matter'.

13 Dorothea Olkowski argues for an ontology of change that breaks open what she sees as the molarity of representation, and effects the ruin of representation. The phrase 'the ruin of representation' has been used by several feminist writers, including Joanna Isaak and Michèle Montrelay. Joanna Isaak initially used the term in her review of the exhibition *Difference: On Representation and Sexuality* (1984-85). She saw the aim of the exhibition as being to 'investigate the means by which the subject is produced and...to effect "the ruin of representation"' (Isaak quoted in Olkowski 1999, 69). This impetus underpins Olkowski's project.

Bibliography

Anderson, Warren D. (1966). *Ethos and Education in Greek Music: the evidence of poetry and philosophy*, Cam/Mass: Harvard University Press.

- (1997). *Music and Musicians in Ancient Greece*, USA: Cornell University Press.

Aristotle (1962). *The Politics*, Translated by T.A. Sinclair Penguin Books.

Armstrong, Isobel (1993). 'So what's all this about the mother's body?: The aesthetic, gender and the polis', in *Women, a cultural review*, Autumn 1993, Vol. 4, No. 2: 172-187.

Bal, Mieke (1991). *Reading Rembrandt*, Cambridge: Cambridge University Press.

- (1994). *On Meaning-making: Essays in Semiotics,* Sonoma CA: Polebridge Press.

- (1996). 'Reading Art', in Pollock, G. *Generations and Geographies in the Visual Arts: Feminist Readings*, London: Routledge.

Bal, Mieke and Norman Bryson (1998) 'Semiotics and Art History: A Discussion of Context and Senders', in Donald Preziosi (ed.), *The Art of Art History: A Critical Anthology*, Oxford: OUP.

Balzano, Wanda (1996). 'Irishness – Feminist and Post-colonial', in Ian Chambers and Lidia Curti (eds). *The Post-Colonial Question: Common Skies, Divided Horizons*, London: Routledge.

Barker, Andrew (ed.) (1984). *Greek Musical Writings*, Vol I. Cambridge: Cambridge University Press.

- (ed.) (1989). *Greek Musical Writings*. Vol II. Cambridge: Cambridge University Press.

Barrett, E. (2001). 'Knowing and Feeling New Subjectivities and Aesthetic Experience', *International Journal of Critical Psychology*, (Forthcoming), Vol T.B.A.

- (1998) *Technics*, curator's Essay, Perth: Craftswest Centre for Contemporary Craft.

Barthes, Roland (1981). *Camera lucida: reflections on photography*, trans. Richard Howard, New York: Hill and Wang.

Basinger, J. (1993). *A Woman's View: How Hollywood Spoke to Women 1930-1960,* London: Chatto and Windus.

Bat-Ami Bar On (ed.) (1994). *Engendering Origins: critical feminist readings in Plato and Aristotle*, New York: State University of New York Press.

Battersby, Christine, (1989) *Gender and Genius: Towards a Feminist Aesthetics*, London: The Women's Press.

- (1991) 'Situating the aesthetic: A Feminist Defence', in Benjamin, Andrew and Osborne, Peter (eds.) (1991). *Thinking Art: Beyond Traditional Aesthetics*, London: ICA: 31-45.

- (1994a). 'Antinomies: the Art of Evelyn Williams', in *Antinomies: Works by Evelyn Williams*, catalogue of a Mead Gallery Exhibition, The University of Warwick: 25–37.

- (1994b). 'Unblocking the Oedipal: Karoline von Günderode and the Female Sublime', in Ledger, McDonagh and Spencer (ed.), *Political Genders: texts and contexts*, London: Harvester Wheatsheaf: 129-143.

- (1995). 'Stages on Kant's Way: Aesthetics, Morality, and the Gendered Sublime', in Peggy Zeglin Brand and Carolyn Korsmeyer (eds.), *Feminism and Tradition in Aesthetics*, Pennsylvania: Pennsylvania State University Press: 88-114.

- (1998). *The Phenomenal Woman: Feminist Metaphysics and the Patterns of Identity*, Oxford: Polity Press.

Baudrillard, Jean (1983). *Simulations*, (Trans. P. Foss, P. Patton and P. Beitchman), New York: Semiotext(e) Inc.

- (1993). 'The Evil Demon of Images', in Docherty, T. (ed.) *Postmodernism: A Reader*, New York and London: Harvester Wheatsheaf.

- (1996). *The Perfect Crime* (trans Chris Turner), London: Verso.

Bazin, André (1967). *Ontology of the Photographic Image*, in *What is Cinema?* Vol. 1, trans. Hugh Gray, Berkeley: University of California Press: 9-16.

Beardsley, Monroe (1966). *Aesthetics: From Classical Greece to the present*, New York: Macmillan.

Beauvoir, Simone, de (1988). *The Second Sex*, London: Picador.

Beckley, Bill with Shapiro, David (eds.) (1998). *Uncontrollable Beauty: toward a new aesthetics*, New York: Allwoth Press.

Beller, Jonathan L. (1995). 'The Spectatorship of the Proletariat', in *boundary 2*, Vol.22, No. 3: 171-228.

- (1998). Capital/Cinema in Eleanor Kauffman and Kevin Jon Hiller (eds), *Deleuze and Guattari: New mappings in Politics, Philosophy and Culture*, Minneapolis: University of Minnesota Press, 77-95.

Belting, H. (1994). Trans. E. Jephcott, *Likeness and presence: a history of the image before the era of art*, Chicago: The University of Chicago Press.

Benjamin, Andrew, (1996). 'Matters insistence: Tony Scherman's Banquo's funeral,' in *Art and Design Profile* No 48, No. 5/6 May-June 1996: 46-53.

Benjamin, Andrew and Osborne, Peter (eds) (1991). *Thinking Art: Beyond Traditional Aesthetics*, London: ICA.

Benjamin, Walter (1969). *Illuminations*, trans. H. Zohn, ed. H. Arendt, Schocken Books.

- (1998). *The Origin of German Tragic Drama*, trans. J. Osborne, Verso. First published as *Ursprung des deutschen Trauerspiels*, Suhrkamp Verlag, Frankfurt,1963.

- (1992). *Illuminations*, London: Fontana Press.

Benn, Gottfried, (1960). *Gedichte*, in (*Gesammelte Werke*, 1958-61). Vol. 3 (ed.), Dieter Wellershoff. Wiesbaden: Limes.

Berg, Maggie (1991). 'Luce Irigaray's "Contradictions": Poststructuralism and Feminism,' *Signs: Journal of Women in Culture and Society*,Vol.17, no.1: 50-70.

Betterton, Rosemary (1996). *An Intimate Distance: Women, Artists and the Body*, London: Routledge.

- (1999) 'A Conversation with Susan Hiller', Sheffield: Site Gallery.

Bird, Jon et al. (1998). *Nancy Spero*, London: Phaidon.

Bois, Yve-Allen (1986). *Endgame: Reference and Simulation in Recent Painting and Sculpture*, Cambridge/Massachusetts: MIT Press.

- (1992 [1986]) 'Painting: the Task of Mourning', reprinted in F. Frascina & J. Harris (eds.) *Art in Modern Culture: an Anthology of Critical Texts*, London: Phaidon Press.

Boland, Eavan (1995). *Object Lessons: The Life of the Woman and the Poet in our Time*, New York: Norton.

Bolt, B. (1987). 'Im/pulsive practices: the logic of sensation and painting', in *Social Semiotics*, Vol. 7, No. 3: 261–268.

- (1998) artist's statement in *Technics*, Perth: Craftswest Centre for Contemporary Craft.

- (2000) 'Shedding light for the matter', In *Hypatia* (forthcoming) Vol. 15, No. 2, 2000.

Bond, A. (1998). 'A paradigm shift in Twentieth Century Art', presented at the AAA Conference, Adelaide. Unpublished Conference Paper.

Bourke C., Schor N. and Whitford M. (eds.) (1994). *Engaging with Irigaray: feminist philosophy and modern European thought*, New York: Columbia University Press.

Braidotti, Rosi (1991) *Patterns of Dissonance*, Cambridge: Polity Press.

- (1994) 'Towards a New Nomadism: Feminist Deleuzian Tracks; or, Metaphysics and Metaboloism', in Constantin V. Boundas and Dorothea Olkowski (eds.). *Gilles Deleuze and the Theatre of Philosophy*, edited by London and NY: Routledge: 159-85.

Brand, Peggy Zeglin (1999). 'Glaring Omissions in Traditional Theories of Art', in Stoehr, K.L. (ed) *The Proceedings of the Twentieth Century World Congress of Philosophy. Philosophies of Religion, Art and Creativity*, Vol.4: 177-186.

Brand, Peggy Zeglin and Korsmeyer, Carolyn (1995) *Feminism and Tradition in Aesthetics*, Pennsylvania: Pennsylvania State University Press.

Brett, G. (1996). 'The Materials of the Artist', in *Susan Hiller*, Liverpool: Tate Gallery.

Breytenbach, Breyten (1993). *Painting the Eye*, Cape Town: David Phillips Publishers.

Bryson, N. (1983). *Vision and painting: the logic of the gaze*, London: The Macmillan Press.

Bryson N. et al. (eds) (1992). *Beyond Recognition: Representation, Power, and Culture*: University of California Press.

Buck-Morss, S. (1989). *The Dialectics of Seeing: Walter Benjamin and the Arcades Project* Cambridge/Massachusetts: MIT Press.

Burch, Noël (1990). *Life to Those Shadows*, ed. and trans. Ben Brewster, London: BFI.

Bürger, P. (1984) *Theory of the Avant-Garde*, trans. M. Shaw, Minneapolis: University of Minnesota Press.

Burkert, Walter (1972). *Lore and Science in Ancient Pythagoreanism*, Cambridge: Harvard University Press.

Butler, J. (1991). *Gender trouble: feminism and the subversion of identity*, New York, London: Routledge.

Butler, Judith (1991a). *Gender trouble: feminism and the subversion of identity*, New York, London: Routledge.

- (1991b). 'Imitation and Gender Insubordination'. In Diana Fuss (ed.), (1991). *Inside/out: lesbian theories, gay theories*, New York and London: Routledge: 13-31.

- (1991c). 'Performative acts and gender constitution,' in Sue-Ellen Case (ed.).

- (1991d). *Performing Feminisms*, Baltimore, MD: Johns Hopkins University Press: 270-282.

- (1993). *Bodies That Matter: On the Discursive Limits of Sex*, New York and London: Routledge.

- (1994). 'Gender As Performance: An Interview with Judith Butler', P. Osborne and L. Segal (eds.), *Radical Philosophy*, 67.

- (1997a). 'Critically queer', in *Playing with fire: queer politics, queer theories*, Shane Phelan (ed.), New York and London: Routledge: 11-30.

- (1997b). *The Psychic Life of Power: Theories in Subjection*, Stanford, California: Stanford University Press.

Carroll, David (1987). *Paraesthetics: Foucault, Lyotard, Derrida*, New York: Methuen.

Carroll, Noel (1999). *Philosophy of Art: a contemporary introduction*, NY/London: Routledge.

Carter, P. (1996). *The lie of the land*, London, Boston: Faber and Faber.

Caruth, Cathy (1996). *Unclaimed Experience: Trauma, narrative, and History*, Baltimore and London: The Johns Hopkins University Press.

Castells, Manuel (1996). *The Information Age: Economy, Society and Culture Volume One, The Rise of the Network Society*, Oxford: Blackwell.

Cavareo, Adriana (1995). *In Spite of Plato: a feminist rewriting of ancient philosophy*, (Serena Anderlini-D'Onofrio and Áine O'Healy, trans.) Oxford: Polity Press.

Chadwick, Henry, (1981). *Boethius: The Consolations of Music, Logic, Theology, and Philosophy*, Oxford: Clarendon Press: 70-107.

Chanter, Tina (1995). *Ethics of Eros: Irigaray's rewriting of the philosophers*, New York, London: Routledge.

Chisholm, C. (1995). 'The "cunning lingua" of desire: bodies-language and Perverse performativity', in E. Grosz and E. Probyn (eds.). *Sexy bodies: the strange carnalities of feminism*, London: Routledge: 19-41.

Chow, Rey (1993). *Writing Diaspora: Tactics of Intervention in Contemporary Cultural Politics*, Bloomington: Indiana University Press.

Citron, Marcia J. (1993). *Gender and the Musical Canon*, Cambridge: Cambridge University Press.

Cohen, David E. (1993). 'Historical aspects of music theory', *Theoria* Vol. 7: 1-85.

Cohen, Richard (ed.) (1986). *Face to Face with Emmanuel Levinas*. SUNY.

Condren, Mary (1989). *The Serpent and the Goddess: Women, Religion and Power in Celtic Ireland*, New York: Harper Collins.

Cornell, Drucilla (1991). *Beyond Accommodation. Ethical Feminism, Deconstruction and the Law*, London/NY: Routledge.

- (1995). *The Imaginary Domain. Abortion, Pornography and Sexual Harassment*, London/NY: Routledge.

Cornford, F.M (1923). In *Classical Quarterly* Vol. XVI : 2.

Cornford, F.M. (1991). *From religion to philosophy: a study in the origins of western speculation*, Princeton, New Jersey: Princeton University Press.

Courtivron, Isabelle de and Marks, E. (eds) (1980). *New French Feminisms*, Amherst: University of Massachusetts Press.

Crafton, Donald (1990). *Emile Cohl, Caricature and Film*, Princeton NJ: Princeton University Press.

Crary, Jonathan (1999). *Suspensions of Perception: Attention, Spectacle and Modern Culture*, Cambridge/Massachusetts: MIT Press.

Crow, T. (1996). *Modern Art in the Common Culture*, New Haven & London: Yale University Press.

Crowther, Paul (1996 [1993]). *Critical Aesthetics and Postmodernism*, Oxford: Clarendon Press.

Cubitt, Sean (1998). *Digital Aesthetics*, London: Sage.

- (1999). 'Introduction. *Le réel c'est l'impossible*: The Sublime Time of Special Effects', in *Screen* v. 40 n.2, Summer, 123-30.

Culler, J. (1975). *Structuralist Poetics*, Ithaca: Cornell University Press.

Cullingford, Butler (1990). '"of Thinking of Her ... as ... Ireland": Yeats, Pearse and Heaney', *Textual Practice*, vol. 4 no.1: 1-21.

Cusick, Suzanne G. et al. (1994). 'Toward a Feminist Music Theory', in *Perspectives of New Music*, Vol. 32 No.1: 6-86.

de Zegher, M.C. (1995). *Inside the visible: an elliptical traverse of 20th century art*, Cambridge/Massachusets: MIT Press.

Deepwell, K. (1994). 'Paint Stripping', in *Women's Art Magazine*, 58, 14-16.

- (1995). *New Feminist Art Criticism*, Manchester: Manchester University Press.

Deleuze, Gilles (1983a). *Nietzsche and Philosophy*, Hugh Tomlinson (trans.), New York: Columbia University Press.

- (1983b). *Francis Bacon: logique de la sensation*, Paris: E.L.A, Editions de la Différence.

- (1984). *Kant's Critical Philosophy: The Doctrine of the Faculties*. Hugh Tomlinson and B. Habberjam (trans). London: Athlone Press.

- (1986). *Cinema 1: The Movement–Image*, Trans. Barbara Habberjam and Hugh Tomlinson, London: Athlone Press.

- (1989). *Cinema 2. The Time Image*, trans. Hugh Tomlinson and R. Galeta. London: Athlone Press.

- (1990). *The logic of sense*, Mark Lester with Charles Stivale (trans.), Constantin V. Boundas (eds.), London: The Athlone Press.

- (1994a). *Difference and Repetition*, trans. Paul Patton, London: Athlone Press.

- (1994b). *What is Philosophy?* trans. Graham Burchell and Hugh Tomlinson. London: Verso.

Deleuze, Gilles and Guattari, Felix (1987). *A Thousand Plateaus*, Minneapolis: The University of Minnesota Press.

- (1988). *A Thousand Plateaus: capitalism and schizophrenia*, Brian Massumi (trans.), London: Athlone Press.

Dennett, Daniel C. (1991). *Consciousness Explained*, Harmondsworth: Penguin.

Derrida, Jacques (1966). *Ethos and Education in Greek Music: the evidence of poetry and philosophy*, Cam/Mass: Harvard University Press.

- (1974). *Of Grammatology*, trans. G. C. Spivak, Johns Hopkins University Press.

- (1978). 'Coming Into One's Own', in G. Harman (ed.) *Psychoanalysis and the Question of the Text*, trans. J. Hulbert, Sir Johns Hopkins University Press.

- (1981a). *Dissemination*, Barbara Johnson (trans.), Chicago: University of Chicago Press.

- (1981b). *Positions*, Chicago: University of Chicago Press.

- (1986). *Glas*, trans. John P. Leavey, Jr. and Richard Rand, Lincoln and London: University of Nebraska Press.

- (1987). *Truth in Painting*, Geoff Bennington and Ian McLeod (trans.) Chicago: University of Chicago Press.

- (1994). *Spectres of Marx*, (trans. Peggy Kamuth, intro Bernd, Magnus & Cullenberg, Stephen) London: Routledge.

Derrida, Jacques and McDonald, Christie V. (1995). 'Choreographies'. *Bodies of the Text:Dance as Theory, Literature as Dance*. Goellner, Ellen W. and Murphey, Jacqueline Shea (eds), New Brunswick, New Jersey: Rutgers University Press, 141-156.

Deutscher, Penelope (1997). *Yielding Gender: Feminism, Deconstruction and the History of Philosophy*, NY/London: Routledge.

Dews, Peter (1987). *Logics of Disintegration: Post-Structuralist Throught and the Claims of Critical Theory*, London, New York: Verso.

Dhomnail, Nuala N', (1993). 'What Foremothers?', *Poetry Ireland Review*, 36 (1993): 18-31.

Di Stefano, C. (1990). 'Dilemmas of Difference: Feminism, Modernity and Postmodernism' in *Feminism/Postmodernism*, L. Nicholson (ed.), New York and London: Routledge.

Dyer, R. (1997). *White*, New York and London: Routledge.

Eagleton, Terry (1990). *The Ideology of the Aesthetic*, Oxford/Cambridge Mass: Blackwell.

Ecker, Gisela (ed.) (1985). *Feminist Aesthetics,* London: The Women's Press.

Elkins, James (1998). *On pictures; and the words that fail them,* Cambridge: Cambridge University Press.

Fallon, M. (1989). *Working hot,* Melbourne, Sybylla.

Feldman, S. and Lawb, D. (1992). *Testimony, Cries of Witnessing in Literature, Psychoanalysis and History*, London: Routledge.

Felski, Rita (1989). *Beyond Feminist Aesthetics*, London: Hutchinson Radius.

Felski, Rita (1995). 'Why Feminism doesn't need an Aesthetic (and why it can't ignore Aesthetics)', in Brand, Peggy Zeglin and Korsmeyer, Carolyn (eds.), *Feminism and Tradition in Aesthetics*. Pennsylvania: Penn State University Press: 431-445.

Fer, Briony (1994). 'Bordering on Blank: Eva Hesse and Minimalism', *Art History* Vol.17, No.4: 424-449.

- (1997). *On Abstract Art*, New Haven & London: Yale University Press.

Fineman, J. (1980). 'The Structure of Allegorical Desire', *October* 12: 47-66.

Fink, Bruce (1995). *The Lacanian Subject: between language and jouissance*, Princeton: Princeton University Press.

Fisher, J. (1994). 'Susan Hiller: *Elan* and other evocations' in C. de Zegher (ed.) *Inside the Visible: an elliptical traverse of 20th century art, in, of and from the feminine*, Cambridge/Mass. & London: MIT Press.

Fiske, J. (1990). *Introduction to Communication Studies*, 2nd Edition, London and New York: Routledge.

Florence, Penny (1995). 'The Daughter's Patricide. (The Miss's Missing Myth)', *European Journal of Women's Studies*, Vol. 2, No. 2, May 185-204.

- (1998a). 'Innovation, sex and spatial structure in visual and aural semiosis', in Lund, Lagerroth & Hedling (eds), *Interart Poetics. Essays on the Interrelations of the Arts and Media* Atlanta GA/Amsterdam: Editions Rodopi.

- (1998b). 'Toward the Domain of Freedom', Interview with Drucilla Cornell, in Cynthia Willett (ed), *Theorising Multiculturalism*, Malden, Mass/Oxford: Blackwell.

Florence, P. and Foster, N. (1998). 'Review Essay and Call for papers', *Women's Philosophy Review*, no.19, (Autumn 1998).

Florence, P. and Foster, N. (eds). (2000). 'Special Issues on Aesthetics',

Women's Philosophy Review, no. 25 (Autumn 2000).

Florence, Penny and Pollock, Griselda (2000). *Looking Back to the Future*, Amsterdam: G&B Arts International.

Florence, Penny and Whittaker, Jason (2000). *Un coup de dés jamais n'abolira le hasard*, by Stéphane Mallarmé, Essays and CD-ROM, Oxford: Legenda.

Fortnum, R. and Houghton, G. (1989). 'Women and Contemporary Painting: Re-presenting Representation', *Women's Artist's Slide Library Journal*, 28:4-10.

Foster, Nicola (2000). 'Boundaries of Sight and Touch: Memoirs of the Blind and the Caressed', in Mottram, Judith (ed.), *Drawing Across Boundaries*, University of Loughborough (forthcoming).

Foucault, M. (1983). *This is not a pipe*, Berkeley: University of California Press.

- (1984). 'What is an author?', in (ed.) P. Rabinow, *The Foucault Reader*, Harmondsworth: Penguin: 101-120.

- (1985). *The History of Sexuality Vol 2: The Use of Pleasure*, R. Hurley (trans.), New York: Random House.

Frascina, F. (1993). 'Realism and ideology: an introduction to semiotics and cubism', in C. Harrison, R. Frascina and G. Perry, *Primitivism, Cubism, Abstraction: The early twentieth century*, New Haven and London: Yale University Press in association with the Open University: 87-183.

Freadman, Anne (1986). 'Structuralist uses of Peirce: Jakobson, Metz et al', in (ed.) Terry Threadgold, Elizabeth Grosz, Gunther Cress, *Semiotics, ideology, language, Sydney: Sydney Studies in Society and Culture*, No. 3: 93-124.

Freeman, Barbara Claire (1998). 'Feminine Sublime', *Encyclopedia of Aesthetics* (ed.), Michael Kelly. Oxford: Oxford University Press.

Frege, Gottlob (1974). *The Foundations of Arithmetic*, trans. J.L. Austin, Oxford: Blackwell.

Freud, S. (1917). 'Mourning and Melancholia', in *The Standard Edition of the Complete Psychological Works of Sigmund Freud Vol. IV*, (trans.) Starchey and Freud. Hogarth Press, (1953-74).

- (1955 [1919]). 'The Uncanny', in Starchey and Freud (eds and trans.) (1955), *The Standard Edition of the Complete Psychological Works Vol 17*, London: Hogarth Press. 217-252.

- (1920). 'Beyond the Pleasure Principle', in J. Strachey & A. Freud (eds and trans) (1953-74), vol. 18 of *The Standard Edition of the Complete Psychological Works*, Hogarth Press.

Fried, M. (1967). 'Art and Objecthood', reprinted in G. Battcock (ed.) (1968) *Minimal Art: an Anthology*, Dutton.

Gatens, M. (1996). *Imaginary Bodies: Ethics, Power and Corporeality*, Routledge: London.

Gayford, M. (1993). 'The Duke, the photographer, His wife and the male stripper', in *Modern painters*, Autumn 1993, Vol 6, No 3: 22-26.

Genova, Judith, (1994). 'Feminist Dialectics: Plato and Dualism', in Bat-Ami Bar On (ed), *Engendering origins: Critical Feminist Readings in Plato and Aristotle*, SUNY UP.

Gibbons, Luke (1996). *Transformations in Irish Culture*, Cork: Cork University Press.

Gilbert-Rolfe, Jeremy (1999). 'Nietzschean Critique and the Hegelian Commodity, or, the French have landed', *Critical Inquiry* (Autumn).
 - (2000). *Beauty and the Contemporary Sublime*, New York: Allworth Press.

Goll, Claire (1922). *Lyrische Films*, Leipzig: Rhein.

Gombrich, E. (1960). *Art and Illusion*, London: Phaidon.

Greenberg, C. (1961). *Art and Culture*, Boston.

Greenlee, D. (1973). *Peirce's Concept of the Sign*, The Hague: Mouton and Co.

Griffiths, Morwenna and Whitford, Margaret (eds.) (1996). *Women Review Philosophy: New Writings by Women in Philosophy*, a Special issue of WPR University of Nottingham.

Grosz, Elizabeth. (1990). *Jacques Lacan: a feminist introduction*, London/NY: Routledge.
 - (1994). *Volatile bodies: towards a corporeal feminism*, Bloomington, Indiana USA: Indiana University Press.
 - (1995). *Space, Time and Perversion*, London and NY: Routledge.

Günter Schulte (ed.) (1996). *Hegel*, München: Diederichs.

Guthrie, W.K.C. (1962-81). *A History of Greek Philosophy*, vols 2 & 3, Cambridge, New York: Cambridge University Press.

Guyer, Paul (1993). *Kant and the Experience of Freedom: Essays on Freedom and Morality*, Cambridge: Cambridge University Press.

Hamburger, Michael (ed. and trans.) (1977). *German Poetry 1910–1975*, Manchester: Carcanet New Press.
 - (1970). *Reason and Energy*, London: Weidenfeld and Nicholson.

Haraway, D. (1991). 'Situated knowledges: the science question in feminism and the privilege of Partial Perspective' in *Simians, Cyborgs and Women*, Free Association Books, 184-201. Also in *Feminist Studies* Vol. 14, No. 3: 575-599.

Haraway, Donna (1994). 'The Promises of Monsters: A Regenerative Politics for Inappropriate/d Others', in *Cultural Studies*, edited by Lawrence Grossberg, et al. London and NY: Routledge: 295-337.

Harding, S. (1990). 'Feminism, Science and the Anti-Enlightenment Critiques', in L. Nicholson (ed.), *Feminism/Postmodernism*, New York and London: Routledge.

Harris, Susan (1994). 'Dancing in Space', *Nancy Spero: Wall Printing Project*, Malmö Konsthall.

Harvey, David (1989). *The Condition of Postmodernity: An Enquiry into the Origins of Cultural Change*, Oxford: Blackwell.

Hayles, N. Katherine (1999). *How We Became Posthuman: Virtual Bodies in Cybernetics, Literature and Informatics*, Chicago: University of Chicago Press.

Hegel G.W.F. (1977). *Hegel's Phenomenology of Spirit*, A.V. Miller (trans), Oxford: Clarendon Press.

Heidegger, Martin (1971). *Poetry, Language, Thought*, London: Harper and Row.

Hein, Hilde and Korsmeyer, Carolyn (1993). *Aesthetics in Feminist Perspective*, Bloomington: Indiana U.P.

Hiller, S. (1996). *Thinking About Art. Conversations with Susan Hiller*, Manchester: Manchester University Press.

Hodge, Joanna (1995). *Heidegger and Ethics*, NY/London: Routledge.

Hofstadter, Albert and Kuhns, Richard (eds) (1964). *Philosophies of Art and Beauty: selected readings in aesthetics from Plato to Heidegger*, Chicago: University of Chicago Press.

Holst-Warhaft, Gail (1992). *Dangerous Voices: Women's Laments and Greek Literature*, London/New York: Routledge.

hooks, bell (1992). *Black Looks: race and representation*, London: Turnaround Books.

Hornblower, Simon and Spawforth A (eds) (1996). *The Oxford Classical Dictionary* (third edition), Oxford/New York: Oxford University Press.

Ihde, D. (1979). *Technics and praxis*, D. Dordrecht, Holland: Reidel Publishing Co.

Irigaray, Luce (1973). *Le langage des dements*, The Hague: Mouton & Co.

- (1977). 'Women's Exile: Interview with Luce Irigaray', interview by Dianna Adlam and Couze Venn, in *Ideology and Consciousness*, no.1: 62-76.

- (1985a). *This Sex Which Is Not One*, Ithaca, NY: Cornell University Press.

- (1985b). *Speculum of the Other Woman*, G.C. Gill (trans), Cornell University Press.

- (1986). 'The Fecundity of the Caress: A Reading of Levinas' *Totality and Infinity* section IV, B, "The Phenomenology of Eros"', in *Face to Face with Levinas*, edited by Richard Cohen. NY: State

University of New York Press, pp. 231-58.

- (1989) 'Sorcerer Love: A reading of Plato's *Symposium*, Diotima's Speech', in *Hypatia*, Vol.3, No.3: 32-44.

- (1991a). 'The Poverty of psychoanalysis', in Whitford, Margaret (editor), *The Irigaray Reader* (pp.79-104), Oxford: Blackwell.

- (1991b). 'The Limits of the Transference', in Whitford, Margaret (editor), 1991, *The Irigaray Reader*, (pp. 105-117), Oxford: Blackwell.

- (1993a) *An Ethics of Sexual Difference*, Carolyn Burke and Gillian C. Gill (trans.), Ithaca: Cornell University Press.

- (1993b). *Je, Tu, Nous: Toward a Culture of Difference*, London: Routledge.

- (1993c). 'The Three Genders' (pp.167-181), in Irigaray, *Sexes and Genealogies*, New York: Columbia University Press.

Issak, J. (1985). 'Women: the Ruin of Representation,' *AFTERIMAGE*, April 1985: 6-8.

Iversen, M. (1981). 'The bride stripped bare by her own desire: reading Mary Kelly's *Post-Partum Document*', in M. Kelly 1983.

- (1997). 'Visualizing the Unconscious: Mary Kelly's installations,' in M. Iversen, D. Crimp, and H. K. Bhabha, *Mary Kelly*, Phaidon.

James, Jamie (1995). *Music of the Spheres: Music Science and the Natural Order of the Universe*, London: Abacus.

Jantzen, Grace (1995). *Power, Gender and Christian Mysticism*, Cambridge: Cambridge University Press.

- (1998). *Becoming Divine: towards a feminist philosophy of religion*, Manchester: Manchester University Press.

Johnston, C. and P. Willemen (1997). '*Nightcleaners*: Brecht and Political Film-Making Practice', in J. Mastai (ed.) *Social Process/ Collaborative Action: Mary Kelly 1970-75*, Vancouver, Charles H. Scott Gallery.

Jones, A. (1998). 'Maksymluk, Meskimmon and Me', *Make*, 80, June – Sept: 36-7.

Judd, Donald (1975). 'Specific Objects', *Collected Writings*. Halifax, Nova Scotia: Nova Scotia College of Art and Design.

Kant, Immanuel, (1929 [1933]). *Critique of Pure Reason*, Norman Kemp Smith (trans), London: Macmillan.

- (1960). *Observations on the Feeling of the Beautiful and Sublime*, John T. Goldthwait (trans), Berkeley: University of California Press.

- (1973). *Critique of Judgement*. James Creed Meredith (trans.), Oxford: Oxford University Press.

- (1974). *Anthropology from a Pragmatic Point of View*, trans. Mary J. Gregor, The Hague: Nijhoff.

Kelly, Eamonn (1996). *Sheela-na-Gigs: Origins and Functions*, Dublin: Country House in Association with The National Museum of Ireland.

Kelly, George Armstrong (1973, engl. org. 1965) 'Bemerkungen zu Hegels "Herrschaft und Knechtschaft"', *Materialien zu Hegel's Phänomenology des Geistes*. Hans Friedrich Fulda and Dieter Henrich (eds.), Frankfurt: Suhrkamp: 189-216.

Kelly, Mary, (1996). *Imaging Desire*, Cambridge/Massachusetts: MIT Press.

- (1983). *Post-Partum Document*, Routledge and Kegan Paul.

Kempner, Hans-Georg, and Vietta, Silvio (1975). *Expressionismus*. Munich: Wilhelm Fink Verlag.

Key, Joan (1997). 'Unfold: Imprecations of Obscenity in the Fold', in Steyn, Juliet (ed). *Other Than Identity: The Subject, Politics, and Art*, 185-197, Manchester: Manchester University Press.

Kirby, V. (1997). *Telling flesh: the substance of the corporeal*, New York, London: Routledge.

Kittler, Friedrich A (1990). *Discourse Networks 1800/1900*, trans. Michael Metteer with Chris Cullens, Stanford University Press, Stanford CA.

- (1997). *Literature, Media, Information Systems: Essays* (ed. and intro.) John Johnston, G+B Arts International, Amsterdam.

- (1999), *Gramophone, Film, Typewriter*, (trans. and intro.) Geoffrey Winthrop-Young and Michael Wutz, Stanford University Press, Stanford.

Kojève, Alexandre (1958 franz. org. 1947). *Hegel: Eine Vergegenwärtgung seines Denkens. Kommentar zur Phänomenologie des Geistes*. J. Fletscher (ed.), Stuttgart.

Korsmeyer, Carolyn (ed.) (1998). *Aesthetics: The Big Questions*, Oxford: Blackwells.

- (1999). *Making sense of Taste: Food and Philosophy*. Cornell UP.

Kosuth, J. (1991). *Art After Philosophy and After: Collected Writings, 1966-1990*, Cambridge/Massachusetts: MIT Press.

Krauss, R. (1994). *The Optical Unconscious*, Cambridge/Massachusetts and London: MIT Press.

Kristeva, Julia (1980). *Desire in Language, A Semiotic Approach to Literature and Art*, translators Thomas Gora, Alice Jardine and Leon Roudiez, ed. Leon Roudiez. New York: Columbia University Press.

- (1986). 'Woman's Time' in *The Kristeva Reader* (ed.) Toril Moi, New York: Blackwell. 187-213.

- (1989). *Black Sun: Depression and Melancholia*, trans. L.S.Roudiez, Columbia University Press.

- (1998). 'A Conversation between Julia Kristeva and Ariane Lopez-Huici' in Beckley, Bill with Shapiro, David (eds) *Uncontrollable*

Beauty: toward a new aesthetics, New York: Allwoth Press, 325-330.

Kwon, M. (1995). 'Bloody valentines: after images by Ana Mendieta', in M.C. de Zegher, *Inside the visible: an elliptical traverse of 20th century art*, Cambridge/Massachusetts: MIT Press: 165-171.

Lacan, Jacques (1953). 'The function and field of speech and language in psychoanalysis', in *Écrits: A Selection*, trans. A. Sheridan, W.W. Norton and Company, 1977.

- (1958). 'Propos directifs pour un congers sur la sexualite feminine', in Jacques Lacan, *Écrits*, Seuil, 1966: 725-736. ['Guiding Remarks for a Congress on Feminine Sexuality', trans. Jacquline Rose, in Juliet Mitchell and Jacquline Rose (eds), *Feminine Sexuality: Jacques Lacan and the ecole freudienne* (1982), London: Macmillan: 86-98].

- (1972). *Ou pire*, unedited seminar 1972.

- (1973). 'L'etourdit', *Silicet*, no.4, pp 5-52, Paris: Seuil.

- (1975 [1972-1973]). *Le Seminair, Livre XX: Encore*, Paris: Seuil.

- (1975-6). *Le Synthome*, unedited seminar.

- (1977a). *The Four Fundamental Concepts of Psycho-Analysis*, trans. A. Sheridan, The Hogarth Press and the Institute of Psychoanalysis.

- (1977b). *Écrits: A Selection*, Alan Sheridan (trans.), London: Tavistock.

- (1986). *Le Seminair, Livre VII: L'ethique de la psychoanalyse*, (ed. J.A. Miller). Paris: Seuil.

- (1992). *The Ethics of Psychoanalysis 1959-1960* (trans.), Denis Potter, London: Routledge.

Leibniz (1973). *Philosophical Writings*, G.H.R. Parkinson (ed.), Mary Morris and G.H.R. Parkinson (trans.), London: Dent.

Levinas, Emmanuel (1969). *Totality and Infinity*, translated by Alphonso Lingis, Pittsburgh: Duquesne University Press.

- (1972). Humanisme de l'autre homme, Fata Morgana Levison, Jerrold (ed.) (1998). Aesthetics and Ethics: Essays at the *Intersection*, CUP.

Lichtenberg Ettinger, Bracha (1992). 'Matrix and Metamorphosis', in *differences*, Vol. 4, No. 3: 176-206.

- (1993). 'Matrix: a Shift Beyond the Phallus', Paris: BLE Atelier.

- (1994). 'The Becoming Threshhold of Matrixial Borderlines', in Robertson (1994), *Travellers' Tales: Narratives of Home and Displacement*, London: Routledge.

- (1995). *The Matrixial Gaze*, Feminist Arts & Histories Network, Department of Fine Arts, University of Leeds publication.

- (1996). 'The With-in-Visible Screen', in de Zegher, C. (ed.), *Inside the Visible*.

- (1997). 'The Feminine/pre-natal weaving in the Matrixial subjectivity-as-encounter', in *Psychoanalytic Dialogues*, 7: 3. New York: Analytic Press.

- (1998). *The Fascinating Face of Flanders*, Stad. Antwerpen.

- (1999). *Régard et éspace-de-bord matrixiels*, Bruxelles: La Lettre Volée.

- (forthcoming). *Matrixial Gaze and Borderspace*, Minneapolis: Minnesota University Press.

Lichtenberg Ettinger, Bracha and Levinas, Emmanuel (1993). *Time is the Breath of the Spirit*, Oxford: MOMA Oxford.

- (1997). *What Would Eurydice Say?* Paris: BLE Atelier.

Lichtenstein, Alfred (1962). *Gesammelte Gedichte* (ed.), Klaus Kanzog, Zürich: Arche.

Lippard, L. (1995). *The Pink Glass Swan: Selected Feminist Essays on Art*, New York: The New Press.

Lippman, Edward A. (1964). *Musical Thought in Ancient Greece*, London/ New York: Columbia University Press, 2.

Loftus, Belinda (1990). *Mirrors: William III and Mother Ireland*, Dundrum: Picture Press.

Longley, Edna (1990). *From Cathleen to Anorexia: The Breakdown of Ireland*, Dublin: Attic Press.

Loraux, Nicole (1995). *The Experiences of Tiresias: the Feminine and the Greek Man*, Princeton: Princeton University Press.

Lury, Karen and Doreen Massey (1999). 'Making Connections', in *Screen*, Vol. 40, No. 3, Autumn, 229-238.

Lyotard, J.F. (1997). 'L'anamnese', in Seppala, M. (ed.), *Doctor and Patient*, Pori Art Museum Publication (Porin Taidemuseo).

- (1978). 'Acinema' (trans.), J.F. Lyotard and Paisley N. Livingstone, *Wide Angle*, Vol. 2, No. 3, 52-9; reprinted in Lyotard, Jean François (1989), *The Lyotard Reader*, ed. Andrew Benjamin, Oxford: Blackwell, 169-80.

- (1994). *Lessons on the Analytic of the Sublime* (trans.), Elizabeth Rottenberg, Stanford: Stanford University Press.

Maldiney, H. (1970). 'L'equivoque de l'image dans la peinture', in *Regard, parole, Espace*, Lausanne: L'Homme Nouveau.

Maloon, T. (1978). 'Mary Kelly, Interview', *Artscribe*, 13: 16-19.

Marks, Laura U. (1994). 'Deterritorialized Filmmaking: A Deleuzian Politics of Hybrid Cinema', in Screen, Vol. 35, No. 3, Autumn, 244-264.

- (1998). 'Video haptics and erotics', *Screen*, 39, 4: 331-348.

Massey, Doreen (1992). 'A Place Called Home?' in *New Formations*, No.17, Summer, 3-15.

- (1993). 'Power-geometry and a progressive sense of place', in John Bird, Barry Curtis, Tim Putnam, George Robertson and Lisa Tickner (eds.), *Mapping the Future: Local Cultures, Global Change*, London: Routledge, 59-69.

Massumi, B. (1992). *A user's guide to capitalism and schizophrenia: deviations from Deleuze and Guattari*, Cambridge/Massachusetts: MIT Press.

Mastai, J. (1997). *Process/Collaborative Action: Mary Kelly 1970-75*, Emily Carr Institute of Art and Design, Vancouver.

McClain, Ernest G. (1978). *The Pythagorean Plato: Prelude to the Song Itself*. New York: Nicolas Hays Limited.

McClary, Susan (1991). *Feminine Endings: Music Gender and Sexuality*. Minneapolis/Oxford: Minnesota Press.

Meaney, Gerardine (1993). 'Sex and Nation: Women in Irish Culture and Politics', in Ailbhe Smyth (ed.), *Irish Women's Studies Reader*, Dublin: Attic Press, pp. 230-244.

Merleau-Ponty, Maurice (1962). *The Phenomenology of Perception*, translated by Colin Smith. London: Routledge and Kegan Paul.

Meskimmon, Marsha (1998). 'In Mind and Body: Feminist Criticism Beyond the Theory/Practice Divide', *Make: The Magazine of Women's Art*, March to May: 3-8.

- (1999). *'We Weren't Modern Enough': Women Artists and the Limits of German Modernism*. University of California Press.

Mills, Lia (1995). '"I Won't Go Back to It": Irish Women Poets and the Iconic Feminine', *Feminist Review*, 50: 69-88.

Mills, Patricia (ed) (1996). *Feminist Interpretations of G. W. F. Hegel*, Pennsylvania: Pennsylvania UP.

Mitchell, W.J.T. (1994). *Picture Theory*, Chicago: The University of Chicago Press.

- (1995). 'Representation', in F. Lentricchia and T. McLaughlin (eds.), *Critical Terms for Literary Study*, Chicago: University of Chicago Press: 11-22.

- (1996). 'What Do Pictures Want?' *October*, 77, Summer, 71-82.

Moi, Toril (1985). *Sexual/Textual Politics: Feminist Literary Theory*, London: Methuen.

Morrison, T. (1974). *Sula*, New York: Bantam Books.

Morse, Margaret (1998). *Virtualities: Television, Media Art, And Cyberculture*, Bloomington: Indiana University Press.

Mosco, Vincent (1996). *The Political Economy of Communication: Rethinking and Renewal*, London: Sage.

Mothersill, Mary (1992). 'Beauty', *A Companion to Aesthetics* (ed.), David Cooper. Oxford: Blackwell Publishers.

Mullin, Molly (1991). 'Representations of History, Irish Feminism, and the Politics of Difference', *Feminist Studies*, 17.1: 29-50.

Mulvey, L. (1989). *Visual and Other Pleasures*, London: Macmillan.

Negroponte, Nicholas (1995). *Being Digital*, London: Coronet.

Nemser, C. (1970). 'An Interview with Eva Hesse' *Artforum* 9, May.

Newman, Barnett (1990). 'The Sublime is Now' in John P. O'Neill (ed). *Barnett Newman: Selected Writings and Interviews*. New York: Alfred A. Knopf.

Nicholson, Linda (ed) (1990). *Feminism/Postmodernism*, New York and London: Routledge.

Nietzsche, Friedrich (1990). *Twilight of the Idols*, R. J. Hollingdale (trans.), London: Penguin.

Olkowski, D. (1999). *Gilles Deleuze and the ruin of representation*, Berkeley: University of California Press.

Ormiston, Gayle L. (1988). 'The Economy of Duplicity: Différance', in David Wood and Robert Bernasconi (eds.), *Derrida and Différance*, Evanston, IL: Northwestern University Press.

Osborne, Peter (1995). *The Politics of Time: Modernity and the Avant-Garde*, London: Verso.

Osbourne, P. and Segal, L. (1994). 'Gender as performative': an interview with Judith Butler (London October 1993), in *Radical Philosophy*, 67: 32-39.

Ovid, (1955). *Metamorphoses*, Penguin Classics.

Owens, C. (1980). 'The Allegorical Impulse: Toward a theory of postmodernism', in S. Bryson et al (ed.), *Beyond Recognition: Representation, Power and Culture*, University of California Press.
- (1983) 'The Discourse of Others: Feminism and Postmodernism', in H. Foster (ed.), *The Anti-Aesthetic: Essays on Postmodern Culture*', Port Townsend: Bay Press. Oxford: Oxford University Press, 242-56.

Patton, Paul (ed.) (1996). *Deleuze: A Critical Reader*, Oxford: Blackwell.

Peirce, C.S. (1955). *Philosophical writings of Peirce*, New York: Dover Publications.

Pensky, M. (1993). *Melancholy Dialectics: Walter Benjamin and the Play of Mourning*, Amherst: University of Massachusetts Press.

Phelan, Peggy (1993). *Unmarked: The Politics of Performance*, London: Routledge.

Pinthus, Kurt (ed.) (1993). *Menschheitsdämmerung*, Berlin: Rowohlt (1st edition: 1920).

Plato (1914). *Phaedo*, H.N. Fowler (trans.), Loeb Classical Library, Harvard UP.

- (1925). *Philebus,* H.N. Fowler (trans.), Loeb Classical Library, Harvard UP.

- (1926). *The Laws*, R.G. Bury (trans.), Loeb Classical Library, Harvard UP.

- (1929). *Timeaus*, R.G. Bury (trans.), Loeb Classical Library, Harvard UP.

- (1930). *The Republic*, Paul Shorey (trans.), Loeb Classical Library, Harvard UP.

- (1951). *Symposium,* Walter Hamilton (trans.), London: Penguin.

- (1985). *Phaedrus and Letter VII and VIII,* Walter Hamilton (trans.), London: Penguin.

Pollock, Della (1998). *'Performing Writing: The Ends of Performance',* Peggy Phelan and Jill Lane (eds), New York and London: New York University Press.

Pollock, Griselda (1988). *Vision and Difference: Femininity, Feminism and Histories of Art*, London: Routledge.

- (1988) 'Screening the Seventies: sexuality and representation in feminist practice, a Brechtian perspective', in G. Pollock, *Vision and Difference*, Routledge.

- (1992). 'Painting, Feminism, History', in Barrett, Michele and Phillips, Anne, (ed.), 1992, *Destabilizing Theory: Contemporary Feminist Debates*, Cambridge UK: Polity Press: 138-176.

- (1996). *Generations and Geographies in the Visual Arts: Feminist Readings*, London: Routledge.

- (1996). 'Gleaning in History or Coming After/Behind the Reapers', in *Generations and Geographies in the Visual Arts*, London: Routledge.

- (1999). *Differencing the Canon: Feminist Desire and the Writing of Art's Histories*, London and New York: Routledge.

Probyn, E. (1990). 'Travels in the Postmodern: Making Sense of the Local', in *Feminism/Postmodernism*. Ed. L. Nicholson. New York and London: Routledge.

Quilligan, J. (1979). *The Language of Allegory: Defining the Genre.* Cornell University Press.

Rego, P. (1998). *Paula Rego*, London: Dulwich Picture Gallery.

Riviere, Joan (1928). 'Womanliness as Masquerade', in Victor Burgin, James Donald and Cora Kaplan (eds) (1989) *Formations of Fantasy*, London: Routledge.

Robinson, Hilary (1995a). 'Irish/Woman/Artist: Selected Readings', *Feminist Review*, 50: 98-110.

- (1995b). 'Reframing Women', *Circa* 72 (1995), pp. 18-23.

- (1997). 'Within the Pale in *From Beyond the Pale*: The Curation of "femininity" in an Exhibition Season at the Irish Museum of Modern Art', *Journal of Gender Studies* 6.3: 255-267.

- (2000). '"Woman" to Disruptive Women Artists: An Irigarayan Reading of Irish Visual Culture', *Irish Studies Review*, Vol.8, No.1.

Rodowick, D. N. (1997). *Gilles Deleuze's Time Machine*, Durham NC: Duke University Press.

Rose, Jacqueline (1986). *Sexuality in the Field of Vision*, Verso.

Rose, M. A. (1993). *Parody: Ancient, Modern and Post-Modern*, Cambridge: Cambridge University Press.

Rosen, Stanley (1987). *Plato's Symposium* (2nd ed.), New Haven & London: Yale University Press.

- (1988). *The Quarrel Between Philosophy and Poetry*, London: Routledge.

Roth, Richard and Roth, Susan King (1998). *Beauty is nowhere: ethical issues in art and design*, Amsterdam: G&B International.

Rowley, Alison (1996). 'On Viewing Three Paintings by Jenny Saville: Rethinking a Feminist Practice of Painting', in Pollock, Griselda 1996, *Generations and Geographies in the Visual Arts: Feminist Readings*, London: Routledge: 88-109.

Rutherford, R. B. (1995). *The Art of Plato*, London: Duckworth Sampson, E.E. (unpublished conference paper) 'To think differently: the acting ensemble – a new unit for Psychological Inquiry', unpublished conference paper presented at the Millennium World Conference in Critical Psychology, University of Western Sydney, Sydney, April 1999.

Sampson, E.E. (1999). *'To Think Differently: The Acting Ensemble – A new Unit for Psychological Inquiry'*, Millennium World Conference in Critical Psychology, University of Western Sydney, unpublished presentation.

Santner, E. (1995). 'Postmodernism's Jewish Question: Slavoj Zizek and the Monotheistic Perverse', in L. Cooke and P. Wollen (eds.), *Visual Display: Culture Beyond Appearances*, Dia Center for the Arts, New York and Bay Press.

Sassen, Saskia (1991). *The Global City: New York, London, Tokyo*, Princeton NJ, Princeton University Press.

- (1994). *Cities in a Global Economy*, Thousand Oaks CA: Pine Forge.

Saussure, Ferdinand de (1996). *Course in General Linguistics*, Charles Bally and Albert Sechehaye and Albert Riedlinger (ed.), Wade Baskin (trans). New York: McGraw-Hill Book Company.

Schiesari, J. (1992). *The Gendering of Melancholia: Feminism, Psychoanalysis, and the Symbolics of Loss in Renaissance Literature*, Cornell University Press.

Schneider, Rebecca (1997). *The Explicit Body in Performance*, London and New York: Routledge.

Schulte, Gunter (ed.) (1996). Hegel, Munich: Diederichs.

Shankman, Steven (ed.) (1994). *Plato and Postmodernism*, Pennsylvania: Aldine Press Ltd.

Silverman, K. (1988). *The Acoustic Mirror: the Female Voice in Psychoanalysis and Cinema*. Bloomington: Indiana University Press.

Simon, S. (1996). *Gender in Translation Cultural Identity and the Politics of Transmission*, London/NY: Routledge.

Simpson, Lorenzo C. (1995). *Technology, Time and the Conversations of Modernity*, London: Routledge.

Smith, B. (ed.) (1983). *Home Girls. A Black Feminist Anthology*, New York: Women of Color Press.

Smith, Daniel W. (1996). 'Deleuze's Theory of Sensation: Overcoming the Kantian Duality' in Patton, P. *Deleuze: A Critical Reader*, Oxford: Blackwell.

Smith, P. (1982). 'No Essential Femininity: A conversation between Mary Kelly and Paul Smith,' *Parachute*, 26: 29-35.

Sobchak, Vivian (1992). *The Address of the Eye: A Phenomenology of Film Experience*, Princeton: Princeton University Press, (1999); 'Nostalgia for a Digital Object: Regrets on the Quickening of QuickTime', in *Millennium Film Journal*, No.34, 4-23.

Spero, Nancy (1987). *Inscribing Woman between the Lines*, Exhibition Catalogue with texts by Jon Bird and Lisa Tickner. London: ICA.
- (March 1988). 'Sky Goddess, Egyptian Acrobat', *Art Forum International*, 26.
- (1994). *Nancy Spero: Wall Printing Project*, Malmö Konsthall.

Stacey, J. (1994). *Star Gazing: Hollywood Cinema and Female Spectatorship*, New York and London: Routledge.

Stewart, S. (1993). *On Longing: Narratives of the Miniature, the Gigantic, the Souvenir, the Collection*, Duke University Press.

Still, Judith & Worton, Michael (eds). *Textualities and Sexualities: Reading Theories and Practices*. Manchester: Manchester UP.

Studer, Claire. (1918). *Mitwelt*. Berlin: Verlag *Die Aktion*.

Sylvester, D. (1980). *Interview with Francis Bacon 1962-1979*, Oxford: Thames and Hudson.

Taussig, M. (1994). *Mimesis and alterity: a particular history of the senses*, New York, London: Routledge.

Tavener, John (1995). 'The Sacred in Art' *Contemporary Music Review*. 1995,Vol.12 Part 2: 49-54.

Thrift, N. (1997). 'The Still Point: Resistance, Expressive Embodiment and Dance'. In Steve Pile and Michael Keith (eds.), *Geographies of Resistance*. London, New York: Routledge: 124-151.

Tuana, Nancy (ed.) (1994). *Feminist Interpretations of Plato*, Pennsylvania: The Pennsylvania State University Press.

Vasseleu, Catheryn (1998). *Textures of Light: Vision and Touch in Irigaray, Levinas and Merleau-Ponty*, Routledge.

Verstraete, Ginette (1998). *Fragments of the Feminine Sublime*. Albany, New York: SUNY Press.

Vertov, Dziga (1984). *Kino-Eye: The Writings of Dziga Vertov*, ed. Annette Michelson, trans. Kevin O'Brien, Berkeley: University of California Press.

Virilio, Paul (1995). *The Art of the Motor*, trans. Julie Rose, University of Minneapolis: Minnesota Press.
- (1996). *Un paysage d'événements*, Paris: Galilée.
- (1997). *Open Sky*, trans. Julie Rose, London: Verso.
- (1998). *Cybermonde: la politique du pire*, entretien avec Phillippe Petit, textuel/Seuil, Paris.
- (2000). *Polar Inertia*, trans. Patrick Camiller, London: Sage.

Vlastos, Gregory (1991). *Socrates: Ironist and Moral Philosopher*, Cambridge: Cambridge University Press.

Walker, Alice (1992). *Possessing the Secret of Joy*, New York: Harcourt, Brace, Jovanovich.

Walker, Alice and Parmar Pratibha (1993). *Warrior Marks. Female Genital Mutilation and the Sexual Blinding of Women*, London: Jonathan Cape.

Walker, John (1978). *John Constable*, New York: Harry N. Abrams, Inc.

Wallace, Michelle (1993). 'Modernism, Postmodernism and the Problem of the Visual in Afro-American Culture' in Hein, Hilde and Korsmeyer, Carolyn, *Aesthetics in Feminist Perspective*, Bloomington: Indiana U.P., 194-205.

Weigel, S. (1996). *Body and Image-Space: Re-reading Walter Benjamin*, trans. G. Paul, R. McNicholl and J. Gaines, Routledge.

Welchman, J. (1995). *Modernism relocated: towards a cultural studies of visual modernity*, St. Leonards, N.S.W: Allen and Unwin.

Werkmeister, Otto Karl (1999). Icons of the Left: Benjamin and Eisenstein, Picasso and Kafka, after the fall of Communism. Chicago, Illinois, University of Chicago Press.

West M.L. (1992). *Ancient Greek Music*, Oxford: Clarendon Press.

White, J. (1957). *The Birth and Rebirth of Pictorial Space*, London: Faber.

Whitford, Margaret (1986). 'Luce Irigaray and the Female Imaginary: Speaking as a Woman', *Radical Philosophy*, No.43: 3-8.
- (1991a). *Luce Irigaray: Philosophy in the Feminine*, New York, London: Routledge.
- (1991b). 'Irigaray's Body Symbolic', *Hypatia*, Vol. 6, No.3: 97-110.

Wilde, O. (1980). *The Complete Works of Oscar Wilde*, (ed.), J.B Foreman, London: Book Club Associates.

Williams, James (1997). 'Deleuze on J.M.W. Turner: Catastrophism in Philosophy?', in *Deleuze and Philosophy*, Keith Ansell Pearson (ed). London: Routledge.

Wilson, S. et al. (1996). *Orlan*, London: Black Dog Publishing.

Winner, Langdon (1977). *Autonomous Technology: Technics-Out-Of Control as a Theme in Political Thought*, Cambridge/Massachusetts: MIT Press.

Winterson, J. (1985). *Oranges Are Not the Only Fruit*, London: Pandora Press.

Wolff, Janet (1999). 'Women at the Whitney, 1910-1930: Feminism, Sociology, Aesthetics', *Modernism/Modernity*, Vol. 6, No. 3 Sept., 117-138.

Wolin, R. (1982). *Walter Benjamin: An Aesthetic of Redemption*, Columbia University Press.

Yakir, Nedira (1998). 'Cornubia: gender, geography and genealogy in St Ives modernism', in Deepwell, Katy (ed.), *Women Artists and Modernism*, New York/Manchester: Manchester University Press, 112-129.

Zegher, Catherine Ed. (1996). *Inside the Visible*, Cambridge/Massachusetts: MIT Press.

Zorach, R. (1999). 'Despoiled at the Source', *Art History*, Vol.22, No.2: June.

Index

357